For the Flourishing C I T Y of,

PHILADELPHIA.

The SNOW PEN,

JOHN Mc. CADDON, Master,

Burthen 260 Tuns,

Well known to be the most healthy and cheapest place in all *America*.

A Stout Vessel and a prime Sailor, will Sail the 1st, of May.

ALL young Men and youg Women, who have a mind to better their fortunes, will meet with proper e____ ____ing to Mrs. *Mc. Donough* in *Bruce's L*____ may be seen every Day. For freight or pa____ Lawton and Brown, near the Draw-Bridge.

Printed by S. Mc. INERNEY in Meeting-house Lane.

City of Independence

View of the City of Philadelphia.

City of Independence

Views of Philadelphia Before 1800

Martin P. Snyder

Praeger Publishers · New York

Front endpaper: Free Library of Philadelphia.
Back endpaper: The Historical Society of Pennsylvania.
Frontispiece: For a description of this plate, see item 164.

Published in the United States of America in 1975
by Praeger Publishers, Inc.
111 Fourth Avenue, New York, N. Y. 10003

Library of Congress Catalog Card Number: 74–29313
ISBN 0-275-22030-3

Designed by Gilda Kuhlman

Printed in the United States of America

To June, my wife and researcher extraordinary

Contents

Preface

ALL CITIES have grown from nothing, but in no other American city is the process of growth more retraceable from the record of views and maps than in Philadelphia. The city was conceived as an entity and thereafter plotted on paper almost 300 years ago, when only a few primitive dwellings stood on the spot. It has followed the pattern of growth planned for it; a pattern that helped set the style in the United States and thus far has served adequately as a background design for movement, activities, and cultural developments far beyond the contemplation of its founder, William Penn.

As the 200th anniversary of the birth of the United States approaches, the *pictorial* record of early Philadelphia becomes ever more important to a nation now widely appreciative of the *written* records of its beginnings. Here Philadelphia mirrors the common experience of American development. Its aspect and growth were not unique. In many ways they paralleled those of other colonial towns and of the cities west of the Atlantic seaboard.

Through engravings, paintings, drawings, and maps, made both in this country and in Europe during those early years, this book traces Philadelphia's extraordinary development: from its planting in the 1680's as a river town; its years as the informal capital of the Thirteen Colonies; through the close of the year 1800, when it ceased to be the capital of the United States.

For a better understanding of the visual material, it is presented in chronological chapter groupings, each preceded by a brief general description. Within each chapter is the story of how the various items presented came into being, with comments as to their makers.

The subject matter is not limited to "prints," printed in duplicate copies from a copper or wooden plate. While it includes them, it also covers paintings, parts of paintings (portrait backgrounds), watercolor drawings, and pen-and-ink or pencil drawings. Of all of these, only one copy was made. Despite this generality, two types of omitted items should be mentioned.

The first consists of plans for intended as well as existing structures that lack features giving some additional flavor. Examples are architects' plans, the plans

prepared for Independence Hall and Cliveden Mansion, and plans for proposed bridges across the Schuylkill River at Peters Island in modern Fairmount Park (1786) and at Market Street (1796).

The second type of omitted items consists of ground plans or surveys simply showing property or street lines. Examples are a manuscript volume of plans (c. 1745) by William Parsons reproduced by Nicholas B. Wainwright in his "Plan of Philadelphia," *Pennsylvania Magazine of History and Biography* 80 (1956): 164; a similar volume *A Plan with the Measures of all the Squares, Streets, Lanes & Alleys* at the Free Library of Philadelphia (1786); an undated survey by Reading Howell of lands owned by Robert Morris along the Schuylkill River north of the city; and a plan of thirty-six lots between Locust and Spruce streets as advertised for auction 10 March 1792 and later in *Dunlap's American Daily Advertiser*. Simple plans and surveys do not convey enough of the spirit of a place to warrant inclusion.

Maps, on the other hand, are cardinal to an appreciation of the features of a place and how it developed. Hence, for example, the original grid plan for Philadelphia, while factual only in part, must be included. Except for the diagonal gash of the Benjamin Franklin Parkway and the green of the Independence National Historical Park area, today's map of center-city Philadelphia posted in telephone booths is amazingly unchanged from William Penn's original grid plan of 1683.

The value, for our purposes, of the building elevation is less than that of maps and perspective pictures but greater than that of ground plans and surveys. Admittedly limited in scope, the elevation can be a useful form.

A line of division sometimes difficult to discern is that between the realistic and the fanciful or imaginary treatment appearing in certain early pictures. The widely known painting of William Penn's treaty with the Indians sprang from Benjamin West's imagination; yet a 1735 watercolor of the city drawn in England from description or memory is so clearly based on fact as to require inclusion despite its fanciful aspects. So-called fictitious views like West's are not treated in the body of the work but have been listed in an appendix.

The geographical area selected is that of the modern city of Philadelphia. The extent of the city was greatly enlarged in 1854 with the Act of Consolidation adopted by the Pennsylvania legislature. However, important items dealing with the outlying area are included in a separate appendix. They are intended to be illustrative rather than complete.

Another sometimes difficult line of division involves the cutoff date of 1800. Many old pictorial items are undated. In exercising informed judgment, recourse must be had to analysis of the paper, knowledge of the artist (and engraver) if he is known, style, the stage of development of the city, and internal evidence. Thus, as examples, paintings of Chalkley Hall (privately owned) and the *Blowing Up of the British Frigate Augusta* in 1777 (Historical Society of Pennsylvania), together with woodcuts of Rickett's Circus, Lailson's Circus, and the South Street Theatre, have not been included here.

The process is sometimes complicated by the existence of retrospective views. Although a picture may show a scene earlier than that viewed by the artist when

he drew it, as in the case of the meeting of Congress in the John Trumbull and Robert Edge Pine–Edward Savage paintings hereafter treated, it merits consideration if the picture itself was created before 1801. But pictures drawn in that year or later have been excluded even where they purport to depict an eighteenth-century subject. In order to enable the purchaser or collector to differentiate, facsimiles and reprints made after 1800 of works discussed herein are listed.

The standard reference works of broad scope should be consulted in addition to the more specialized ones cited herein, particularly David McNeeley Stauffer's *American Engravers upon Copper and Steel* and Mantle Fielding's continuation of that work; George C. Groce and David H. Wallace, *The New-York Historical Society's Dictionary of Artists in America 1564–1860*; the Philadelphia city directories; and for perspective on architectural development George B. Tatum's *Penn's Great Town*. A helpful modern map of the area involved, locating the early structures on the current street plan, is *Part of Old Philadelphia* by Grant Simon, published by The American Philosophical Society in 1952.

For the scholar and collector technical data are given as to title, artist, the medium in which the work was done (the etching and engraving processes both being listed as engraving), date, size, states, and any attribution of authorship and publication it may carry. Untitled items have been assigned titles, which appear in parentheses. The whereabouts of oils and drawings, and of prints found only at one location, are listed.

A numbering system has been introduced under which earlier and later states of the numbered items are assigned capital-letter suffixes, while reprints and copies are assigned lowercase-letter suffixes. Measurements are in inches, height being stated first.

Figures 22, 33, 42, 46, 94, 95, 96, 101, 102, 110, 116, 137, 143, 151, and 170 and items (100A) and (167) are also reproduced in color. Photographic credits that accompany the illustrations indicate the location of the items shown. When no caption appears, the item is in the author's collection.

Reference works dealing with the numbered items treated are listed in the notes at the back of the book. The notes are arranged under the chapter and title headings and according to the sequence of the numbered items.

An iconography does not seek to judge the relative merit of artistic renderings. Except for general comments as to quality, it seeks to set out the complete visual record (which is necessarily uneven artistically) of the development of a place and its people.

MARTIN P. SNYDER

1

Grid Plans Projecting
A New-World Town

Tʜᴇ ɢʀᴀɴᴛ by Charles II of the vast area of Pennsylvania placed William Penn in what was then an almost unheard-of position. Suddenly he had the great wealth of 45,000 square miles of land which he knew would support agriculture and commerce, but this wealth was nonliquid. Penn became perforce a real-estate promoter and developer on a colossal scale, which for his time far exceeded the largest land development projects of today. The magnitude of Penn's task can be visualized by imagining ourselves, unqualified as engineers or community planners, projecting a real-estate development the size of eastern Pennsylvania in some remaining open area on the American continent.

To convert his real property into usable cash, Penn had to sell tremendous acreages in the New World. To sell, he had to find buyers. To induce buying, he had to find persons who would be willing to emigrate and become settlers, develop their lands, conduct new business enterprises, and by such activities confer increased value on the portions of Penn's provincial grant remaining unsold.

All buyers like a good investment, but settlement on the large scale Penn required called for inducements. Escape from religious intolerance was a great attraction, but he could not sit idly by in reliance upon this alone. He developed contacts throughout England and Wales. He established Quaker agents in Holland to persuade continentals suffering from persecution to emigrate. He engaged in many of the promotional activities of later developers, such as offering free bonus land to those who would commit themselves to purchase a sizable acreage. To those required to emigrate as servants, he offered the opportunity to become landowners ultimately. He made use of a developer's brochure like those of today.

Penn envisioned and called for the plotting of a very large acreage for his initial town to be carved from the forest. But those who preceded him found that the banks of the Delaware, along which the settlement was planned, were already occupied by settlers. When Penn arrived in person, he reduced his projections by deciding on a town area forming a band of land a mile wide, extending two miles between the Delaware River on the east and the Schuylkill River on the

west. This chosen site legally became a town, then a borough, and in Penn's Charter of 1691 a "city"—a term to be understood in the context of those times.

Penn's surveyor general drew a plan of the area and its projected use, which Penn lost no time in transmitting to London as a tangible inducement to settlers. The plan was broad-gauge and simple. It divided the area into a checkerboard without regard to refinements affecting individual plots, and for the most part ignored topography—a fact which later caused considerable trouble for Penn. The plan was reproduced on a copperplate, and the engravings taken from the plate were issued as part of a printed promotional brochure. The plan was copied and reissued with similar brochures distributed in Holland and Germany. For some decades the plan appeared as an inset on maps of the broader area of the Province of Pennsylvania, and even on European sailing charts. Not until 1762, however, was a map published that depicted the city as it had actually developed.

Thomas Holme's Portraiture of Philadelphia, 1683

The conscious advance layout of the city of Philadelphia into squares has often been mentioned as a very early example of city planning and as evidence of William Penn's farsightedness. But he had precedents. The great fire of London in 1666 was a vivid memory, and Penn had witnessed the orderly rebuilding of that city. The standard grid form of military camps was well known. Burlington, New Jersey, with which Penn was fully familiar, had been laid out in similar form in 1677. There was every reason for Penn to be aware of the desirability of a network of streets intersecting at right angles and of lots sufficiently large to prevent the spread of fire.

Nonetheless, this was one of the first cities fully planned at birth. Today the truly unique and beneficial start given to Philadelphia is taken for granted. The grid plan is commonplace in American cities. A degree of order has been brought out of the chaotic, if appealing, street arrangements of many European cities by deliberate surgery and by rebuilding after wars. But granted that, with unlimited space available, Penn had an opportunity given to few, he acted upon it in a way that later imitation has stamped with high approval.

There is, then, much more than ordinary significance in our having a visual record of the original plan for Philadelphia made on Penn's instruction at the time of the first colonization. As in most cases of early pictorial material, this record was a response to a practical need.

Penn needed a plan of his proposed city that would show prospective purchasers both the advantages of the general layout and just where their acreage would lie in relation to the whole. The plan prepared by his surveyor general, Thomas Holme, was done on the spot. The outer boundaries once selected, the area within them was broken into numbered lots, except for five large squares set aside for recreation. Since settlement was expected to spread inward from both rivers, the plan gave equal emphasis to both the Schuylkill and the Delaware sides. Yet the two waterfronts, which were the most accessible points, were not apportioned for ownership. The plan showed that along the Delaware waterfront a scattering of homes was already in existence.

In *A Short Advertisement upon the Scituation and Extent of the City of Philadelphia And the Ensuing Plat-form thereof,* Holme wrote that

the Model of the City appears by a small Draught now made, and may hereafter, when time permits, be augmented; and because there is not room to express the Purchasers Names in the Draught, I have therefore drawn Directions of Reference, by way of Numbers, whereby may be known each mans lot and Place in the City. . . . The City, (as the Model shews) consists of a large Front-street to each River, and a High-street (near the middle) from Front (or River) to Front, of one hundred Foot broad, and a Broad-street in the middle of the City, from side to side, of the like breadth.

In August 1683 Penn sent Holme's material to the Society of Traders in London with a lengthy letter in which he reported:

Philadelphia . . . is at last laid out to the great Content of those here, that are any wayes Interested therein: The Scituation is a Neck of Land, and lieth between two Navigable Rivers, Delaware and Skulkill, whereby it hath two Fronts upon the Water, each a Mile, and two from River to River. . . . I say little of the Town it self, because a PLAT-FORM [Holme's plan] will be shewn you by my Agent, in which those who are Purchasers of me, will find their Names and Interests. . . . It is advanced within less than a Year to about four Score Houses and Cottages.

After receiving this material, Penn's London agent, Philip Ford, wrote him that "as for the map of the city, it was needful it should be printed; it will do us a kindness, as we were at a loss for want of something to show the people."

The plan was engraved as the frontispiece of a promotional pamphlet, dated 1683, that contained both Penn's letter and Holme's "advertisement." In an oval at the bottom appeared a bird's-eye view showing the town spread between the two rivers above their confluence. Manuscript copies of the plan in watercolor and in ink are extant, copied probably at various later dates but possibly including the original drawing. This must have been the same size as the engraving. Not only was this standard practice, but the engraving work is crude and the engraver probably lacked the skill to reduce his plate from a larger drawing. His name does not appear, but Penn had his work done by Quakers and his limited choice explains the engraver's limited knowledge. Andrew Sowle, a Quaker, was the printer.

Changes in the identity of the principal sellers of the engraved plan account for two states of it (i.e., editions recognizable by changes on the plate itself) in the years of its use by Penn. The copperplate survived in its second state and many years afterward was brought to Philadelphia by Dr. George Logan of that city. In 1812 slight alterations were made to it and it was republished in the printed volume of *Philadelphia Ordinances* for that year. The plate is preserved at the Historical Society of Pennsylvania.

In the nineteenth century lithographic reproductions of the plan were published. James Coleman, a London bookseller, issued his reprint of Penn's letter and the plan in 1881, in time for the 200th anniversary of the founding of Philadelphia. In 1895 another reprint appeared in the *Pennsylvania Archives*.

The question arises whether the plan was ever more than a fiction as applied to actual town development. Hannah Benner Roach in "The Planting of Philadelphia" has traced Penn's instructions, Holme's preparation of an initial sketch oriented only toward the Delaware River, and Penn's arrival and idea of acquiring complementing lands fronting on the Schuylkill to permit "a city truly urban in plan," followed by the acquisition of those lands. It was this larger area that Holme used for the plan. Mrs.

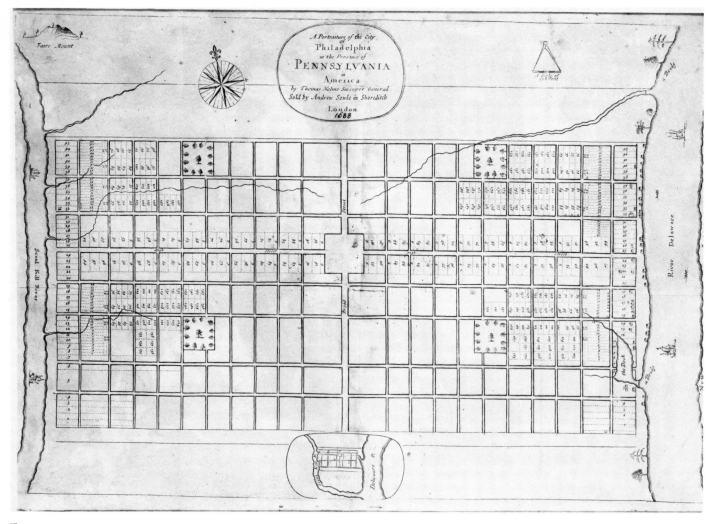

Fig. 1

Roach concludes that it represented a compromise between local conditions and the demands of the settlers, and that in some details it was departed from to meet actual needs, although never in any of its basic pattern. Holme had envisioned this, but no modifications were ever incorporated in any revision of the plan as he thought might happen "when time permits." Acceptance of it in England at the start as reflecting the actual facts did no harm, for the plan was then like an oversized garment which, with minor changes, is grown into and becomes a good fit. The city boundaries shown on the plan remained those of Philadelphia until 1854, when many additional areas were incorporated into the city.

(1) A Portraiture of the City of Philadelphia in the Province of Pennsylvania in America by Thomas Holme Surveyor General. Engraving, 1683, 11¾ × 17¾. Attribution: Sold by John Thornton in the Minories. and Andrew Sowle in Shoreditch. London. Source: *A Letter from William Penn Proprietary and Governour of Pennsylvania in America, to the Committee of the Free Society of Traders* (London, 1683), frontispiece.

LATER STATES

(1A) As above, but without the words "John Thornton in the Minories. and."

Fig. 1 (1B) *Fig. 1.* As (1A), but with light lines extending streets through Centre Square.

REPRINTS

(1a) James Coleman, *Coleman's Re-Print of William Penn's Original Proposal and Plan for the Founding & Building of Philadephia in Pennsylvania, America, in 1683* (London, 1881), frontispiece.

(1b) J. Thomas Scharf and Thompson Westcott, *History of Philadelphia* (Philadelphia, 1884), 1:96.

(1c) William Henry Egle, ed., *Pennsylvania Archives, Third Series* (Harrisburg, Pa., 1894), 4; see folded maps in back of book.

(1d) Modern reproduction issued by Historic Urban Plans, Ithaca, New York, 1965.

Dutch and German Editions of the First Plan of Philadelphia, 1684

Benjamin Furly, a Quaker trader in Rotterdam and owner of 4,000 acres in Pennsylvania, represented Penn's interests on the Continent. Doubtless it was through him that a Dutch edition of Penn's letter promoting his colony was promptly printed in Amsterdam. This was directed at the many Quakers and others who might wish, for reasons of religious toleration in the main, to emigrate to Penn's widely heralded grant in North America. With the reprinting of the letter came a new engraved plan of the Philadelphia city grid prepared from Thomas Holme's *Portraiture*.

Fig. 2

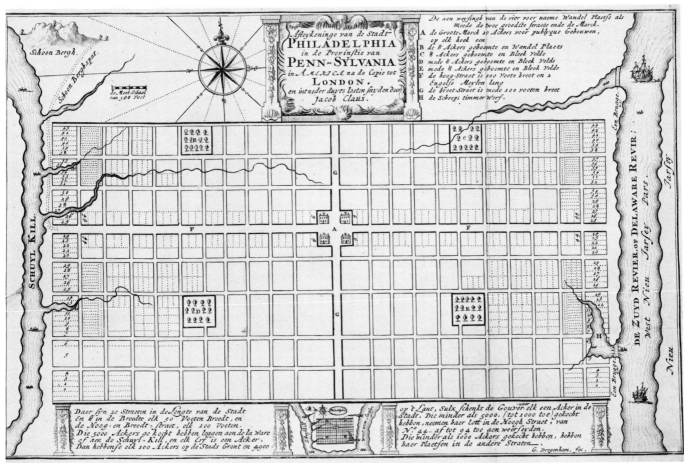

The new plan was by no means an exact copy of the original engraved in London. It contained many improvements. It was a more finished work throughout. The title and the bird's-eye view were enclosed in formal entablatures of some pretension in place of the imperfect freehand ovals on the English copperplate. Listed references and a description identified and described the prominent natural and other features. Lot numbers remained on the plate only near the two rivers. This change permitted it to be smaller than its predecessor. No successive editions of the plate are known. This allows the inference that it is even rarer than the English form issued one year earlier.

About the same time, Penn's letter was translated into German and published in Hamburg. This was accompanied by still a third engraving of the plan of Philadelphia, copied from the Amsterdam version. It is unsigned and much more primitive than even the London edition. No embellishments appear as were attempted in London and improved in Amsterdam. There is every indication that it was a hasty effort. The descriptive wording again appears below the grid; but here the engraver completed the first line of text in lettering of one size, and then realized that the space and the remaining words would permit larger letters. Both sizes remain. In error, the Northwest Square is shown smaller in area than the three others and too far to the west. References G and H are listed and described but do not appear on the map. No compass points are given.

It was, however, an entirely different vehicle from the promotional tracts that spread knowledge of Holme's plan far afield through the next hundred years and more. Oddly, the plan was made a feature of the Dutch sea charts of the North American coast. Beginning in the 1680's and running through the Revolution, it was reproduced as an inset, still of quite respectable size.

Fig. 3

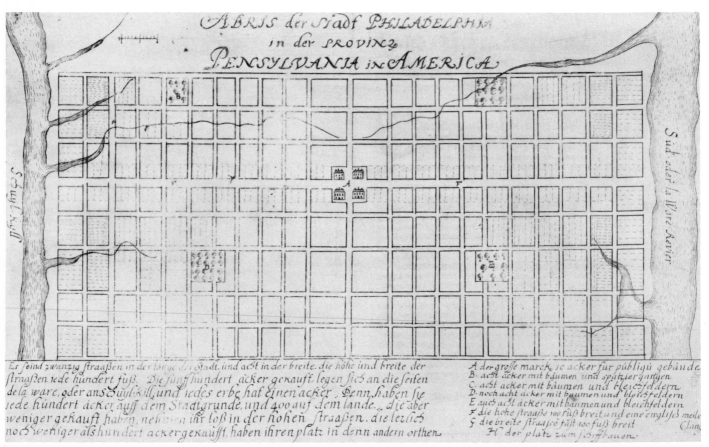

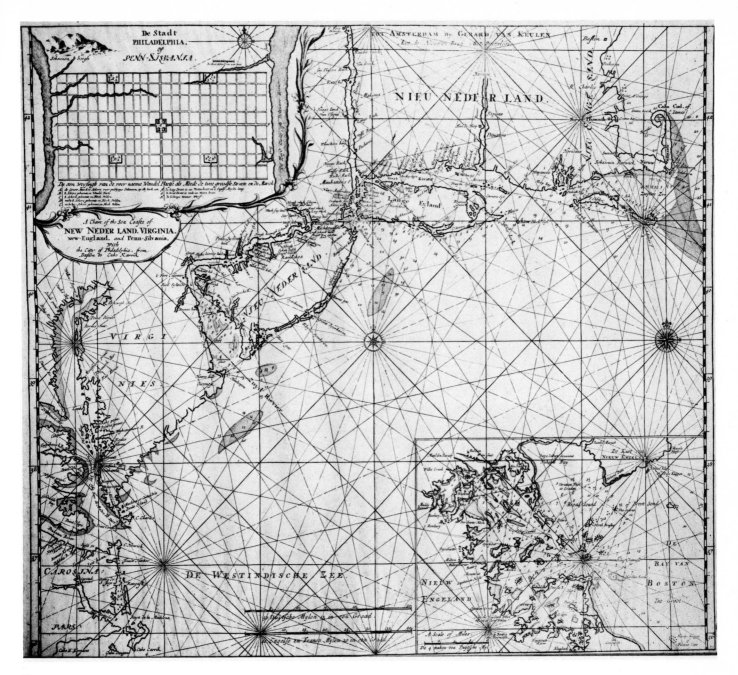

Fig. 4

(2) *Fig. 2.* Afteykeninge van de Stadt Philadelphia in de Provinstie van Penn-Sylvania Fig. 2
in America na de Copie tot London, after Thomas Holme. Engraving, by G. Drogen-
ham, 1684, 7¾ × 12½. Attribution: en intneder duyts laeten snyden door Jacob Claus.
G. Drogenham, fec. Source: Jacob Claus, *Missive van William Penn Eygenaar en
Gouverneur van Pennsylvania, in America* (Amsterdam, 1684).

(3) *Fig. 3.* Abris der stadt Philadelphia in der Provinz Pensylvania in America, after Fig. 3
Thomas Holme. Engraving, 1684, 7½ × 12½. Source: *Beschreibung Der in America
neu-erfunden Provinz Pensylvanien* (Hamburg, 1684).

(4) De Stadt Philadelphia of Penn-Silvania. Inset to: Pas-caert van Nieu Neder Land, Virginia, Nieu Engeland, Als mede Penn-Silvania, met de Stad Philadelfia, van Baston tot C. Carrik, after Thomas Holme. Engraving, by Hendrick Doncker, 1688, 3⁹⁄₁₆ × 6⅞ (inset), 20 × 29 (map). Attribution: By Hendrick Doncker inde Nieuwen brugsteeg. Source: Hendrick Doncker, *De Nieuwe Groote Vermeerderde Zee-Atlas ofte Water-Werelt* (Amsterdam, 1688).

Fig. 4

(5) *Fig. 4.* De Stadt Philadelphia, of Penn-Silvania. Inset to: A Chart of the Sea Coasts of New Neder Land, Virginia, new-England, and Penn-Silvania, with the Citty of Philadelphia, from Baston to Cabo Karrik, after Thomas Holme. Engraving, by Gerard van Keulen, 1734, 5¾ × 9 (inset), 20¼ × 23 (map). Attribution: Tot Amsterdam By Gerard van Keulen Aan de Nieuwen Brug Met Previlegio. Source: Johannes van Keulen, *De Nieuwe Groote Lichtende Zee-Fakkel* (Amsterdam, 1734), plate 33.

Grid Plans of Philadelphia, 1687–1720

With his plan of the capital city serving its intended purpose, Holme was set to work surveying the province beyond it. In a few years he completed a map of its eastern portion. This was published first as a very large, and later as a smaller, engraving. In both, the grid plan of the city was carefully inserted in recognition of the fact that Philadelphia was the focal point and that the city plan had strong sales value in all promotion of the province generally.

Neither the larger nor the smaller print bears a date. In 1926 P. Lee Phillips proved the 1687 publication date of the earlier and larger map through an advertisement in the *London Gazette* on 9 January of that year:

> A New and Exact Map of the improved part of the Province of Pensilvania in America, being three Counties, viz. Bucks, Philadelphia and Chester. Giving the Figure of every particular Persons piece or parcels of land taken up there, it contains 7 sheets of Paper, and is Five Foot long, and three Foot six Inches deep. Surveighed by Captain Thomas Holmes, Surveyor General of the said Province. Price rolled and coloured 10 s. Sold by John Thornton at the sign of England, Scotland, and Ireland, in the Minories, and by Robert Greene at the Rose and Crown in Budge-Row.

As a prominent part of the promotion, the plan of Philadelphia appeared in the top right corner in a size perhaps half as large as that of the earlier English pamphlet issue. Below the map, in nine blocks of very large lettering, was added "A General Description of the Province of Pennsilvania in America."

This map had great importance in the development of the colony. The first issue identified the names and lots of the owners of land sold up to 1687, while a second edition issued about 1701–5 took into account later changes.

Interest in this very early item revived in the nineteenth century. In 1846 a Philadelphia bookseller, Lloyd P. Smith, issued a reproduction of 200 copies and in 1870 Charles L. Warner published another facsimile.

Probably within a few years after 1687, and certainly before 1699, a smaller edition of the provincial map was engraved and published in London. About one-third the

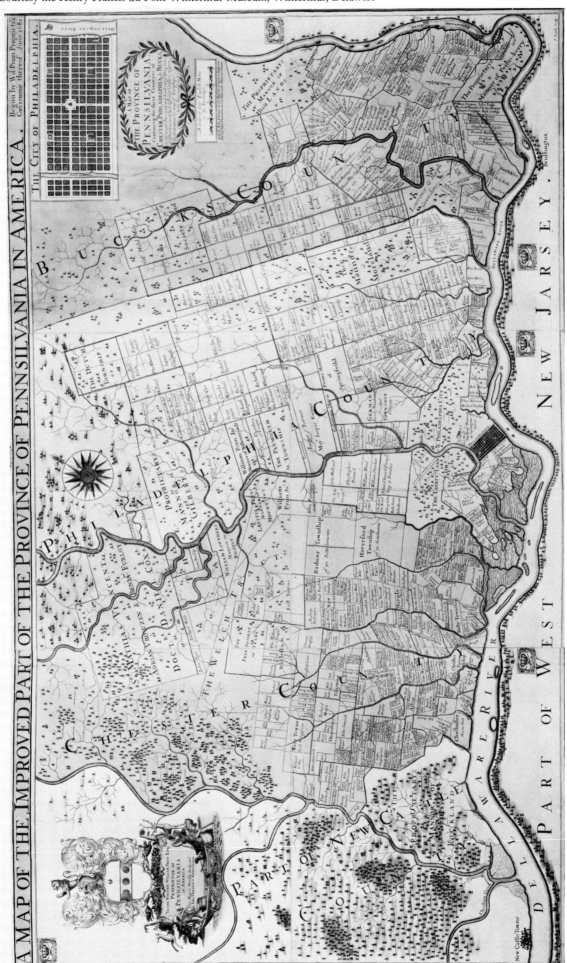

Fig. 5

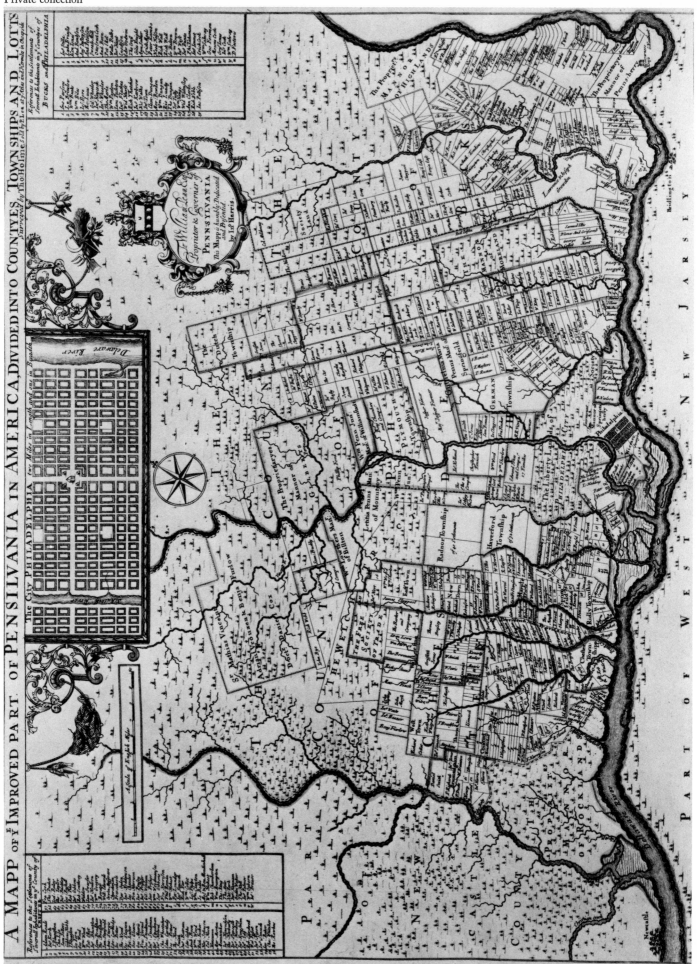

Fig. 6

size of the original, it lacked the printed description and was changed in various ways from the larger issue, but the familiar grid of the city occupied the top center. This reduced version went through a second edition, which is attributed to a time "soon after 1699," as well as a third at an unknown later date. An 1876 facsimile of this map was printed by Samuel Smedley in connection with the Centennial.

(6) The City of Philadelphia. Inset to: A Map of the Improved Part of the Province of Pennsilvania in America. Begun by Wil: Penn Proprietary & Governour thereof Anno 1681, by Thomas Holme. Engraved on seven sheets, with description, by F. Lamb, 1687, 4⅝ × 10¾ (inset), 33½ × 55½ (map). Attribution: Sold by Rob: Greene at the Rose & Crowne in Budgrow. And by John Thornton at the Platt in the Minories. London F. Lamb Sculp.

LATER STATE

(6A) *Fig. 5.* As above, but on six sheets and without description. Walter Klinefelter, "Surveyor General Thomas Holme's 'Map of the Improved Part of the Province of Pennsilvania,'" *Winterthur Portfolio* 6 (Charlottesville, Va., for The Henry Francis du Pont Winterthur Museum, Winterthur, Del., 1970): 72; and see p. 45, fn. 12.

Fig. 5

REPRINTS

(6a) Facsimile "by the Anastatic process," by Lloyd P. Smith, Philadelphia, 1846.

(6b) Lithographic facsimile by Charles L. Warner, Philadelphia, 1870.

(7) *Fig. 6.* The City Philadelphia two Miles in Length and one in Breadth. Inset to: A Mapp of Ye Improved Part of Pensilvania in America, Divided into Countyes Townships and Lotts, by Thomas Holme. Engraving, probably by John Harris, 1687–1690, 2⅞ × 7 (inset), 15¾ × 21¼ (map). Attribution: by Jno Harris. Sold by P. Lea at ye Atlas and Hercules in Cheapside.

Fig. 6

LATER STATES

(7A) As above, but without attribution to Lea and with attribution: Sold by Geo: Willdey at the Great Toy, Spectacle, China-ware, and Print Shop, at the corner of Ludgate Street, near St. Paul's, London.

(7B) As (7A), but with the attribution to Willdey erased.

REPRINT

(7a) Facsimile by Samuel L. Smedley, Chief Engineer & Surveyor of Philadelphia, 1876.

2
The Primitive Town

CONTRARY TO Penn's expectations, settlement did not commence on both river fronts and work toward the center. It started on the Delaware and moved slowly westward. Caves were hollowed from the bank of the river, their roofs formed of bark or sod and their chimneys of stone. Many such structures soon encroached on the line of Front Street, laid out on the Holme plan as the eastern boundary of the town. In a short time they were demolished by order of the Provincial Council. By the year 1700 the town boasted several hundred brick houses, often with shop windows opening upon the street. To a Swedish pastor who visited it that year, "even Uppsala . . . would have to yield place to it."*

The settlement was twenty-five years old when its first building for provincial business was erected. This was a courthouse in medieval style standing in the center of the main street designed to run to the Schuylkill but close to the Delaware. This structure supplemented earlier stocks, pillory, and successive prisons. When the first picture of the town was painted, about 1720, Philadelphia was entirely a place of homes, gardens, churches, and warehouses, except for the one intersection at Second and High streets. Bampfylde Moore Carew of Devon, England, a visitor in 1739, found it "one of the finest cities in all America." He remarked of its buildings that "generally speaking, they are better edifices than in the cities of England, a few excepted, and those only in a few streets."†

Carew's was not the only comment upon the city even at this early time. In 1744, when two more pictures had appeared, Dr. Alexander Hamilton of Annapolis reported in his journal of travels up and down America's east coast that Philadelphia

* Ruth L. Springer and Louise Wallman, "Two Swedish Pastors Describe Philadelphia, 1700 and 1702," *Pennsylvania Magazine of History and Biography* (hereafter cited as *PMHB*) 84 (1960): 194, 207, 214.

† Joseph Jackson, *Encyclopedia of Philadelphia* (Harrisburg, Pa., 1931) 2:374.

is much like one of our country market towns in England. When you are in it the majority of the buildings appear low and mean, the streets unpaved, and therefore full of rubbish and mire. It makes but an indifferent appearance att a distance, there being no turrets or steeple to set it off to advantage, but I believe that in a few years hence it will be a great and a flourishing place and the chief city in North America.*

Even before Carew and Hamilton saw the town, and when its population was less than 7,500, a most significant structure had been erected—probably the most important single building ever to appear in Philadelphia. Original drawings for the design of the Statehouse, intended for use by the Provincial Assembly, survive. Upon its completion in the 1730's (except that its tower was not added until after 1750), it was "the largest and most elaborately formal public building in the colonies."§ It has become so closely associated with American independ-

§ Carl Bridenbaugh, *Cities in Revolt* (New York, 1955), p. 307.

ence and our Constitution that few realize it is a product of the city's very early period of development and within a short time will become 250 years old. At the time of its construction, Philadelphia was not even the equivalent in size of many rural present-day American communities; its appearance was still strongly that of the country market town. The Statehouse was the first known step toward its transition into an American city in the Georgian style. The building is now known as Independence Hall.

Second and High Streets, 1698

A visual record of the town at the end of the seventeenth century exists in an item that is partly a plan and partly a view: a record drawn in 1698 in the official Survey and Warrant Books of Philadelphia, which was prepared by the surveyor general to show the lots assigned to William and Letitia Penn at the heart of the city. It depicts the immediate area of Second and High streets, extending east along High to Front Street, and even beyond it to King Street (now Water Street) very near the Delaware River.

Great interest attaches to that intersection because it was already the focal point of the life of the town. In 1698 it did not yet boast the Old Courthouse, which was to stand in the center of High Street, facing the river, from about 1707 until 1837. But it did have two curious features, each of which appears as a tiny drawing on the plan.

Of these, the first was the "cage." John F. Watson in his *Annals of Philadelphia* mentions an order by the Town Council in 1682 that a cage for offenders should be built seven feet long and five feet broad. This was Philadelphia's first prison, located at the meeting point of its two most important streets. In 1695 it was replaced by a brick prison house that also stood in the center of High Street just east of the cage. This latter structure also appears on the 1698 plan, extending with its yard at least one hundred feet down the center of the street. It is curious that with the building of the

* Carl Bridenbaugh, ed., *Gentleman's Progress: The Itinerarium of Dr. Alexander Hamilton, 1744* (Chapel Hill, N.C., 1948), p. 192.

brick prison the cage was not removed, but their coexistence is corroborated by the records: In 1705 the council ordered conversion of the cage structure into a watch house, together with erection of a whipping post and pillory at the site.

The need for a public prison in a Quaker town had to be met years before that of a separate building for the machinery of dispensing justice. But the plan shows that by 1698 a courthouse was projected near this same intersection. It is marked for a plot to the west of Front Street straddling the center of High Street.

The second feature of the 1698 intersection was the "bell." This was the great town bell, erected upon a mast in the street, from the foot of which royal and provincial proclamations were announced. When the Courthouse was built, the bell was removed and installed in the cupola of the low tower on the new building.

By marking two more public sites, the plan becomes the earliest map of the center of Philadelphia as it first developed. The great Meeting House of the Friends is one of these sites. It stood at the southwest corner of High and Second streets. Erected only three years earlier, in 1695, it had its own generous grounds for horses. The meeting-house was replaced in 1755 by a larger building; but in 1723 it had received a young man from Boston with his loaf of bread, the newly arrived Benjamin Franklin. The original public wharf at the foot of High Street is the other public facility shown on the plan.

In 1882 W. F. Boogher "recovered" the original plat of 1698 and published a lithographic "facsimile" of it. He was perhaps more inspired by the labeling on the original

Fig. 7

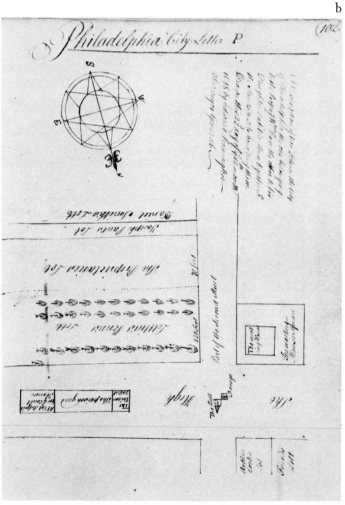

of "The Proprietaries Lot" and "Letitia's [sic] Penn's Lott" than by the insight afforded by the old plan into the heart of city life. While the lithograph is faithful to the original, it presents the scene with more formality and in more decorative fashion.

Fig. 7

(8) *Fig. 7.* Draft of Letitia's front Lott, by Edward Penington. Pen drawing, 12th month 23d, 1698, 14¼ × 11½. Source: Warrants and Survey Returns, 2:101–2, in Philadelphia City Archives, record series 225.3.

REPRINT

(8a) Lithograph titled: Fac-simile, of the original plat of the Lots assigned to William and Letitia Penn, drawn 23d of 12th month 1698, and recovered 4th of 9th month 1882 by W F Boogher. (A photostat of original is at Free Library of Philadelphia.)

The *Peter Cooper* South East Prospect, *c. 1720*

Almost nothing is known of the origins of this large, signed oil painting that portrays the Philadelphia waterfront in its earliest recorded form. J. Thomas Scharf and Thompson Westcott, authors of the most painstakingly detailed history of the city, report that painter Peter Cooper was admitted to the status of a freeman of Philadelphia in 1717. This fact and the scene depicted have led to a date of about 1720 being assigned to the work.

The buildings in the picture are to some degree quite fancifully shown. This has led to divided opinion. Some, trained in American iconography, find this quality no impediment to pronouncing the picture genuine and a "treasure of American topographical painting." Others, equally trained, assign to it "all the marks of a later rendering," and call it "nearly valueless as a record." In fact, its authenticity seems quite clear.

Certain it is that this painting has been in the Library Company of Philadelphia since 1857. The circumstances of its then coming to light are known. George Mifflin Dallas, the American minister to England, wrote in that year from London:

> I will send for the Phila. Liby an antique daub painted as is believed here in 1720 purporting to be "The South East Prospect of the City of Philadelphia by Peter Cooper, Painter." . . . One of the members of Parliament in looking over the rubbish of a City curiosity shop picked it up & brought it to me. The principal buildings of the City at that day are pointed out & 24 good old Philadelphia Householders are named in the margin. Although worthless on any score but that connected with Auld Lang Syne it presents at half a glance so strong a contrast to the Consolidated City of 1857 that it has its interest for a corner of the Phila Library.

But the painting can be traced to a much earlier date. In 1822 John Nichols, an officer of the Royal Society of Antiquaries of London and its printer, published a volume in which he wrote:

> Dr. Rawlinson communicated to the Society of Antiquaries an old Painting on canvas of the S. E. prospect of Philadelphia from the River, by William [sic]

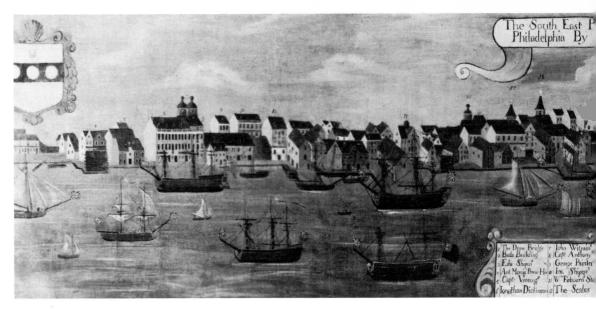

Fig. 8

Cooper, painter, with references to the several places. It is 7 feet 9 inches long, and 1 foot 9 inches broad. At the one end are the coat of arms of Sir William Penn, and the other that of the Colony of Pennsylvania.

Richard Rawlinson, a fellow of the Society of Antiquaries from 1741 until 1750, was a man given to great argument. This fact may explain his leaving, upon his death in 1755, most of his collections to the Bodleian Library, Oxford, while some were sold and could well have come to "the rubbish of a city curiosity shop."

James N. Barker, writing in Philadelphia in 1827, states that the Rawlinson incident took place in 1750, but the minutes of the society fail to corroborate this. Nichols was probably working from Rawlinson's personal records.

The key figure in the making and dating of the picture is probably William Burgis, a designer of American city views active from about 1718 to 1731. Burgis is well known in the pictorial history of America. According to I. N. Phelps Stokes, Burgis drew his view of the harbor of New York about 1720. In 1721 that engraving was advertised in Philadelphia for sale as "A Curious Prospect of the City of New York, on 4 sheets of Royal Paper, to be sold by Andrew Bradford." That picture approximates six feet four inches in width and one foot nine inches in height. It bears the coat of arms of the governor of New York. Burgis was responsible for a similar waterfront view of Boston dated about 1725. The engraving of his drawings is said to have taken place in London.

There can be little doubt that Peter Cooper's view was modeled upon the Burgis scene of New York. Its size, approach from over the water, coat of arms of Penn, and title all suggest it. Each of the two views includes a key identifying just twenty-four buildings. No other artistic work by Cooper is known. The best conjecture is that he was a house or sign painter, or both—certainly not an artistic innovator—and that his work was commissioned by someone acting for the Penn family in promoting the province, after William Penn's death in 1718, for an engraving in competition with Burgis's *New York*. Probably the painting was found insufficient in quality. To Joseph Jackson, its formal features leave "little doubt but that it represents some sort of official work."

Though undeniably primitive in execution, Cooper's view will repay close examina-

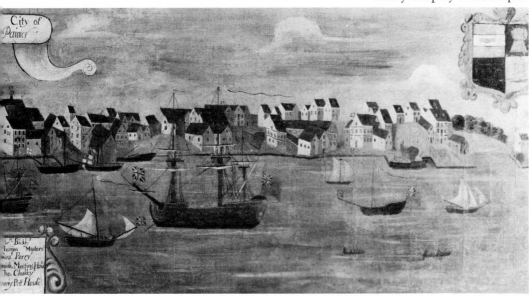

tion. Robert Smith's comment upon it may explain details that at first appear fanciful. He is struck by the "considerable amount of architectural information it contains, including the houses of Flemish and Dutch origin with gabled fronts facing the street, like those of London and Dublin, none of which now remain in Philadelphia." It is when Cooper, feeling the need for height and importance, creates an imaginary skyline of minarets and towers that he offends the modern eye. But his panorama of Philadelphia, still shown as a town of dwellings without the marks of large public buildings, is unmistakable; and his is the only contemporary record of structures such as the great townhouse of Samuel Carpenter designed by Philadelphia's first designer of homes, James Porteus.

(9) *Fig. 8.* The South East Prospect of the City of Philadelphia, by Peter Cooper. Oil on canvas, c. 1720, 20½ × 97¼. Attribution: By Peter Cooper, Painter. Source: Library Company of Philadelphia. *Fig. 8*

COPY

(9a) Another similar painting, apparently of the same age and of the same size, is in a private collection.

The G. Wood Watercolor of Philadelphia, 1735

Completely different in feeling and approach from Cooper's *South East Prospect* is this light, airy, red-splashed watercolor. Although it is also titled a "prospect," there is no attempt to depict with fidelity the scene portrayed. Indeed, the area shown is too expansive to permit that.

Fortunately the work is dated and signed. It was brought from England with the report from the importing dealer that it was part of an album of port scenes drawn by an artist who worked in Bristol. The curator of the National Maritime Museum in Greenwich, England, confirms these facts.

In the picture Philadelphia is viewed from "Wickacove," or, as it was usually

spelled, Wicacoe. This was an area in the vicinity of Old Swedes Church, along the Delaware River, south of the early settlement of Philadelphia but long since a part of the city. Wicacoe is a shortened form of an American Indian word meaning "a dwelling house." In about 1654 an Indian village of that name was granted by the Dutch governor on the Delaware to certain Swedish settlers. The grant ran up the Delaware as far as present-day South Street, Philadelphia, and west to about present-day Seventeenth Street. The relative placement of Wicacoe and the city in the picture is accurate, as is the relative position of all important landscape and architectural features of the area listed in a key appearing below the view.

This and other internal evidence in the watercolor adequately support its authenticity. "The Sweeds Church" (now Old Swedes) is listed and appears west of Wickacove. "Society Hill," one of the references, was in 1735 a term in common usage because of the activities of the Free Society of Quakers—a usage only recently revived. "The Governours House," another listed point, was so known in 1735 because William Penn had occupied it in 1700. Later called the Slate Roof House, it stood on Second Street north of Walnut. An early shipyard marked in the area of Race and Vine streets on the Delaware accords with the fact; and "The Island," also identified, appeared in later maps as Windmill Island in the Delaware and remained until 1896 as an obstruction to navigation. Camden, New Jersey, was at this time "Coopers Ferry" as listed. The Market House at Second Street, labeled as such, was the center of government as well as commerce.

While fanciful in its technique, the drawing shows many important activities and landmarks. Despite, or because of, its exaggeration, it is most decorative.

Fig. 9 (10) *Fig. 9.* The prospect of Philadelphia from Wickacove, by George Wood. Watercolor, 1735, 7⅜ × 14⅛. Attribution: exactly Delineated by G: Wood. 1735. Source: The Henry Francis du Pont Winterthur Museum, Winterthur, Delaware.

Fig. 9

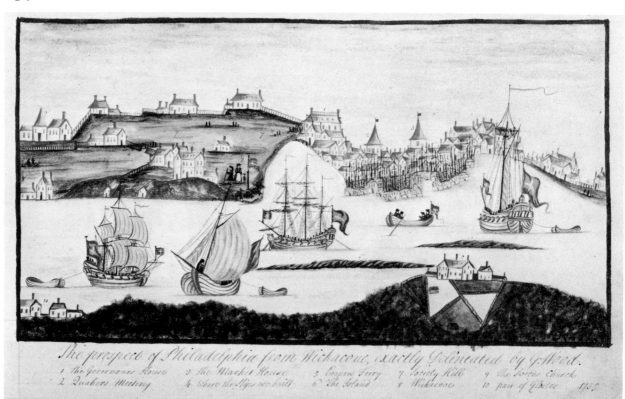

THE AMERICAN
WEEKLY MERCURY.

From Thurſday *September* 4, to Thurſday *September* 11, 1740.

Fig. 10 a

First Printed View, 1740

Neither the Cooper nor the Wood view was reproduced as an engraving. This fact makes the first instance of a printed view in multiple copies (a "print") a signal event. That distinction is held by a tiny waterfront scene showing the harbor.

The view appeared first as a part of the identifying heading on a weekly newspaper, and later for a short time as the heading on a monthly magazine, both published by Andrew Bradford. More than a thousand issues of *The American Weekly Mercury* had been distributed before the new cut was introduced with no. 1080 for the week ending 11 September 1740. At that time Bradford was also planning another publishing venture—a periodical reporting on colonial governmental proceedings and containing essays on religious and economic topics. This magazine displayed the new print just as the weekly did, but only three issues of *The American Magazine, or a Monthly View of The Political State of the British Colonies* appeared in early 1741. The weekly continued to use the cut for several more years.

The publications in which the view appeared would not have depicted any but their home city. A sharp rise from the water is shown, indicative of the town as seen from the landing places then in use at, or near, present-day Market Street. But beyond this the scene seems unidentifiable. Towers appear both left and right, that on the right possibly standing behind an open space leading away from the Delaware. The Market House on High Street at Second had a low belfry, and High Street was the main entry from the river into the town. At the extreme right a large building is shown in what might be the position occupied by Christ Church. Certainly its eastern end con-

tains a very high and large window generally similar to the Palladian window of the church, the first example of that feature erected in the British colonies. If this is the church, the picture is correct in not showing its steeple, which had not yet been built. The high east gable and the lower west roof also seem to appear. Yet at the left side of the picture a structure that appears to be a large steepled church, broadside to the viewer, must be apochryphal.

Joseph Jackson asserts that this engraving was cut into type metal, certainly a common practice at the time. Sinclair Hamilton, in cataloguing early American wood engravings, suggests that it was prepared in that medium.

Fig. 10

(11) *Fig. 10.* (Philadelphia Waterfront). Printer's type metal or wood engraving, 1740, 1⁹⁄₁₆ × 3¹⁄₁₆. Source: Two publications by Andrew Bradford, Philadelphia: *The American Weekly Mercury*, no. 1080 (11 September 1740), *et seq.*, and *The American Magazine, or a Monthly View of The Political State of the British Colonies* (January-March 1741).

Fig. 10 b

3

The First Flowering:
Scull and Heap

I N THE year 1755 it was recorded that "one day at William Allen's the conversation turned on the uncommon Event of such a town as Philadelphia arising, amidst a wilderness, in So short a time, and becoming So fine and populous a City as we all saw it."*

The reference to a wilderness was no turn of phrase, but was accurate in a strict sense. When the city was plotted, its site was completely covered with trees of great size. The extension of habitations west from the Delaware was possible only by cutting away the forest. Known as the "Governor's Woods," it had its own paid caretaker. In 1750 this dense cover extended westward from present-day Eighth Street to the Schuylkill River; at the time of the Revolution, it had receded to Broad Street. The contrast between town and surroundings was the greater because of the square regularity of the streets in the open portion. As early as 1748 the Swedish botanist Peter Kalm found that "some are paved, others are not, and it seems less necessary since the ground is sandy, and therefore absorbs the wet. But in most of the streets is a pavement of flags, a fathom or more broad, laid before the houses, and posts put on the outside three or four fathoms asunder."† Although perhaps even then improved beyond those elsewhere, the streets benefited from Franklin's civic consciousness. In 1757 he introduced a bill for paving them. He also designed and saw in use a new kind of street light that did not cloud within a few hours like those imported from London.

There was now ample evidence of the city's "arising," as mentioned at William Allen's. With the 1750's Hamilton's prophecy began to come true, for the yeast of Penn's advanced ideas began to raise a city both vertically and horizontally. Steeples and towers—so necessary to a city in Peter Cooper's mind that he created them—appeared in reality. The commanding belfry of Christ Church, "one of the handsomest and certainly one of the most elaborate Palladian churches in

* Carl Bridenbaugh, *Cities in Revolt* (New York, 1955), p. 210.
† Joseph Jackson, *Encyclopedia of Philadelphia* (Harrisburg, Pa., 1931), 4:969.

America,"* rose about the same time as the tower of the Statehouse. The former received its famous peal of bells in 1754, the latter its still more famous bell in 1755. Population began to increase. By 1760 the plotted mile of Delaware waterfront had expanded to two miles crowded with wharves. The architectural ferment was resulting in buildings of far more than simply local importance.

Now a steady and meaningful pictorial record of the city began, limited at first to the Statehouse and a pioneering overall view of the waterfront. Maps appeared outlining the actual built-up extent of the city upon the original grid plan. Roads to the outlying districts were mapped and tables of distances prepared, for this was the center of a dependent countryside. In 1750 Philadelphia entered upon fifty years as the "richest, busiest, and most cosmopolitan city of America."†

Fortuitously, two local citizens devoted themselves to portraying this provincial center by a formal record. Their achievements were tremendous in comparison with what had gone before. They created first a pioneer local engraving, a map of the area that was locally transferred to copper in reverse from the original drawing on paper. This required a special tool for cutting into the metal, and the printing of the copies could only be made by forcing damp sheets of paper into the inked lines in a special press. In a few more years they produced a detailed picture of the Delaware waterfront, which, because of its great size, had to be engraved in London.

The Scull and Heap Map of Philadelphia, 1752

On 4 June 1752 the *Pennsylvania Gazette* announced:

> Just published, and sold by Nicholas Scull, George Heap, William Bradford, and David Hall, (Price Five Shillings)
> A MAP of PHILADELPHIA, and parts adjacent (with a perspective view of the STATE-HOUSE) in which is laid down the roads, rivers, creeks and publick buildings, that are within seven miles of the said city, with the situation of most of the dwelling houses of the inhabitants within that distance.

This was the joint product of Nicholas Scull and George Heap, surveyors and near relatives, and it made available to the public Scull's official work as a surveyor in the environs of the city.

Scull (1700–1762) had begun making surveys as early as 1722. After serving for three years as the elected sheriff of Philadelphia, he was commissioned in 1748 surveyor general of the province. He held this post until the end of 1761. Apparently as a part of his official duties in surveying newly seated lands, he did much valuable work in plotting the roads spreading out from the grid of the capital city and, along and between them, the locations of the families then living in the surrounding country within an area now bounded roughly by the communities of Darby, Merion, Germantown, and Kensington. After publishing in 1752 the map presenting this informa-

* George B. Tatum, *Penn's Great Town* (Philadelphia, 1961), p. 28.
† Carl W. Drepperd, *American Pioneer Arts and Artists* (Springfield, Mass., 1942), p. 42.

tion, Scull collaborated with Heap two years later in producing the largest and, in documentary terms, the most valuable single view of the city ever to be published. In 1759 he completed a most worthwhile map of the improved parts of the whole province, and from his surveys was prepared the first detailed plan of the interior parts of the city, published only after his death.

It must be recognized that for the primary subject matter of his 1752 map—the area surrounding Philadelphia—Scull was indebted to a predecessor, Surveyor General Benjamin Eastburn, who held the office from 1733 to 1741. A plan of much of that area prepared by Eastburn in 1731, for example, which includes a small representation of the city lying between its rivers, is extant. It includes as well a table of distances "from ye Court House" just as the Scull and Heap map of 1752 does.

The ascertainable facts about Heap have been brought together by Nicholas B. Wainwright. Perhaps a nephew of Scull and certainly his junior, Heap's experience in public office was as coroner, but he was by no means as much a public figure as Scull. On the other hand, Heap's contribution to the joint projects of the two men was great, for Heap could draw. His part in the map of 1752 may have been limited to drawing the elevation of the Statehouse, but he was the catalyst of the great view of 1754, without whom it would not have come into being.

Surmounting the 1752 map with Heap's drawing of the façade of the new Statehouse was masterly. Not only was it prophetic of the part the building would play in making a nation, it was the first use of what later in the century would become a symbol of Philadelphia used on many maps and in many illustrations. At the date of the map the tower of the building was not complete, but so that his picture would not at once be outdated, Heap worked from plans for the belfry and showed it as it would be. The resulting toppling effect accounts for the reaction of Thomas Penn in England. Upon seeing the map, he pronounced Heap "ignorant of the Rules of Perspective." Two years later, however, he would be grateful for Heap. In the later pirating of Heap's drawing, some copiers were not disturbed by the leaning belfry, but others included a correction of its lines.

On the map itself, the old grid of streets, some of which were not actually opened, was sufficient for Scull's purpose. Only one public building, the Courthouse at Second and Market streets (which was also the marketplace), was identified. This was done to mark the location from which the distances were measured and set out in the table. Scull was directing attention to the country lying outside the grid area.

It is amazing how quickly and over how long a period—200 years—copies of this appealing publication have appeared. It has been republished more than any other Philadelphia view or map. Wainwright has told the story of this, and in so doing has disproved the assumption of many that the map first appeared in 1750, or, as one reproduction would have it, 1749, and that it was first engraved in England.

Perhaps Thomas Penn made his copy immediately available to the *Gentleman's Magazine* in London, for within three months of publication in Philadelphia in 1752 that periodical issued a new engraving of the Statehouse elevation without the map below it. This is said to be the first separate printed view of a Philadelphia building.

In its August 1753 issue, the same magazine displayed a new engraving of the map alone. During the Revolution, when the demand for information about the colonies rose, this plate was pulled from the files and republished with certain changes.

In the 1760's the long line of republications of the Scull and Heap map continued

both in England and on the Continent. The grid strung between the rivers and part of the surrounding area formed an engraved book illustration printed in London in 1761 and in later years. In 1764 a part of the map formed a plate in a new atlas published in Paris.

In response to the same awakening of interest in America which prompted the *Gentleman's Magazine* to republish the map, no less than five more reissues of it appeared during the Revolution: one in England, one in France, and three (one a partial reproduction) in Germany. These completed the pirating of Scull and Heap's work in the eighteenth century.

Still, interest persisted. In 1850 and 1851 David Lobach of Berks County, Pennsylvania, and one John Shearer issued lithographic facsimiles from the same stone through the press of Thomas S. Wagner and James McGuigan, Philadelphia lithographers. Curiously, one of these reissues bore in large size and ancient style the numerals "1750," while the other bore instead, in figures of like style, the date "1749"—both incorrect surmises as to the date of publication of the original. By 1893 the same lithographic stone appears to have become the property of Benjamin R. Boggs, who substituted his own publication line and published another edition showing the date "1750" for that of original publication.

The great number of republications made the map well known in the twentieth century. It was an obvious choice for reissue at the time of the Sesquicentennial in Philadelphia in 1926, and appeared under the imprint of the Philadelphia Trust Company as well as that of the Public Ledger. Apparently the most recent reprint has emanated from a Philadelphia curiosity shop in 1971.

Fig. 11

(12) *Fig. 11.* A Map of Philadelphia, and Parts Adjacent. With a Perspective View of the State-House, by Nicholas Scull and George Heap. Engraving by Lawrence Hebert, 1752, 20⁷⁄₁₆ × 12. Attribution: By N. Scull and G. Heap.　　L Hebert Sculpt. Insets: 1. Untitled description of the State House. 2. Untitled description of the city, including number of dwelling houses in 1749. 3. A Table of Distances of Particular places within This Map Beging. at the Court House.

LATER STATE

(12A) As above, but with Allen house substituted for Lutheran church in Table of Distances.

REPRINTS

Fig. 12

(12a) *Fig. 12.* Lithograph with addition of numerals "1750," published by David Lobach, Lobachsville, Berks County, Pennsylvania, 1850. Printed by Wagner & McGuigan, Philadelphia.

(12b) As (12a), but without attribution to Wagner & McGuigan.

Fig. 13

(12c) *Fig. 13.* Lithograph with addition of numerals "1749," published by John Shearer, 1851. Printed by Wagner & McGuigan, Philadelphia.

(12d) Photolithograph with numerals "1750," published by Benj. R. Boggs, Philadelphia, 1893.

(12e) Map portion only, J. Thomas Scharf and Thompson Westcott, *History of Philadelphia* (Philadelphia, 1884), 1:14.

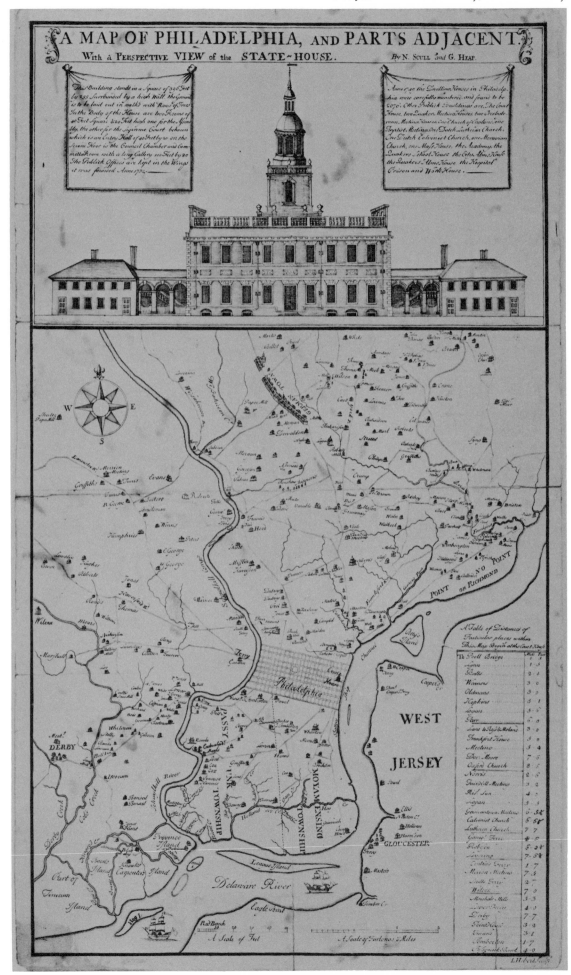

Fig. 11

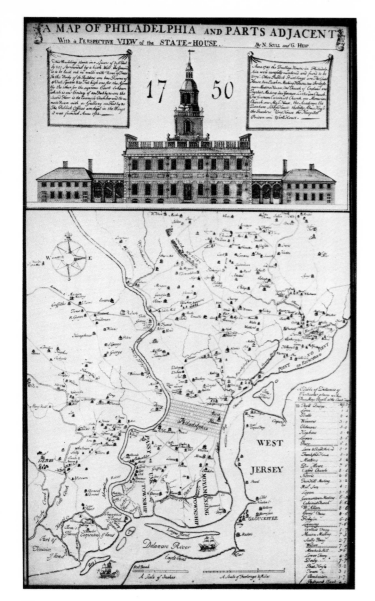

Fig. 12

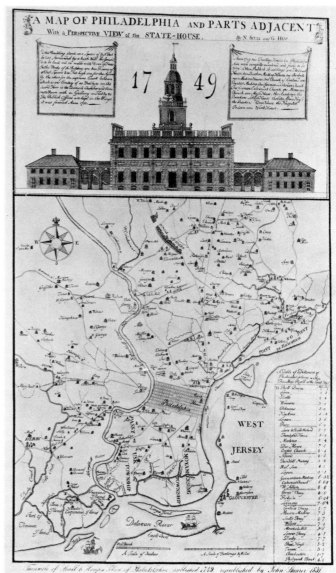

Fig. 13

(12f) Reproduction in color, Philadelphia Trust Company, 1926.

(12g) Reproduction, Philadelphia Public Ledger, 1926.

(12h) Reproduction, Cape May Country Store, Cape May, New Jersey, 1950.

(12i) Reproduction, Old Curiosity Shop, Philadelphia, 1971.

(13) For the manuscript plan showing the city then and areas outside it (Blockley, Lower Merion, City Liberties, Roxborough, Germantown, and Bristol Township) prepared by Scull's predecessor, Benjamin Eastburn, in 1731, see quarto volume: Logan and Dickinson Manuscripts, Historical Society of Pennsylvania, p. 165.

Fig. 14

(14) *Fig. 14. A View of the State-House in Philadelphia*, by George Heap. Engraving, 1752, 4¼ × 7½. Attribution: Gent. Mag. Sepr. 1752. Source: *Gentleman's Magazine* (London, September 1752), p. 402.

(15) A small (1¾ × 2¾), early (c. 1760) pen drawing of the Statehouse façade showing its tower as treated by Heap is in the Peale-Sellers papers, no. B P 31 (former Isaac Norris scrapbook), at American Philosophical Society, Philadelphia.

Fig. 14

(16) *Fig. 15*. A Map of Philadelphia and Parts Adjacent, by N. Scull and G. Heap, by Nicholas Scull. Engraving, 1753, 13⁷⁄₁₆ × 11⅝. Source: *Gentleman's Magazine* (London, August 1753), p. 373. Inset: The Distances of particular Places, in this Map; from the Court House.

Fig. 15

LATER STATE

(16A) *Fig. 16*. As above, but Table of Distances deleted and map extended into space thus made available. Source: *Gentleman's Magazine* (London, December 1777), p. 573.

Fig. 16

Fig. 15

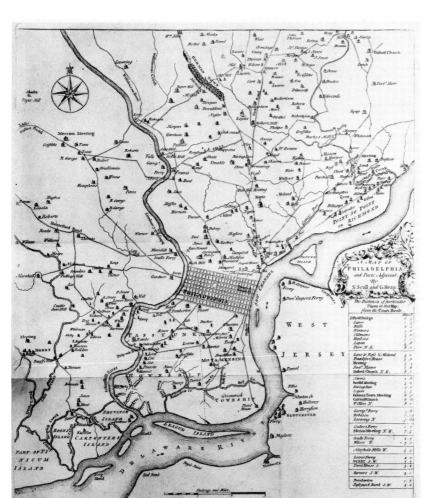

Fig. 16

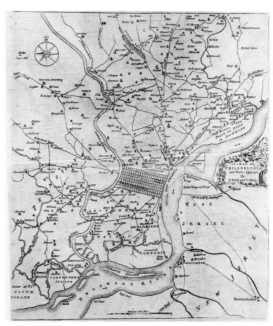

The Scull and Heap East Prospect, *1754*

In 1750 Thomas Penn, proprietor of Pennsylvania, wrote to his agent in the province, Richard Peters, expressing a desire for "a perspective view of the city, either from the Jersey shore or from Windmill Island." Penn was anxious to show off the accomplishments of his colony in a way similar to William Burgis's giant views of the "flourishing city" of New York and the "great town" of Boston. He projected the view as an engraving on copper from which he could draw prints as presents to his friends. After many vicissitudes such a view did come into being. I. N. Phelps Stokes describes it as the "largest and most important engraved view of Philadelphia," and Wainwright as "the most distinguished of all prints of the city of Philadelphia in terms of age, rarity, and historic importance." Wainwright has told the story in detail.

Peters pointed out in reply to Penn that mapmaker Lewis Evans had already attempted the same project "but was much disappointed, no place on the Jersey Side or on the Island taking in ye whole so as to discribe distinctly and advantageously." He discouraged Penn from his plan, saying that "the City of Philadelphia will make a most miserable Perspective for want of Steeples" and that "was there any here yt could do it I would set them about it directly but there is no body here."

Penn was not to be put off, and with more prodding Peters engaged James Claypoole, Sr., a local artist, in the summer of 1751. Claypoole's sketches failed to meet the need. In 1752 another local artist, John Winter, whose name later appeared on one of the Pennsylvania Hospital views, was assigned the task. His efforts to sketch the city from the New Jersey shore were abortive and he gave up further work of his own accord.

Knowing of these developments, George Heap, creator of the elevation of the Statehouse, now decided to make his own drawing of the city, have it engraved, and sell the resulting prints as a commercial venture. He had a certain public recognition, both through his service as coroner in 1749–50 and his publication with Nicholas Scull of the map of the environs of the city. Justifiably, he approached the matter with confidence and shortly produced the drawing from across the Delaware. By 28 September 1752 it was on display and Heap advertised for subscriptions in the *Pennsylvania Gazette* of that date:

Proposals for Publishing by Subscription,
A PROSPECT
Of the
CITY OF PHILADELPHIA.
Taken from the East. By GEORGE HEAP.
CONDITIONS,

That the Prints shall be seven Feet four inches in Length, taking in the Extent of not a Mile and Half.

That, in order to have the Work executed in the best Manner, the Plates shall be engraved in England, and well printed, on fine white and strong Paper.

That the Price of each Prospect be Twenty Shillings, Money of Pensilvania; one Half to be paid at the Time of Subscribing, the Remainder on Delivery of the Prints.

He stated that subscriptions would be taken

at Philadelphia, by Nicholas Scull, in Second-street, and by the Author in Third-street, where the Prospect (which has been taken with great Care and Exactness, and is allowed by good Judges to make a most beautiful Appearance) may be seen by any inclining to encourage this Undertaking.

Heap insisted on taking his drawing to London personally. He sailed at the end of 1752, was immediately and unaccountably seized by an illness, and died before the ship left Delaware Bay.

At this juncture the drawing was returned to Philadelphia, and Scull succeeded in buying it from Heap's widow. Now Penn protested, for he wanted the drawing in order to produce his own engraving for use as he saw fit. After further correspondence the drawing was shipped to him.

The resultant engraving was printed in London from four large copperplates. To form one picture the four sheets of paper had to be combined to the size of eighty-two by twenty inches. The ravages of time upon such a giant and indeed unwieldy picture readily account for its extreme rarity today, although a substantial number were quickly drawn from the plate. Of the first state, 450 copies were shipped to Philadelphia for subscribers who paid one pound each, while 50 remained in England for Penn. Of a second state with corrections, 247 went to America and 3 to English subscribers.

It is astounding but cannot be doubted that the plate engendered so much local interest. The first shipment of the prints was clearly insufficient, for promptly upon its arrival, Scull placed deliveries to the subscribers on a first come, first served basis by notice in the *Pennsylvania Gazette* of 28 November 1754:

> NOTICE is hereby given to the Subscribers for the perspective View of the City of Philadelphia, that NICHOLAS SCULL, of the said City, hath Copies of the same at his House in Second-street, and ready to be deliver'd to the Subscribers: And it being doubtful whether there be a Sufficient Number for all who have subscrib'd, they who apply first, will be first serv'd.

Although in drawing the waterfront from such a distance the artist was required to omit some details and move the scene closer to the eye of the onlooker, still Heap captured more of the spirit of a city than Burgis had done in his views of New York and Boston. Opinions differ on the work, but Joseph Jackson's characterization of it as the "most ambitious effort at picturing an American city made before the Revolution" seems preferable to Lawrence Gipson's as "an impressive example of artistic distortion."

Surely it is impressive. The use of almost seven feet of paper to portray less than a mile of waterfront, from present-day South Street to Vine Street on the north, permitted the detail that is its great feature. To achieve Penn's purpose the picture bore the Penn coat of arms, a handsome dedication to Thomas and Richard Penn as proprietors, an enthusiastic word description, and a reference key. Through this key we learn that the town boasted four churches, four important streets, the Courthouse, the recent Statehouse, and the new Academy (chartered in 1753 as "The Academy and Charitable School"; later the University of Pennsylvania). A number of steeples broke the skyline, from the Statehouse on the south to the recent towers of the Academy, Christ Church, and other churches on the north. The visual features were ample to meet Penn's desires, except for one flaw: The foreshore of the Delaware did not appear

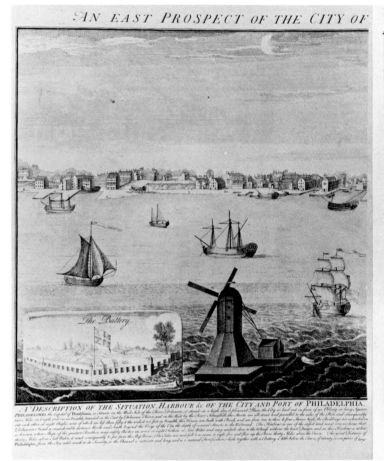

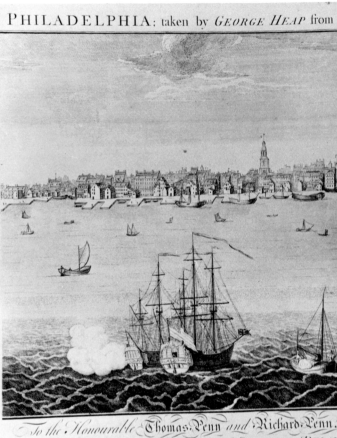

Fig. 17 a b

and the city failed to show itself as a river port. Nevertheless, the very fact that Windmill Island was depicted before the town, displaying the curious sight of a windmill in the river, was proof to those knowing the area that the artist worked from Cooper's Ferry (now Camden), New Jersey.

This huge print has become known to later generations not from its original form, but rather from a popular but much smaller reissue published in London during the Revolution and from an illustration in the *London Magazine* reduced from a later version of the original.

(17) An East Prospect of the City of Philadelphia; taken by George Heap from the Jersey Shore, under the Direction of Nicholas Skull Surveyor General of the Province of Pennsylvania, by George Heap. Engraving, by Gerard Vandergucht, 1754, 20⅛ × 82⅛. Attribution: G. Vandergucht Sculp Published according to Act of Parliament Septr. 1st. 1754. Inset: The Battery.

LATER STATE

Fig. 17 (17A) *Fig.* 17. As above, but with spelling correction to "Scull."

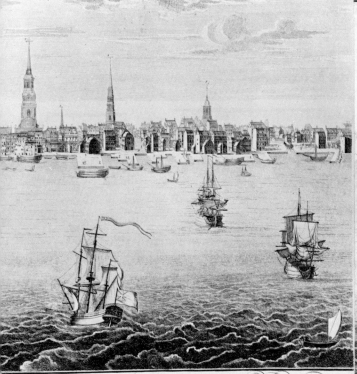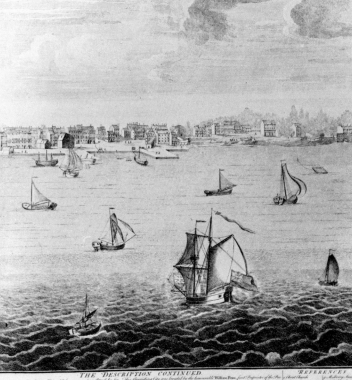

and absolute *Proprietors of the Province of* PENNSYLVANIA

this *Perspective View is humbly Dedicated by* Nicholas Scull

THE DESCRIPTION CONTINUED. REFERENCES

c d

The Contracted Scull and Heap East Prospect, *1756*

When Thomas Penn first saw Heap's drawing for the *East Prospect,* he objected to its great size. He consulted two London engravers as to whether the print should appear in smaller form. One of the engravers, Thomas Jefferys, had published prints since 1750, was appointed in 1755 geographer to the Prince of Wales, and was to become one of the best-known print dealers of the century. Jefferys told Penn the print would sell better if reduced to two-thirds the size of the drawing. Gerard Vandergucht, the other engraver, thought that the subscribers should receive the print in the approximate advertised size of seven feet four inches. There was obvious business merit in supplying what had been partially paid for in advance: The large size, reduced slightly to six feet ten inches, was incised into the copper and struck off in 750 copies, with Vandergucht doing the work.

But Jefferys's comment had struck a sympathetic chord in Penn, who preferred to roll prints on rollers rather than take up the space of a frame. Then there was the matter that the large engraving did not clearly show the city as a river port. Penn instructed Vandergucht to draw a reduced version of the picture that would include

the New Jersey shore in the foreground. The new drawing was completed in the summer of 1755 and the plate engraved by Jefferys. Unfortunately, it did not please the public as much as it pleased Penn. It was too cluttered and diffused.

Though reduced in width by more than half to about thirty-five inches, the new print remained over eighteen inches in height in order to accommodate more subjects. The smaller waterfront view extended across the top. One of three new features introduced below was the Battery, which had been an inset to the larger original view. A second was the Statehouse façade, which had not appeared in the 1754 version but was now copied in enlarged size from the engraving published in the *Gentleman's Magazine* four years earlier. Perhaps this part of the plate was engraved by R. Bennett in Jefferys's workshop, for separate engravings of it, undated, have appeared bearing his name.

The third feature placed below the waterfront view was a map of the city, the genesis of which is not apparent. It utilized the checkerboard approach, the only one yet taken by mapmakers, but for the first time applied it in factual terms. The large central square, existing only in theory, was not included, but new streets opened along the Delaware were now plotted. Only one of the other four public squares appeared, because it was then in use as a public burial ground. Sectarian burial grounds were also marked. Seven buildings were identified. The courses of both the north and south branches of Dock Creek were made clear. All this information must have been obtained from records of Eastburn, and perhaps Scull, as surveyor general of the province. The map is thus the first attempting to show points within the city. It was a step toward the detailed map of the built-up area soon to be published from the work done by Nicholas Scull, which reproduced in small size at one corner an intermediate map prepared by Eastburn.

Fig. 18

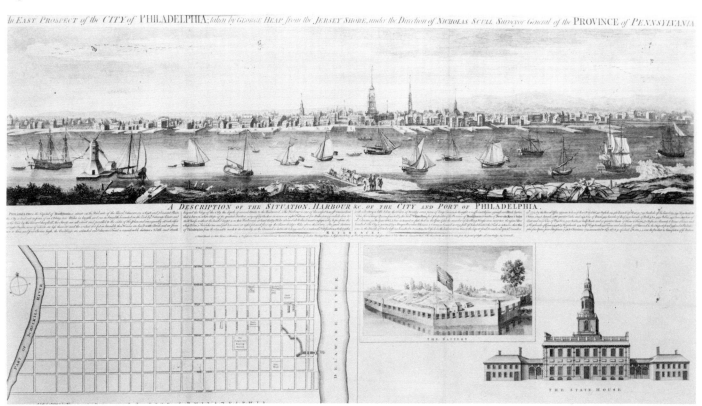

There was but one edition of the new version of the *East Prospect,* except for a minor spelling correction. Less than half the number of the original giant engraving were printed—only 300 copies. Despite Penn's preference for the reduced plate, by October 1756 only twenty copies had been sold in London. Peters reported from Philadelphia in 1757 that there were objections to inaccuracies in the map. Although the new prints were known to have arrived in the city, no inquiry was made for them.

At one point Penn indicated that he could have copies printed without the map, and thus presumably without the bottom half of the picture. Copies are occasionally seen of the waterfront portion alone, but they appear to be only a cutoff portion of the form of original issue rather than a print from a reduced or new plate.

The 1756 copperplate remained for years in the hands of Jefferys, who apparently owned it and printed from it as needed for sale. In 1768 it appeared as a sheet in his elephant folio volume *A General Topography of North America and the West Indies,* reduced in price to five shillings. Printings by Jefferys or his partner, William Faden, may have continued for a long period.

Within a few years after its appearance, the waterfront portion of the 1756 plate was used as a *London Magazine* illustration. In 1854 a lithographic reproduction of the whole engraving was published in Philadelphia by L. N. Rosenthal in approximately the size of the original.

(18) An East Prospect of the City of Philadelphia; taken by George Heap from the Jersey Shore, under the Direction of Nicholas Skull Surveyor General of the Province of Pennsylvania, by George Heap. Engraving, by Thomas Jefferys, 1756, 19⅜ × 35⅞. Attribution: Engrav'd & Publish'd according to Act of Parliament, by T. Jefferys, near Charing Cross. Insets: 1. A Plan of the City of Philadelphia. 2. The Battery. 3. The State House.

LATER STATE

(18A) *Fig. 18.* As above, but with spelling correction to "Scull." *Fig. 18*

REPRINTS

(18a) Lithograph by L. N. Rosenthal, Philadelphia. Published by E. H. Coggins, 1854.

(18b) Modern reproduction issued by Historic Urban Plans, Ithaca, New York, 1971.

(19) A separate engraving in the size of the above inset 3. is titled: A View of the State House in Philadelphia, with attribution: R. Bennett Sculp.

John Bartram's House and Gardens, 1758

A glimpse into the private domain of a unique eighteenth-century Philadelphian is provided by a plan drawn by John Bartram showing his own house and grounds.

Bartram's travels and investigations in the search for new and exotic plants, as well as the fame of his gardens in which many were displayed, are well known. He became in Europe perhaps the best-known American scientist after Dr. Franklin. Not only

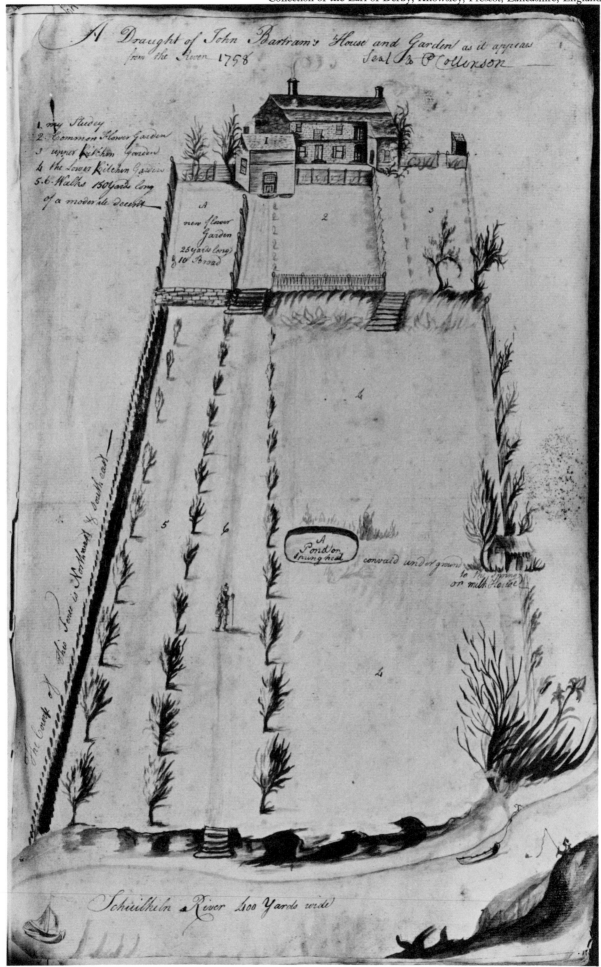

Fig. 19

was he appointed botanist to the king of England: he conducted botanical correspondence with the queen and with English noblemen and commoners. This last fact readily explains how a manuscript plan of Bartram's home and of the layout of his gardens would have been drawn in his own hand and sent abroad with one of his letters.

In about 1733 Bartram began corresponding with Peter Collinson, a London Quaker who was both a merchant and a botanist. Bartram sent his sketch to Collinson in 1758, who wrote back on 6 April 1759 that "we are entertained with thy Draught of thy House & Garden the situation most delightful and that for plants is well chosen." After Collinson's death in 1768 the plan and other Bartram material was acquired by Aylmer Bourke Lambert, another botanist; and in 1842, after the latter's death, it was bought at auction for the Earl of Derby, in whose library it remains.

Though not signed, the plan is dated and includes a keyed list of subjects such as "my study." Bartram had designed, and perhaps physically built, the house and its famous gardens sloping to the Schuylkill River. He drew his home in small size so as to keep it in scale with his extensive grounds. These were visited many times by Washington and Franklin, as well as by almost all foreign visitors of consequence to Philadelphia. It is said that Bartram's fear that the British troops would overrun his gardens —the work of a lifetime—hastened his death in September 1777 as the occupation forces approached the city.

(20) *Fig. 19.* A Draught of John Bartram's House and Garden as it appears from the River 1758, by John Bartram. Drawing, 1758, 16½ × 10½. Source: Library of the Earl of Derby, Knowsley, Prescot, Lancashire.

Fig. 19

4

The Awakening City and Broadening Iconography

THE FIFTEEN years preceding the American Revolution saw the face of Philadelphia change radically with continued growth. New public buildings arose, two of them of lasting fame.

The cornerstone of the Pennsylvania Hospital had been laid in 1755. It stood one-third completed, as it was to remain for several more decades. Efforts to obtain public subscriptions to a building fund brought forth two prints picturing it as it would be when completed. The hospital structure has so impressed analysts of the colonial period as to be called "the most ambitious piece of construction in the colonies, and completed, it would have rivalled similar English projects in both monumentality and magnificence."*

In 1767 the city constructed a new and enlarged almshouse that stood well out in the country near the hospital. Carpenters' Hall, destined for public use, was privately built and was first occupied in 1773.

A description of "the beautiful City of Philadelphia," published in the *London Magazine* in October 1761, reported that William Penn had made a treaty with the Indians and bought the province from them:

> At first 20 miles of territory, did not, it seems, cost so much as one acre at Philadelphia would now, but afterwards the price was raised tenfold. . . . There is also a fine quay two hundred feet square, to which ships of four or five hundred tons may come up, with wet and dry docks for building and repairing of ships, magazines, warehouses, and all manner of conveniences for importing and exporting of merchandise; most of the houses are well built with brick, but still a great many more are wanting to complete the plan. However more could not have been expected than has been done in so short a time, the ground not having been laid out much above seventy years.

The large number of spaces still wanting for houses now appeared graphically

* Carl Bridenbaugh, *Cities in Revolt* (New York, 1955), pp. 21–22.

on the first detailed map of the improved portion of the city to be published. This great improvement upon the earlier simple grid plan completed the work of Surveyor General Nicholas Scull. Twelve years later John Reed issued another large map of a totally different kind in order to illustrate his argument that William Penn had in part deprived the earliest settlers of their rightful lands.

In 1764 especially hard-fought local political battles led for the first time in America to broadside cartoons upon which were displayed views of the Old Courthouse on High Street. Later came more unusual items: an engraving of baptism in the Schuylkill River; Philadelphia scenery as the background in two Charles Willson Peale portraits; a drawing of the first building of the College (later the University of Pennsylvania) converted from a hall for visiting preachers; and just before the Revolution a small view of the front of the new prison placed on the paper currency issued to raise money for its erection.

As the conflict with England approached, Philadelphia's achievements had made it the largest English-speaking city in the world—except for London itself. Franklin, in his prime and already the colonies' best-known personage and agent abroad, lent luster to the city. Philadelphia was now the recognized capital of the war effort and of the whole group of the colonies. During the British occupation of the city its population was tallied under order of William Howe at 21,767—a figure abnormally small, for many thousands of residents had left as refugees.

The Jacob Duché House, c. 1760

An oil painting dating from perhaps 1760 of a single interesting Philadelphia home, in the possession of the Library Company of Philadelphia, is a picture with manifold facets of interest.

The house was built by an indulgent father for a son who, in the eyes of Americans, began with a great deal and threw it all away. Colonel Jacob Duché's family typified that of the early settler in Philadelphia who had made good. The Duchés said they had arrived with William Penn. They had become wealthy in trade, and the colonel was mayor of Philadelphia in 1761. His son Jacob was in the first class of the College, was ordained in England, and was a writer as well. One view is that in 1760, when the young man married a sister of Francis Hopkinson, later a signer of the Declaration of Independence, Jacob, Sr., built the house and gave it to the young couple. A splendid structure of brick, it occupied the corner of Third and Pine streets, running northward on the east side of Third. Its formality and the elegance of its details fit the statement that it was copied from a wing of Lambeth Palace in London; although its style, said to be Elizabethan, seems to incorporate certain Georgian features.

Young Duché's career prospered. After 1762 he was assistant minister of Christ Church and St. Peter's, the latter only a step from his home. In 1768 he was made a member of the American Philosophical Society, and in 1772 he published a series of essays that were widely acclaimed. A number of his sermons were printed, and he was regarded as a fine speaker. When the first Continental Congress convened in 1774 in Carpenter's Hall, Duché was chosen to give the invocation. His impressive delivery on that occasion was the subject of a lengthy written description by John Adams. He was chosen chaplain of the Congress.

So matters continued until the British occupied the city and Duché was imprisoned for a night by order of Sir William Howe. A different man came forth from it, one who in October 1777 wrote to General Washington demanding that he withdraw from the American cause and advocating the withdrawal by the Congress of the Declaration of Independence. Finding himself in a completely untenable position, Duché did not remain even so long as the British were in control, but in December 1777 left for England.

At this juncture the Duché house was confiscated. By resolution of the Colonial Assembly a few years later the chief justice of Pennsylvania, Thomas McKean, was permitted to make use of the property.

After writing to Washington and other prominent citizens seeking permission to return, in 1792 Duché was allowed to come back to Philadelphia, where he died early in 1798. The house still stood, occupied to his chagrin by a signer of the Declaration he had sought to have revoked. Only about 1830, when the area was being developed more intensively, was the Duché house removed to make way for a row of much smaller homes. The picture of it, on the contrary, shows a part of the city that was practically unsettled, although it had at one time abutted on a waterway, a branch of Dock Creek.

The date of the painting, the identity of its author, the reason it was made, and the

Fig. 20

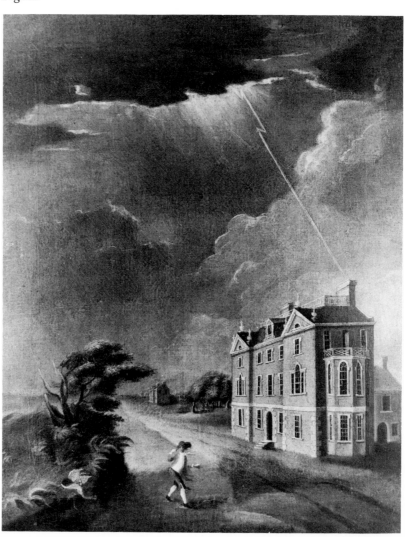

provenance through which it came to the collection of the Library Company—all remain undiscovered.

(21) *Fig. 20.* (The Jacob Duché House.) Oil on canvas, probably c. 1760, 29¾ × 23¾. Source: Library Company of Philadelphia.

Fig. 20

With respect to the effects of a lightning strike on Philadelphia homes, see the engraving (22) titled: Back view of Docr. Shippens House, and accompanying account in *Memoirs of the American Academy of Arts and Sciences* (Boston, 1785), 1:248–52, 256, reproduced in *Antiques* 100 (1971): 64.

Competing Views of the Pennsylvania Hospital, 1761

At a time when formal views were rarely published, a competition between print dealers seems to have brought about the publication of two views of one structure. They portrayed the second Philadelphia building to appear as the subject of a print, and the first to be pictured that stood beyond the limits of the built-up city: the Pennsylvania Hospital, conceived by Dr. Thomas Bond, dedicated 1755, and only partly built. They showed it as it would appear when completed many years later, rather than as it actually was, and conveyed the flavor of the surrounding country setting.

Begun at the corner of Eighth and Pine streets, an area of farms, the hospital was largely an enterprise of private philanthropy. Bringing to hand the funds to cover building costs was a slow process, for the primary source was individual subscriptions. The initial enthusiasm was sufficient to cover the cost of erecting only the easterly one-third of the planned structure, which was to consist of east and west wings connected by an imposing central block. So the project stood until the 1790's.

To provide a suitable form of thanks to the proprietors of the province for their gift in aid, and to generate enthusiasm and increase contributions, the managers of the hospital encouraged the making of an engraving that would show how the institution would appear when completed. Their choice fell upon Robert Kennedy, of whom Carl Bridenbaugh has written that few print retailers did as large a business. Possibly James Claypoole, Jr., was also invited to submit a drawing. He was a young artist and the son of the man who, ten years earlier, had attempted sketches for the great *East Prospect of Philadelphia*. Whether or not both Kennedy and Claypoole were invited to participate, both published engravings of the same scene.

If drawings were submitted for approval, the managers could hardly be censured for selecting that by Kennedy, or rather prepared for him by John Winter and one Montgomery. Winter had long experience in Philadelphia. He had advertised in the city as early as 1739–40, and was the first person requested to produce the drawing for the *East Prospect*. His concept was the more flattering and probably the less faithful to the realities of 1761. Kennedy spared no expense. Not only did he retain two artists for the drawing, but he commissioned Henry Dawkins to do the engraving. Dawkins may be regarded as dominating his profession in the city during the 1760's.

Kennedy clearly had official approval for his venture. Confident in this, perhaps he had no inkling that Claypoole was about to publish a rival print. On 22 October 1761 Kennedy informed the public of his timetable by an announcement on the front page of the *Pennsylvania Gazette*:

A Prospective View of the Pennsylvania Hospital, taken by Messieurs Winter and Montgomery, for the Subscriber (with the Approbation of the Managers of the said Hospital) which is now engraving and may be expected in two Weeks.

The PUBLIC may be assured that it will be finished in the neatest Manner &c. the Subscriber presumes that this Undertaking will be highly favored by all Lovers of the Institution. Those Gentlemen that would chuse to have them coloured, framed and glaized, are requested to send their Commands to the Subscriber, in Third-street, between Market and Arch Streets, and opposite Mr. Joseph Fox's.

Robert Kennedy

N.B. Copper-Plate Printing, performed in the neatest Manner, and at the most reasonable Rates.

But his repetition of the same advertisement a week later was met in the same issue with the actual publication of the rival engraving, which had apparently been both drawn and transferred to copper by Claypoole alone:

JUST PUBLISHED,

A Perspective View of the PENNSYLVANIA HOSPITAL, with the Buildings intended to be erected. Taken from the South-East, by JAMES CLAYPOOLE, junior, and to be sold by him, in Walnut-street, Philadelphia: Also by DAVID HALL. Price One Shilling, plain; or Two, neatly coloured.

Claypoole's notice even occupied the exact head-of-column spot on page one where Kennedy's had appeared a week earlier. But any consternation Claypoole caused was not acknowledged by Kennedy in his notice of 5 November:

To the Gentlemen Contributors to the
PENNSYLVANIA HOSPITAL.

The Perspective View of the PENNSYLVANIA HOSPITAL. with the Elevation of the Plan, lately taken by Messieurs Winter and Montgomery, is now engraved, and ready for the Press; and as you have been Friends to the Institution, it is humbly hoped you'll be pleased to favour this Undertaking; which, you may be assured, is the best Piece of the Kind ever prepared in America.

Robert Kennedy.

Finally, on 26 November Kennedy gave full details to his expected purchasers:

To the gentlemen managers and contributors to the Pennsylvania Hospital.
Gentlemen,
The PERSPECTIVE VIEW of the Pennsylvania Hospital, taken with your Approbation, is now finished, in a neat Manner. To you, Gentlemen, I owe the speedy Appearance of this Performance, not only by your countenancing my first Proceedings, but also by your generous contributing and large subscribing. . . . I am enabled to sell them as follows, plain 2s, 6d. coloured in the neatest Manner 4s., coloured, framed gilt and glazed with Bristol Glass 11s, 6d, with London Crown glass 11s. double framed, frosted and gilt in the neatest Manner 16s, 6d. To prevent imposition, my prints are distinguished by their true Perspective, and masterly Work. Sold by Mr. Rivington, Mr. Hall, Mr. Dunlap, Mr. Bradford, and the Subscriber, living in Third Street, opposite Joseph Fox, Esq.

Robert Kennedy

It may be surmised that Kennedy had the best of the bargain because of his official

connections. The minutes of the hospital managers recorded in April 1762 that "Robert Kennedy's acco being produced for two prints of the Hospital framed & glazed intended for the Proprietors amotg to £ 2.10 the Treasurer is desired to pay it." A year later the household expenses approved by the managers included "cash paid Robert Kennedy for Prints of the Hospital £ 8." Such recognition, the number of persons selling Kennedy's prints, his advertised multiple choices of framing, and his established business as a dealer, all lead to the inference that more copies of his view than of Claypoole's were distributed.

This conclusion is further supported by the fact that the Kennedy print appeared in two states. Sufficient copies must have been pulled from the plate to warrant its being corrected to prevent possible misunderstanding by the viewer. By adding numerals in the lawn in front of the east wing and changing the engraved material below the picture, it was made clear on the plate that most of the great building was still in the planning stage. Indeed, without this correction the print would have failed in some of its purpose in soliciting funds for the "intended" completion of the buildings.

Both pictures were about the same size and were suitable for framing. Both were colored in the opaque gouache manner then popular. They seem of about the same quality. The appearance of two such items concerning the same structure at so early a date, locally produced, is unmatched in America. But then, so was the projected building. It has been described as a landmark in architecture, designed on a scale far greater than anything of the kind theretofore planned in America and a hospital of which any city in Europe would have been proud.

Fig. 21

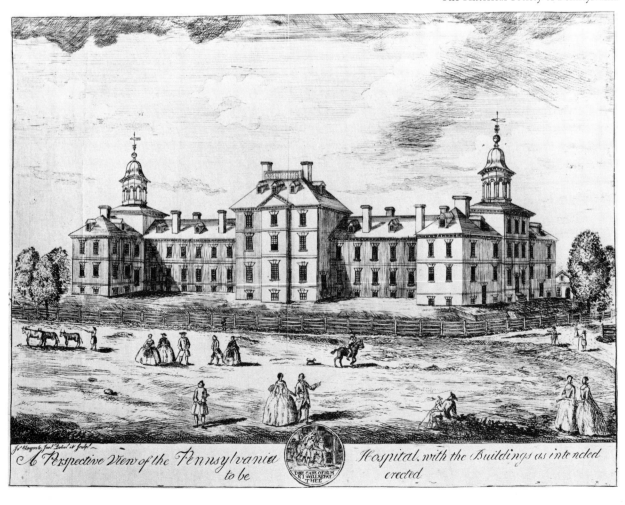

The later careers of both Kennedy and Claypoole are of interest. Kennedy was still advertising his Hospital print in the fall of 1762:

To be TAUGHT,
The ingenious and curious Amusement of Painting on Glass, in its Perfection, by ROBERT KENNEDY, at the Copper-plate Printing-Office, in Third-street, between Market and Arch-streets, Philadelphia. He is now prepared for the Reception of those who chuse to be instructed in this Branch of Science; but two Months of the Season, in which it is practicable, remain from the First of August. . . .
 Of whom may be had, the Prospect of the Hospital as usual, and a Collection of other framed and glazed Pictures, among which are human Figures, Prospects, Land Skips, the Seasons, the Sciences on Glass & otherwise, rural and humorous Pieces, &c. &c.

The coloring of the Hospital engravings with opaque colors, together with their size, indicates that they may have been intended for use in the diagonal mirror or peep-show machine. Kennedy's advertisement nearly five years later listed this equipment along with a wide variety of other wares and even another vocation, although he no longer advertised the "prospect" of the Hospital:

To the PUBLIC
Ladies and Gentlemen,
I take this Method to acquaint you, that I have for Sale, at the lowest Rates . . . a very neat and general Assortment of Maps and Prints, plain and coloured, neatly framed and glazed, in most Sizes and Fashions, suitable for Household Furniture, or the Cabinets of the CURIOUS. Also a Variety of Copper-plate

Fig. 22

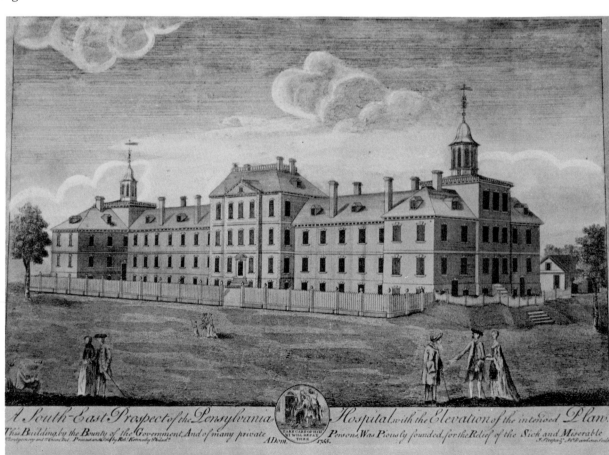

Writing Pieces for the Use of Schools, drawing Books, Japan Prints, Diagonal Mirrors, and coloured Prints for Ditto, Crown Glass of all Sizes, Gold and Silver Leaf, Shell and wax work Boxes, of the neatest Kind, fit for Ladies. I likewise frame, gild and glaze Pictures at the cheapest Rates, and repair, clean and gild old Paintings, Looking Glasses, &c. and varnish Pictures of all Kinds; Maps of the World at 5s each, and all other Pieces in Proportion. As I have had several Years Experience, I flatter myself I have acquired such a Degree of Knowledge of the Branches of my Profession as will enable me to give Satisfaction to those who shall be pleased to favor me with their Employ. I am the Public's most obedient servant

Robert Kennedy.

N.B. I likewise carry on the Business of House Painting and Glazing.

While Kennedy stuck to his last as a shopkeeper for the arts, Claypoole was concentrating on portraiture. A year after publication of his Hospital view, his work was seen by Charles Willson Peale; and a few years later Claypoole decided to embark for further study in London. His ship was blown by contrary winds to Jamaica. Finding ample commissions there for his talents without more formal training, he remained until his death in the 1790's.

(23) *Fig. 21.* A Perspective View of the Pennsylvania Hospital, with the Buildings as intended to be erected, by James Claypoole, Jr. Engraving, by James Claypoole, Jr., 1761, 9¼ × 13½. Attribution: Jas Claypoole, Junr Delint et Sculpt.

Fig. 21

(24) *Fig. 22 and Colorplate 1.* A South-East Prospect of the Pensylvania Hospital, with the Elevation of the intended Plan. This Building, by the Bounty of the Government, And of many private Persons, Was Piously founded, for the Relief of the Sick and Miserable, A Dom, 1755, by [?] Montgomery and John Winter. Engraving, by John Steeper and Henry Dawkins, 1761, 8⅜ × 13¾. Attribution: Montgomery and Winter Del. Printed and Sold by Robt. Kennedy Philada. J Steeper & H Dawkins Sculpt.

Fig. 22 and Colorplate 1

LATER STATE

(24A) As above, but with the words "A Dom, 1755" replaced by "Built A Dom, 1755. from N. 1 to 2" and addition of numerals 1 and 2 in right portion of picture below building.

REPRINT

(24a) Samuel T. Freeman & Co. catalogue, *Old Philadelphia Prints: The Latta Collection* (Philadelphia, 1916), no. 225 (listing for sale a "facsimile of the engraved plate").

English and American Adaptations of the Scull and Heap East Prospect, *1761 and 1765*

It was not the *Gentleman's Magazine,* but rather its presumed competitor the *London Magazine,* which brought Scull and Heap's *East Prospect of Philadelphia* to the attention of the English public. A new engraving of the scene, specially prepared in the maximum size adaptable for this use, appeared in the October 1761 issue as one of a series of American city views.

This third version of the print showed the foreshore, a clear indication that it was a reworking of the smaller of the two originals. Even so, much simplification and reduction were required and, to avoid a cluttered appearance, the shipping boats in the river had to be redistributed. Because the new copperplate was still more than nineteen inches wide, all copies show the folds necessary to fit the view inside the magazine pages.

Despite the inevitable loss of detail, this pirated version well preserves the flavor of the originals. Unobtrusively, it incorporates as insets not only the Battery first pictured in 1754, but also the Statehouse reduced in size from the 1756 edition. Naturally, it is far more easily found than either of its predecessors. Like them, it was issued only in black and white.

A few years later, the central portion of the *East Prospect* reappeared in simplified form in the only known American republication of any part of Scull and Heap's original. It formed the cover of a German-community almanac published at Philadelphia in 1765.

Almanacs were popular from the earliest years in the province. Samuel Atkins's *Kalendarium Pennsilvaniense* for 1686, a Philadelphia publication, was the first book printed in the Middle Colonies. In his preface written in 1685 Atkins mentioned the idea of embellishing the almanac with a drawing of the town which, had it materialized, would have been of the utmost importance in its pictorial history:

> I had thoughts to have inserted a Figure of the Moons Eclips, a small Draught of the form of this City, and a Table to find the hour of the day by the Shadow of the Staff: but we having not Tools to carve them in that form that I would have them, nor time to calculate the other, I pass it for this year, and . . . promise it in the next.

Unfortunately there was no later issue, for Atkins became involved in difficulties with the Provincial Council because of his reference in the 1686 almanac to "the Lord Penn."

The publication of local almanacs in the German community near Philadelphia commenced with that for 1739, composed by Christopher Saur in 1738 when he established himself as a printer. Within a few years Saur followed the German tradition of a cover picture. Thus, when Henrich Miller brought out a rival calendar in the 1760's, he looked for a suitable cover motif and for his issue compiled in 1765 used that of Scull and Heap's *East Prospect*. Perhaps this combined recent memories of the approach to Philadelphia for the Germans who had already arrived, and salesmanship of the city for persons who might receive the almanac in Germany.

The woodcut is crude, but in contrast to the newspaper heading of twenty-five years earlier, readily identifiable. The opening of High Street extending away from the Dela-

Fig. 23

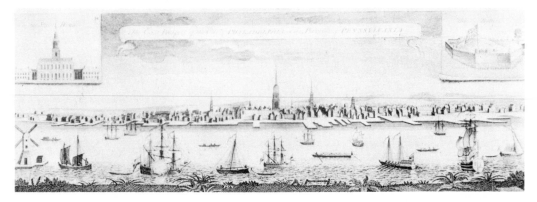

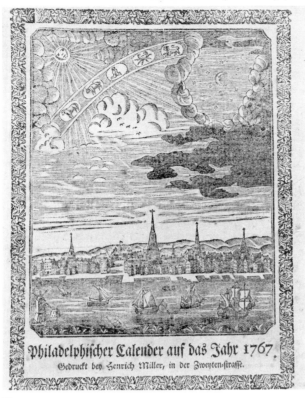

Fig. 24

ware and the viewer is easily seen. The steeple of Christ Church to the north and the tower of the Statehouse to the south appear in their proper places. Two additional steeples on the north side are those of the Presbyterian church and of the German Reformed church. As a sure trademark of the city, Windmill Island and its windmill are faithfully copied at the lower left from the original engraving. In the prevalent German style, the terrestrial scene is surmounted by a symbolic sky containing both the sun and the moon, as well as the signs of the zodiac.

The name of the artist does not appear. Presumably he, too, came from among the Pennsylvania Germans. The only person known to have had the ability to cut the block was Justus Fox. A man of many vocations, he was employed by the Saurs who, however, may have lent his talents for this purpose. Fox had arrived in Philadelphia from Mannheim, Germany, at the age of fourteen in 1750, and in 1759 he had already cut a wood engraving for the cover of the Saur almanac.

The inside cover of the first issue of Miller's almanac to carry the *East Prospect* contained for the reader a "Short Account of the City of Philadelphia," including reference to its churches and other public buildings—even the Fort, or Battery. Although this did not again appear, the cover picture was continued without change for fifteen years.

(25) *Fig. 23.* The East Prospect of the City of Philadelphia, in the Province of Pennsylvania, after George Heap. Engraving, 1761, 6⅜ × 19¼. Attribution: Engrav'd for the London Magazine. Source: *London Magazine* (October 1761). Insets: 1. the State House. 2. the Battery.

Fig. 23

(26) *Fig. 24.* (The East Prospect of Philadelphia), after George Heap. Wood engraving, 1765, 6 × 4¹³⁄₁₆. Source: Henrich Miller, *Der Neueste, Verbessert und Zuverlassige Americanische Calender Auf das 1766ste Jahr Christi* (Philadelphia, 1765), and subsequent years until issue for 1780.

Fig. 24

European Reproductions of the Scull and Heap Map, 1761 and 1764

Small portions of the Scull and Heap map of 1752, copied in the exact size of the original, formed illustrations for two European books in the early 1760's.

The first, the smaller and much the rarer picture, pirated the city grid portion of the original. J. Newbery of London published in 1761 a set of volumes entitled *A Curious Collection of Voyages, Selected from The Writers of All Nations* in which this appeared as a page-size engraving with a title reworded from that assigned by the American authors of the map. Apparently the work went through several editions, for P. Lee Phillips locates the same map at the same page of a 1769 imprint by Messrs. Newbery and Carnan published under the title *The World Displayed*. Surprisingly, this miniature engraving was reprinted in lithographic form in the nineteenth century.

The second and larger reproduction appeared as a plate in the octavo atlas *Le Petit Atlas Maritime,* by Jacques Nicolas Bellin (Paris, 1764). Prophetically, from the viewpoint of the battle on land and water to open the Delaware to the British in 1777, Bellin chose to copy only that part of the original map that began somewhat north of the grid of city streets but extended south below the juncture of the Schuylkill with the Delaware and included the islands in the neighborhood of the later Fort Mifflin. In this he foreshadowed the approach taken during the Revolution by numerous British "surveys" of Philadelphia.

The identifications of Bellin's points of interest are quaint and the original hand coloring adds to the decorative quality of this small map.

Fig. 25

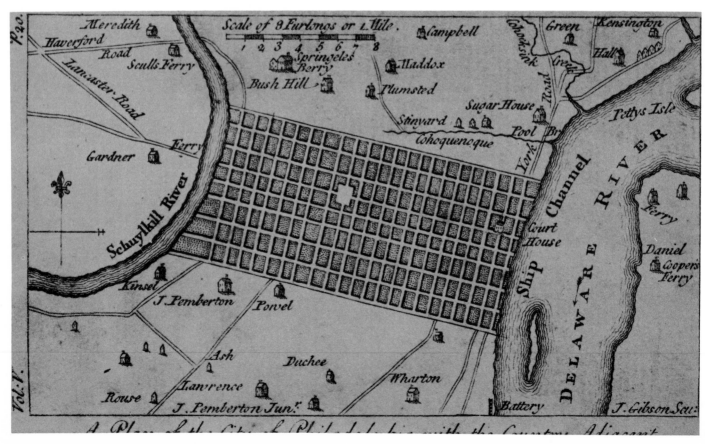

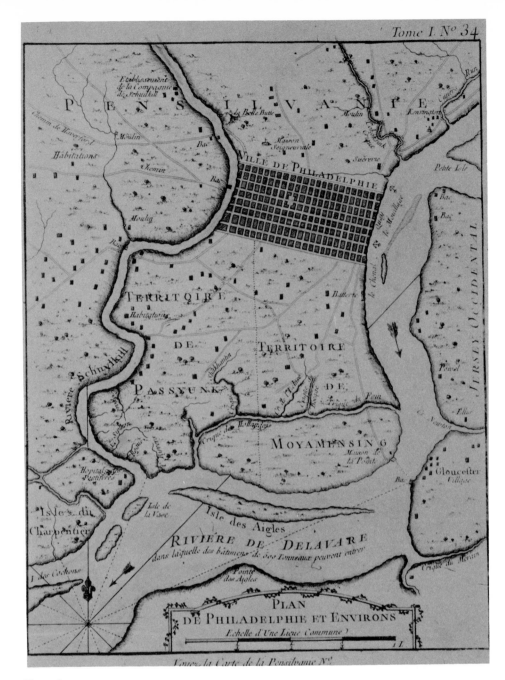

Fig. 26

(27) *Fig. 25.* A Plan of the City of Philadelphia, with the Country Adjacent, after Nicholas Scull. Engraving, by J. Gibson, 1761, 2½ × 4⅜. Attribution: J. Gibson Scu: Vol: V. P. 20. Source: *A Curious Collection of Voyages, Selected from The Writers of all Nations* (London, 1761), 5, opp. p. 20.

Fig. 25

REPRINT

(27a) Lithograph, without attribution or date, approximately the size of the original engraving, titled "Philadelphia."

(28) *Fig. 26.* Plan de Philadelphie et Environs, after Nicholas Scull. Engraving, 1764, 8⅛ ×6⅜. Attribution: Tome I. No. 34. Source: Jacques Nicolas Bellin, *Le Petit Atlas Maritime* (Paris, 1764).

Fig. 26

The Clarkson-Biddle Map of Philadelphia, 1762

The first detailed map of the interior of the city, published under names not recognizably connected with Nicholas Scull, actually completes his great contribution to Philadelphia iconography.

As surveyor general of the province, Scull's duties had included surveys of the streets and lots in the city. It is likely that he himself had combined these into the drafts of a map, and possible that he had planned to have such a map engraved and sold at the shop of Matthew Clarkson. This would round out a decade of valuable work marked by the publication of his map of the surroundings of the city in 1752, his work with George Heap on the *East Prospect* of 1754, and his map of the province that had appeared in 1759.

Scull's death in 1761 prevented completion of such a project. Luckily, the work was carried on by his daughter and executrix Mary Biddle. Clarkson provided the engraving and the map appeared near the end of 1762.

In common with many others, Clarkson's commercial activities were only in part directed to copperplate printing. Commissions of that kind did not require all his attention or provide the needed income. He was basically a tradesman and advertised the sale of tobacco, beer, wine, coffee, chocolate, and sugar. But he also had in stock "neatly framed mezzotints or glass paintings of the four seasons . . . together with scenes . . . of London and of Amsterdam." By the summer of 1761 he was active in engraving, for in his advertisement of 30 July he proclaimed:

COPPER-PLATE-PRINTING
By a workman from London,
Is performed, in all its Branches, for Matthew Clarkson, in Second-street, nearly opposite the Baptist Meeting-house. Where those who have Work to be done in that Way, may depend on its being executed in as neat a Manner as in England, with the greatest Care and Dispatch, on very reasonable Terms.

With Kennedy, Claypoole, and others on the scene, competition must have been keen for such engraving work as there was. Clarkson chose to capitalize on his own name without divulging that of the "workman." Clarkson was a well-known public figure who later served as an alderman and from 1792 to 1795 served as mayor of Philadelphia.

In the *Pennsylvania Gazette* for 7 and 14 October 1762, he appeared along with Scull's daughter as a publisher of the projected engraving of Scull's map by advertising:

PROPOSALS
for Printing by SUBSCRIPTION,
a plan of the improved Part of the City of Philadelphia; with Part of the District of Southwark, and Northern Liberties.

Showing the Streets, Alleys, Public Buildings, Wharffs, River Delaware, Island, Sand bars, Fort, Part of the New-Jersey Shore, &c.

Surveyed and laid down by the late Nicholas Scull, Esq.; Surveyor-General of the Province of Pennsylvania.

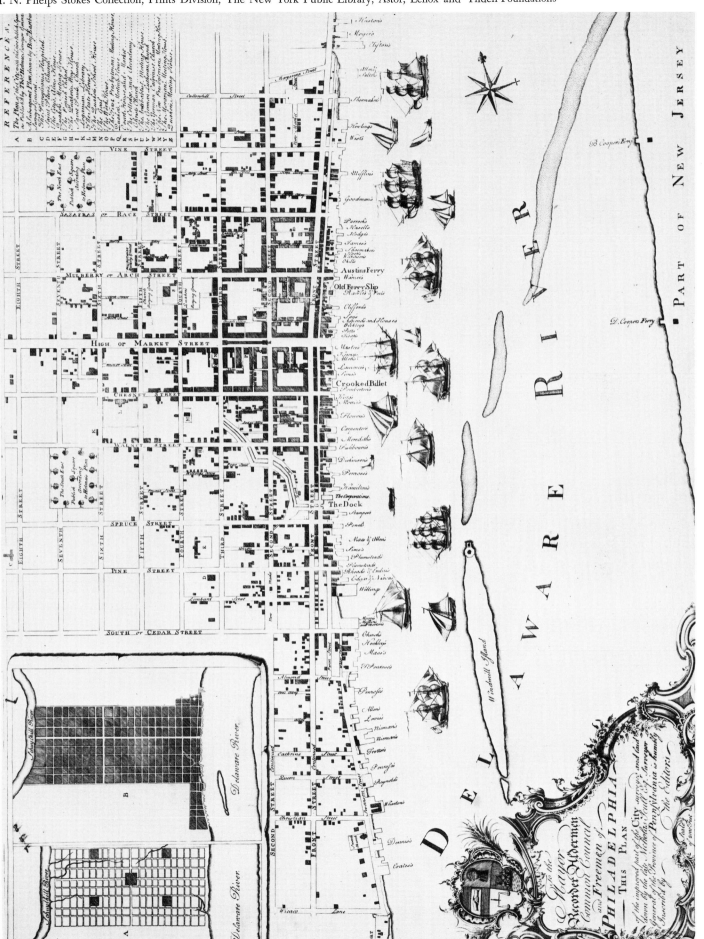

Fig. 27

Also the Plan of the city, with the Five public Squares, as published by Thomas Holmes, Surveyor-General. And a subsequent Plan, drawn by Benjamin Eastburn, Surveyor-General.

<div align="center">CONDITIONS</div>

I. That the above Plan shall be neatly engraved, and printed on a Sheet of the best Imperial Paper.
II. The Price to Subscribers to be One Spanish Piece of Eight, One Half of which to be paid at the Time of subscribing; the other Half at the Delivery of the Plan.
III. The Plan will be printed and ready to be delivered to the Subscribers, by the first Day of November next.

Subscriptions are taken in by William Bradford, David Hall and Lewis Weiss. And by the Editors, Mary Biddle, and Matthew Clarkson.

The third condition was almost met. On 11 November the *Gazette* announced:

<div align="center">

This Day is published,
(On a Sheet of Imperial Paper)
And to be Sold by Matthew Clarkson, and Mary Biddle,
Price Seven Shillings and Sixpence,
A Plan of the improved Part of the City of Philadelphia. . . .

</div>

The plan was prepared in great detail. Each building in the improved area was outlined. The exact locations of numerous institutions were now recorded for the first time: the old city Almshouse at Third and Pine streets, the Quaker almshouse on Walnut Street, the Loganian Library fronting on State House Square, the Jail and Workhouse at Third and Market streets, and the Quaker schoolhouse on Fourth Street. Twenty-three keyed references included, in addition, three Quaker meeting-houses and ten churches. This was the first map to locate and identify all the streets and alleys, the two existing markets and a projected third one, and at least sixty-five public and private docks that by now cluttered the waterfront.

A number of the keyed buildings soon disappeared. The city Almshouse was replaced, as was the Jail and Workhouse. The First Presbyterian Church on Market Street and the Second on Arch Street gave way to successors on the old sites. Some of the buildings listed in the reference key were never pictured, while others were later depicted only on the basis of description and recollection after their removal or destruction.

In the upper left corner of the new map were inserted small reproductions of two earlier plans of the city, in the familiar grid form, extending the full distance between the two rivers. Of these, the one Clarkson labeled as "published" by Thomas Holme was his first plan dating from 1683. The other, labeled as "drawn" by Benjamin Eastburn, surveyor general of Pennsylvania from 1733 to 1741, seems never to have been published separately and to be preserved only by means of this inset. At first glance these two small plans seem a curious addition to the far larger scale of the main map. The probable explanation lays bare long-continued and basic disputes.

The drawing for Clarkson's map was probably first prepared without the two incongruous reproductions. Before the engraving was cut, Clarkson presented the drawing

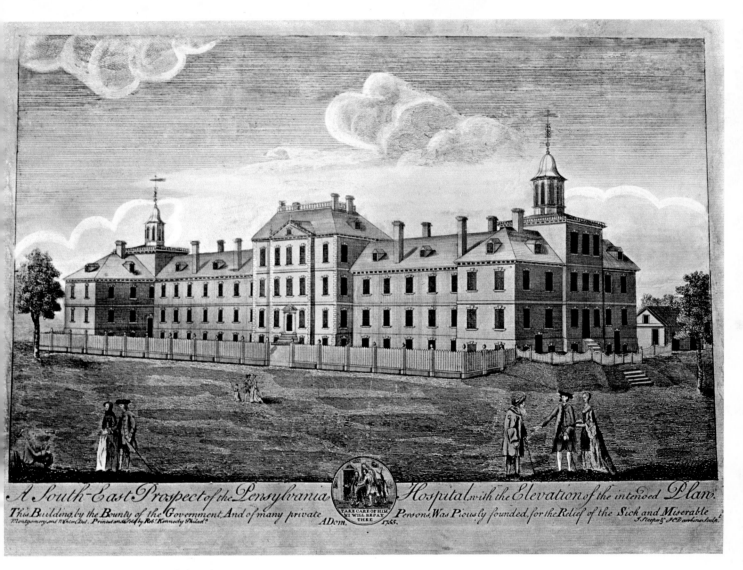

A South-East Prospect of the Pensylvania Hospital, with the Elevation of the intended Plan.
This Building, by the Bounty of the Government, And of many private Persons, Was Piously founded, for the Relief of the Sick and Miserable

TAKE CARE OF HIM
XI WILL REPAY
THREE

A Dom. 1755.

Colorplate 1. For a description of this plate, see item 24.

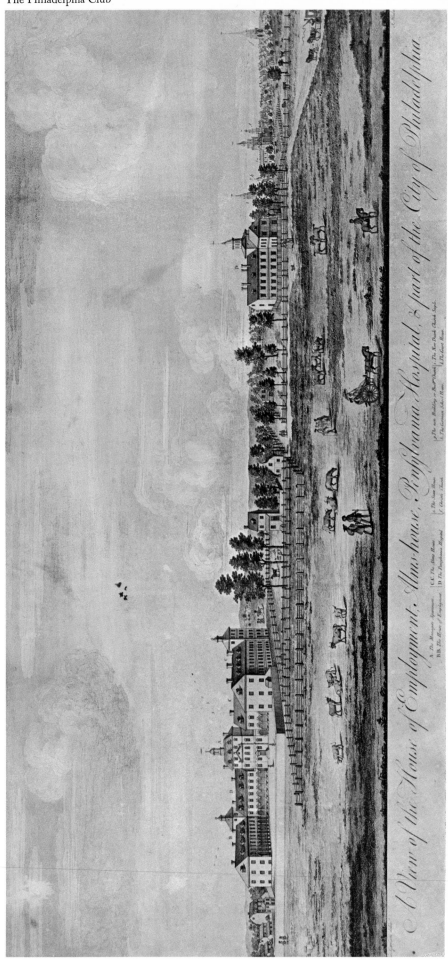

A View of the House of Employment, Alms-house, Pennsylvania Hospital, & part of the City of Philadelphia.

Colorplate 2. For a description of this plate, see item 35.

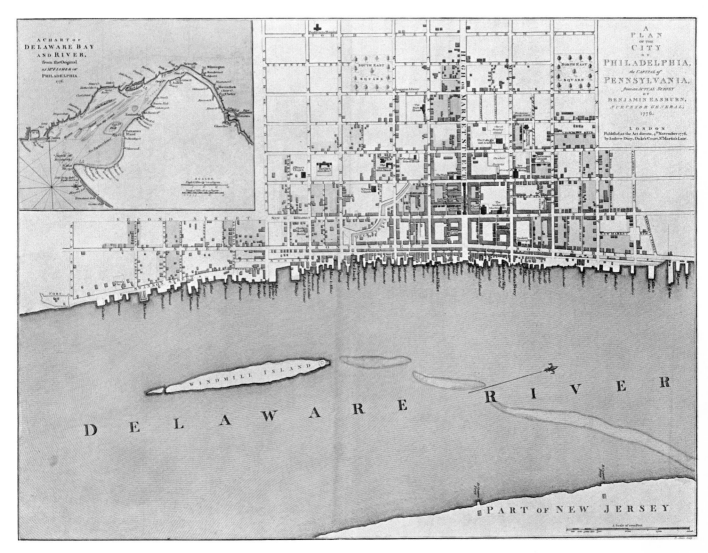

Colorplate 3. For a description of this plate, see item 44.

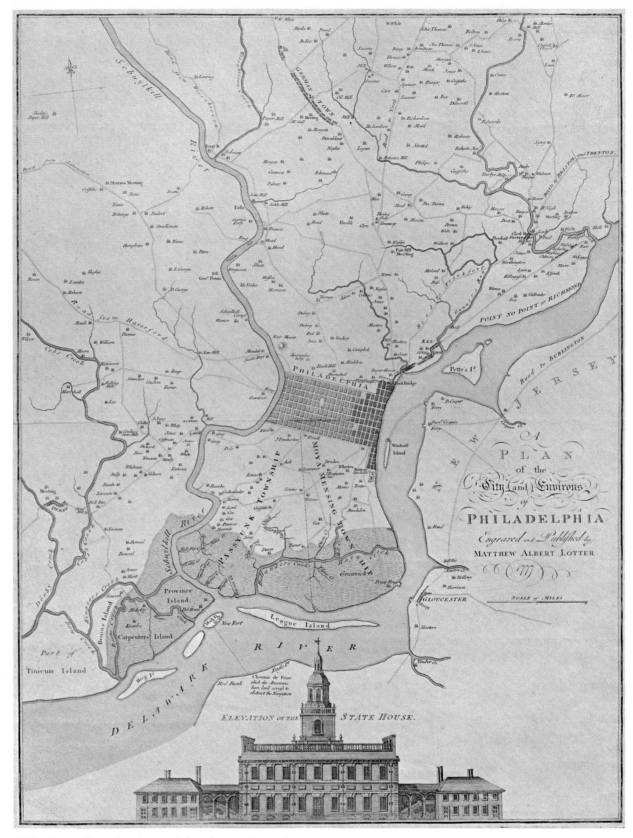

Colorplate 4. For a description of this plate, see item 48.

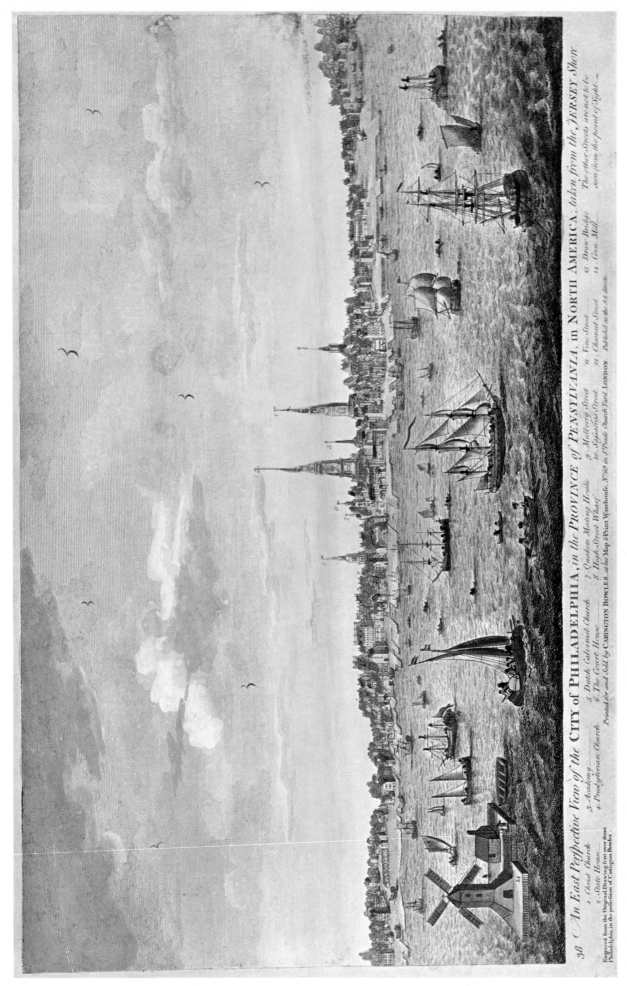

38 — An East Perspective View of the CITY of PHILADELPHIA, in the PROVINCE of PENSYLVANIA, in NORTH AMERICA; taken from the JERSEY Shore.

1. Christ Church 5. Dutch Calvinist Church 7. Quakers Meeting House 9. Mulberry Street 10. Vine Street 12. Draw Bridge The other Streets are not to be
2. State House 6. The Court House 8. High Street Wharf 10. Sassafras Street 11. Chesnut Street 13. Corn Mill seen from the Point of Sight.—
3. Academy
4. Presbyterian Church Printed for and Sold by CARINGTON BOWLES, at his Map & Print Warehouse, No 69 in S.t Pauls Church Yard LONDON Published as the Act directs

Engraved from the Original Drawing sent over from
Philadelphia, in the possession of Carington Bowles.

Colorplate 5. For a description of this plate, see item 100A.

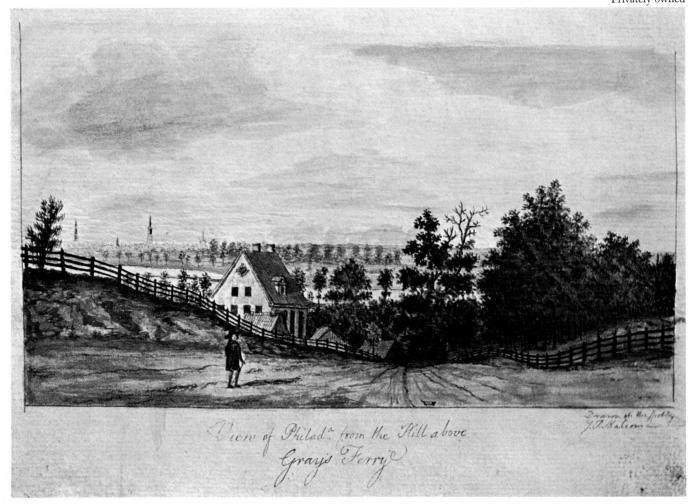

View of Philadª from the Hill above Grays Ferry

Drawn of the spot by J. J. Malcom

Colorplate 6. For a description of this plate, see item 135.

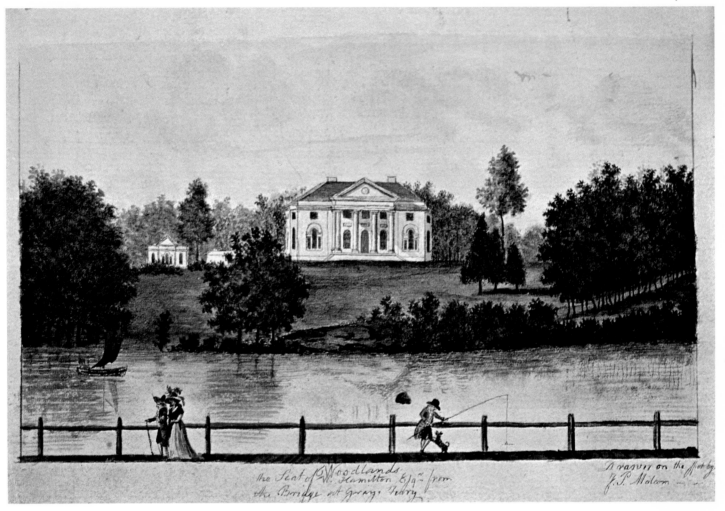

the Seat of W. Hamilton Esq. from
the Bridge at Grays Ferry

Drawn on the Spot by
J. P. Malcom

Colorplate 7. For a description of this plate, see item 136.

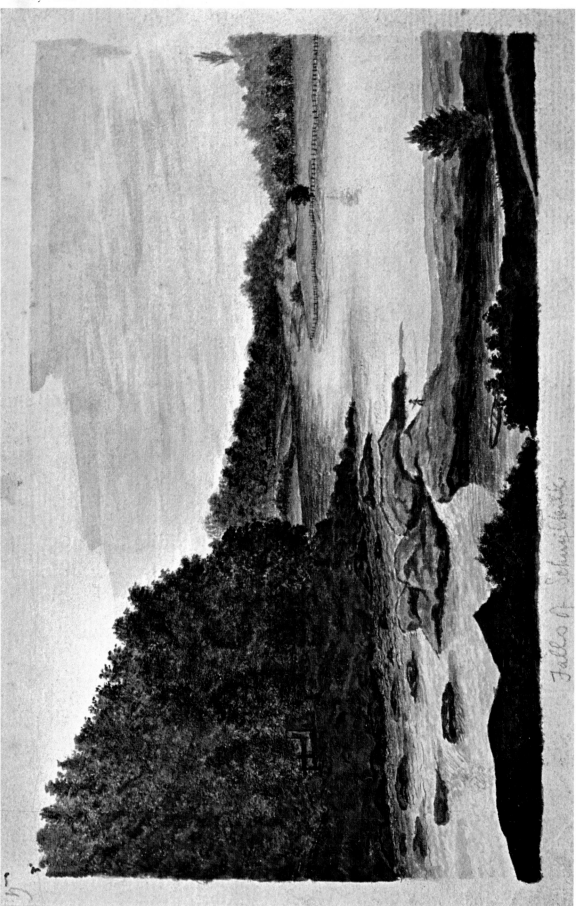

Colorplate 8. For a description of this plate, see item 137.

to the Common Council of Philadelphia. It already bore a dedication to the officials and the freemen of the city. He may have had an informal understanding that this would result in financial assistance for the publication, for he was awarded by the city the sum of "Ten pistoles towards defraying the Expence of the plate [but only] on Condition, nevertheless, that the Publick Squares laid down in the original Plan of the City, be so described that the Claim of the Inhabitants of the said City may not be prejudiced."

The subject of the city's public squares was intensely controversial at the time. In 1741 Thomas Penn, as provincial proprietor, had purported to sell a part of the northeast square (shown in full on Clarkson's map) to the Lutheran church, which had been using it as a burial ground. His right to do this was questioned. Although a warrant was issued at once, payment by the church and issuance of a deed was delayed until twenty-two years later, when John Penn, nephew of the grantor and without knowledge of the background, arrived and completed the requested sale. In 1800 the city attempted to eject the church, following which the Lutherans took a lease of the ground until 1819. Only in 1836 did the Pennsylvania Supreme Court settle the matter by voiding Penn's act as an invasion of the permanent rights of the public to the square, given by William Penn in the *Portraiture* of the city printed in 1683.

Again in 1751 Thomas Penn conveyed a large part of the area of the northeast square to the Pennsylvania Hospital, but its managers refused to accept it, saying not only that the spot was unhealthy but that it had been set aside for the public. "The dissatisfaction . . . among our fellow citizens on the proprietaries claiming a right to make that grant, is so great, that if there were no other objection, we would not run the risk of increasing it."

Beyond all this, the proprietary had conveyed the northwest square to private ownership but had appropriated a similar area slightly to the west. The southwest and center squares had been moved the same distance to the west, while Broad Street was also moved westward so as to create fourteen city blocks to the east of it and only eight to the west, in place of the earlier equal division of eleven blocks in each direction.

Hence, the council's requirement of Clarkson is readily understood. His adding to his copperplate a small reproduction of each of the two earlier plans of the city appears to have been his response. His reference in the index key to that of Holme emphasizes the subject of the squares. The Holme reproduction records the original squares and street layout; the Eastburn reproduction reports the changes made in them.

Presumably the copperplate was cut locally by the "workman from London" who was in Clarkson's employ. The plate was generous in size and the largest yet produced at home. Granted that the cutting of map lines was much simpler work than catching the varied shapes and the perspective in a picture, the result is competent.

Eighteenth-century copying followed publication by less than fifteen years: British, French, and German reproductions of the whole or a part of the work were published during the American Revolution. The nineteenth century also saw reissues in 1858, and in 1875–76 for the Centennial. Two twentieth-century imprints also exist. Clearly the original publication broke so much new ground that it has more than usually attracted persons interested in the early history of the city.

Fig. 27

(29) *Fig. 27.* To the Mayor Recorder Aldermen Common Council and Freemen of Philadelphia This Plan of the improved part of the City Surveyed and laid down by the late Nicholas Scull Esqr. Surveyor General of the Province of Pennsylvania is humbly Inscrib'd by The Editors, after Nicholas Scull. Engraving, 1762, 19⅜ × 25¾. Attribution: Published according to Act of Parliament, Novr. 1st 1762, and sold by the Editor's, Matthew Clarkson, and Mary Biddle in Philadelphia. Insets: 1. The Plan of the City, with the Five Publick Squares as Publish'd by Thos. Holmes, Surveyor General. 2. A Subsequent Plan drawn by Benjn. Eastburn Surveyor General.

LATER STATE

Existence of differing states employing "Mary" and "M" Biddle in attribution line is possible. Compare reprint (29a) below.

REPRINTS

(29a) Lithographic facsimile titled: Philadelphia 100 Years Ago! by Worley, Bracher & Matthias, Philadelphia. Republished by Joseph H. Bonsall & Samuel L. Smedley, 1858.

(29b) Reissue of reprint (29a), 1875, described in P. Lee Phillips, *A Descriptive List of Maps and Views of Philadelphia in the Library of Congress* (Philadelphia, 1926), no. 153.

(29c) Miller and Moss, Philadelphia, 1876.

(29d) Photographic reproduction from reprint (29a), Society of Colonial Wars in the Commonwealth of Pennsylvania, 1957.

(29e) Modern reproduction issued by Historic Urban Plans, Ithaca, New York, 1969.

The Four Political Cartoons of 1764–65

William Murrell in his *History of American Graphic Humor* characterizes Philadelphia as "the birth place of the American cartoon." This accolade was won by the issuance of political copperplate broadsides before and after the violent local election contests of 1764.

Franklin was fighting for his political life, while the Quakers were split into camps supporting and opposing the proprietary, and the German and Scots-Irish population had for the first time grown to be perhaps the controlling factor at the polls. Murrell's words convey the spirit of the exciting contest that found expression, among other ways, in recourse to scurrilous political cartoons:

> The citizens were bursting with excitement over a number of matters that had suddenly come to one head and had gone completely to all theirs. And accompanying and commenting upon these matters was a veritable cloudburst of pamphlets, broadside satires, mock epitaphs, and cartoons—real cartoons, before which time there had been none produced in America, and which were so forceful and well executed as to compare favorably with any done within the next fifty years.

The cartoons played a part in defeating Franklin's bid for re-election to the assembly. His generally straddling position earned him the criticism of both contending

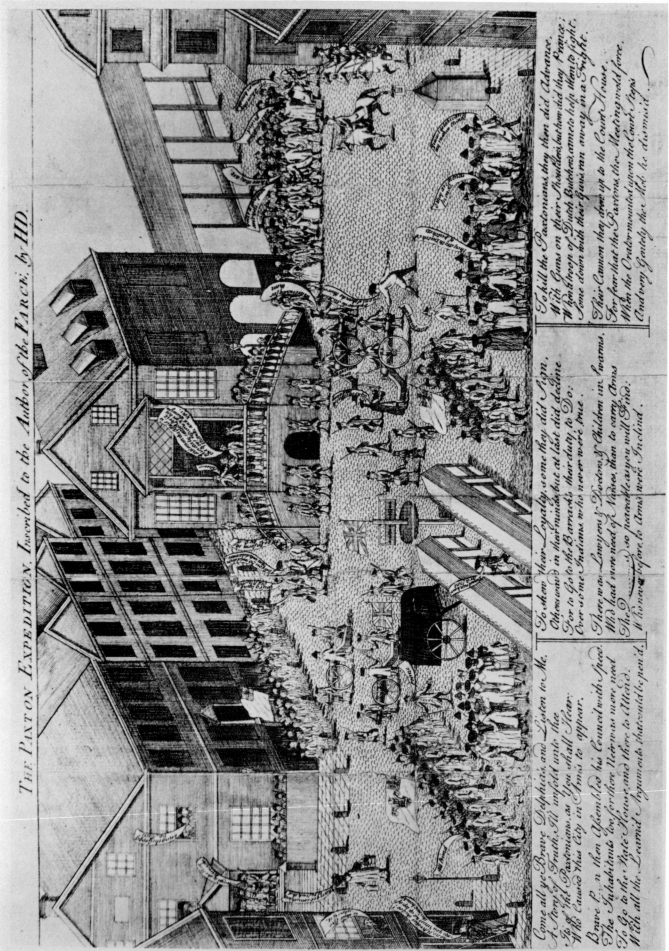

THE PAXTON EXPEDITION. Inscribed to the Author of the FARCE; by HD.

Come all ye Brave Dutchia's, and Listen to Me.
A Story of Truth, I'll unfold unto thee
To y.e. Paxtonians, as You shall Hear
Who Caused this City in Arms to appear.

Brave P——n then Usembled his Council with Speed
The Inhabitants too, for there Nets were need
To Go to the State-House, and there to Attend
With all the Learned Arguments that would be pen'd.

To them their Loyalty some they did Sign,
Othersome in their minds but at last did decline
For to Go to the Barracks, their duty, to Do.
Over some Indians who never were true.

There was Lawyers & Doctors & Children in Swarms
Who had more need of Nurses, than to carry Arms
The D—— so Inexorable as you will find
Who never before to Arms were Inclind.

To kill the Paxtonians, they then did Advance,
With Guns on their Shoulders, but how did they Prance;
Whole troops of Dutch Butchers, came to help them to fight,
Some down with their Guns ran away in a Fright.

Their Cannon they drew up to the Court House,
For fear that the Paxtons, the Meeting wold force.
When the Orator mounted upon the Court Steps
And very Gently, there Met he dismis'd.

Fig. 28

sides. On election day, October first, he lost his assembly seat in the only political contest he was ever to lose.

The creation of a printed cartoon required an artist. Whether because the earlier local printmakers were not politically active or because the new broadsides were distributed free of charge, a new name appeared. On the only one of the prints to show attribution, the name was Henry Dawkins.

Dawkins has left for the record a colorful career. He was in New York as early as 1753, and two years later advertised that he "engraves in all sorts of metals." Soon afterward he settled in Philadelphia as assistant to the engraver James Turner. By 1758 he was in business for himself, illustrating books and engraving bookplates and caricatures. Just before the Revolution he appears to have returned to New York, where in 1776 he became notorious: He was arrested on suspicion of using his talents to forge colonial money. Although the records of his Masonic lodge in Philadelphia refer to his being publicly hanged, by some turnaround he received $1,500 from the government in 1780 for engraving the plates for proper Continental bills. Sale of his stock of copperplates in 1786 suggests that this was the year of his death.

Four engravings have survived containing local pictures related to the 1764 campaign. It cannot definitely be claimed that these were all the work of Dawkins—particularly as they assert opposing political views—but all four appear to exhibit the same style.

Each broadside consists of lengthy rhymes surmounted by a picture of the voting area. This centered around the Old Courthouse standing in the middle of High Street, which had never before been pictured although it had been erected about 1707. Its medieval style was revealed not only by its position in the center of the street but by its architecture: An arcade in the open air below provided space for the primitive market, while rooms above were intended for the Provincial court and assembly. These were reached by an outside stair that the citizens mounted in order to cast their ballots in the upper entranceway.

Although the Courthouse was torn down in 1837, it was still in the 1760's the nerve center of the town, as the Statehouse was of the province. Chronologically, it should have been recorded in prints before the Statehouse, but it cut a poor figure in comparison with the latter. It took the affairs of the man of the street to bring it into the pictorial record.

An event loaded with political overtones and known as the "Paxton Expedition" called forth the first and pictorially the best of the cartoons. In the assembly Franklin chose as a method of protest against the Quaker party's pacifism to denounce certain white frontiersmen who had murdered peaceful Conestoga Indians living near Lancaster, Pennsylvania. Provoked, the so-called Paxton Boys responsible for this behavior threatened to march to Philadelphia and kill any Indians found there. Making good their threat, they advanced as a mob from Lancaster toward the city. Many citizens were so frightened as to consider moving away. The governor called a public meeting before the Courthouse where volunteers and arms were mustered in defense. Before they were needed, a committee of three, including Franklin, deflected the encounter by meeting the advancing group at Germantown, some miles from the city, and persuading them to return to their homes.

The humor of the situation Franklin caused, with formidable military preparations followed by the bursting of the bubble through gentle talk, made political capital for

his foes. Thus came into distribution the broadside headed *The Paxton Expedition, Inscribed to the Author of the Farce, by HD,* showing the Courthouse and a warlike scene before it where the defense was centered. Into an area bristling with cannon Dawkins introduced more than a hundred figures ready to offer resistance to the terrorists who did not arrive. Six rhymed stanzas were engraved below the picture, the last two of which completed the ridicule of the whole affair:

> To kill the Paxtonians, they then did Advance,
> With Guns on their Shoulders, but how they did Prance;
> When a troop of Dutch Butchers, came to help them to fight,
> Some down with their Guns, ran away in a Fright.

> Their Cannon they drew up to the Court House,
> For fear that the Paxtons, the Meeting would force,
> When the Orator mounted upon the Court Steps
> And very gently the Mob he dismis'd.

I. N. Phelps Stokes describes the print as "the earliest known engraved interior view of Philadelphia," i.e., of the interior of the town; but this ignores the rendering of the Statehouse façade as early as 1752 and 1756, and both the 1761 plates of the Pennsylvania Hospital.

The Paxton broadside, while not a part of the election campaigning, had obvious impact upon it. The three that followed were centered in that event. First in sequence was *The Election a Medley, Humbly Inscribed, to Squire Lilliput Professor of Scurrillity,* whose title sets its tone. This was pro-Franklin. Next appeared *The Counter-Medly, being a proper Answer to all the Dunces of the Medly and their Abettors.* This reached the peak of viciousness, introducing a villainous caricature of Franklin

Fig. 29

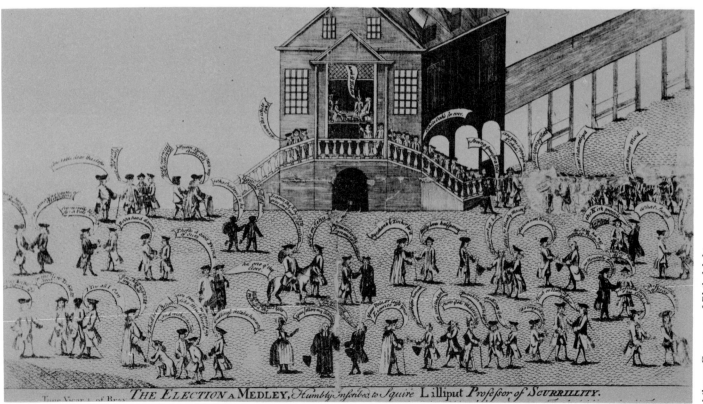

THE ELECTION A MEDLEY, Humbly Inscribed to Squire Lilliput Professor of Scurrillity.

specially labeled as the agent of the Devil "for all my realms" and in the act of carrying out his instructions. The last, *The Election Humbly Inscrib'd, to the Saturday-Nights Club, in Lodge Alley,* included in its heading a couplet of Alexander Pope's:

> Calm thinking Villains whom no faith can fix.
> Of crooked Councils, and dark Politicks.

The picture of the Old Courthouse on each of these immediately brought the reader to the point labored in the lengthy rhymes. The *Medley* had thirty-three sections of verse intended to be sung to various tunes; the verses, according to the *Counter-Medly,* were the work of no less than twelve persons.

Many of the verses on the various copperplates appear to be the work of David James Dove. Dove had arrived from England in 1750 and was both a schoolteacher and an active participant in the city's political campaigns. He was deeply involved in all maneuvers against the Proprietary party. Composing scurrilous rhymes well suited for anonymous broadsides was his forte. He has been proved by Edgar Richardson to be the author of the verses on the last of the four plates to appear: In a letter sent to London dated 8 February 1765, William Franklin, governor of New Jersey, reported that William Allen, chief justice of the Pennsylvania Supreme Court, was responsible

Fig. 30

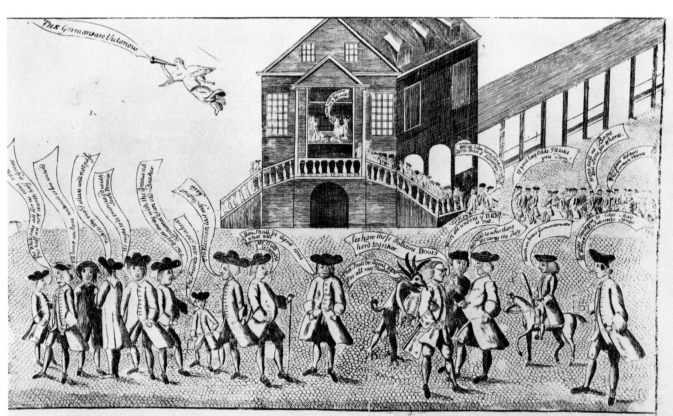

The COUNTER-MEDLY, being a proper ANSWER to all the DUNCES of the MEDLY and their ABETTORS.

Library Company of Philadelphia

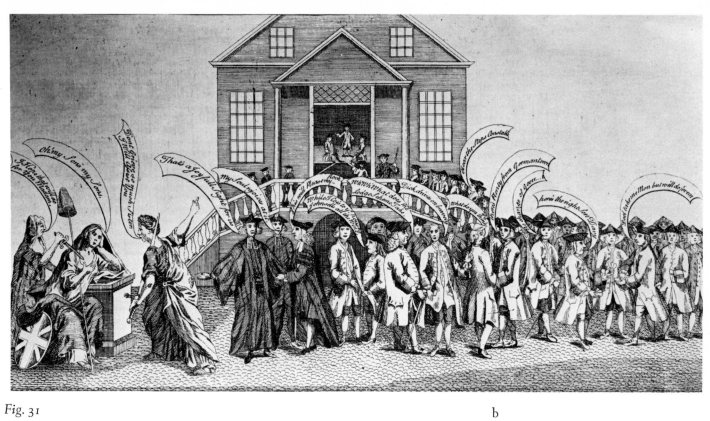

Fig. 31 b

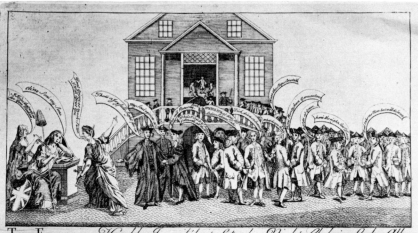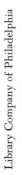

(Detail)

for the appearance of the plate, hired Dove to write the verses for it, and spent more than twenty-five pounds in having the print produced complete with the rhymes.

All four of the broadsides appeared within approximately one year. The Paxton affair took place in February 1764, while the last plate contains the internal date 1765 and was in circulation when its origin was reported by Governor Franklin's letter.

The portrayals of the Courthouse appearing in these four cartoons are the only ones known until William Birch showed the busy corner in his series of views of the city thirty-five years later.

Fig. 28 (30) *Fig. 28.* The Paxton Expedition, Inscribed to the Author of the Farce, by HD, by Henry Dawkins. Engraving, by Henry Dawkins, 1764, 7 × 13 (headpiece of broadside).

Fig. 29 (31) *Fig. 29.* The Election a Medley, Humbly Inscribed, to Squire Lilliput Professor of Scurrillity, after Henry Dawkins. Engraving, 1764, 8 × 14⅜.

Fig. 30 (32) *Fig. 30.* The Counter-Medly, being a proper Answer to all the Dunces of the Medly and their Abettors, after Henry Dawkins. Engraving, 1764, 8³⁄₁₆ × 14³⁄₁₆.

Fig. 31 (33) *Fig. 31.* The Election Humbly Inscrib'd, to the Saturday-Nights Club, in Lodge Alley. Calm thinking Villains whom no faith can fix. Of crooked Councils, and dark Politicks. Pope. After Henry Dawkins. Engraving, 1765, 6⅜ × 12⅛.

The City from the South, 1767

Nicholas Garrison was in 1767 an elected overseer of the poor in Philadelphia. To that fact we owe the existence of an extremely valuable engraving of the city as it appeared just before the Revolution. Approximately twenty-seven inches wide and hence able to depict important detail, it is the only view of the city as a whole from the south, showing it spreading westward only to the vicinity of the Statehouse. It has become one of the most valued American city views of the century.

Garrison was the son of an English sea captain of the same first name. He served on ships his father sailed to America in the 1740's and 1750's. Like his father, he was a Moravian. Upon his marriage in 1757 or 1758, he settled in the Moravian center of Bethlehem, Pennsylvania, some fifty miles from Philadelphia. He was a grocer there, but, as he could draw, he engraved views of Bethlehem and of Nazareth, a nearby town.

Garrison moved in 1762 to Philadelphia, where, shortly afterward, he became involved in poorhouse matters. By the 1760's the public almshouse built many years earlier between Third and Fourth streets was badly overcrowded. In February 1766 *An Act for the Better Employment, Relief and Support of the Poor* authorized contributors to its purposes to buy new ground and erect a large three-part building. One part, the Almshouse, was to maintain the idle and helpless poor; a second, the House of Employment, was to provide for the housing and employment of the working poor; and a third was to house the superintendent. The contributors arranged to buy a

country block, far west of the outgrown building, bounded by Spruce and Pine, Tenth and Eleventh streets. As these events took place, overseers of the poor were publicly elected with the duty of supervising the expenditure of public charitable funds. Garrison was one of these. The overseers, the contributors, and the managers of the House of Employment now worked together. Garrison was brought into the details of the new venture.

Although the Pennsylvania Hospital, two blocks to the east, stood unfinished for lack of funds, the new institution was promptly begun and completed by subscriptions and a mortgage. An interesting C-shaped building with an internal arcade facing south was opened in October 1767. Garrison's picture must have been issued in commemoration of that event.

Garrison may first have made an oil painting of the scene, which served as the prototype for his engraving, or produced the painting a bit later as a gift to the institution. Such a painting came to light in the 1950's. Like the engraving, it depicted both the new building housing the poor, which was destroyed in 1835, and the Pennsylvania Hospital, which survives. The painting was given to the latter and is displayed in its library.

The large painting seems to have been made from a rise to the south of the scene it portrays. This is essentially but not exactly the scene of the engraving. A few figures appear at the corner of Ninth and Pine streets in the center foreground. The latter is but a dirt track. As in the print, the outline of the city and its towers fails to cover the open country between the neighborhood of Sixth and Walnut streets and the new building, set in farmland, which is the central subject of the picture.

The painting appears to be unsigned, and both it and the engraving are undated. But the minutes of the Hospital record the gift to it in 1768 of a colored copy of the print.

Fig. 32

Library of the Pennsylvania Hospital, Philadelphia

The engraving was done in London by James Hulett, perhaps a friend or connection of Garrison. Hulett was active as an engraver in the 1750's and 60's. Although he could have worked from the painting, which was later returned to America, it is more likely that a drawing served as his model. Slight changes from either would be permissible if intended to make the scene more agreeable and less rough, particularly if the print were to be offered for sale in London. In the custom of the day, a key to eight important buildings appears.

If the print was sold, its availability at shops in Philadelphia must have been short lived. Pierre Eugène Du Simitière, a collector and the organizer of one of the first museums in the province, arrived about 1770 and recorded a copy of the engraving as coming to his attention in 1779.

A second edition was published in October 1787, probably in London. Garrison appears to have had nothing to do with this. He was a patriot and fled from Philadelphia to New Jersey just before occupation of the city in 1777 by the British. In 1780 he moved to Berks County farming country in the Pennsylvania interior. The printing of more copies may have had to do with a solicitation of funds during the period of heavy debt of the institution following the end of the Revolution.

Fig. 32

(34) *Fig. 32.* (Almshouse and Pennsylvania Hospital), presumably by Nicholas Garrison. Oil on canvas, c. 1767, 24 × 34½. Source: Library of the Pennsylvania Hospital, Philadelphia.

*Fig. 33 and
Colorplate 2*

(35) *Fig. 33 and Colorplate 2.* A View of the House of Employment, Alms-house, Pensylvania Hospital, & part of the City of Philadelphia, by Nicholas Garrison. Engraving, by James Hulett, c. 1767, 11¼ × 26½. Attribution: Nic. Garrison delint J. Hulett sculp.

LATER STATE

(35A) As above, but with additional attribution: Published Oct. 17, 1787 by J. Harris, Sweeting's Alley & No. 8 Broad Street.

Fig. 33

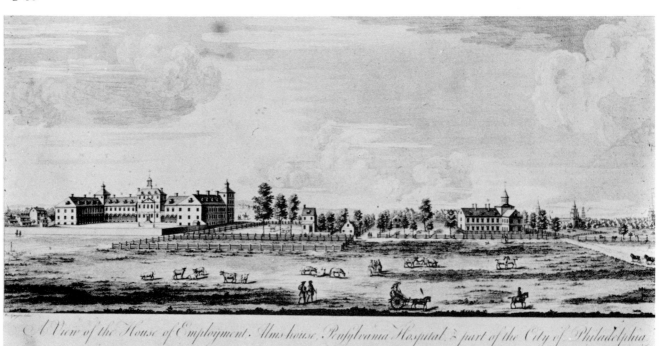

A View of the House of Employment. Alms house, Pensylvania Hospital, & part of the City of Philadelphia

Baptism on the Schuylkill at Spruce Street, 1770

A small unsigned engraving, attributed by Mantle Fielding to James Smither, gives a unique insight into the forest area lying along the east bank of the Schuylkill River at Spruce Street as it was at the Revolution—an area included within the geographical boundaries of the city since 1682, but then still in the open country "a mile and a half out of Philadelphia."

Morgan Edwards, minister of the First Baptist Church in Philadelphia, published in 1770 *Materials Towards a History of the American Baptists* and included as the frontispiece of the work what Joseph Jackson has called "a most remarkable engraving." It depicts a baptism in the river, a crowd of the faithful forming a standing congregation along the well-forested bank, and the preacher exhorting them from atop a large rock. Nearby, their horses stand tethered and their carriages wait beside a small building.

Edwards described the scene in an appendix to his book. After pointing out that he and his predecessor, as well as a clergyman of the Church of England, had made the river a place of baptism, he described the spot shown in the print, which he said

> is not only convenient for the celebration of baptism but most delightful for rural sceneries. Hither the towns people in summer resort for recreation and entertainment. . . . Round said spot are large oak, affording fine shade. Underfoot, is a green, variegated with wild flowers and aromatic herbs. Just by was lately erected a house for dressing and undressing . . . it is divided into two rooms by a hanging partition, and so contrived that when the partition is lifted up and the doors opened, and the folding shutter in the front let down, that it resembles an alcove, facing a prospect of land, wood, water, rocks, hills, boats, &c. In the midst of this spot is a large stone rising about three feet above ground, round which I have often seen the people . . . kneel to pray after baptism had been administered. The top is made level by art, and steps hewn to ascend; on the top stands the minister to preach to the people who resort thither to see baptism performed; and a multitude of hearers he commonly has. I have once reckoned there 32 carriages, and have often seen present from 100 to 1000 people, all behaving much better than in some other places. . . . By way of conclusion to this appendix I will add the hymn that is wont to be sung in this place upon the occasions before named.

SCHUYLKILL HYMN

Jesus master O discover
Pleasure in us, now we stand
On this bank of Schuylkill river,
To obey thy great command, . . .
. . .
Of our vows this stone's a token
Stone of witness bear record
'Gainst us, if our vows be broken
Or if we forsake the Lord. . . .

The scene pictured did not remain long. Watson wrote that the trees at the spot, often called the "Baptisterion," were cut down for fuel by the British army during the Revolution, i.e., within ten years. Yet Willis P. Hazard, when he prepared his addi-

Fig. 34

Fig. 34

tions to Watson's *Annals of Philadelphia* in 1879, more than a hundred years after the engraving, found the old building still standing, "but it has been altered into two small dwelling houses, numbered 306 and 308 South Twenty-Fourth street. The original door faced Spruce street, but it has been bricked up for years."

(36) *Fig. 34.* (Baptism on the Schuylkill), attributed by Mantle Fielding to James Smither. Engraving, 1770, 2¾ × 5⅛. Source: Morgan Edwards, *Materials Towards a History of the American Baptists* (Philadelphia, 1770), 1, frontispiece.

First Building of the College of Philadelphia, c. 1770

A drawing in the equivalent of today's lead pencil preserves the aspect, at about the time of the Revolution, of what was then Philadelphia's largest building. Mounted in the notebooks of Pierre Eugène Du Simitière, the Swiss-born artist, naturalist, and antiquary, there can be no doubt of its authenticity.

The building was erected for use by visiting ministers of the gospel, particularly the great George Whitefield, an English evangelist whose voice was said to have carried a mile and whose delivery of sermons had a most remarkable effect. The clergy already established in America regarded his evangelism as abnormal and closed their pulpits to him. Upon his first visit to Philadelphia in 1739 at the age of only twenty-

five, he was forced to speak from the balcony of the Old Courthouse at Second and High streets. His audience overflowed the streets, and his voice was readily heard near the Delaware, more than a city block away.

Franklin felt that Whitefield had a most beneficial effect upon the morals and behavior of the townspeople. He became an admirer. Soon after Whitefield's appearance a movement to provide a proper hall for visiting preachers resulted in the building of a meetinghouse on the west side of Fourth Street between High and Arch. The hall, built in 1742, was larger than the Statehouse, for Whitefield drew as many as fifteen to twenty thousand listeners. For architectural relief of the long roofline, a low steeple was set upon the top. Whitefield last preached there in 1746.

In these same years trustees establishing a charitable school in the city erected smaller buildings alongside the great new meetinghouse. With the aid of Franklin, a prime mover in improving facilities for the education of the young, not only were the lesser buildings acquired, but the great hall as well, for a "College, Academy and Charitable School" opened in 1751 and was incorporated by charter in 1755. In this way the University of Pennsylvania came into being, although it was not chartered under that name until 1791.

No exact date can be ascribed to Du Simitière's drawing. He made Philadelphia his home from about 1770 until his death in 1784. Although no other drawings by him of buildings in the city appear to have survived, he is known to have drawn in black line, produced by finely sharpened chalk.

The great hall did not remain for long; and this, apparently the only contemporary picture of it, has been copied many times.

(37) *Fig. 35.* (Probably in another hand) Old Academy & Charity School, 4th below Arch, probably by Pierre Eugène Du Simitière. Black chalk drawing, c. 1770, 5¼ × 7½. Source: Library Company of Philadelphia, Du Simitière Collection.

Fig. 35

Fig. 35

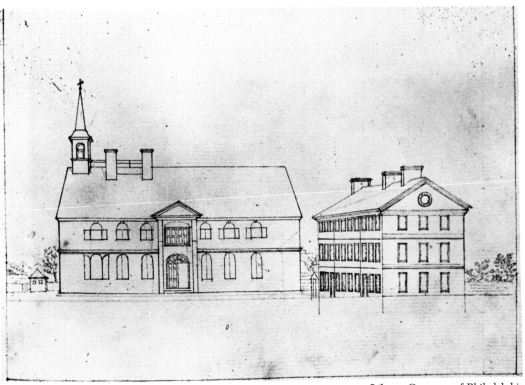

Charles Willson Peale's Portrait Backgrounds, 1770 and 1773

Charles Willson Peale, patriarch of American painters of the Revolutionary period, visited Philadelphia several times from Maryland before the war in order to execute portraits. In those of Mr. and Mrs. John Dickinson he introduced interesting Philadelphia-area landscape backgrounds.

The portrait of John Dickinson, Maryland-born statesman and author, was produced in 1770. Peale posed Dickinson in three-quarter length before a natural background that included a view of the Falls of the Schuylkill. This was already a well-known landmark of Philadelphia, and Peale surely expected those viewing the picture to know it immediately as that of a Philadelphia resident.

Actually, the "falls" was the result of the constricting of the river's flow by huge rock masses scattered across it. One sloping rock extended more than halfway across the stream and was covered or uncovered depending on the water's height. Boats manned by qualified persons could usually navigate the area safely, although it was known as the most hazardous spot on the entire river. Peale carefully drew a separate watercolor sketch of the scene before adapting it to the canvas. His drawing is preserved in the collection of Peale's descendant and biographer, Charles Coleman Sellers.

This appears to have been the earliest picture of the falls, which became a popular subject for artists in the 1790's. At that time it was pictured in a magazine engraving, a landscape in oil, another portrait background, and at least two more drawings.

The phenomenon of the Falls of the Schuylkill disappeared after the building of the Fairmount Dam in 1821. The resultant raising of the level of the river submerged the picturesque rock structure.

When Peale received his commission in 1773 for a companion portrait of Mrs. Dickinson, the former Mary Norris, the painter conceived that a matching natural background was called for. The scene chosen is that of Philadelphia in the distance, viewed from a country road in the vicinity of farm buildings. The city appears simply as a brick-colored mass with little attempt at delineation. It is nonetheless readily identified by the imposing steeple of Christ Church on the left and the slender one of the Second Presbyterian Church on the right. In order to show the towers in this position, Peale must have drawn from the area of Kensington lying to the north and east of the city. The whereabouts of the presumed separate drawing made for the purpose is unknown.

Peale's interest in his adopted city was persistent. He used Philadelphia's buildings and scenery in his portrait of the French minister to the colonies during the Revolution, in magazine engravings published after the war, and in an attempted series of city scenes which, if patronized, would have preceded that of William and Thomas Birch by nearly a dozen years.

Fig. 36 (38) *Fig. 36.* The lower falls of Schuylkill 5 miles from Philadelphia, by Charles Willson Peale. Drawing, c. 1770, 7¾ × 12¾. Source: Collection of Charles Coleman Sellers, Carlisle, Pennsylvania.

Fig. 36

Fig. 37

(Detail) The Historical Society of Pennsylvania

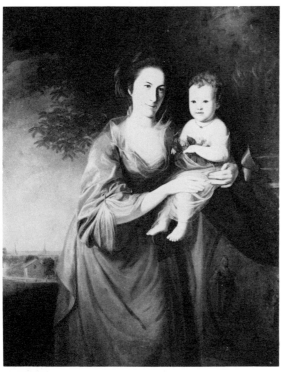

Fig. 38

(Detail) The Historical Society of Pennsylvania

Fig. 37 (39) Fig. 37. (Portrait of John Dickinson), by Charles Willson Peale. Oil on canvas, 1770, 49 × 39. Source: Historical Society of Pennsylvania.

Fig. 38 (40) Fig. 38. (Portrait of Mary Norris Dickinson and Daughter), by Charles Willson Peale. Oil on canvas, 1773, 49 × 39. Attribution: C: W: Peale. pinx. 1773. Source: Historical Society of Pennsylvania.

Reed's Map of Philadelphia, 1774

John Reed was a promising younger merchant in Philadelphia before the Revolution. He was also convinced that he and his family had been unjustly deprived by William Penn of lands rightfully theirs lying outside the city. That conviction carried him to the publication of a small book and a new and different kind of Philadelphia map.

By agreement entered into between Penn and his "first purchasers" in 1681, those buying land in Philadelphia became entitled to a free bonus or premium of land in an area commencing just outside the bounds of the city and known as the "liberties." Reed's position was that, despite his agreement, Penn had, probably intentionally, re-allotted to others the liberty lands rightfully those of the first purchasers and their descendants, of whom Reed seems to have been one.

Reed was breaking no new ground in his contention. In 1683 written grievances had been drawn up for presentation to Penn by purchasers who disputed the surveys by Thomas Holme of their country lands. The truth seems to be that upon his arrival in the province Penn had to square the actualities of land conditions with the neat symmetry shown on Holme's *Portraiture* of the city. This involved facing the hard realities of topography; the effect of marshes and small streams in creating unusable areas; the problem of holding vacant lands for absent owners when those already at work were in need of them; and changes required to accommodate actual survey results both in and outside the town.

John Reed was dismayed by comparing what had transpired in land devolution with early statements by Penn and letters, later lost, to and from Surveyor General Holme. Upon talking with others, he found sufficient interest in his point of view to warrant publishing it. He saw this as requiring both a thin volume setting out portions of the already ancient records not readily available to the public, and a map that would show particularly the "liberty lands" outside and around the city divided into the portions awarded to the original purchasers, labeled to show the areas of their ownership.

Thus Reed needed a large map and an experienced engraver. He engaged for the purpose James Smither, then in his early thirties. Smither had emigrated from London about five years earlier and had worked in the shop of bookseller and print publisher Robert Bell. Smither was now a leading local engraver. An ardent loyalist, he had not yet met the accusations of treason that later forced him to leave the city. To meet Reed's requirements Smither designed a map so large as to require three separate copperplates—just as the Scull and Heap *East Prospect* twenty years earlier had required four.

When the engraved pieces were joined, the new map measured approximately five feet in width and two and one-half feet high. Dedicated to "the Honourable House of Representatives of the Freemen of Pennsylvania" in a splendid cartouche, it was embellished with views of the Hospital (still unfinished), the new Almshouse, and the Statehouse, and set out the lists of first purchasers from Penn. The actual improved extent of the city itself appeared on and spreading north and south from the original grid form and included the fast-growing suburb of Kensington. At the same time, a separate and larger reproduction of Holme's *Portraiture of Philadelphia* was introduced showing the differences in the actual locations of the north-south streets between Eleventh Street and the Schuylkill from the locations plotted in 1683.

To obtain his inset views, Smither directly copied from the Kennedy engraving of the Hospital as it would some day be, the Almshouse portion of Garrison's engraving, and the elevation of the Statehouse in the 1756 reduced version of Scull and Heap's *East Prospect*.

As the date for delivery to his subscribers of the map and book approached, Reed addressed a public letter to them in the *Pennsylvania Gazette* of 13 July:

> To the Subscribers for the Plan or Maps of the City and Liberties of Philadelphia, with the Catalogue of Purchasers, &c.
>
> Gentlemen,
> I have the Pleasure to inform you that the Maps are now ready to be delivered, and the Book of Explanation, which is to accompany the same, is in the Press, and will be ready to be delivered in about three Weeks Time at farthest, at my House, between Sixth and Seventh-streets, in Arch-street. There needs very little to be said, in regard to the Usefulness of these Maps, as it is well known at this Time. Let it suffice, that it is a short and full Account of all the Lands granted by William Penn, Esq; Proprietor and Governor of Pennsylvania, to the several Purchasers in England, Ireland, Scotland and Germany, with the Number of their Lots appurtenant to their Purchase, whereby the Descendants may, at first View, see the Inheritance of their Forefathers, and those inclining to Purchase, may do it with Safety.
> And whereas, in the Pennsylvania Packet, No. 140, the following Note is published, viz. "Reed's Plans of the Liberties of Philadelphia, with a List of Subscribers, and Book of References to each Plan, to be sold by Benjamin Davis."—I think it necessary to inform the Subscribers, that those maps are not sold by Mr. Davis, nor by any other Person on my Account, except by Mr. Nicholas Brooks, between Market and Chestnut-streets, in Second-street, near Blackhorse-alley, and that the Book contains a List of Purchasers, and not a list of Subscribers. I am, Gentlemen, your most obedient humble Servant,
>
> July 6, 1774. John Reed.
>
> N.B. Any Gentleman inclining to have their Maps framed, painted, gilded and varnished, may have them done in the neatest manner, by applying to Mr. Brooks, or to Mr. James Gillingham.

In his preface to the book, Reed showed his consciousness of the controversy he was stirring, for the province was then still governed by William Penn's grandson:

> It was not altogether for the little benefit which may arise to myself, that induced me to publish this work . . . but through the persuasion of many responsible gentlemen of this province, and your generously subscribing for the encouragement thereof, and my being fully convinced of the benefit it would be to the public in general, and particularly to the descendants of those whose forefathers became purchasers of lands in the province of Pennsylvania; these were the reasons, save a desire I had to give the public a full description of the city and liberties, and shew in what right the city lots and liberty lands are held.
> And notwithstanding the insinuations of some of the Proprietary officers are, that the intention of this work is to cause confusion and contention among the people of this province, &c. I can with truth declare, that I know but few whose property it affects; and that was occasioned when people applied for their rights; the surveyor laying them on lands long since surveyed and patented to others, in order (as I apprehend) for the better securing to themselves the lands formerly reserved for the purchasers not then come over. Unless the heirs of those who

became purchasers of land in this province, should be so unreasonable as to apply for and recover the estates purchased and paid for by their forefathers of the proprietaries; This indeed may, perhaps, effect such who have heretofore endeavoured to keep those purchases concealed.

Philadelphia, September 1, 1774.

The disputatious nature of Reed's approach was stressed in the nineteenth century as being characteristic of the book and the map. Lloyd P. Smith, a law bookseller, in republishing both items in 1846, stated that they

seem to have been prepared under a spirit engendered by those controversies which gave rise to Dr. Franklin's Historical Reviews of Pennsylvania, and by sentiments adverse to the Proprietary interests. These feelings, however unperceived they may have been to the Author [!], have coloured the discussion and narrative, and led to the most whimsical mistakes in the additions to the list of first purchasers. . . . In the text William Penn is accused of having tried to depart from the original plan of the city to the injury of the inhabitants, and against their will; an accusation which has been judicially declared to be erroneous and unjust.

In support of his last statement, Smith quotes from an opinion of the Supreme Court of Pennsylvania in 1836 that "the controversial spirit pervading it [the book], detracts from the weight it would otherwise possess, as an authority." Nevertheless, Smith thought that "the book deserves consideration for the antiquity of its date, and, as a colonial production, for the light it sheds upon several obscure points of historical enquiry."

More can be said for the new kind of map, the planning and production of which required at least as much original effort as the book. Reed's thesis and attitude have not been found to detract from the map's accuracy. The court found that it "exhibits great research and industry."

Both Reed and Smither were colorful personalities. Reed in 1783 became a partner in the merchant-adventuring firm of Reed and Forde and went on to wealth through an enormous trade with Spanish America, but he was unsuccessful in recovering his birthright. Smither in 1778 was accused of high treason in the printing of spurious colonial currency. With the British evacuation of the city, he left Philadelphia that spring for New York. There in the following year he advertised himself in the *Royal Gazette* as an engraver and sealcutter producing "in the most elegant manner Coats of Arms, Seals, Maps, Copper Plates, and all other kinds of engraving." Smither returned to Philadelphia in 1786 and reversed his field by engraving portraits of William Penn and John Adams before his death in 1797.

A number of reproductions attest to continuing nineteenth-century interest in Reed's map. In addition to the 200 copies of Smith's 1846 reprint, there was a republication in facsimile by Charles L. Warner in 1870 and another in the Pennsylvania Archives in 1894. All the reissues were approximately the size of the original.

The map has found favor with modern scholars. Oliver Hough, in an article on Captain Thomas Holme, pointed out that neither of Holme's maps had shown the names of the owners of the "town lots in the liberty lands" given to the first purchasers in addition to their other tracts, which "deficiency was supplied by John Reed." William E. Lingelbach says the item, "more widely used than any other early map," shows

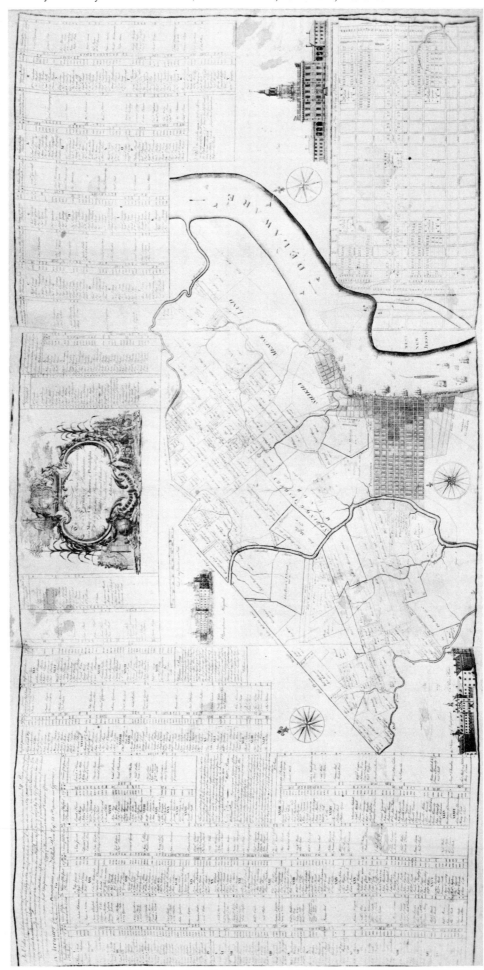

Fig. 39

"the degree to which the Founder's plans had prevailed, or been modified, in the Philadelphia known to Washington, Franklin and Jefferson." According to Carl Bridenbaugh, "excellent maps exist for all of the cities; that of John Reed . . . gives the most detail." Most recently, Hannah Benner Roach has considered Reed's efforts in depth in "The Planting of Philadelphia." She concludes that although his logic and even his computations are suspect, the map itself "must be accepted as generally accurate."

(41) *Fig. 39.* To the Honourable House of Representatives of the Freemen of Pennsylvania this Map of the City and Liberties of Philadelphia With the Catalogue of Purchasers is Humbly Dedicated by their most Obedient Humble Servant John Reed, by James Smither. Engraving, by James Smither, 1774, 29½ × 59. Attribution: James Smither Sculp Printed by Tho: Man. Insets: 1. the House of Employment & Alms House. 2. Pennsylvania Hospital. 3. State House. 4. A Ground Plan of the City of Philadelphia.

Fig. 39

LATER STATE

(41A) As above, but without the attribution "Printed by Tho: Man."

REPRINTS

(41a) Facsimile reproduced "by the Anastatic process" by Lloyd P. Smith, Philadelphia, 1846. See *Old Print Shop Portfolio* 29 (New York, 1969): 1.

(41b) Lithographic facsimile by Charles L. Warner, Philadelphia, 1870.

(41c) William Henry Egle, ed., *Pennsylvania Archives, Third Series* (Harrisburg, Pa., 1894), 4; see folded maps at back of book.

(41d) "A Map of Old Philadelphia," 1932, with cartouche: Philadelphia from the Map made by John Reed in 1774. J. L. Smith Co., Philadelphia.

(41e) The manuscript journal of Count Luigi Castiglioni [see "Italian Version of Reed's City Map, 1790" and (134) Fig. 93] contains copies of the first three insets described above, drawn c. 1785–88.

The New Walnut Street Jail, 1775 and 1778

An unusual circumstance produced the first engraving of the Walnut Street Jail across from the Statehouse gardens. It appeared on the paper money issued by the Province of Pennsylvania in 1775 in order to pay the cost of building the jail structure.

This was the only issue of colonial currency to bear the image of a Philadelphia building or scene. While unsigned, the small print may be attributed to James Smither, the engraver of the John Reed map a year earlier. The later accusation of treason by Smither in printing spurious currency implies that he had considerable experience with the printing of paper money, regardless of the merits of the charge.

Another early view of the new jail, again in very small size, formed a part of the engraved title page of John Norman's *Philadelphia Almanack* for 1778 and 1779. This was more creditable work in that the building was shown in perspective from the

northwest rather than in frontal elevation as upon the paper currency. However, the engraver of the money may have worked from the builder's plans before the structure could be drawn as such.

The new prison was required to accommodate the increasing number of criminals and debtors. But before it could be placed in use, the British occupied the city and filled the building with American prisoners of war. After long years as the county jail it was sold at auction in 1835 when the Moyamensing Prison was opened and the old ground area broken up for dwellings. Its darkest days were, however, its earliest. In 1777–78 William Cunningham, the British jailer for the occupying troops, starved and beat the Continental prisoners; with great cruelty he left them in unheated quarters over the winter after the explosion of the British ships *Augusta* and *Merlin* blew out the windows, and carried many of them to the potter's field across Sixth Street (now Washington Square). Cunningham was hanged in England in 1791 for forgery.

Fig. 40 (42) *Fig. 40*. (Walnut Street Jail), attributed to James Smither. Engraving, 1775, 1¼ × 2⁵⁄₁₆. Source: Province of Pennsylvania currency, issue of 10 April 1775, 50 shillings and £5 denominations.

Fig. 41 (43) *Fig. 41*. (Walnut Street Jail), attributed to John Norman. Engraving, 1778, 3¹³⁄₁₆ × 2⅜ (title page including view). Source: John Norman, *The Philadelphia Almanack For the Year 1778 Calculated For Pensylvania and the neighbouring Parts.*

Fig. 40

Fig. 41

5

The Period of the American Revolution

THE REVOLUTION produced many battles and even campaigns, such as those on Long Island and in New Jersey, before the war approached Philadelphia in the latter part of 1777. After sailing up the Chesapeake, the British Fleet under Admiral Howe landed its army units at Head of Elk in August. A first and unsuccessful attempt to stop them was made at the Brandywine Creek in September. Soon the redcoats had advanced to the neighborhood of Paoli, twenty miles west of Philadelphia, but without crossing the Schuylkill River protecting the city on that side. Here Anthony Wayne's too-near approach to the British—by an encampment only a few miles from them—brought on their night attack at drawn bayonet that cut down the sleeping colonists. The ferocity of the British action earned for this encounter the name of "Paoli Massacre." With the way clear, October found the British, who had readily forded the Schuylkill, settling in the American nerve center.

Early in the month the Americans tried to retake Germantown, some six miles outside the city. The effort failed, primarily from inability to coordinate fully in carrying out a complex military plan of action.

Still the greatest battle lay ahead in the opening of the Delaware. The beleaguered invasion forces required this source of direct supply, but the colonists presented a formidable barrier in Mud Fort (renamed Fort Mifflin), which the British had built for the city's protection a few years earlier. Lying just below the town in the vicinity of the present-day airport, this was literally blasted apart to the water level in November after a month of almost continuous attack.

The British chief engineer in Philadelphia, Captain John Montrésor, was in a position to be peculiarly helpful to Admiral Howe in his reduction of Fort Mifflin: He had been in charge of the construction of those same fortifications only three years earlier. Montrésor was a colorful personality whose commission was earned by long experience. As early as 1755 he was engineer to General Braddock, and in the following year to General Shirley. By 1765 he won the rank of engineer extraordinary and captain lieutenant. Late in 1775 came his special commission from the king as chief engineer in America.

One of the functions of a victorious corps was to record the occasions when its valor was exhibited. Thus, trained cartographic officers were a part of Montrésor's engineer corps. When the strategies of the war brought it to Philadelphia, sketches of the various engagements were made on the scene. But with the reduction of Fort Mifflin the local battles came to an end.

After the river was secured, the British engineer unit busied itself with the preparation of plans of the broader area of the occupied city and its surroundings. These were designed to show the relationship of the town to its outlying defenses, rather than the full detail of its public and private buildings. The departure of the British forces for New York in the spring of 1778 terminated the making of new British pictures and maps of Philadelphia. Their abrupt interruption appears from a number of partially finished items still extant. But a slight stream of locally produced American items had already begun to replace them.

European Republications of the Clarkson-Biddle Map, 1776–78

With the start of the Revolution, demand arose in Europe in 1776 for detailed information about the centers of population in America. Andrew Dury, a print publisher in London, was the first person to respond as to Philadelphia. He reissued the Clarkson-Biddle map of 1762 in the same size as the original, showing all important buildings inside the city. Finding nothing pertinent to 1776 in the two small early plans that had been used to fill the upper left corner of the plate, he replaced them with a reduced version of the Joshua Fisher *Chart of the Delaware* (first issued in 1756) so as to show the city's location in relation to the Atlantic.

Dury omitted from his reengraving the cartouche and the table of references, as well as a few of the individual buildings, that had appeared on the original. Probably because of his ignorance of the facts, he omitted any credit to Nicholas Scull for the survey work and gave it, instead, to "Benjamin Easburn, Surveyor General"—Scull's predecessor and the author of one of the two Clarkson-Biddle insets. With colored outlines and in folio atlas size, Dury's is a handsome plan of Philadelphia that preserves all the detail of his model of about fifteen years earlier. However, in the interval the population had nearly doubled.

In 1776 Gabriel Nicolaus Raspé of Nuremberg had commenced publication of his *History of Wars In and Outside Europe*. Having access to the original Clarkson-Biddle map, and seeking a small and simple plan of Philadelphia to meet his engraving needs, he chose one of the two upper-corner inset maps Dury had elected not to use. His copy, in exactly the size of his model, employs a German title together with English designations for the two bounding rivers. It shows no date or attribution. The rarity of the result exceeds its importance.

The interest in accurate information about Philadelphia was seemingly as great with the French as with the English. George Louis le Rouge, the royal geographer, published a small adaptation of the Clarkson-Biddle map in Paris, omitting all frills. Apparently he followed Dury's reissue rather than the American original.

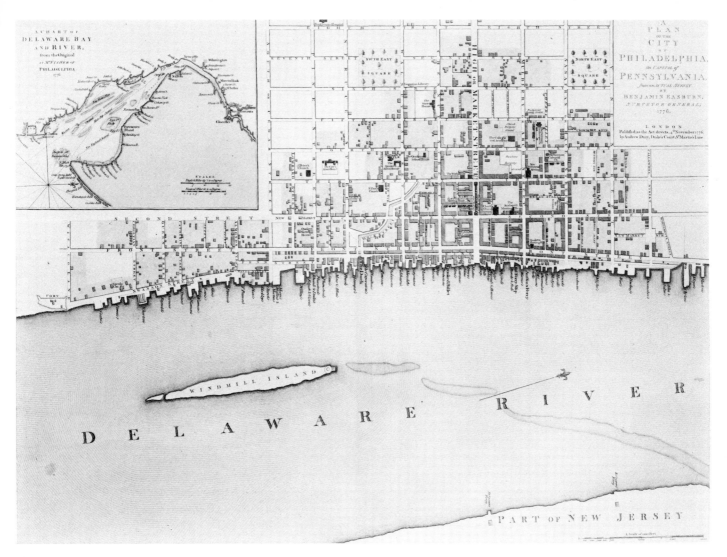

Fig. 42

(44) *Fig. 42 and Colorplate* 3. A Plan of the City of Philadelphia, the Capital of Pennsylvania, from an Actual Survey by Benjamin Easburn, Surveyor General; 1776, after Nicholas Scull. Engraving, by P. André, 1776, 19⅜ × 26¼. Attribution: London Publishd, as the Act directs, 4th November 1776, by Andrew Dury, Duke's Court, St Martin's Lane. P. André Sculp. Inset: A Chart of Delaware Bay and River, from the Original by Mr Fisher of Philadelphia. 1776.

Fig. 42 and Colorplate 3

Earlier state

(44A) P. Lee Phillips, *A List of Maps of America in the Library of Congress* (Washington, 1901), p. 699, indicates an earlier state without André's name.

(45) *Fig.* 43. Grundriss der Stadt Philadelphia, after Thomas Holme. Engraving, 1777, 6⅜ × 3⅜. Source: Gabriel Nicolaus Raspé, *Geschichte der Kriege in und ausser Europa Vom Anfange des Aufstandes der Brittischen Kolonien in Nordamerika an* (Nuremberg, 1776), 6, frontispiece.

Fig. 43

(46) *Fig.* 44. Philadelphia, par Easburn, Arpenteur Général de Pensilvanie, after Nicholas Scull. Engraving, by George Louis le Rouge, c. 1776, 8½ × 14. Attribution: A Paris. Chez le Rouge Rue des Grands Augustins. 1. Source: Apparently published separately.

Fig. 44

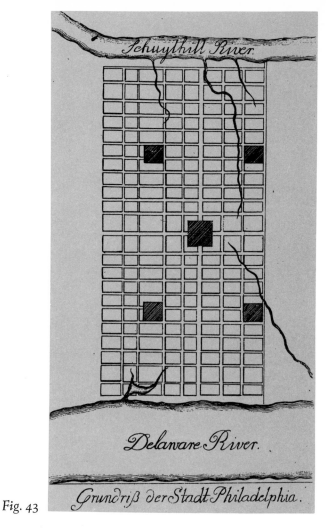

Fig. 43

PHILADELPHIE,
par Easburn,
Arpenteur Général de Pensilvanie.
A Paris.
Chez le Rouge Rue des Grands Augustins.

Renvois

1. Cimetiere des Presbyteriens.
2. Académie. Collège.
3. Lutheriens Allemands.
4. St Pierre.
5. Hôtel Dieu.
6. Catholiques.
7. Hopital
8. Ecolles
9. Cimetiere
10.10.10. Temples.
} des Quaquers.
11. Geole.
12. Presbyteriens.
13. Calvonistes Allemands.
14. St Paul.
15. Premiers Presbyteriens.
16. Maison de Force.
17. Palais et Marché.
18. Congrez.
19. Christ.
20. Anabatistes.
21. Moraves.
22. Eglise Suedoise.
23. Lombard Street.

Fig. 44

European Republications of the Scull and Heap Map, 1777–78

The only Philadelphia map (aside from that of Clarkson and Biddle) available at the start of the war was the one by Scull and Heap placing the city in its environs—a map now almost twenty-five years old. In March 1777, six months before Philadelphia came into the military campaigns, William Faden of London issued a re-engraving of it, enlarged to the size of his folio atlas sheets.

Faden had been the partner of Thomas Jefferys, the leading London engraver of the 1760's, and with Jefferys's death had succeeded to the tradition of the finest quality in engraved maps and atlases. He dominated his field, and in 1775 had been appointed geographer to the king.

Faden was careful to give credit on his plate to the pioneer American mapmakers. Instead of placing the elevation of the Statehouse across the top, as Scull and Heap had done, Faden inserted it at the bottom without setting it off by bounding lines. Nor was he slavish in copying the country homes; rather, he made an effort at updating the Philadelphia environs in what has been characterized by J. Thomas Scharf and Thompson Westcott as "a few prominent alterations." The result is most decorative. By perpetuating the Statehouse as a symbol at the time of the Revolution, Faden unconsciously contributed to its continued use in later American productions until the very end of the eighteenth century.

The watercolor prototype for Faden's map is housed at the Library of Congress. The engraving went through several states in which were added details such as the depth of the Delaware at the city. Those editions have been traced by Lawrence Wroth of the John Carter Brown Library at Brown University. In 1847 Thomas Fisher of Philadelphia published a lithographic copy of Faden's reissue, to which he added seven columns of printed matter giving information and statistics about the city.

No sooner had Faden introduced his copy with innovations than his work was pirated almost verbatim by the German map engraver Matthew Albert Lotter. In failing to give credit to either of the American or British sources, Lotter produced what P. Lee Phillips of the Library of Congress described as "an anonymous reproduction of Faden's 1777 reproduction of Scull and Heap's map."

Actually the Lotter engraving shows minor differences from Faden's work, particularly in the placing of the Statehouse. But even the styles of lettering used for dating and authorship are the same, and Lotter retained the English language throughout. The overall size is slightly smaller than Faden's—presumably that of the sheets in the T. C. Lotter folio *Atlas Géographique* in which this appeared.

Lotter came from a line of distinguished German cartographers connected by their work and by blood. The name of J. B. Homann is well known for his early eighteenth-century work in Nuremberg. One of his students was Matthew Seutter, whose maps, published in Augsburg, were of high standards. Seutter's son-in-law was Tobias Conrad Lotter, who passed his knowledge to his son Matthew, the Faden copyist.

At the end of the year 1777, the *Gentleman's Magazine* did even more to give the old American map broader circulation for current purposes. In its December issue it republished the engraving, which had first appeared in the magazine in 1753, showing only the map portion of the American original. The reissue is a new state, readily distinguishable from the earlier one by omission of the table of distances, the extension of

New Jersey roads into the resulting void, and some damage to the engraved cartouche.

With the entry of the French as formal partners of the colonists in the spring of 1778, added reason was supplied for new European maps of Philadelphia. As one plate in his 1778 atlas *Pilote Américain Septentrional,* French royal geographer le Rouge published in Paris his own strong and decorative reengraving of the Faden map, omitting the embellishment of the Statehouse but retaining substantially Faden's size. Le Rouge must have arranged to be supplied with the English prints of these years, for he presented as the frontispiece of his atlas a reissue in upright format of the 1775 Boydell of London print that copied West's painting visualizing Penn's treaty with the Indians.

A second German version of the Scull and Heap map appeared in 1778 as Raspé brought forth a reissue with publication of additional volumes of his *History of Wars*

Fig. 45

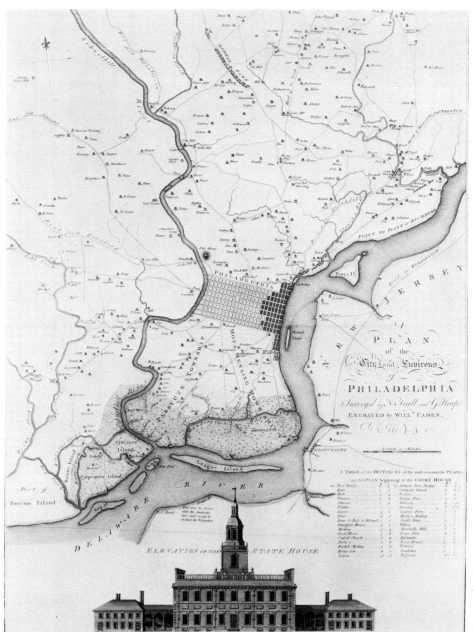

In and Outside Europe. He did not show the Statehouse, and for the first time the size of the engraving was substantially reduced for folding into an octavo volume. Raspé incorporated elements of both the Faden and Lotter predecessors.

Lastly, the Scull and Heap map layout was in some instances used for other emphasis. L. Jackson of London reissued it with only slight modification and a box of written comment on the Battle of Fort Mifflin, which extended through mid-November 1777. Johann Martin Will of Augsburg carried the same idea further. Upon a somewhat tortured Scull and Heap background he portrayed the occupied city caught between the teeth of British fortifications along both its north and south sides. To this he added sites and text referring to the military actions fought nearby in the fall of 1777: army positions at the Battle of Germantown, 4 October; the attack at Red Bank, New Jersey, 22 October; and the Battle of Fort Mifflin. His various inaccuracies suggest that this was a hurried "news map" of 1778.

(47) *Fig. 45*. A Plan of the City and Environs of Philadelphia Survey'd by N. Scull and G. Heap Engraved by Willm. Faden. 1777, after Nicholas Scull and George Heap. Engraving, by William Faden, 1777, 24⅝ × 18⅛. Attribution: London Publishd according to Act of Parlt March 12th 1777 by W. Faden Successor to the late Mr Jefferys Geographer to the King Charing Cross. Inset: Elevation of the State House. Source: William Faden, *The North American Atlas* (London, 1777) and *Atlas of Battles of the American Revolution* (London, 1793).

Fig. 45

STATES

As described in Henry Stevens and Roland Tree, "Comparative Cartography," in *Essays Honoring Lawrence C. Wroth* (Portland, Maine, 1951), p. 305, at p. 351:

As above, with unnamed island between "Hog" and "Mud" islands, no soundings in river.

(47A) With island mentioned above named "Port Island" and three lettered references to it introduced.

(47B) With "Billingsport Island" below Hog Island, joined by *cheveaux de frises* with south bank of river.

REPRINTS

(47a) Lithograph by Thomas Fisher, Philadelphia, 1847.

(47b) Facsimile, Philadelphia Public Ledger, 1926.

(47c) Modern reproduction issued by Historic Urban Plans, Ithaca, New York, 1969.

(48) *Fig. 46 and Colorplate 4*. A Plan of the City and Environs of Philadelphia Engraved and Published by Matthew Albert Lotter. 1777, after Nicholas Scull and George Heap. Engraving, by Matthew Albert Lotter, 1777, 23¼ × 18. Inset: Elevation of the State House. Source: Tobias Conrad Lotter, *Atlas Géographique* (Nuremberg, 1778).

Fig. 46 and Colorplate 4

(49) *Fig. 47*. Environs de Philadelphie. par Scull et Heap, Publie à Londres par Faden en 1777. Traduit de l'Anglais, after Nicholas Scull. Engraving, by George Louis le Rouge, 1778, 22½ × 17¾. Attribution: A Paris. Chez le Rouge Ingr. Geographe du Roi Rue des Gd. Augustins. 1778. Source: George Louis le Rouge, *Pilote Américain Septentrional* (Paris, 1778).

Fig. 47

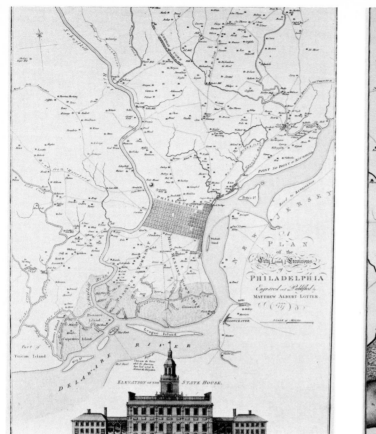

Fig. 46

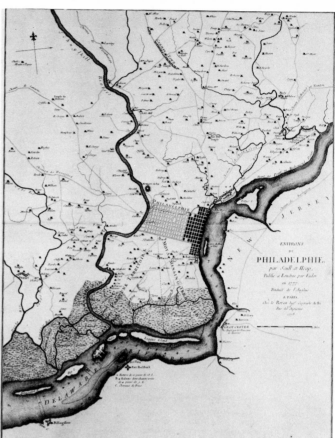

Fig. 47

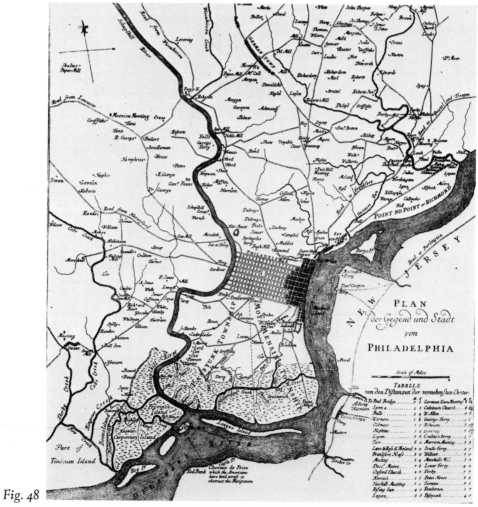

Fig. 48

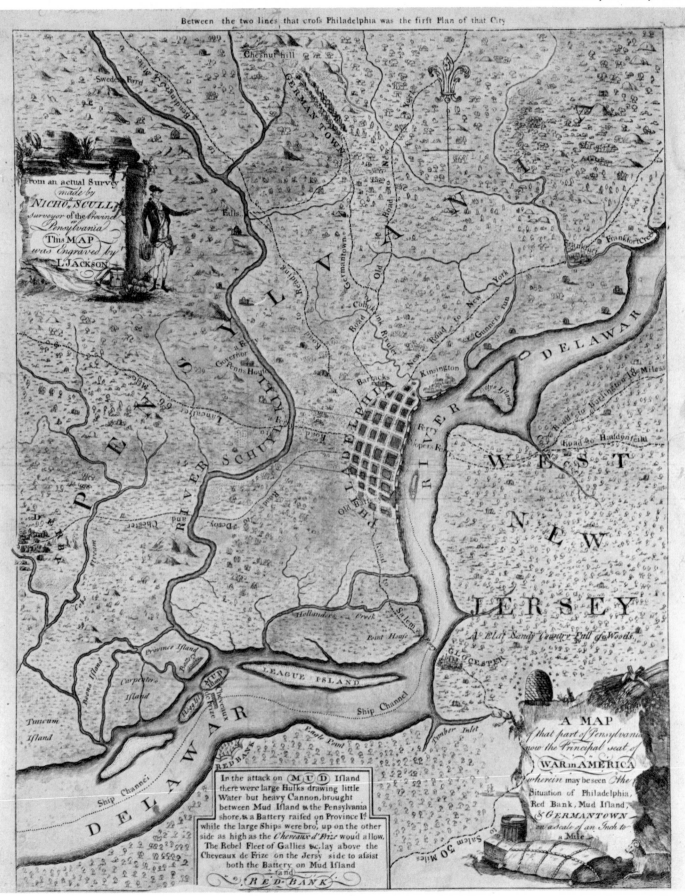

Between the two lines that cross Philadelphia was the first Plan of that City

From an actual Survey
made by
NICHO.ᵃˢ SCULL,
Surveyor of the Province
Pensylvania
This MAP
was Engraved by
L. JACKSON

In the attack on (MUD) Island
there were large Hulks drawing little
Water but heavy Cannon, brought
between Mud Island & the Pensylvania
shore, & a Battery raised on Province I.ˢ
while the large Ships were bro.ᵗ up on the other
side as high as the Cheveaux d'Frize wou'd allow,
The Rebel Fleet of Gallies &c. lay above the
Cheveaux de Frize on the Jersy side to assist
both the Battery on Mud Island
and RED-BANK

A MAP
of that part of Pensylvania
now the Principal seat of
WAR in AMERICA
wherein may be seen the
Situation of Philadelphia,
Red Bank, Mud Island,
& GERMANTOWN
on a scale of an Inch to
a Mile

Fig. 49

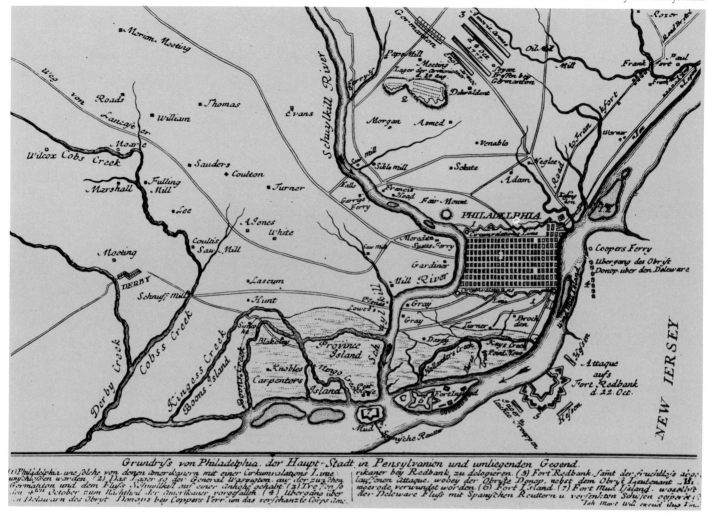

Fig. 50

Fig. 48

(50) *Fig. 48.* Plan der Gegend und Stadt von Philadelphia, after Nicholas Scull. Engraving, 1778, 14 × 12¼. Source: Gabriel Nicolaus Raspé, *Geschichte der Kriege in und ausser Europa Vom Anfange des Aufstandes der Brittischen Kolonien in Nordamerika an* (Nuremberg, 1776), 10:1.

Fig. 49

(51) *Fig. 49.* A map of that part of Pensylvania now the Principal seat of War in America wherein may be seen the Situation of Philadelphia, Red Bank, Mud Island, & Germantown. Engraving, by L. Jackson, 1777, 15¼ × 11¾. Attribution: From an actual Survey made by Nichos. Scull Surveyor of the Province of Pensylvania This Map was Engraved by L. Jackson. London 1777.

Fig. 50

(52) *Fig. 50.* Grundriss von Philadelphia, der Haupt-Stadt in Pensylvanien und unliegenden Gegend, after Nicholas Scull. Engraving, by Johann Martin Will, 1778, 6⅞ × 11⅛. Attribution: Ioh. Mart. Will excud. Aug. Vind.

The Line of British Defense Forts, 1777

On 26 September 1777, the very day of their entry into Philadelphia, the British commenced work upon defensive fortifications and batteries. One of their first tasks was to build a line of stone fortresses stretching from the Delaware to Fairmount overlooking

the Schuylkill, which were built to isolate the city from the north. In his journal for 29 September 1777 Montrésor noted that "early this morning I begun on fixing the Situation for forming a chain of redoubts for the defense of this city. This afternoon I attended Lord Cornwallis in viewing the Position I had fixed on for the works, extending along the heights from Delaware to Schuylkill, North of the city."

The designs of these ten structures and of the barriers erected in the main roads piercing the defense line—all abandoned in place upon the British withdrawal—were recorded in detail in a drawing by Colonel Lewis Nicola. His life illustrates the diverse backgrounds of the American patriots. Nicola was born in France of Huguenot parents but educated in Ireland. He emigrated to Philadelphia in 1766 with twenty-six years of military experience already behind him. Supporting himself as a merchant, Nicola published three military manuals in 1776–77 in support of the Revolution.

Nicola's rendering of the British defenses, strung across relatively high ground in the area of present-day Fairmount Avenue, shows the individual ground plans of the redoubts, whose shapes and entrance points presumably conformed to the terrain. He shows the narrow and tortuous entrances into the more important of the strong points. He not only portrays the barriers blocking the roads to Kensington and Germantown, but illustrates their method of operation. He marks the site of each of twenty-nine houses destroyed to make way for the forts. His drawings, assembled on one large sheet, combine a certain artistry with the accuracy of his record of a military subject.

At least three other less detailed plans of these works were produced: a second and anonymous American drawing; one by Montrésor as their designer; and the third by the talented John André, who was quartered in Dr. Franklin's house. The defense line also appeared as a small feature on a large Faden engraving published at the start of 1779.

Fig. 51

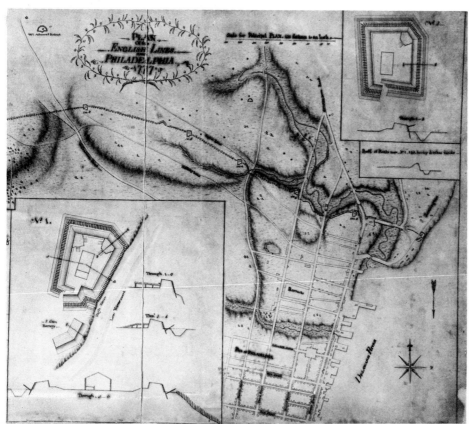

(Detail)

Fig. 51

(53) *Fig. 51*. Plan of the English Lines near Philadelphia. 1777, by Lewis Nicola. Ink drawing with watercolor, 1777, 14¾ × 38½. Source: Historical Society of Pennsylvania.

For other items depicting the forts see (88), (89), (90), and the following:

(54) Manuscript titled: State of the British Lines and Country on the North April 1st 1778, anonymous, 9½ × 15, at Harvard University Library, Sparks Manuscripts, described in Peter J. Guthorn, *American Maps and Map Makers of the Revolution* (Monmouth Beach, N.J., 1966), p. 40, item (D)(1).

(55) Manuscript titled: A Draught, and Calculation of An Entrenchment from Delaware to Shulkill Run in Angles, to the Best Advantage the Ground will Admit, by John Montrésor (unsigned), 11¾ × 18½. Source: Atwater Kent Museum, Philadelphia.

(56) Manuscript titled: Redouts near Philadelphia, by John André, 7¼ × 11, at Huntington Library, San Marino, California, pictured in Henry Cabot Lodge, ed., *Major André's Journal* (Boston, 1903), 1:134–35.

The Battle of Germantown, 1777

The complex sequence of events that the Americans triggered in their effort to take Germantown on 4 October 1777 was recorded in several manuscript plans, but as with the earlier battles at Brandywine and Paoli, only one engraving was published illustrating the encounter.

It was William Faden's intention that his atlas should record the whole progress of the British as they advanced toward and into Philadelphia. Yet recording the battles before Germantown and the long-lasting and important siege on the Delaware ending in November appears to have taken precedence over engraving the Germantown engagement. Faden's plates of Brandywine and Fort Mifflin appeared in the spring of 1778, of Paoli in the summer, and of the invested city at the start of 1779. The king's troops had by then left Philadelphia behind. Pressing new engraving work was at hand. Thus it was not until 1784 that Faden filled the gap he had left by issuing a large plate of the *Surprise of Germantown*.

The drawing Faden reproduced for this was made by a young engineer who (luckily for early plans of Philadelphia) elected to remain in the area. John Hills was active in America as early as 1777, but it is not known whether he was at Germantown or copied earlier plans in preparing his drawing of it. Hills served as an ensign under Montrésor before becoming lieutenant and assistant engineer in the 23d Regiment of Foot.

Hills also prepared a plan engraved by Faden tracing the movements of the Royal Army from its landing on the Chesapeake in the summer of 1777 to its departure the following year. Although drawn in August 1778, this too was delayed in publication by Faden until 1784, when he seems to have been bringing his engraved record to completion.

Hills's specialty was the preparation of maps of counties, towns, roads, and army positions in New Jersey. After the war he advertised as a surveyor and mapmaker there; but before 1790 he was working in Philadelphia, where he remained.

By necessity in explaining his plan of the Battle of Germantown, Hills included a full table of references and descriptions. The work is careful and of high quality, although Justin Winsor's studies led him to conclude that it was "not trustworthy as to roads."

Another contemporary map of the engagement was prepared by or for Montrésor, a third by John André, and still another American plan remains anonymous.

(57) *Fig.* 52. Sketch of the Surprise of German Town. by the American Forces commanded by General Washington. October 4th 1777; by J. Hills, Lt. 23d. Regt. & Asst. Engr., by John Hills. Engraving, by William Faden, 1777 (map), 1784 (engraving), 17¾ × 20⅝. Attribution: London, Published by Wm. Faden, Geographer to the King, Charing Cross, March 12th 1784. Source: William Faden, *Atlas of Battles of the American Revolution* (London, 1793).

Fig. 52

Fig. 52

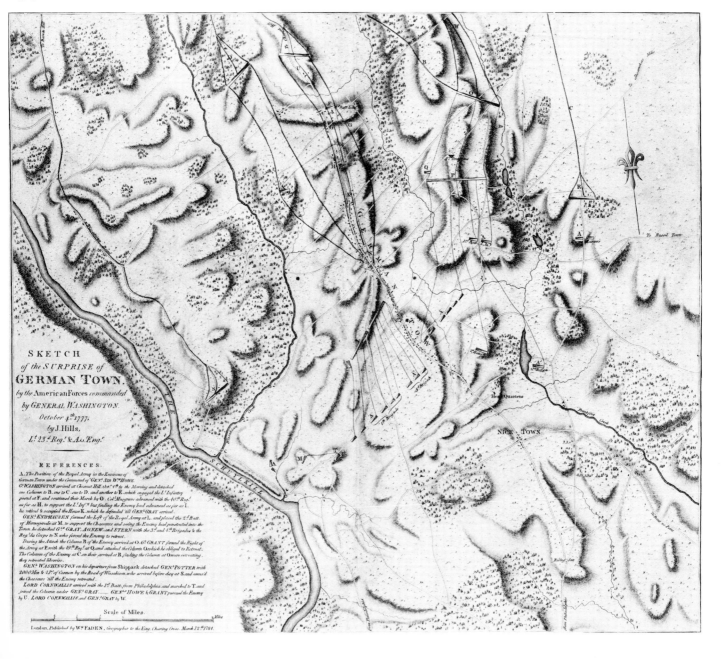

(57A) As above, but printed on nineteenth-century paper.

Note: For manuscript plans of the Battle of Germantown see:

(58) A Sketch of the Battle of German. Tn. 4th October 1777. where the Rebels were repulsed; by or under direction of John Montrésor, 13¾ × 11, at Library of Congress, and (59) nearly duplicate map at Harvard College Library, described in P. Lee Phillips, *A Descriptive List of Maps and Views of Philadelphia in the Library of Congress* (Philadelphia, 1926), no. 326, and reproduced in Justin Winsor, *Narrative and Critical History of America* (Boston, 1887), 6:426.

(60) Anonymous plan depicting the disposition of the American forces, 7 × 13½, at Huntington Library, San Marino, California, described in Peter J. Guthorn, *American Maps and Map Makers of the Revolution* (Monmouth Beach, N.J., 1966), p. 40, item (D)(7).

Plans by John André (61) titled: Battle of German Town, 22½ × 20¼, and (62) titled: Position of the Army after the Battle of German Town, 5⅜ × 6¾, at Huntington Library, San Marino, California, pictured in Henry Cabot Lodge, ed., *Major André's Journal* (Boston, 1903), 1:102–3, 106.

Maps and Views of Fort Mifflin and Its Locality, 1777–78

Simply because Fort Mifflin—a structure insignificant architecturally—lay athwart the British lifeline, it was drawn and mapped by the British to the extent that more pictures and plans were made of it than of any other subject in Revolutionary Philadelphia. The Delaware River had to be opened at all costs for British seaborne supplies. The resultant weekslong siege of Fort Mifflin on Mud Island culminated on 15 November 1777 in a combined military and naval attack that forced evacuation of the fort at midnight.

A watercolor signed by Montrésor to indicate either authorship or approval, *View of Mud Island before its Reduction,* may have begun the series. It shows a low and menacing group of wooden buildings. At about the same time a map bearing Montrésor's stamp shows *A Plan of the Attacks Against Fort Miflin.* Both these subjects also appeared as insets in a larger manuscript titled a *Survey of the City of Philadelphia,* of which substantially identical copies (except for size) are in the United States and in the British Museum. The fort alone is also the subject of a plan as opposed to a picture.

After ultimate abandonment of the ruined fortress by its remaining American defenders, one would expect pictures and plans of it to cease. To the contrary, the work on this subject continued until the British in their turn abandoned Philadelphia. Pierre Eugène Du Simitière, the artist, collector, and antiquarian already mentioned, reports in his notebook (at the Library Company of Philadelphia) in July 1778 that he then produced "a view of Fort Mifflin on Mud Island, copied from an original of Capt. Montrésor's begun last month."

There were other forms of Fort Mifflin treatment as well. An engraved *Plan of the Operations of the British & Rebel Army, in the Campaign, 1777,* published in London

in 1779, extends considerably to the west and south of the then city and includes *Mud Island Fort with its Environs* as an inset. In the field of propaganda, a most revealing item is a crude caricature, published in London in the very month of the siege, entitled *The Takeing of Miss Mud I'land*. The land outlines near the island are cleverly distorted and arranged to picture a female figure, which, however, turns out on approach to be extremely dangerous, belching the fire and smoke of cannon blasts from all angles. W. Humphrey, the publisher of this scurrilous piece, had no hesitation in placing his name upon it, and gave his address as well.

Still another phase of the attack to be recorded was the disposition of the British and American ships in the Delaware. A watercolor in the style of Montrésor's work, concentrating on the stretch of the river that included Mud Island, was engraved by Faden in 1778 with all the ships positioned and named. A variation of this appeared in a plan by the British Lieutenant John Hunter dated 1778 "marking the position of His Maj: Ships on the 15th November 1777." From Hunter's drawing a plate was engraved in London by J. W. F. DesBarres in 1779 for the *Atlantic Neptune*. There is also a large British aquatint of the naval battle on the Delaware as seen just before the evacuation of the fort. Although "Drawn on the Spot & engraved by Lieut W. Elliott" in London, it was not published until 1787. The artist and engraver rose to the rank of captain in the Royal Navy before his death in 1792.

(63) *Fig. 53*. View of Mud Island before it's Reduction 16th. Novr. 1777 under the Direction of John Montrésor Esqr. Chief Engineer in America taken from the Dyke in the Front of the Six Gun Battery on Carpenter's Island, by Pierre Nicole. Watercolor, 1777, 11¼ × 29¾. Source: Library of Congress. *Fig. 53*

Note: For other manuscript views and plans relating to the British reduction of Fort Mifflin see:

(64) Three insets titled: View of the Rebel Fort and Works, on Mud Island; Fort Mifflin on Great Mud Island; and Plan of the Attacks, against the Rebel Works on Mud Island surrender'd 16 November 1777; to drawing titled: A Survey of the City of Philadelphia and its Environs . . . comprehending likewise the Attacks against Fort Mifflin on Mud Island, and until its Reduction, 16th November 1777. By Pierre Nicole, 59¼ × 34½, described in P. Lee Phillips, *A Descriptive List of Maps and Views of Philadelphia in the Library of Congress* (Philadelphia, 1926), no. 327.

Fig. 53

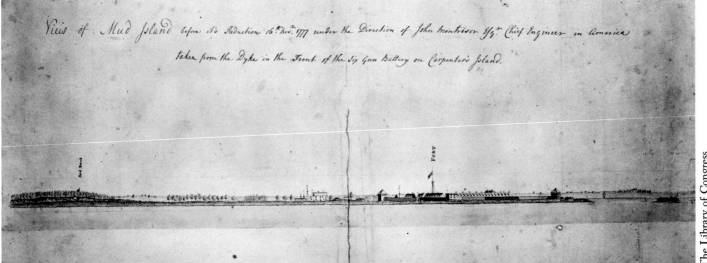

(65) Inset titled: Mud Forte, to drawing titled: Plan of Part of the river Delaware, from Chester to Philadelphia, in which is mark'd the position of His Maj: Ships on the 15th of November 1777. By Lieut. John Hunter, 36 × 11, described in *ibid.*, no. 323. Pictured in Samuel Stelle Smith, *Fight for the Delaware 1777* (Monmouth Beach, N.J., 1970), p. 37.

(66) Plan of Fort Mifflin on Mud Island with the Batteries on Province Island, 8¹³⁄₁₆ × 5⅞, described in P. Lee Phillips, *A Descriptive List of Maps and Views of Philadelphia in the Library of Congress* (Philadelphia, 1926), no. 322.

(67) A Plan of Mud Island and Fort Mifflin with the Siege thereof, and its Evacuations the 15th of November 1777. By Captain of Guides & Pioneer Charles Blaskowitz, 20 × 19¼, pictured and described in *Old Print Shop Portfolio* 29 (New York, 1970): 108.

(68) Esquisse des forts sur le delaware. Forts Mercer & Mifflin, 8 × 13, at Historical Society of Pennsylvania, described in Peter J. Guthorn, *American Maps and Map Makers of the Revolution* (Monmouth Beach, N.J., 1966), p. 40, item (D)(3).

(69) Commodore Hazelwood's letter 9 December 1779, copy and accompanying plan at Historical Society of Pennsylvania.

(70) (71) (72) (73) Four sketches of Mud Island and the siege of Fort Mifflin, by François de Fleury, Engineer to Fort Mifflin for the American Army, at Cornell University Library, Sparks Collection, described in Peter J. Guthorn, *American Maps and Map Makers of the Revolution* (Monmouth Beach, N.J., 1966), p. 22, items 18(3)–18(6), and in part reproduced in Justin Winsor, *Narrative and Critical History of America* (Boston, 1887), 6:432–35.

(74) Untitled plan of the redoubts on Carpenter's and Province Islands, attributed to Jean de Villefranche and countersigned by Duportail, 10¼ × 15, at Library of Congress, described in Peter J. Guthorn, *American Maps and Map Makers of the Revolution* (Monmouth Beach, N.J., 1966), p. 36, item 47(2).

(75) Mud Island with the Operations for reducing it—15th. Novr. 1777, by John André, 14¾ × 9½, at Huntington Library, San Marino, California, pictured in Henry Cabot Lodge, ed., *Major André's Journal* (Boston, 1903), 1:116–17; and (76) rough draft described in Peter J. Guthorn, *British Maps of the American Revolution* (Monmouth Beach, N.J., 1973), p. 9, item 28.

Note: For an engraved plan of Fort Mifflin see:

(77) A Plan of Mud Island Fort with its Environs, inset to: A Plan of the Operations of the British & Rebel Army, in the Campaign, 1777, J. Lodge sculp., 10¹⁄₁₆ × 12⅞, in Joseph Galloway, *Letters to a Nobleman on the Conduct of the War in the Middle Colonies* (London, 1779), frontispiece. (77A) Later state of the engraving lacks attribution. Inset reproduced in Justin Winsor, *Narrative and Critical History of America*, 6:437. A related map is in Captain Hall, *The History of the Civil War in America* (London, 1780), 1, frontispiece, described in (311). See P. Lee Phillips, *A Descriptive List of Maps and Views of Philadelphia in the Library of Congress* (Philadelphia, 1926), no. 318.

Fig. 54 (78) *Fig. 54.* The Takeing of Miss Mud I'land. Engraving, 1777, 8¹⁵⁄₁₆ × ·7⅜. Attribution: Sold by W. Humphrey 227 Strand London.

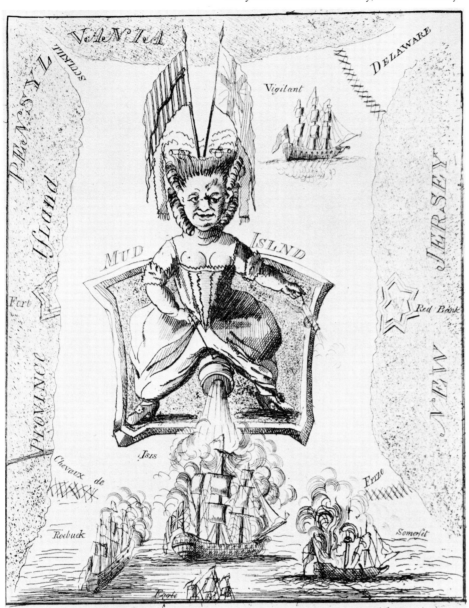

Fig. 54

(78A) As above, but with addition to the title of "Nov. 1777."

(79) *Fig. 55.* A Sketch of Fort Island. Inset to: The Course of Delaware River from Philadelphia to Chester, Exhibiting the several Works erected by the Rebels to defend its Passage, with the Attacks made upon them by His Majesty's Land & Sea Forces. Engraving, by William Faden, 1778, 5⅞ × 5⅛ (inset), 17⅜ × 26¾ (map). Attribution: Engraved by William Faden Charing Cross April 30th 1778. Source: William Faden, *Atlas of Battles of the American Revolution* (London, 1793). The Library of Congress has the original drawing for this engraving (80), described in P. Lee Phillips, *A Descriptive List of Maps and Views of Philadelphia in the Library of Congress* (Philadelphia, 1926), no. 320.

Fig. 55

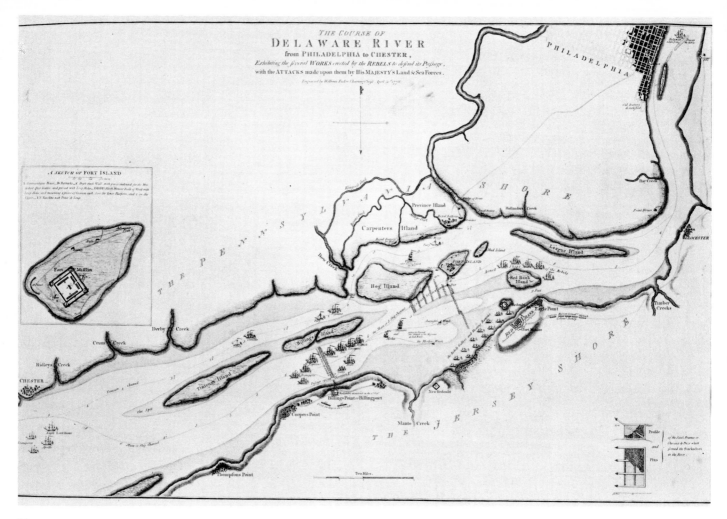

Fig. 55

LATER STATES

(79A) As above, but with changes as follows: Inset title: A Plan of Fort Mifflin on Mud Island, with the Attacks made by the King's Troops and Vessels. Inset size: 9⅞ × 9⅜. Map title: The Course of Delaware River from Philadelphia to Chester with the several Forts and Stackadoes raised by the Rebels, and the Attacks made by His Majesty's Land and Sea Forces. Attribution: Publish'd by W. Faden, Charing Cross as the Act directs March 20th 1779. Addition of a List of the Rebel Fleet, taken from the map listed in P. Lee Phillips, *A Descriptive List of Maps and Views of Philadelphia in the Library of Congress* (Philadelphia, 1926), no. 324. Changes in number and location of vessels. Source: The original drawing for this edition is also in the Library of Congress in the form of a marked-up copy of (79). See *ibid.*, no. 320. Phillips was apparently not aware of this intermediate state.

(79B) As (79A), but with changes as follows: Map title: the word "Rebels" replaced by "Americans." Attribution: London: Printed for Wm. Faden, Geographer to the King, Charing Cross, Jany. 1st 1785. 2d. Edition. List: the word "Rebel" replaced by "American." Further changes in number and location of vessels.

REPRINT

(80) Engraving titled: Philadelphia, 4¾ × 6¼, in J. Luffman, *Select Plans* (London, 1802), 2:70.

Note: For manuscript and printed items relating to (79) see:

(81) Manuscript map of "proposed Fortifications for the defence of the River Delaware & the City," by Jean de Villefranche, approximately 51¼ × 61¼ irregular, at Bureau of Land Records, Harrisburg, with tracing at Historical Society of Pennsylvania, described in Peter J. Guthorn, *American Maps and Map Makers of the Revolution* (Monmouth Beach, N.J., 1966), p. 36, and in Hubertus M. Cummings, "The Villefranche Map for the Defense of the Delaware," *PMHB* 84 (1960):424.

(82) Manuscript titled: View of the enemy fleet Before philadelphia 19 January 1778, by François de Fleury, 7 × 9½, at Cornell University Library, Sparks Collection, described in Peter J. Guthorn, *American Maps and Map Makers of the Revolution* (Monmouth Beach, N.J., 1966), p. 23.

(83) Manuscript untitled, by George Spencer, at Huntington Library, San Marino, California, 6 × 7¼, described in Peter J. Guthorn, *British Maps of the American Revolution* (Monmouth Beach, N.J., 1973), p. 43, item 1.

(84) Manuscript titled: A Plan of the Attacks Against Fort Miflin on Mud Island Which Surrendered 16th November 1777. . . . By Ensign T. Wheeler, 29¾ × 20, described in P. Lee Phillips, *A Descriptive List of Maps and Views of Philadelphia in the Library of Congress*, no. 324. See also Peter J. Guthorn, *British Maps of the American Revolution* (Monmouth Beach, N.J., 1973), p. 47.

Fig. 56

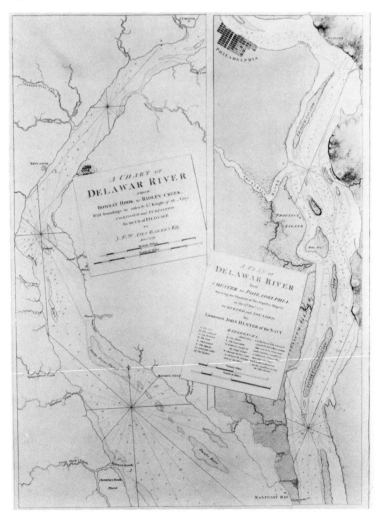

Manuscript titled: Plan of Part of the river Delaware, from Chester to Philadelphia. . . . By Lieut. John Hunter. [(65) above]. See also Peter J. Guthorn, *British Maps of the American Revolution* (Monmouth Beach, N.J., 1973), pp. 29–30, item 2.

Fig. 56 (85) *Fig. 56.* Engraving of the manuscript last mentioned, titled: A Plan of Delawar River from Chester to Philadelphia. Shewing the Situation of His Majesty's Ships &c on the 15th Novr. 1777. Surveyed and Sounded by Lieutenant John Hunter of the Navy, 29½ × 9⅛, being part of chart of the Delaware River from Philadelphia to Bombay Hook described in P. Lee Phillips, *A Descriptive List of Maps and Views of Philadelphia in the Library of Congress* (Philadelphia, 1926), nos. 310, 314. Source: *The Atlantic Neptune* (London, 1780).

Fig. 57

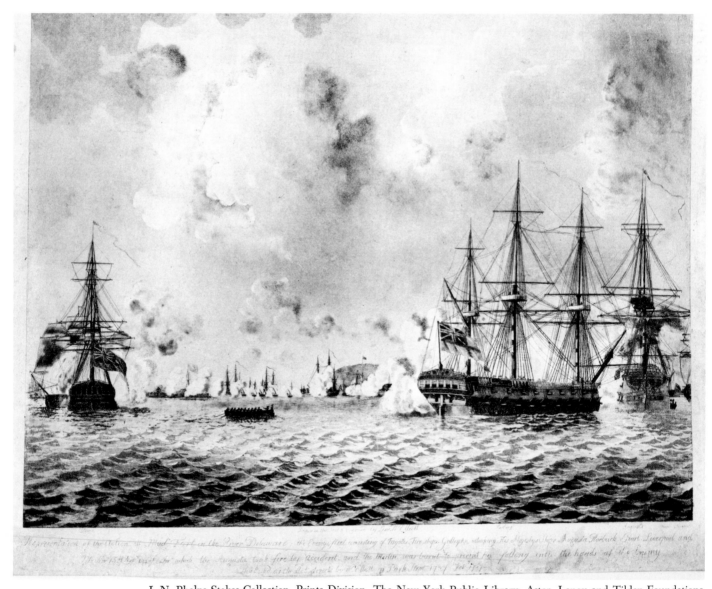

I. N. Phelps Stokes Collection, Prints Division, The New York Public Library; Astor, Lenox and Tilden Foundations

Fig. 58

(86) *Fig. 57*. Representation of the Action off Mud Fort in the River Delaware; the Enemys fleet consisting of Frigates, Fire Ships, Galleys &c attacking His Majestys Ships Augusta Roebuck Pearl Liverpool and Merlin 15th Novr 1777. In which the Augusta took fire by Accident, and the Merlin was burnt to prevent her falling into the hands of the Enemy, by W. Elliott. Aquatint, engraved by W. Elliott, 1777 (drawing), 1787 (engraving), 17⅞ × 20¾. Attribution: Drawn on the Spot & Engraved by Lieut W. Elliott Publishd as the Act directs by W. Elliott 71 Park Street 17th of Feby 1787.

Fig. 57

LATER STATE

(86A) As above, but with reference in title to "Merlin Sloop," date of engagement given as 22 October 1777, and attribution stating London as place of publication.

The Robertson Watercolor View of Philadelphia, 1777

Archibald Robertson was one of the British engineer officers participating in the occupation of the city. Two weeks after the Battle of Fort Mifflin had ended with American withdrawal, he crossed to the New Jersey shore and rendered in sepia wash a

beautiful view of Philadelphia—seemingly securely British—from the distance. Its size permitted considerable detail and its quality is apparent.

I. N. Phelps Stokes and Daniel C. Haskell tell how fifty-six drawings of various scenes in America during the Revolution were found by Stokes in the possession of Robertson's descendants. Almost all were purchased for the New York Public Library, where they are preserved in the Spencer Collection. The drawings have been reproduced and published along with Robertson's diaries. In Stokes's estimation the group constitutes "the most important collection of American Revolutionary views in existence."

Robertson's point of sight was somewhat upriver from that which George Heap had used in drawing the city some twenty years before. The detail Robertson was able to introduce into the portion of the scene north of Market Street underscores Heap's feat in bringing out the details in his much larger and earlier drawing, preserved in the giant 1754 engraving.

Fig. 58 (87) *Fig. 58.* View of Philadelphia, 28 Nov. 1777, by Archibald Robertson. Sepia watercolor, 1777, 14⅛ × 21⅝. Source: New York Public Library, Spencer Collection.

Montrésor's Map of Philadelphia and Its Approaches, 1777–78

As soon as the Delaware waterway was secured in November 1777, the British engineer corps turned to mapping an area centering upon the city itself and extending out on all sides to the newly constructed defenses. The point of view selected was a change from that of the old Scull and Heap map. The desire was to show in some detail the south and west countryside, particularly the distances to towns downriver and the location of the connecting roads. In final form only the southern portion of the territory covered by Scull and Heap appeared, in which the course of the Delaware formed a prominent boundary on both the south and the east, the maps extending on the west beyond the Schuylkill. In all instances the Fort Mifflin area appears to have been included.

Apparently the earliest rendering of this type of plan is in a manuscript dated 15 December 1777, signed by John Montrésor as chief engineer, but numerous, almost identical manuscripts are known.

The new approach also departed from the practice of showing only the complete grid of city streets as laid out from river to river. The actual extent of the built-up city appears, ending at the eighth street from the Delaware. At that distance inland, habitations extend only one square to the north and one to the south of the central High Street.

Another feature of great interest is the locating of the defensive fortifications of the British—not only the ten stockades running from river to river just north of the city, but also those beyond the Schuylkill in what is now West Philadelphia and those lying to the south.

It may be surmised that before the British left Philadelphia a drawing of this kind, including the Fort Mifflin area, was sent to London for engraving by William Faden.

However, for his purposes the preferable form might well omit Fort Mifflin, which he was to publish separately on copper. A substitute drawing omitting it was probably sent to Faden at his request only after the army arrived in New York. His handsome engraving of it "with the Works and Encampments of His Majesty's Forces" appeared on 1 January 1779.

Fig. 59

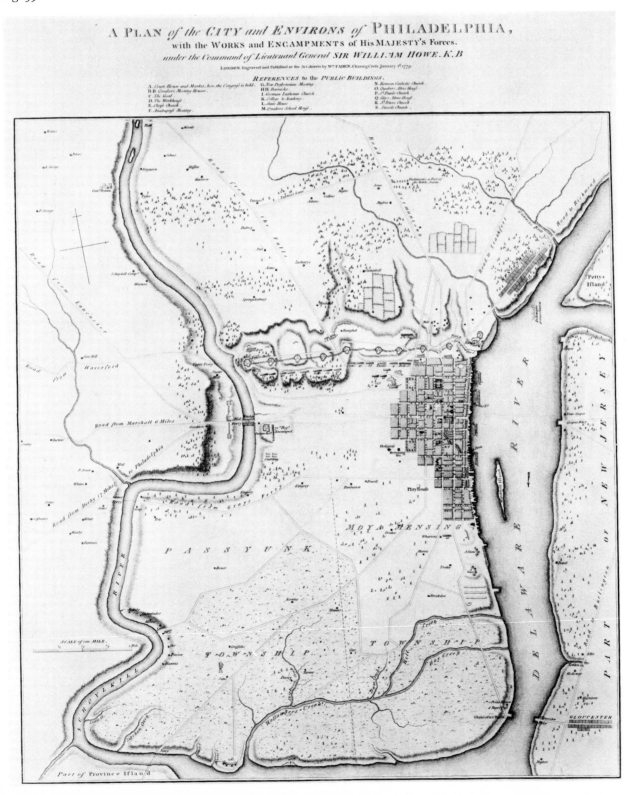

Fig. 59

(88) *Fig. 59.* A Plan of the City and Environs of Philadelphia, with the Works and Encampments of His Majesty's Forces, under the Command of Lieutenant General Sir William Howe. K. B, probably by Pierre Nicole. Engraving by William Faden, 1777–78 (plan), 1779 (engraving), 20⅛ × 18½ (plan), 24⅛ × 19¼ (plate including title). Attribution: London. Engraved and Published as the Act directs by Wm. Faden. Charing Cross. January 1st 1779. Source: Probably a drawing by Pierre Nicole titled: A Survey of the City of Philadelphia and its Environs shewing the several Works constructed by his Majesty's Troops, under the Command of Sir William Howe, since their possession of that City 26th September 1777. [See (64).] An untitled plan (89) more nearly identical to the engraving, 20½ × 18¾, is also at the Library of Congress. See P. Lee Phillips, *A Descriptive List of Maps and Views of Philadelphia in the Library of Congress* (Philadelphia, 1926), no. 169. The engraving appeared in William Faden, *Atlas of Battles of the American Revolution* (London, 1793).

REPRINTS

(88a) J. Thomas Scharf and Thompson Westcott, *History of Philadelphia* (Philadelphia, 1884), 1:360.

(88b) Modern color reproduction issued by Historic Urban Plans, Ithaca, New York, 1965.

Fig. 60

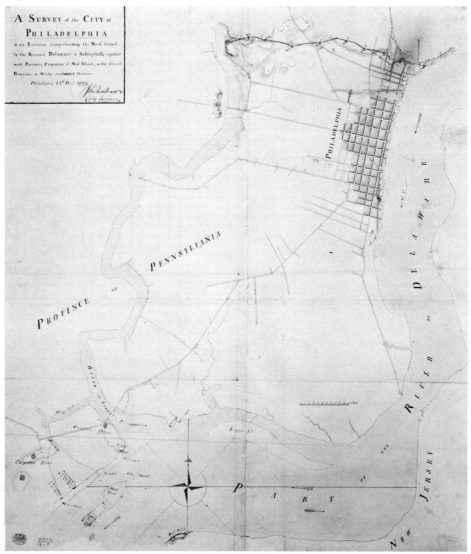

Note: For other manuscript items relating to the engraving see:

(90) Plan of the City of Philadelphia and its Environs shewing its Defences during the Years 1777. &: 1778 . . . by John Montrésor, 45⅝ × 33¾, at Library of Congress, described in P. Lee Phillips, *A Descriptive List of Maps and Views of Philadelphia in the Library of Congress,* no. 329.

(91) *Fig. 60.* A Survey of the City of Philadelphia & it's Environs comprehending the Neck formed by the Rivers of Delaware & Schuylkill; together with Province, Carpenters, & Mud Islands, & the several Batteries & Works constructed thereon. Philadelphia 15th Decr 1777. John Montrésor Chief Engineer, 31⅞ × 27⅜, at the British Museum.

Fig. 60

(92) To His Excellency Sir Henry Clinton K. B. General and Commander in Chief of his Majesty's Forces, within the Colonies laying on the Atlantic Ocean from Nova Scotia to West Florida inclusive &c. &c. &c. John Montrésor Chief Engineer, 26¼ × 38¾, at the University of Michigan, William L. Clements Library, Clinton Papers, described in Randolph G. Adams, *British Headquarters Maps and Sketches* (Ann Arbor, Mich., 1928), pp. 77–78.

(93) Untitled plan of Philadelphia, 35¼ × 27¾, at the William L. Clements Library, described in *ibid.,* p. 77.

(94) Untitled plan of roads leading out of the city, 12½ × 15¾, at Library of Congress, described in P. Lee Phillips, *A Descriptive List of Maps and Views of Philadelphia in the Library of Congress,* no. 170.

(95) (96) (97) (98) Plans of British Army positions within present-day Philadelphia, by John André, at the Huntington Library, San Marino, California, reproduced in Henry Cabot Lodge, ed., *Major André's Journal* (Boston, 1903), 1:124, 128, 132, 134.

(99) Untitled plan of a British camp on the Schuylkill River, by Sir Henry Clinton, at the William L. Clements Library, described in Randolph G. Adams, *British Headquarters Maps and Sketches* (Ann Arbor, Mich., 1928), p. 78.

The Carington Bowles Reissue of the Scull and Heap East Prospect, 1778

Probably the most decorative of all the reissues of Scull and Heap's 1754 *East Prospect* of Philadelphia is the last, published by Carington Bowles of London during the British occupation of Philadelphia. It is of better quality and a more ambitious as well as larger work than the *London Magazine* reissue of 1761.

Bowles operated a print "warehouse" in the shadow of St. Paul's Church. His was a sharp eye, for he was able to acquire the original drawing made by George Heap that had been transported to London with such difficulty twenty-five years earlier. He stated on the new print that it was prepared directly from that source—a claim of greater merit than simply copying an earlier engraving.

I. N. Phelps Stokes in his *Iconography of Manhattan Island* quotes from a sales catalogue issued by Bowles in 1790. This listed the Philadelphia view as one of a collection of 271 prints "designed to be used in the Diagonal Mirror, an Optical Pillar

machine, or peep show. Price 1 s. plain or 2 s. beautifully coloured." Such usage required a standard size and presented space limitations in rendering the scene. One section of the Philadelphia shore line and wharves downstream from Market Street was omitted for this purpose, so that the Statehouse tower appears over a different point of the shore than in the original much wider engraving. With this exception the presentation of the waterfront is the same as in the original and, true to the drawing, the near New Jersey shore is not included.

No copy of this print has been seen without coloring (applied by the use of gouache rather than clear watercolor) dating from the time of its issue. The unusual result is notable. Harry Shaw Newman, of New York's *Old Print Shop,* wrote of the view that it is "colored with the thick, opaque pigment in clear, brilliant tones which distinguish many of Carington Bowles' prints, a type especially attractive which has kept its depth and brilliance. . . . Being for use in a machine, so that the buildings stood out in perspective, they were drawn with definiteness with regard to public buildings, churches and landmarks, and this makes them of great historical interest today."

The first issue of the engraving bore the date "1 Jany 1778" on the plate. As it continued in use, this legend was removed so that the viewer would regard the scene as current. A number appearing on the plate, which identified the position assigned to the print in the overall collection, was also later removed, as was the reference to the original drawing. In about 1794 Carington Bowles was succeeded by Bowles & Carver, and the new name appeared on the plate. But no change was made in the engraved picture itself. Differences appearing from one copy to another result from variations in the hand coloring at the time of issue.

Apparently another portion of the collection was a set of views of American cities, in matching size, assembled long before the Revolution by J. Carwitham of London. The appearance of the Philadelphia view in the same collection with the Carwitham engravings of New York and Boston has led some experts to attribute it to Carwitham and to assign, incorrectly, a date many years before the 1754 publication to the scene portrayed originally by George Heap. The earlier date was simply when Carwitham was active.

H. N. Stevens, the Vermont-London bookseller and bibliophile, has traced the corresponding Carwitham view of New York and shown that it was still sold in London as late as 1825. It can be assumed on this basis that the Scull and Heap reissue was published over a period of at least forty-five years.

Fig. 61 (100) *Fig. 61.* An East Perspective View of the City of Philadelphia, in the Province of Pensylvania, in North America; taken from the Jersey Shore, after George Heap. Engraving, 1752 (scene), 1778 (engraving), 9½ × 16⅜. Attribution: Printed for and Sold by Carington Bowles, at his Map & Print Warehouse, No. 69 in St. Pauls Church Yard, London. Publish'd as the Act directs, 1 Jany 1778. Engraved from the Original Drawing sent over from Philadelphia, in the possession of Carington Bowles. 38.

LATER STATES

Colorplate 5 (100A) *Colorplate 5.* As above, but lacks the date "1 Jany 1778."

(100B) As (100A), but lacks reference to being engraved from the original drawing, and "Carington Bowles at his" is replaced by "Bowles & Carver at their."

(100C) As (100B), but lacks the number "38."

38 *An East Perspective View of the* CITY of PHILADELPHIA, *in the* PROVINCE *of* PENSYLVANIA, *in* NORTH AMERICA; *taken from the* JERSEY *Shore*.

Fig. 61

A Locally Produced Map of Philadelphia, 1778

The growth of the city since the release of its first and only "interior" map in 1762 was greater in the outskirts than in important structures in the center. The dearth of new maps for the use of visitors on war business may have been due both to this fact and to the regularity of the grid layout.

It was an enterprising new arrival who saw a need for a new map. P. Lee Phillips attributes it with little reason for doubt to John Norman, who had come to Philadelphia from London in 1774 while in his twenties. An engraver, he published the *Philadelphia Almanack For the Year 1778* that included a pocket-sized map of the city limited in area substantially to its formal boundaries: the two rivers; Vine Street on the north; and Cedar or South Street. While the plate lacks attribution, Norman would surely have used his own talents rather than pay an outsider for the copperplate.

The map is mostly devoted to identifying streets and alleys, but is of more interest today in being the first to show the location of the British officers' barracks on Second Street north of Callowhill. The few other nonstreet identifications include the old drawbridge at Dock Creek and Front Street near the Delaware, first labeled in Peter Cooper's painting of the waterfront about sixty years earlier, but not shown by either Clarkson and Biddle or their copyist, Andrew Dury.

Fig. 62 (101) *Fig. 62. A Plan of the City of Philadelphia, attributed to John Norman. Engraving, 1777, 6⅞ × 6½. Source: John Norman, The Philadelphia Almanack For the Year 1778 Calculated For Pensylvania and the neighbouring Parts, frontispiece.*

Fig. 62

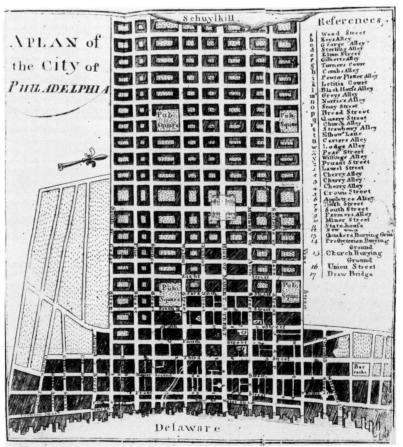

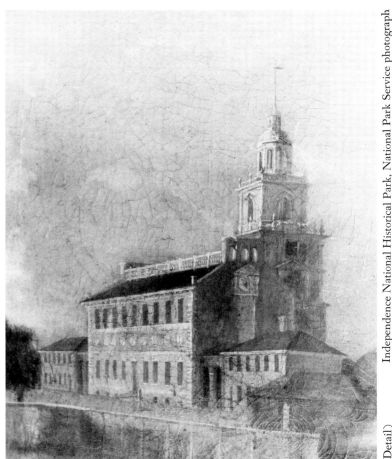

Independence National Historical Park, National Park Service photograph

Fig. 63

(Detail)

The Statehouse by Charles Willson Peale, 1779

Conrad Alexandre Gérard, first French minister to the Americans, arrived in Philadelphia in midsummer, 1778, soon after the announcement of the formal alliance with his country. Congress, sitting in Philadelphia, thought it desirable to commission a portrait of the welcome new emissary and chose Charles Willson Peale to create it. The work was still in process not long before the minister's departure in 1779.

Gérard was housed in the old John Dickinson house, which was placed a short distance from the north side of Chestnut Street west of Sixth, quite near the Statehouse. One of the city's best-known residences, it remained until the 1830's, when it was demolished to make way for the now-long-gone Arcade Building. Peale stood his subject before a window of the house through which the Statehouse could be seen, thus bringing the outdoor view into the portrait.

Although Congress paid Peale, it did not formally accept the painting, which went into Peale's collection and only much later came to form a part of the historical collection preserved at Independence Hall.

Probably it was as a study of the Statehouse for this commission that Peale portrayed that building from the same direction in a drawing of 1778, which nine years later was published as an engraving in the *Columbian Magazine*.

(102) *Fig. 63.* (Portrait of Conrad Alexandre Gérard), by Charles Willson Peale. Oil on canvas, 1779, 96 × 60. Source: Independence National Historical Park, Independence Hall Collection, Philadelphia.

Fig. 63

The Mock Execution of Benedict Arnold, 1780

Benedict Arnold's part in the conquest of Burgoyne made him a hero. Upon the British evacuation of Philadelphia, Arnold was given command of the city. Soon, however, his obvious sympathy for the Tories, and his open venality, turned the feelings of the citizenry from admiration to hatred. Unable to stop an approaching prosecution at the behest of the Supreme Executive Council, Arnold chose to depart the scene in advance. His conviction in absentia by a court-martial hardened his attitude and sealed his fate, for it led to his proposal to the British for the treacherous surrender of West Point.

News of Arnold's treason reached Philadelphia on 27 September 1780. Within a day a hollow paper figure of the traitor was paraded and hung upon a gallows. Then more formal plans were set afoot for parading another Arnold figure through the streets to a prearranged spot where it would end in flames. No less an artist than Charles Willson Peale created the effigy. Dressed in a red coat, and with two faces, it sat in a cart before a large black figure of the Devil shaking a purse of money in its ear. A lantern affixed to the front proclaimed "Major General Benedict Arnold, late Commander of the Fort West-Point. The crime of this man is high treason." Gentlemen on horseback were followed by Continental officers and a guard of the city infantry and, just before the cart, by a fife-and-drum corps playing the Rogue's March. According to the contemporary account, "the procession was attended with a numerous concourse of people, who after expressing their abhorrence of the Treason and the Traitor, committed him to the flames, and left both the effigy and the original to sink into ashes and oblivion."

William Murrell in his *History of American Graphic Humor* lends perspective to such actions by pointing out that they have been customary throughout recorded time for the victims of popular disapproval. Indeed, in Philadelphia as recently as 1774 two effigies had been drawn through the streets in a cart, one of Governor Thomas Hutchinson of Massachusetts being represented with two faces, hung in effigy, and burned before a vast crowd.

Perhaps in the case of Arnold the incident would quickly have been forgotten, but the Revolution was not yet won and the lurid scene had propaganda value. In the *Pennsylvania Gazette* for 1 November appeared the following:

> Just published and to be sold by Francis Bailey, The Continental Almanac. Containing, besides everything necessary in an Almanac, a description of the Figures (the Devil and General Arnold, etc.) exhibited and paraded through the streets of Philadelphia, on Saturday the 30th of September, 1780, illustrated with a Plate neatly engraved, Prophesies, etc etc. Also Andre's Trial.

The woodcut, in simple but strong black and white, was admirably suited to convey the stark drama of the occasion. It even included a view at West Point. Beneath it, but on the same folding sheet, appeared a lengthy prose description and the usual verses.

The same scene, but in reverse, was included as a folding illustration in Steiner and Cist's almanac for 1781, published in Philadelphia for the German-speaking community. Sinclair Hamilton finds this cut far more lively, and the figures better drawn,

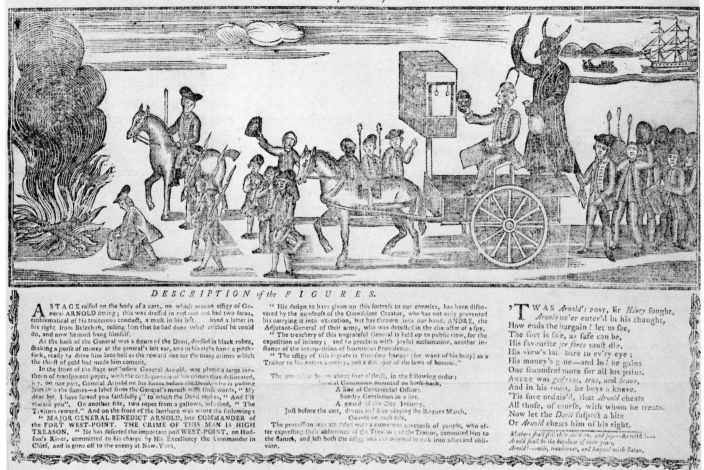

A REPRESENTATION of the FIGURES exhibited and paraded through the Streets of PHILADELPHIA, on *Saturday*, the 30th of *September* 1780.

DESCRIPTION of the FIGURES.

A STAGE raised on the body of a cart, on which was an effigy of General ARNOLD sitting; this was dressed in red coat and had two faces, emblematical of his traiterous conduct, a mask in his left. hand a letter in his right from Belzebub, telling him that he had done what mischief he could do, and now he must hang himself.

At the back of the General was a figure of the Devil, dressed in black robes, shaking a purse of money at the general's left ear, and in his right hand a pitchfork, ready to drive him into hell as the reward due for the many crimes which the thirst of gold had made him commit.

In the front of the stage and before General Arnold, was placed a large lanthorn of transparent paper, with the consequences of his crimes thus delineated, i.e. on one part, General Arnold on his knees before the Devil, who is pulling him into the flames—a label from the General's mouth with these words, "My dear Sir, I have served you faithfully;" to which the Devil replies, "And I'll reward you". On another side, two ropes from a gallows, inscribed, "The Traitors reward." And on the front of the lanthorn was wrote the following:

"MAJOR GENERAL BENEDICT ARNOLD, late COMMANDER of the FORT WEST-POINT. THE CRIME OF THIS MAN IS HIGH TREASON. "He has deserted the important post WEST-POINT, on Hudson's River, committed to his charge by His Excellency the Commander in Chief, and is gone off to the enemy at New-York.

"His design to have given up this fortress to our enemies, has been discovered by the goodness of the Omniscient Creator, who has not only prevented his carrying it into execution, but has thrown into our hands ANDRE, the Adjutant-General of their army, who was detected in the character of a spy.

"The treachery of this ungrateful General is held up to public view, for the exposition of infamy; and to proclaim with joyful acclamation, another instance of the interposition of bounteous Providence.

"The effigy of this ingrate is therefore hanged (for want of his body) as a Traitor to his native country, and a betrayer of the laws of honour."

The procession began about four o'clock, in the following order:
Several Gentlemen mounted on horse-back,
A line of Continental Officers,
Sundry Gentlemen in a line,
A guard of the City Infantry,
Just before the cart, drums and fifes playing the Rogues March,
Guards on each side.

The procession was attended with a numerous concourse of people, who after expressing their abhorrence of the Treason and the Traitor, committed him to the flames, and left both the effigy and the original to sink into ashes and oblivion.

'TWAS *Arnold's* post, Sir *Harry* fought,
Arnold ne'er enter'd in his thought,
How ends the bargain? let us see,
The fort is safe, as safe can be,
His favourite *per force* must die,
His view's lay bare to ev'ry eye;
His money's gone—and lo! he gains
One scoundrel more for all his pains.
ANDRE was *gen'rous*, *true*, and *brave*,
And in his room, he buys a knave.
'Tis sure ordain'd, that *Arnold* cheats
All those, of course, with whom he treats.
Now let the *Devil* suspect a bite
Or *Arnold* cheats him of his right.

Mothers shall fill their children, and say—Arnold !—
Arnold shall be the bug-bear of their years,
Arnold !—vile, treacherous, and leagued with Satan.

Fig. 64

making it radically different in details and in spirit from Bailey's print. He questions whether it might have been cut by the experienced Justus Fox.

Interest in this unusual pictorial response to local events continued into the nineteenth century. A facsimile of the Bailey sheet was issued by Edward Rogers, a Philadelphia wood engraver, about 1855. In 1872 Thompson Westcott reprinted the Bailey scene in his "History of Philadelphia," published serially in *The Sunday Dispatch* commencing in 1867.

(103) *Fig. 64.* A Representation of the Figures exhibited and paraded through the Streets of Philadelphia, on Saturday, the 30th of September 1780. Wood engraving, 1780, 4¼ × 11. Source: Anthony Sharp, *The Continental Almanac, for 1781* (Philadelphia, 1780), printed and sold by Francis Bailey.

Fig. 64

REPRINTS

(103a) Wood engraving with attribution: E. Rogers Phila Fac-Simile; c. 1855.

(103b) Wood engraving in Thompson Westcott, "A History of Philadelphia," *Philadelphia Sunday Dispatch,* 1867, 30 June 1872.

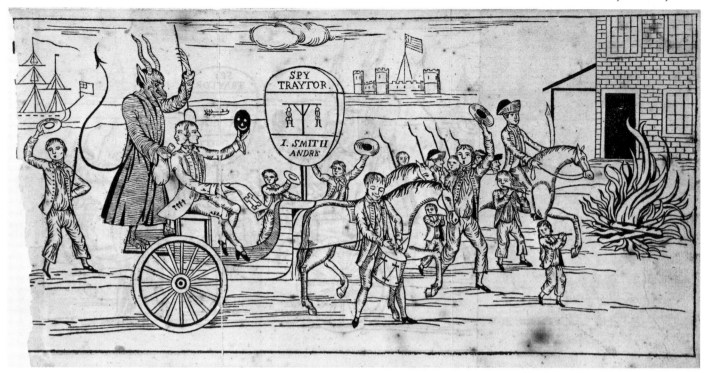

Fig. 65

Fig. 65

(104) *Fig. 65.* (The Parade of Arnold's Treason). Wood engraving, 1780, 7³⁄₁₆ × 15⁷⁄₁₆. Source: Steiner and Cist, *Americanischer Haus- und Wirthschafts-Calender Auf das 1781ste Jahr Christi* (Philadelphia, 1780).

Visits by the French Army, 1781 and 1782

As active participants in the American Revolution, the French army of Rochambeau produced detailed journals and marching observations that were accompanied by finished maps of the cities visited and of the camps set up. Philadelphia became a part of this written and pictorial record.

The French had embarked from Brest in 1780 for Newport and had remained there during the winter of 1780–81. In the spring they moved across Connecticut to meet the Continentals on the Hudson. In marching south to Yorktown and the final battle that won the Revolution, Philadelphia was approached just after the first of September 1781. The field notes of the engineers and the journals of observant officers take up the story:

> On either side of the road you find woods, country houses, and ruins that are monuments to the wrath of the English. Half a mile from the city you see remains of General Howe's lines. Soon you cross one of the works that the English had built for the defense of the town. . . .*
>
> When we came within sight of the city, the army halted and the troops spruced up. With drums beating and flags unfurled, we entered it at a walk. . . . The streets and the line of march were crowded with people who were absolutely amazed to see such a fine army. . . . They could not conceive how, after a long

* Howard C. Rice, Jr., and Anne S. K. Brown, eds., *The American Campaigns of Rochambeau's Army* (Princeton, N.J., 1972), 2:75.

and tiring march over such frightful roads, we could be in such good condition, or how we could possibly have brought so much artillery in our train.

It took us an hour and a half to cross this large and beautiful city. We passed the State House where the members of Congress were assembled on the front steps. We saluted them, then passed the house of the Chevalier de La Luzerne, the ambassador of France to Congress, where the quality of the town were assembled. We then went to camp on the Schuylkill River a mile from town.*

The Congress expressed its profound gratitude for the generous help of our king and the effort he was making for his allies. . . . The President of the Congress, wearing a black velvet coat and dressed in a most singular fashion, asked M. de Rochambeau if it would be proper for him to salute the field officers. He replied that the King of France usually did. His Excellency concluded from this that he might do likewise without demeaning himself.†

The *Pennsylvania Packet* of 8 September 1781 gave more detail of the congressional review:

On Monday and Tuesday last the French army, under the command of his Excellency Count de Rochambeau, passed in review before his Excellency the President and the Honorable the Congress of the United States, at the State House in this city. . . . The President was covered, his Excellency General Washington, Commander-in-Chief, the Count de Rochambeau, &c., stood on his left hand, uncovered. The President took off his hat and bowed in return to every salute of the officers and standards. The troops made a most martial and grand appearance. The orders of his most Christian Majesty are to pay the same honours to the President of Congress as to the Field Marshal of France and a Prince of the Blood, and to Congress the same as to himself.‡

A fine watercolor map of the march that day from Red Lion Tavern at Frankford to the camp on the city side of the Schuylkill at Market Street shows the whole of the city, the fortifications restored at Fort Mifflin and Red Bank, New Jersey, and the pontoon bridge thrown across the Schuylkill by the British during their occupation and now used by the French for their departure southward. The map also marks the mansion in present-day Fairmount Park then occupied by the French ambassador as a summer home and now known as Randolph Mansion.

A separate map drawn on this occasion outlines in grid form the built-up area of the city, with the single indication for orientation of the Old Courthouse and market in Market Street. It includes the dirt track, split into two separated roads for its midlength, running west in roughly the line of Market Street to the pontoon bridge lying below bluffs on which the army camped.

It was exactly a year to the day when the French returned, victorious, after wintering at Williamsburg, Virginia:

The troops paraded before Congress as they had done the year before. The Chevalier de La Luzerne, the French envoy to the United States, had us to dine both days in the pavilion he had had built for the fete he gave to celebrate the

* *Ibid.,* 1:46.
† *Ibid.,* p. 134.
‡ *Ibid.,* p. 46.

birth of the Dauphin. . . . At the east end of the room was a rising sun surmounted by 13 stars (the arms of America) with an Indian watching the sunrise and apparently dazzled by its rays. Beside the Indian in the same picture was a woman, representing England, emptying a sack of gold into the hands of another Indian, who throws the gold at her feet with obvious contempt. . . . The pavilion was 100 feet long; its walls were supported by a colonnade 30 to 40 feet high.*

This structure had been erected on the grounds of the French Legation on Chestnut Street to the design of Pierre-Charles L'Enfant, a French engineer in American service. The fete for which it was created, held on 15 July 1782, involved the presence of both Rochambeau and Washington and a collation prepared by thirty cooks borrowed from the French army.

An interesting map records the second visit of the army and shows the dike built across the mouth of Poquessing Creek at the Delaware in relation to the network of roads leaving the city for the north. The nearby portion of the developed city area is also shown as the springboard for roads commencing north from Front, Second, and Fourth streets. The campsite chosen was along the road to Germantown, north of the city and west of Kensington.

* *Ibid.*, p. 77.

Fig. 66

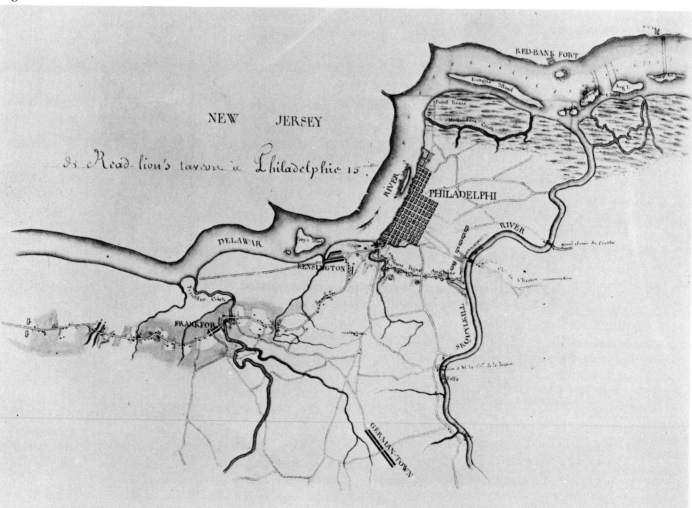

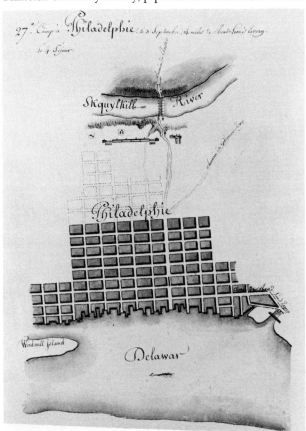

Fig. 67

We camped a mile above the city, where a great many people came to see us, and our regiment in particular. Some were seeking a brother, others a cousin; what was cruel for our soldiers was that they dared not venture outside the camp beyond the line of stacked arms, while no American dared come inside.*

This seemingly peculiar arrangement was necessary to prevent desertions from the army, "for there are many of them who would prefer to seek their fortune in this country."† Several deserters from the Deux-Ponts regiment are said to have settled in Frankford.

(105) *Fig. 66.* de Read lion's tavern à Philadelphie 15 milles. by Louis-Alexandre Berthier. Watercolor, 1781, 8¼ × 12⅜. Source: Princeton University Library, Berthier papers.

Fig. 66

(106) *Fig. 67.* 27e. Camp à Philadelphie, le 3 Septembre, 14 miles de Read-Lion's Tavern, by Louis-Alexandre Berthier. Watercolor, 1781, 12 × 7⅞. Source: Princeton University Library, Berthier papers. Rochambeau's copy is in the library of Paul Mellon, Upperville, Virginia.

Fig. 67

(107) 27 eme Camp à Philadelphie Le 31 Aoust 16 Miles de Chester Le 1m. Septembre Sejour, by Louis-Alexandre Berthier. Watercolor, 1782, 12 × 7⅞. Source: Princeton University Library, Berthier papers. Rochambeau's copy is in the Library of Congress. See P. Lee Phillips, *A Descriptive List of Maps and Views of Philadelphia in the Library of Congress* (Philadelphia, 1926), no. 330.

* *Ibid.*, p. 162.

† *Ibid.*, p. 162, fn. 139. Frankford.

6
Postwar Beginnings

IN THE twenty-five years preceding the Revolution the production of Philadelphia views and maps had been gaining momentum as a city record because of diverse stimuli such as the pride of Pennsylvania's proprietor, the pressures of a political campaign, the commemoration of new buildings, and the subject desired on certain paper currency. With the war this was almost halted, and with peace came basic needs which had to be met before the city could resume its development on the kind of solid base that would again encourage artistic output in quantity.

Commerce had to be rebuilt: Not until about 1790 did international trade regain its prewar state. New forms of government were required: The Articles of Confederation were drafted in Philadelphia. Much physical repairing and rebuilding was necessary. The thought of the British wintering comfortably in the city does not conjure up visions of destruction; but the burning of "Somerton" in what is now Fairmount Park, the home of Charles Thomson, secretary of the Continental Congress, is symptomatic of what actually happened. British fortifications had to be removed and barracks converted to other uses. Personal suffering had to be redressed, caused by such seemingly small things as the destruction of fences, the loss of livestock, and the disappearance of woodlands in the search for firewood by the British.

The Marquis de Chastellux has left a graphic account of the physical changes wrought by the occupation, as seen late in 1780:

> The nearer you approach to Philadelphia, the more you discover the traces of the war. The ruins of houses destroyed, or burned, are the monuments the English have left behind them, but these ruins present only a picture of temporary misfortune, and not that of long adversity. By the side of these ruined edifices, those still standing indicate prosperity and plenty. . . . Before entering Philadelphia, you cross the lines thrown up by the British in the winter of 1777–78; they are still discernible in many places. The part of the lines I now saw was that of the right, the flank of which is supported by a large redoubt, or square battery, which also commands the river. Some

parts of the parapet were constructed with much refinement. . . . As soon as I had crossed these lines my eye was struck by several large buildings, the two principal ones were a range of barracks constructed by the English, and a large hospital previously built at the expense of the Quakers.*

The years commencing with the peace were years of experimentation locally in many fields. In that of government, the inadequacies of the Articles of Confederation led to the holding of the Constitutional Convention at Philadelphia in 1787. In that of culture, a local artist tried without success in the same year to interest the public in the only published one of a projected series of city views. And yet success met the efforts at that time of a local group whose new monthly magazine—the first in America—gave mass distribution to engraved city views and encouraged the infant art of realistic landscape drawing.

Still, a unifying event bringing enthusiasm and confidence was needed to inspire a new growth and direction, and with it modern public improvements. This did not occur until 1790.

Plan of The Solitude, Home of John Penn, c. 1784

The Solitude was perhaps the first home of distinction to be built in Philadelphia after the Revolution. Much more formal than the simple plan drafted by John Bartram of his house and garden in 1758 is that prepared by a surveyor for John Penn, presumably at about the time the house was erected in 1784. Here is revealed the taste and the requirements of an eighteenth-century English gentleman who moved in very different circles from Bartram.

Penn's father, Thomas, son of William Penn the Founder and the active proprietor of the colony for many years, died at the outbreak of the Revolution. The Penn family properties were then transferred to the state of Pennsylvania. At the conclusion of hostilities in 1783 Thomas's son John appeared in Philadelphia with intent to recover the estates if possible, but the legislature was disinclined to act favorably. Penn decided nonetheless to remain in his family's former province. He bought acreage along the Schuylkill near present-day Girard Avenue and there built his mansion.

John Penn was a bachelor. It is interesting to note that his establishment in the new world called for separate flower and kitchen gardens, a "wilderness," a bowling green for his pleasure, his own dock and landing on the river, and even that favorite of English landscaping, a ha-ha wall and ditch designed to keep cattle at a proper distance, but inconspicuously.

Despite his substantial investment in the new house, Penn left Pennsylvania after only four years and never returned. He left The Solitude to his brother, whose son visited it in 1852. In 1869 it became a part of the new Zoological Gardens. It remains standing today after many years of use as executive offices for that organization.

* Howard C. Rice, Jr., ed., *Travels in North America . . . by the Marquis de Chastellux* (Chapel Hill, N.C., 1963), 1:130.

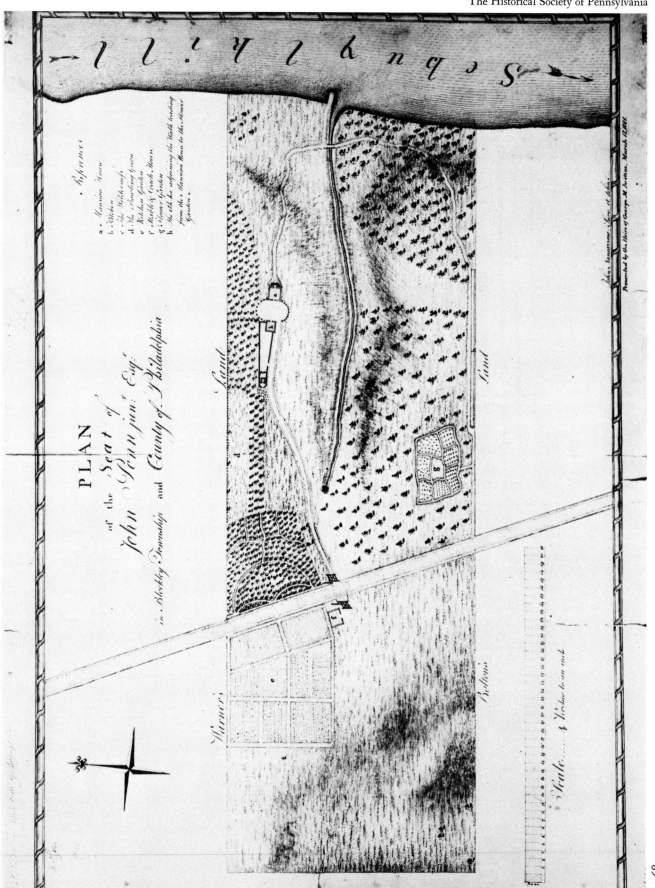

PLAN
of the Seat of
John Penn junr Esqr
in Blockley Township and County of Philadelphia

Fig. 68

Fig. 68

(108) *Fig. 68.* Plan of the Seat of John Penn junr. Esqr. in Blockley Township and County of Philadelphia, by John Nancarrow. Pen drawing, c. 1784, 19 × 28⅛. Attribution: John Nancarrow Surv. et delin. Source: Historical Society of Pennsylvania.

Carpenters' Hall, 1786

As a historic shrine, Carpenters' Hall has been the subject of many small guidebooks and pamphlets and has often been pictured in them. Apparently there is only one eighteenth-century view of it, however. This appeared in 1786, twelve years after its substantial completion, in the first *Rule Book* published by its builder and owner, the Carpenters' Company of Philadelphia. The print shows the front elevation of the structure, without any effort to place it among the buildings that then surrounded it. This gives the view a modern air, for in the effort to free it from the danger of fire the architects of Independence National Historical Park have in recent years caused it to stand free, as the *Rule Book* showed it.

The moving spirit in the design and direction of the cruciform building was Philadelphia's active carpenter-architect, Robert Smith. Construction over the years 1770–74 led to a lease of the second floor of the hall by the Library Company of Philadelphia and use of the ground floor, soon after furnishings were installed, by the first Continental Congress. Even after Congress was placed in the Statehouse upon reconvening

Fig. 69

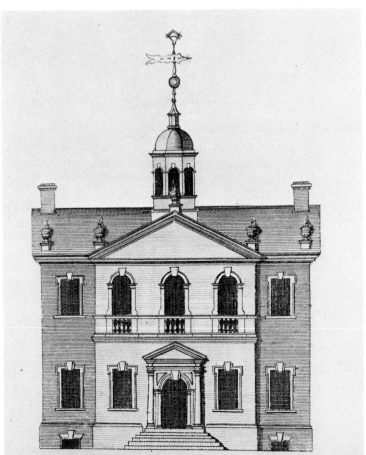

The Historical Society of Pennsylvania

in the following year, the hall was used by important smaller political groups, such as the 1776 Provincial Convention of Pennsylvania, which declared the colony's independence. In 1777 Carpenters' Hall was used as a hospital, and in 1778 and later it was a storage place for military supplies.

It was after all these events, but before its later very varied history, that the façade appeared as a copperplate in the *Rule Book*. Thomas Nevell, one of three members of the Carpenters' Company who took title to the ground in 1768 for the benefit of the organization, made the drawing, which was engraved and printed by Thomas Bedwell along with floor plans and other plates. Except for two details shown in the engraving—one perhaps never installed and one slightly changed upon installation—the hall appears there as it now stands.

Bedwell performed variously as an engraver, miniaturist, "hanging paper manufacturer," "manufacturer of the extract of bark," and drawing master during the years 1779–95. This is probably his only engraving of a Philadelphia subject.

Fig. 69

(109) *Fig. 69.* (Carpenters' Hall), by Thomas Nevell. Engraving, by Thomas Bedwell, 1786, 4⅝ × 3¼. Source: *Articles of the Carpenters Company of Philadelphia: and their Rules for measuring and valuing House-Carpenters Work* (Philadelphia, 1786). [See (120) Fig. 79 showing Carpenters' Hall in distance.]

The Pennsylvania Hospital, 1787

At a midsummer meeting of the Board of Managers of the Hospital in 1787, procedures were set in motion that resulted in an engraving of the structure as it then stood. This was in strong contrast to the pictures that more than twenty-five years earlier had projected a future still not realized. The eastern one-third of the impressive planned building had in the interim been supplemented not by other linking portions, but rather by a separate laboratory standing to the north since 1768. It was probably to protect the insane from jeers and insults that a high brick wall had been thrown around the two units.

The minutes of the managers show that on 30 July

> the present method of giving Certificates to the Students in Physic, who attend the practice of the Hospital, being found inconvenient, the board think some future regulations necessary, in the form thereof; wherefore the sitting managers with the attending physicians are requested to draw up the form of a Certificate and enquire into the Expence of having a plate engrav'd for the purpose of striking off a number of the said certificates, and report their proceeding at our next meeting.

At the August meeting the wording for the certification was approved and the committee empowered "to get a plate engraved for the purpose, with a Plan of the Hospital thereon, or such ornaments as they with the attending physicians approve." Any student receiving a certificate was required to pay "one Spanish milled dollar" for affixation of the hospital's seal.

Although the minutes for September noted that the plate was not yet completed, at the October meeting

an impression of the form of a Certificate for the Students of Physic, was produced and approved; and the Steward is desired to pay Robert Scott his account for engraving it, being Eleven pounds 8/6; and the Committee who had this business under their Care, are requested to have 200 struck off and then to deliver the plate to the Treasurer.

The quoted minutes imply that Robert Scot engraved an entire certificate. If so, the surviving small print of the hospital bearing his name could well be a remaining cut-down portion of the copperplate salvaged when a replacement certificate was created in the early 1800's. This supposition is supported by the fact that all copies of Scot's engraving that have been found have been printed on nineteenth-century paper.

Scot signed his engraving in such way as to show that he had drawn the subject as well as prepared the copperplate. His work was simple, careful, and precise. It was superior in quality to much of the work published in the *Columbian* and other magazines that were soon to follow. Its clean directness has current appeal.

Scot had settled in Philadelphia six years earlier, having appeared from Virginia with experience both as a watchmaker and in general engraving. His style in the latter probably had to do with his employment in 1793 by the United States Mint in Philadelphia, where he remained a diesinker well into the nineteenth century.

Scot's appears to have been the first of a series of views of the hospital engraved as embellishments for its presentation certificates, and the only one in the eighteenth century.

(110) (Pennsylvania Hospital), by Robert Scot. Engraving, by Robert Scot, 1787, size unknown. Attribution: R Scot Del & Sc.

LATER STATE

(110A) *Fig.* 70. Reduced copperplate, 3⅜ × 5½, showing hospital only, apparently nineteenth century.

Fig. 70

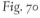

Fig. 70

The Accident in Lombard Street, 1787

Disappointingly, even Charles Willson Peale, the portrait painter who had studied under Benjamin West in London, found problems after the Revolution in supporting his family through his portrait commissions. Since 1776 he had resided in Philadelphia, the largest American city. He had been commissioned by Pennsylvania to paint General Washington in full length, and he had painted many other famous Americans. He had also become widely known for his service as an officer in the conflict. As a member of the Pennsylvania legislature he had achieved prominence in still another field, and he had even announced in 1786 the opening of a natural history museum. But withal, he felt compelled to explore new avenues of artistic effort in the search for income.

Thus it was that in February 1787 Peale determined to popularize prints suitable for framing. His studies in England had introduced him to the technique of mezzotinting. Combining this with his talent for portraiture, he announced a series of portraits in that medium for sale. Franklin was already completed, he said, while Washington, Lafayette, and the Reverend Pilmore of Philadelphia were projected. The persons selected for portrayal were living and popular. Peale looked for substantial return from sales at the price of one dollar unframed and three dollars framed.

It soon became apparent that public interest in such items was almost nonexistent. Although their quality was high, by October the price had been reduced to two-thirds of a dollar. Perhaps the public knew the features of such persons too well already, thought Peale. Then, too, the *Columbian Magazine* had just begun publishing as illustrations engravings prepared by others from Peale's drawings of city buildings and landscapes. A city-view type of print might elicit greater response.

On 5 November 1787 Peale put out a feeler by advertising in the *Pennsylvania Packet*

A New Print.
A Perspective View of Lombard-street; being the first number of an intended Series of Prints, to be taken of the principal streets in Philadelphia.—Price one quarter of a dollar.

Here was a novel idea, but the experiment was financially another failure. This was the only item of the "intended series" to appear, and only a few copies are known: not even a sufficient number to bring a listing in David McNeely Stauffer's *American Engravers upon Copper and Steel*. Very few could have gone into circulation.

In releasing this print Peale seems to have made two basic mistakes. One was his choice of subject. Peale sought to find popular interest and support by moving from portraiture to a genre scene on the street where his own home stood. In fact, Peale's house occupied the foreground of the engraved scene; but no imposing public building stood on Lombard Street to attest to the importance of America's *de facto* capital. Rhymes were introduced at the bottom of the plate in order to describe the incident portrayed and so bring life to an otherwise static picture. It has been surmised that in focusing attention on a child's dropping to the ground a newly purchased pie, the artist was portraying his own daughter in a family story. Since no effort was made at quality in the rhymes, it has even been thought that perhaps the copperplate was first made for family fun and only offered to the public after being praised by neighbors.

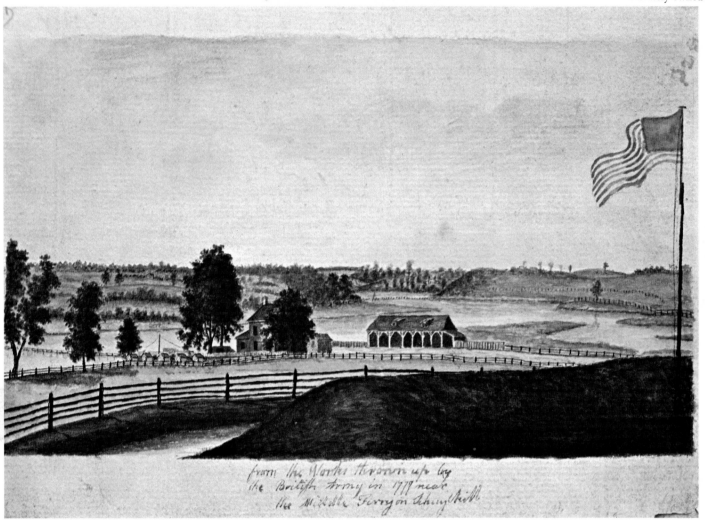

Colorplate 9. For a description of this plate, see item 142.

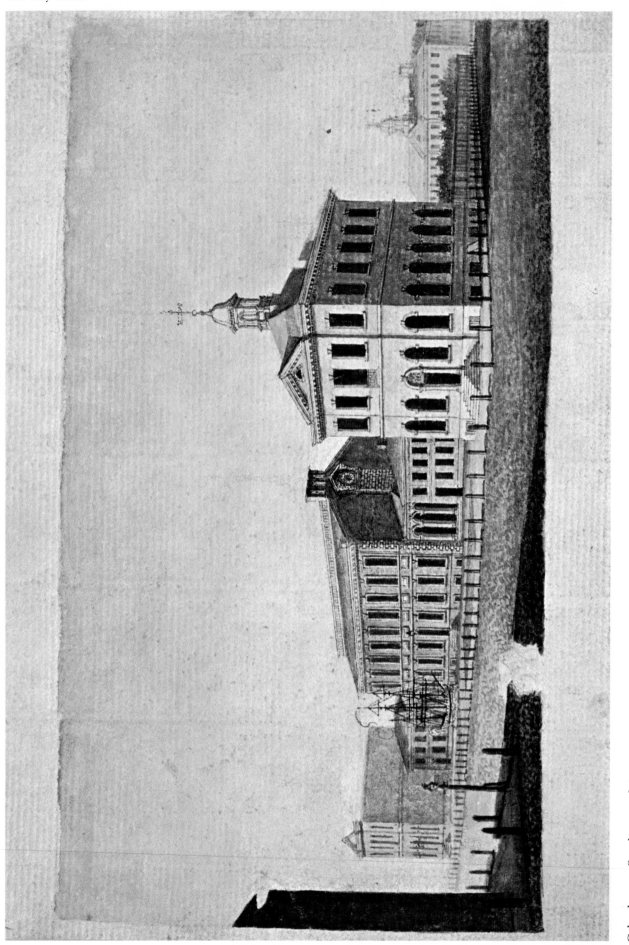

Colorplate 10. Statehouse and Congress Hall. For a description of this plate, see item 143.

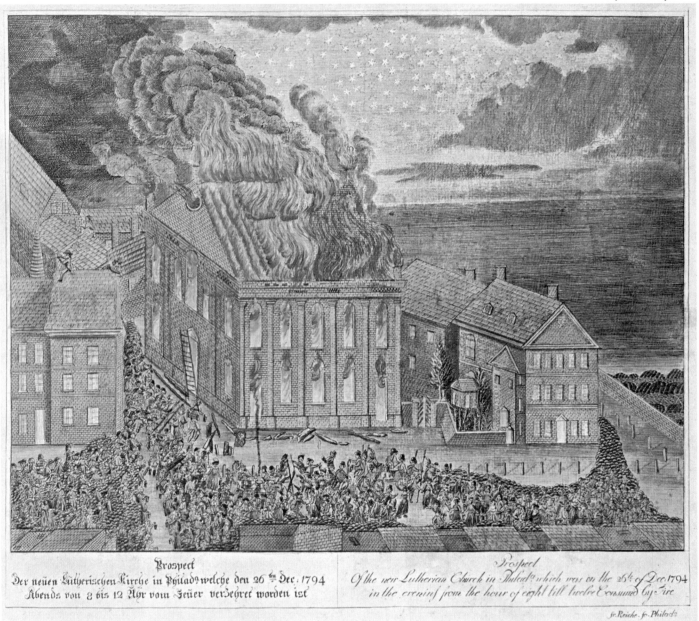

Prospect
Der neüen Lutherischen Kirche in Philad⁹ welche den 26ᵗⁿ Dec. 1794
Abends von 8 bis 12 Uhr vom Feüer verzehret worden ist

Prospect
Of the new Lutherian Church in Philad⁹ which was on the 26ᵗʰ of Dec. 1794
in the evening from the hour of eight till twelve Consumed by Fire

Jr. Reiche. fc. Philad⁹

Colorplate 11. For a description of this plate, see item 157.

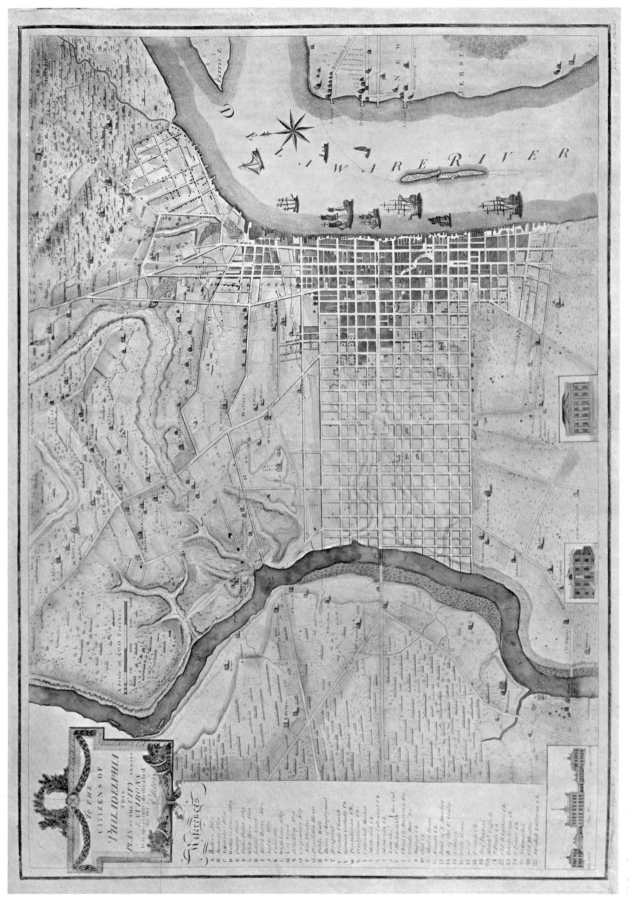

Colorplate 12. For a description of this plate, see item 167

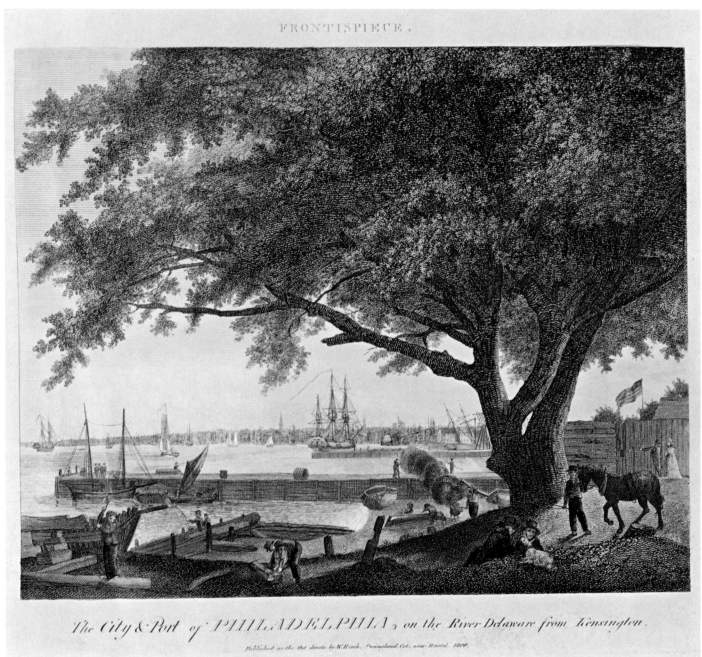

FRONTISPIECE.

The City & Port of PHILADELPHIA, on the River Delaware from Kensington.

Published as the Act directs by W.Birch, Springland Cot. near Bristol. 1800.

Colorplate 13. For a description of this plate, see item 199.

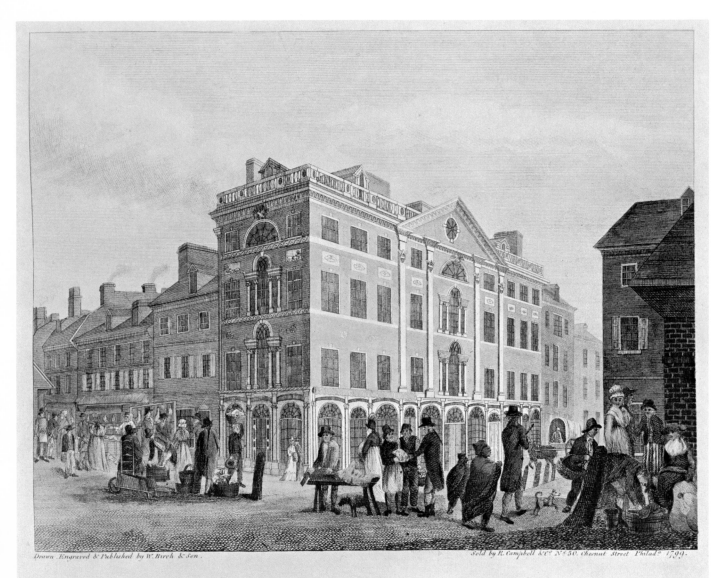

Drawn Engraved & Published by W. Birch & Son. Sold by R. Campbell &Cᵒ Nᵉ 50. Chesnut Street Philadᵃ 1799.

South East CORNER *of* THIRD, *and* MARKET *Streets.*

PHILADELPHIA.

Colorplate 14. For a description of this plate, see item 205.

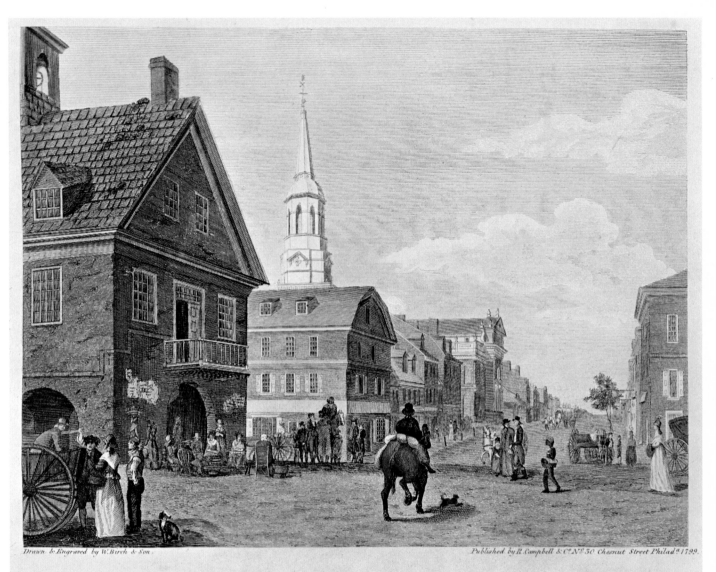

Drawn & Engraved by W. Birch & Son. Published by R. Campbell & C.º Nº. 30 Chesnut Street Philadª. 1799.

SECOND STREET. North from Market S.t w.th CHRIST CHURCH.

PHILADELPHIA.

Colorplate 15. For a description of this plate, see item 212.

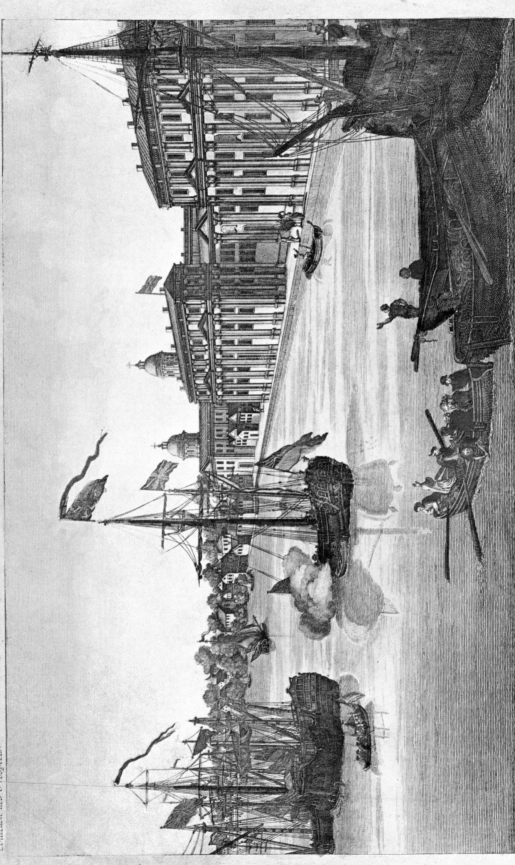

Philadelphia.

Die Haupt Stadt in der Nord-Americanischen Provinz Pensylvanien, sie ist vom William Penn (dem Caroll II. König in Engelland die ganze Provinz geschencket hatte) um Jahr 1682. zwischen 2. Schiffreichen Flüssen angelegt und deswegen Philadelphia genennet worden, weil die Einwohner in Brüderlicher Einigkeit daselbst leben sollen.

Philadelphie.

La Ville Capitale de Pensylvanie, Province Nord-Americaine, William Penn, à qui Charles II Roi d'Angleterre donna cette Province entiere, la planta en 1682 entre deux fleures navigables, et l'apella Philadelphie, parceque les habitans y vivent dans une Harmonie fraternelle.

Se vend au Magazine au Negoce continu a l'Academie Imperiale d'Empire des tres laborieux avec Privilege de Sa Majesté Imperiale et avec Defense a un chacun de ne faire ni de vendre de copies.

Grave par Balth. Frederic Leizelt.

Colorplate 16. For a description of this plate, see item 242.

Peale's second mistake was in releasing a work in a medium where his competence was inferior. As mentioned by Charles Coleman Sellers, the artist's technique as an engraver or etcher was amateurish. The print lacks strong lights and darks and gives no feeling of depth, strength, or finish. The use of mezzotint could have been most successful, but the simpler line method Peale used produced the print in less time and with less work than the mezzotint would have required.

Actually the *Columbian's* publication of engravings prepared from Peale's drawings, which had begun in July 1787, supplied no parallel. Although the magazine distributed such prints in large numbers, its subscribers were, from that point of view, a captive group who probably viewed simply as news illustrations the pictures they were receiving and would not have thought of purchasing such an item separately. Conversely, Peale offered his prints from his own home, without a preexisting group of buyers or the help of a publisher or even a print seller.

Though lacking in interest to his contemporaries, Peale's print conveys a very good idea of what the streets of the largest American city looked like then. A placid and low outline met the eye. *Quiet* was the rule. The house marked "Baker" and containing his shop looked no less residential than the others. Even the presence of four chimney sweeps was indicative of home needs.

Fig. 71

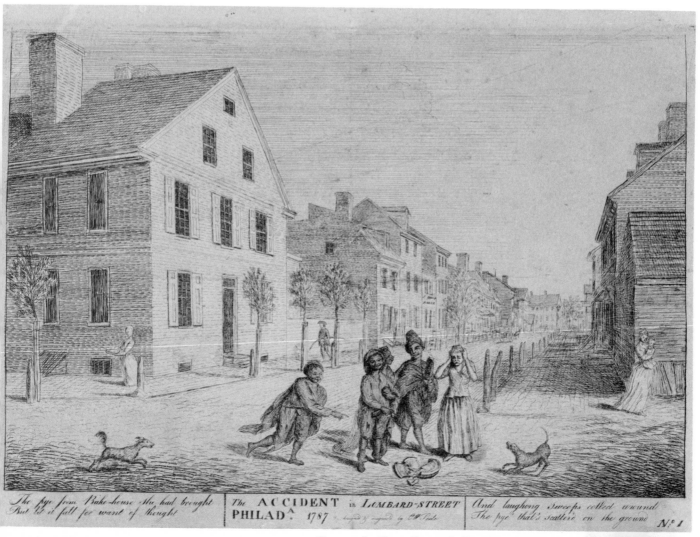

The pye from Bake-house she had brought / But to it fell for want of thought | The ACCIDENT in LOMBARD-STREET PHILAD.ᵃ 1787. designed & engraved by C.ᵂ Peale | And laughing Sweeps collect around / The pye that's scattered on the ground | Nᵒ 1

Courtesy the Henry Francis du Pont Winterthur Museum, Winterthur, Delaware

It seems clear that at so short a time after the Revolution the United States was too preoccupied with getting on its feet to permit much interest in prints as independent artistic products, whatever their subjects or merit. After another decade, and with the city the focal point of a great new political and cultural era, William Birch rightly perceived a much more solid base of support for a print series akin to that which Peale had attempted.

Fig. 71

(111) *Fig. 71*. The Accident in Lombard-street Philada. 1787, by Charles Willson Peale. Engraving, by Charles Willson Peale, 1787, 7¼ × 11¾₆. Attribution: Design'd & engrav'd by C W Peale.

(112) The American Philosophical Society owns a sketch in oils of Peale's house at Third and Lombard Streets, 5¼ × 7½, showing a skylighted gallery built by Peale in 1782 for the display of his paintings of heroes of the Revolution. This is attributed to James Peale, c. 1794. See Charles Coleman Sellers, "Peale's Museum," in *Historic Philadelphia*, ed. Luther P. Eisenhart (Philadelphia, 1953), p. 253, fig. 1.

Magazine Illustrations: Eighteen Philadelphia Views, 1787–95

The Constitutional Convention of 1787, held in Philadelphia's Statehouse, was a unifying event of tremendous importance that could have generated the enthusiasm needed to restore the prewar flow of views of the city. Yet this did not occur, probably because ratification by the states was a slow process. Even the great Federal Procession held in the city in 1788 celebrated only ratification by the ninth state. In the meantime, however, a new type of commercial venture had brought a demand for city views and introduced a new concept: that of supplementing pictures of the city's buildings with landscape scenes nearby.

This new venture was the publication of America's first monthly magazine, the *Columbian*. It was designed to emulate those long published in London, particularly the *Gentleman's Magazine*. Since the latter included engravings of town and country subjects, a similar approach was considered necessary in Philadelphia. Fortunately one of the publishers, James Trenchard, was himself an engraver. Born in Salem County, New Jersey, he had come to Philadelphia in 1777 and learned the art from James Smither, the dominant figure in the profession locally in that decade.

The new magazine was of small size and the views it carried were, except for an occasional folding plate, limited to a maximum of about four by seven inches. In the state of the art at that time, the local engravers seemed unable to impress into copper any of the nuances of the original drawings they were copying. This was particularly true of landscape, where their effort was entirely new and experimental. James Thomas Flexner sees the resulting engravings in American magazines as "unexciting renditions of physical topography," and points out that although they bore titles, "the accompanying text often generalizes, trying to catch in words wide implications which the pictures miss." Yet he agrees that "nobody in the United States knew how to make . . . really satisfactory landscape engravings" at the time. These scenes were "primi-

tive" in quality, but their publication in the magazine stimulated interest in such work and, with it, improvements in the results obtained, which might otherwise have been much longer delayed.

Trenchard's first plates in the *Columbian Magazine* reproduced the work of one of the best available talents. For the issue of July 1787 he appears as "JT" to have engraved Charles Willson Peale's drawing of the Statehouse. This had been made in 1778 as a study for the background of Peale's portrait of Conrad Alexandre Gérard, the French minister to the colonies, commissioned by the Continental Congress. The August issue brought a foldout almost fourteen inches wide copying Peale's landscape drawing *An East View of Gray's Ferry, on the River Schuylkill*. This scene engraved by "JT" has received high praise from Edgar P. Richardson in his in-depth studies of early American pictorial efforts. To him this is "an example of Peale's transparent directness of vision and charm of statement . . . the most successful expression of a growing awareness of nature that had yet been produced in America. Eighteenth-century landscapes up to this time were generalized views based upon a decorative formula rather than upon observation. This engraving stands out startlingly among them." Richardson emphasizes that the American engraver had to do everything himself, whereas in London at this time there was a whole industry centering around prints, their craftsmen, shops, and publishers.

Trenchard seems to have engraved at least two more of the *Columbian's* Philadelphia scenes. The earlier, still in 1787, was the first view of Christ Church. Although it lacks the name of the artist and engraver, the style of the drawing has been attributed to Peale. Probably Trenchard as engraver was not quite ready to permit publication in the magazine of plates cut by his assistant James Thackara, although that time was approaching. Another, which appeared in the issue of May 1789 under Trenchard's name, returned to a small-size rendering by Peale of another scene at Gray's Ferry. It showed the same site earlier published, but this scene prepared for the welcoming of General Washington en route to his inauguration in New York City as first president. Perhaps the general recalled, in crossing the floating bridge, that it had been laid by the British during their occupation of the area.

Thackara, a native Philadelphian born in 1767, developed a style close to Trenchard's. His career ran until 1848 and included a period as curator of the Pennsylvania Academy of the Fine Arts. At least one of the remaining four views of Philadelphia published by the *Columbian Magazine* was his engraving. This was *A View of the New Market from the Corner of Shippen* [now Bainbridge] & *Second-streets,* published early in 1788.

In 1789 came two landscapes along the Schuylkill. One was a quiet river scene without a building in sight, but the other included Bush Hill, a well-known mansion in the vicinity of present-day Eighteenth and Spring Garden streets but then sitting in open country on a height above the city. The house had been built by Andrew Hamilton, whose successful defense of Peter Zenger in New York gave rise to the traditional reference to the ability of a "Philadelphia lawyer." Public interest in Bush Hill was generated on 4 July 1788 when it was the terminus of that great parade and patriotic celebration, the Federal Procession, following the establishing of the United States Constitution by New Hampshire's ratification. As the site of a fete and dinner alfresco on that occasion, the lawn overlooking the city and both rivers became known as Union Green.

At the start of 1790 the last local *Columbian* view introduced to readers a scene of much interest showing the area of Sixth and Chestnut streets with many important buildings and with much open space still around the Independence Square of today.

With their wide diversity, the *Columbian Magazine* views of Philadelphia form a highly interesting series. Joseph Jackson's criticism that they "did not give much of the atmosphere of the city" seems to ask too much too soon for these new-direction prints, although he concedes that with them "the art of engraving here advanced a step." These prints laid the groundwork for much greater things a short time later.

Seven more Philadelphia pictures of this type were published in other American magazines by 1795: three in the *Massachusetts Magazine* and four in the *New York Magazine*. All but one of these were engraved from drawings by Jacob Hoffman, who is said to have been a landscape artist residing in Philadelphia. They included *Upper Ferry on Schuylkill* picturing the earliest bridge at the present-day Museum of Art; private estates; the completed portion of the Pennsylvania Hospital; and an attempt at rendering the Falls of the Schuylkill. One most unusual subject was the interior of the New Theatre at Sixth and Chestnut streets when it was first opened to the public in February 1794, apparently engraved from a painting by J. Lewis of Philadelphia.

Whereas before the separation American portrayals of Philadelphia were often copied in England, no such copies appeared of the magazine engravings. This may have been due to a combination of anti-American feeling and the fact that English engraving had advanced far beyond such relatively crude prints. Because a Philadelphian reversed the usual process by moving at this time to England, however, three Philadelphia scenes not copied from other publications appeared in the *Universal Magazine* of London.

James Peller Malcom, born 1767 in Philadelphia and educated there and at Potts-town during the Revolution, returned to the city about 1784 to study engraving. By 1786 he was advertising his ability in that field by stating that he "has engraved two plates as specimens of his work, at his house the bank side of Front between Chestnut and Walnut-streets." On 4 May 1787 he offered a new allegorical engraving, after his own design, for subscriptions at four shillings each.

It was about 1789, under the patronage of prominent citizens, that Malcom was sent to England to complete his art studies. Apparently before he left America, he arranged publication by the magazine in London of three copperplates of Philadelphia subjects that he cut himself. These were published in 1787, 1788, and 1789: Walnut Street behind the Statehouse showing the jail of 1775; a close-up view of Bush Hill; and the exterior of Christ Church. As to the last of these the magazine stated that "a correspondent at Philadelphia favoured us with this plate and description."

Three of the *Columbian Magazine* views were the subject of restrikes issued in the nineteenth century. The *South East View of Christ's Church,* the *View of the State House,* and the *View of the New Market* survived as copperplates and were the source of late prints. On hard paper but without a number, they are thought to have been printed by the bookseller Robert Desilver about 1830. With the engraved numbers 24, 25, and 26 inscribed on the plates, they formed a part of the series of early engravings assembled by the antiquarian John McAllister, Jr., from which copies were pulled in 1860 and perhaps later.

The magazine views were much more widely disseminated than any engravings preceding them. The *Columbian* had the largest circulation of any eighteenth-century

American magazine—nearly one thousand subscribers. This type of publication with its engraved illustrations was an important factor in the changeover from aristocratic patronage to public, patriotic support of the arts following the Revolution.

Philadelphia Views from the Columbian Magazine

(113) *Fig. 72.* A N.W. View of the State House in Philadelphia taken 1778, by Charles Willson Peale. Engraving, probably by James Trenchard, 4⅝ × 6¹³⁄₁₆, issue of July 1787. Attribution: C. W. Peale delin J T sculp Columb. Mag.

Fig. 72

LATER STATES

(113A) As above, but on hard paper (probably issued by Robert Desilver).

(113B) As above, but with figure "25" at top right outside neat line, 1860 (plate then owned by John McAllister, Jr.).

(114) *Fig. 73.* An East View of Gray's Ferry, on the River Schuylkill, by Charles Willson Peale. Engraving, probably by James Trenchard, 7¼ × 13½, issue of August 1787. Attribution: C. W. Peale delin. J. T. Sculp. Columb. Mag.

Fig. 73

(115) *Fig. 74.* A South East View of Christ's Church, attributed to Charles Willson Peale. Engraving, attributed to James Trenchard, 7⁹⁄₁₆ × 6¹⁄₁₆, issue of November 1787. Attribution: Columb. Mag.

Fig. 74

LATER STATES

(115A) As above, but on nineteenth-century paper.

(115B) As above, but on hard paper and with "1787" added below title (probably issued by Robert Desilver).

(115C) As (115B), but with figure "24" at top right outside neat line and "Philada." added after title, 1860 (plate then owned by John McAllister, Jr.).

(116) *Fig. 75.* A View of the New Market from the Corner of Shippen & Second-streets Philada, probably by James Thackara. Engraving, by James Thackara, 3⁷⁄₁₆ × 6⅝, issue of February 1788. Attribution: Thackara Sc Columb. Mag.

Fig. 75

LATER STATES

(116A) As above, but on hard paper and with "1787" added below title (probably issued by Robert Desilver).

(116B) As (116A), but with figure "26" at top right outside neat line, 1860 (plate then owned by John McAllister, Jr.).

(117) *Fig. 76.* A View on the Schuylkill; with a S W. Prospect of Bush-Hill, one of the Seats of William Hamilton, Esq, attributed to Charles Willson Peale. Engraving, 3¾ × 7⅛, issue of February 1789. Attribution: Columb. Mag.

Fig. 76

(118) *Fig. 77.* An East View of Gray's Ferry, near Philadelphia; with the Triumphal Arches, &c. erected for the Reception of General Washington, April 20th. 1789, by Charles Willson Peale. Engraving, by James Trenchard, 3⅝ × 6¹¹⁄₁₆, issue of May 1789. Attribution: C. W. Peale delin. J. Trenchard sculp. Columb. Mag.

Fig. 77

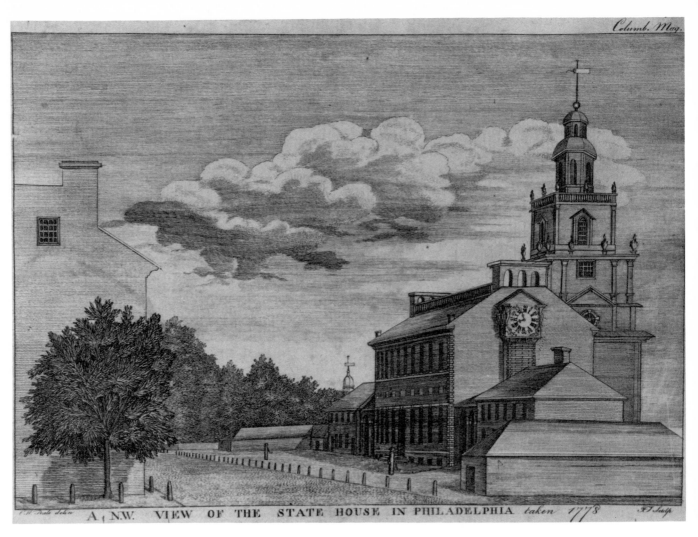

A N.W. VIEW OF THE STATE HOUSE IN PHILADELPHIA *taken* 1778

Fig. 72

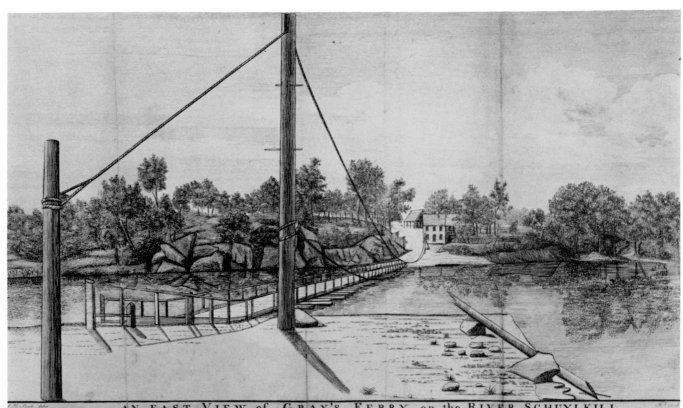

AN EAST VIEW of GRAY'S FERRY, on the RIVER SCHUYLKILL.

Fig. 73

A South East View of Christ's Church.

Fig. 74

Columb. Mag.

WINE
Tea
Brandy
Coffee
&c

A View of the New Market from the Corner of Shippen & Second-streets Philad.ᵃ

Fig. 75

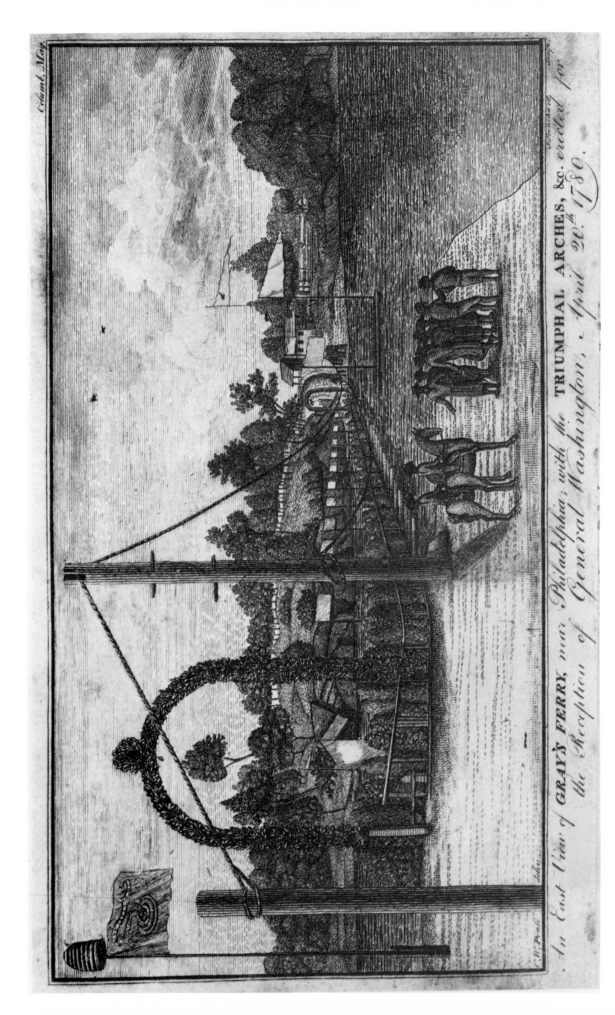

An East View of GRAY'S FERRY, near Philadelphia; with the TRIUMPHAL ARCHES, &c. erected for the Reception of General Washington, April 20th 1780.

Fig. 77

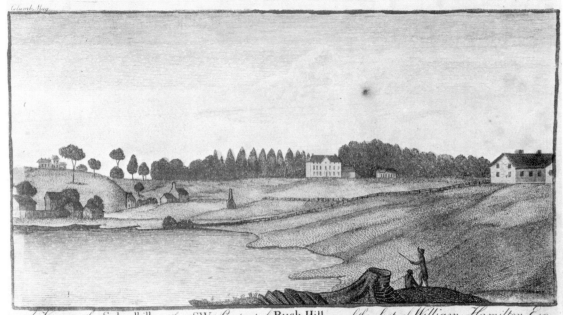

A View on the Schuylkill; with a SW. Prospect of Bush-Hill, one of the Seats of William Hamilton, Esq;

Fig. 76

(119) *Fig. 78.* A View on Schuylkill, near Philadelphia, attributed to Charles Willson Peale. Engraving, attributed to James Trenchard, 3⅝ × 6¹⁵⁄₁₆, issue of November 1789. Attribution: Columb. Mag. *Fig. 78*

(120) *Fig. 79.* View of several Public Buildings, in Philadelphia, attributed to Charles Willson Peale. Engraving, attributed to James Trenchard, 3⅝ × 7⅝, issue of January 1790. *Fig. 79*

Philadelphia Views from the Massachusetts Magazine

(121) *Fig. 80.* Upper Ferry on Schuylkill, by Jacob Hoffman. Engraving, probably by Samuel Hill, 3⅝ × 6¼, issue of September 1792. Attribution: J. Hoffman Del. Massa. Mag. No. IX. Vol. IV. *Fig. 80*

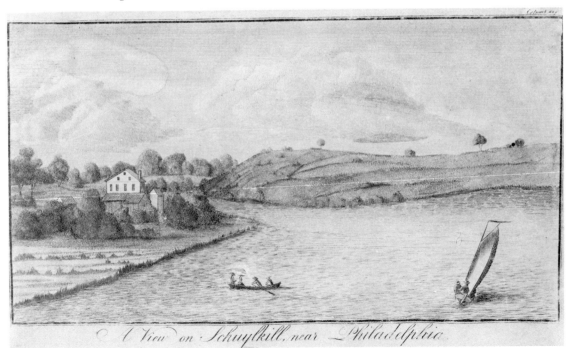

A View on Schuylkill, near Philadelphia

Fig. 78

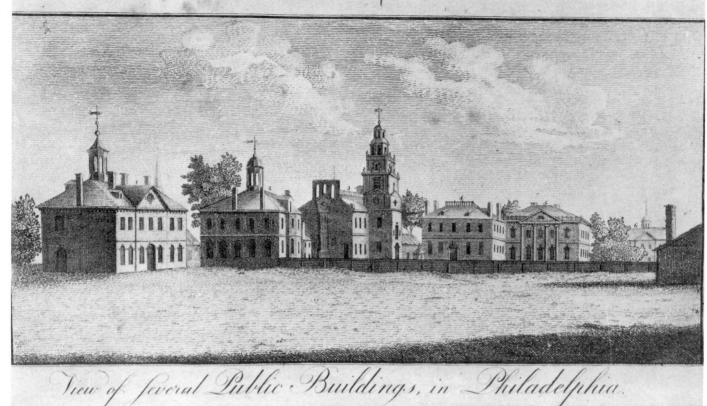

View of several Public Buildings, in Philadelphia.

Fig. 79

Fig. 80

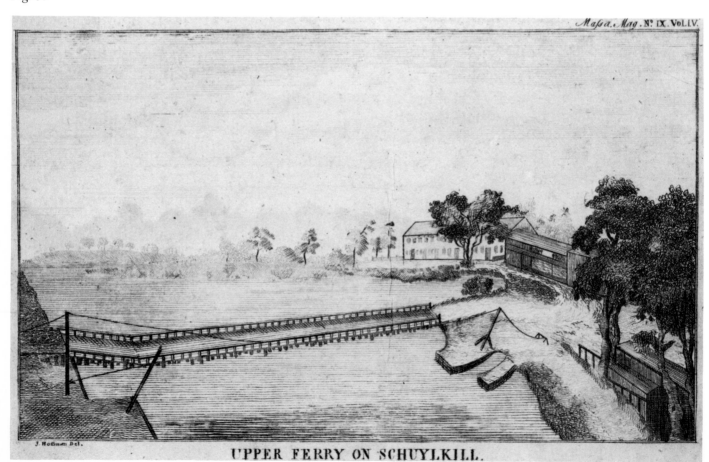

J. Hoffman Del.

UPPER FERRY ON SCHUYLKILL.

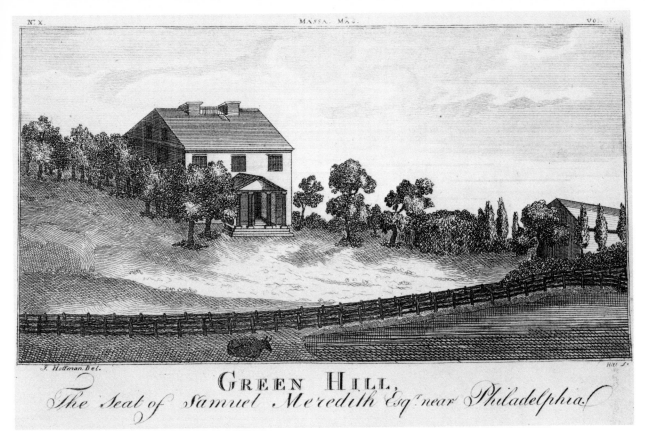

J. Hoffman. Del. Hill Sc.

GREEN HILL,
The Seat of Samuel Meredith Esqr near Philadelphia.

Fig. 81

(122) *Fig. 81.* Green Hill, The Seat of Samuel Meredith Esqr. near Philadelphia, by Jacob Hoffman. Engraving, probably by Samuel Hill, 3½ × 6¹¹⁄₁₆, issue of October 1792. Attribution: J. Hoffman. Del. Hill Sc No. X. Massa. Mag. Vol. IV. (This scene is said to be located on the east side of Ridge Avenue north of Poplar Street.)

Fig. 81

(123) *Fig. 82.* Pennsylvania Hospital, by Jacob Hoffman. Engraving, probably by Samuel Hill, 3⅝ × 6⅝, issue of December 1792. Attribution: J. Hoffman, del. Massa. Mag. No. XII. Vol. IV.

Fig. 82

Philadelphia Views from the New York Magazine

(124) *Fig. 83.* Bush-Hill, The Seat of William Hamilton Esqr. near Philadelphia, by Jacob Hoffman. Engraving, by Cornelius Tiebout, 3¼ × 5⅝ (oval), issue of February 1793. Attribution: J. Hoffman, Del. Philada. Tiebout, Sct. N. York Mag.

Fig. 83

(125) *Fig. 84.* A View of the Falls of Schuylkill, 5 miles from Philadelphia, by Jacob Hoffman. Engraving, by Cornelius Tiebout, 3¾ × 6⅜, issue of May 1793. Attribution: J. Hoffman del. C. Tiebout.

Fig. 84

(126) *Fig. 85.* Inside View of the New Theatre, Philadelphia, by J. Lewis. Engraving, by W. Ralph, 3¹³⁄₁₆ × 6⅝, issue of April 1794. Attribution: J. Lewis, Philadelphia pinxt. Ralph, sculp N. York.

Fig. 85

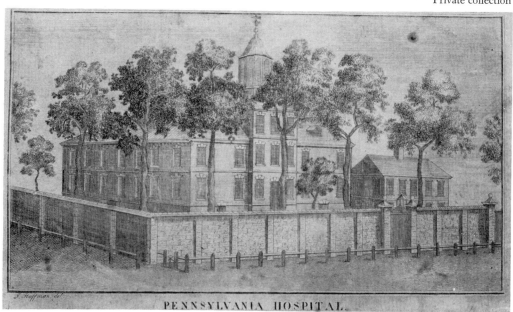

Fig. 82

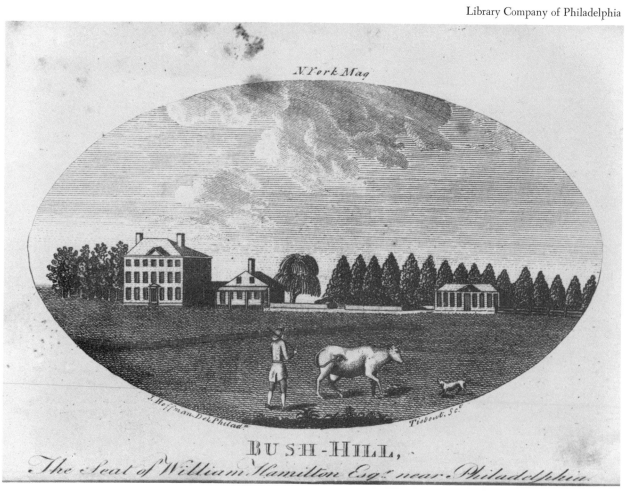

Fig. 83

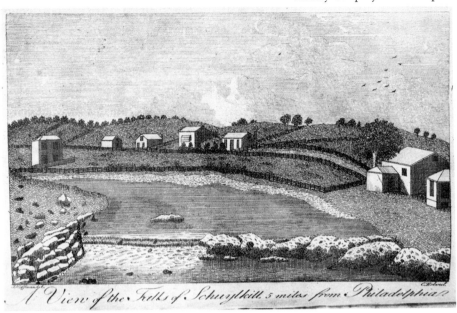

A View of the Falls of Schuylkill, 5 miles from Philadelphia.

Fig. 84

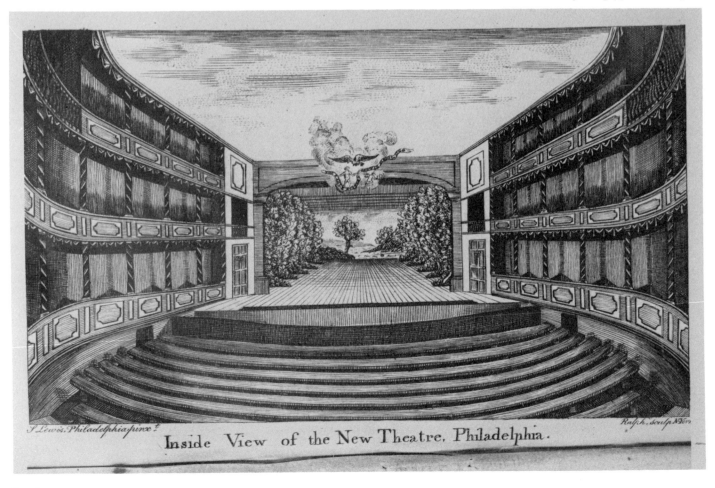

Inside View of the New Theatre, Philadelphia.

Fig. 85

Fig. 86

Fig. 86 (127) *Fig. 86.* A View near Philadelphia, by Jacob Hoffman. Engraving, by John Scoles, 3½ × 6 (oval), issue of August 1795. Attribution: Jacob Hoffman, del. I. Scoles sc. (Probably Springettsbury and Bush Hill in background. The scene is said to be looking northwest from Sixteenth and Spring Garden streets.)

Philadelphia Views from the Universal Magazine

Fig. 87 (128) *Fig. 87.* Bush Hill. The Seat of Wm. Hamilton Esqr. near Philadelphia, by James Peller Malcom. Engraving, by James Peller Malcom, 3 × 4¾, issue of December 1787. Attribution: James P. Malcom Del. et sc.

Fig. 88 (129) *Fig. 88.* Christ Church, Philadelphia, by James Peller Malcom. Engraving, by James Peller Malcom, 6 × 4¼, issue of July 1788. Attribution: J. P. Malcom del: et sculp.

LATER STATE

(129A) As above, but with addition at top center of "Lady's Magazine.—Supplement, 1814." Source: *Lady's Magazine* (London, 1814), p. 620.

Fig. 89 (130) *Fig. 89.* The Jail, Philada., by James Peller Malcom. Engraving, by James Peller Malcom, 3 × 5½, issue of July 1789. Attribution: Malcom delt. et sc.

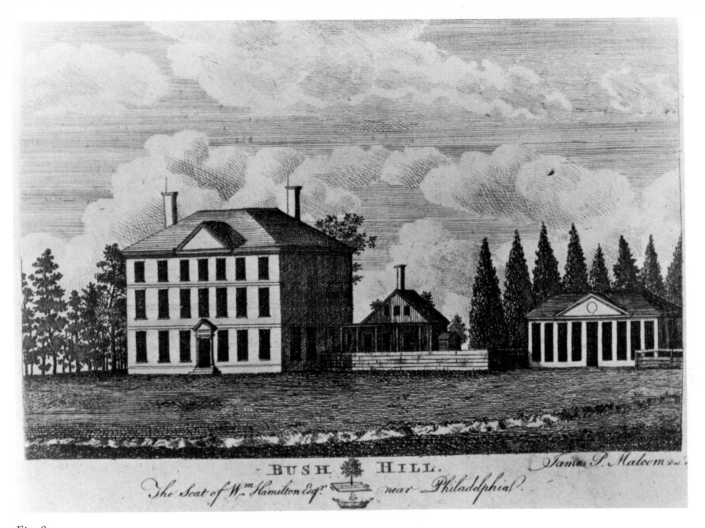

BUSH HILL.

The Seat of W^m Hamilton Esq^r near Philadelphia.

James P. Malcom del.

Fig. 87

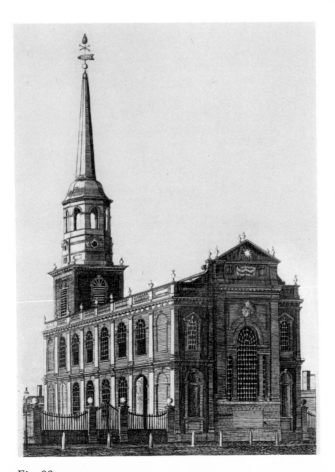

Fig. 88

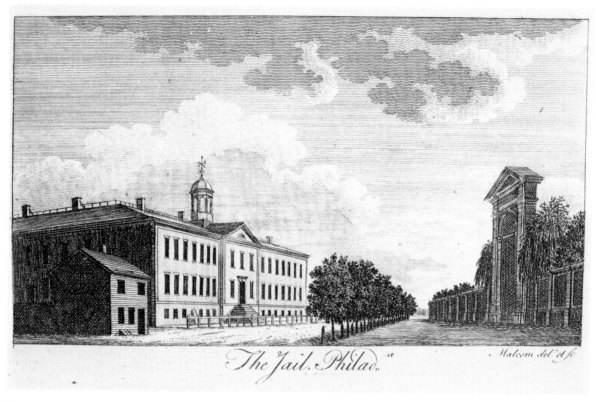

The Jail, Philad. ^a Malcom del. et sc

Fig. 89

The First Plans of South Philadelphia, 1788

P. Lee Phillips, of the Library of Congress, early expressed the opinion that John Hills, the British army mapmaker whose work was used by Faden in his engravings of the revolutionary war battles, was the same John Hills who published in 1796 as a Philadelphian the most complete eighteenth-century map of the city. Phillips's conclusion seems clearly correct, for the link is almost certain and is strengthened by two manuscript maps, unknown to Phillips, prepared by Hills in Philadelphia as early as 1788.

It will be recalled that during the Revolution and as a British officer Hills prepared maps of various parts of New Jersey. In 1784, a year after the peace, "J. Hills, Surveyor, Architector & Draftsman" undertook a general map of that state. At that time he had addresses both in Princeton and New York, but the latter was probably a remnant of an earlier residence. In a newspaper advertisement Hills said it would be "a favour if any gentleman travelling through Princeton will call on Mr. Hills, at the post-office, to point out any error that he may be liable to make in his map."

Three years later the Pennsylvania legislature ordered a survey of the area lying south of the city of Philadelphia and between its two rivers, so that it could be laid out for further development in an orderly way. A commission was appointed for the accomplishment of these aims. By 1788 John Hills was selected for the detailed work.

The legislature had declared that

> the District of Southwark has become populous and the freeholders thereof are daily erecting buildings and making improvements therein, but for want of a public and general regulation of the streets, lanes and alleys, they are irregularly placed and there is danger that in time they become a heap of confused buildings without order or design.

In response, Hills prepared for the commission a giant plan of Southwark in watercolor, designed to "prevent future irregularities in building" and as "a convenience in the improvement and division of estates." Old and proposed new streets were distinguished by colors. The district adjoined the city south along the Delaware; and the plan is of special interest in showing the actual low water line and a planned filling-in of the river at this early date to accommodate a new proposed street along it as fixed by the port wardens.

The governing statute also found it to be

> highly necessary that every town or part of a town should have a direct and convenient communication with the country in order to any easy exchange of the necessaries of life with each other and there is no road from the district of Southwark to the surrounding country but what is circuitous and inconvenient.

Fig. 90

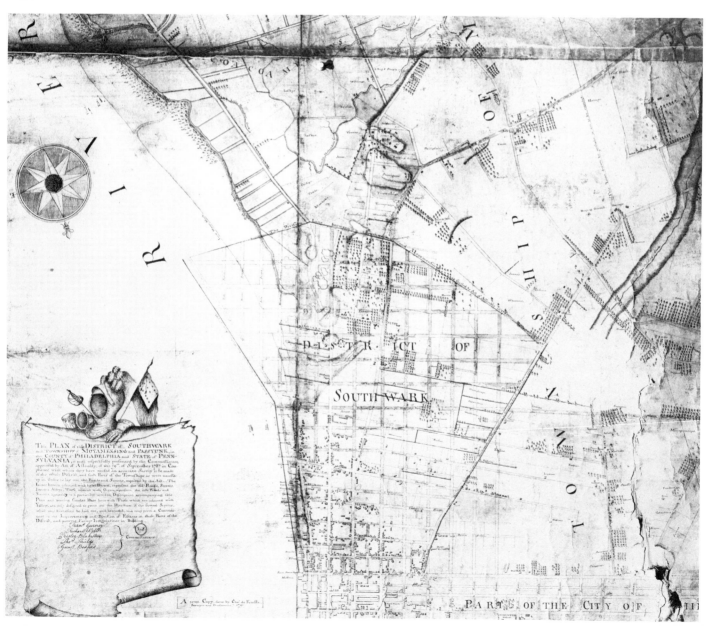

(Detail)

Hills's second plan covered the whole of the assigned area—the District of Southwark and the townships of Moyamensing and Passyunk—to show "the intended New Roads and Streets as laid out by the Commissioners."

Early in 1790 the commissioners filed their report "agreeably to the two plans herewith returned and presented and by us signed." It was accepted by the Supreme Executive Council except for one street.

It seems highly likely that from this exposure to Philadelphia Hills determined to make it his home. He was included as a surveyor and draftsman in the first census of the city, taken in 1790, and remained until his death more than twenty-five years later.

(131) A Plan of the Townships of Moyamensing and Passyunk the District of Southwark in the County of Philadelphia and in the State of Pennsylvania shewing the intended New Roads and Streets as laid out by the Commissioners appointed by the General Assembly in the Year 1787, by John Hills. Watercolor, 1788, 67½ × 73½. Attribution: Surveyed by John Hills 1788. Source: Philadelphia City Archives.

COPY

Fig. 90 (131a) *Fig. 90.* Charles de Krafft, watercolor, similar size, 1790.

(132) A Plan of the District of Southwark Situated in the County of Philadelphia in the State of Pennsylvania, by John Hills. Watercolor, 1788, 71¼ × 69. Attribution: 1788 Survey'd by John Hills. Source: Philadelphia City Archives.

COPY

(132a) Charles de Krafft, watercolor, similar size, 1790.

The Interior of Independence Hall, c. 1788–96

Opinion is divided as to whether the well-known picture *Congress Voting Independence* is the work of Robert Edge Pine or Edward Savage, or both. The oil painting appears to be the first consciously historical approach by an artist in America to one of its great political events. If Pine was involved, even only partially, then the painting dates clearly from the eighteenth century. Savage seems responsible for the unfinished engraving made from it, but neither painting nor print bears attribution or date.

Pine was a London painter of portraits and historical pictures, a "nerveless, dry and uninspired practitioner." Very soon after the American Revolution, in 1784, he crossed to Philadelphia with an idea that placed him in the vanguard, along with John Trumbull, in painting historical pictures of great events connected with the Revolution. He completed portraits from life of General Washington and other heroes, and in the view of some began the first historical painting showing the Continental Congress in the act of adopting the Declaration of Independence.

For a time Pine's studio was in Independence Hall. His pictures were still exhibited there in the congressional chamber at the end of 1794. The painter of the scene took great pains to copy the actual interior of the hall in which the historic action was taken. In fact, his is the only picture showing how it appeared at that time. When in

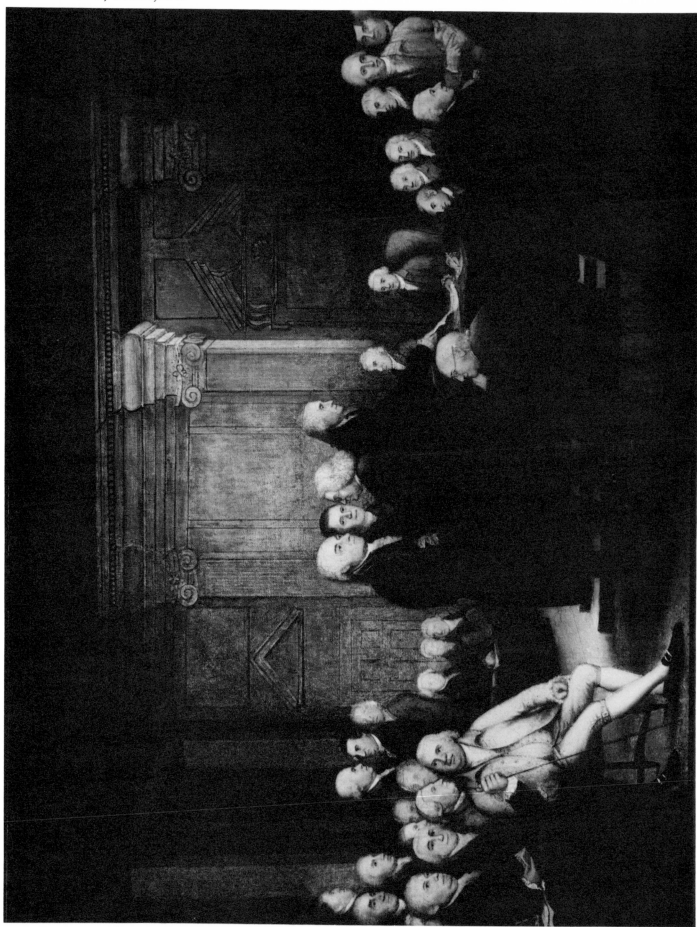

Fig. 91

the 1950's the government gathered together every picture showing any part of Independence Hall in its early years, the unique worth of this one record became apparent.

Earlier writers had it that the painting, left unfinished at Pine's death in 1788 in Philadelphia, was purchased by Savage, completed by him, and used as the original for the engraving commenced by Savage and in turn left unfinished by him at his death in 1817. Savage, a native of Massachusetts, commenced painting in Boston in about 1785, and after periods in New York and England, settled in Philadelphia seven years after Pine's death. George C. Groce and David H. Wallace find him occupied until 1801 with painting, engraving, and print selling, as well as operating a picture gallery and a museum—all in Philadelphia. In that year he moved to New York, "his interest in engraving having ceased." At that point he could well have laid aside his unfinished copperplate.

Against this background James M. Mulcahy, museum specialist with the National Park Service concerned with the restoration of the building, made a new investigation and concluded that the oil painting was in no part the work of Pine but only of Savage. His reasoning is supported by documentary and other evidence. He considers the picture "a source of prime importance" for the contemporary appearance of the Assembly Room, one which "presents as true a picture . . . as we are ever likely to find." But as to dates, he was able only to place the painting somewhere "during the period 1796–1817." If the work is Savage's however, it would seem likely that it was made before he left Philadelphia.

An article by Lee H. Nelson, written ten years after Mulcahy's treatise, assigns the *engraving* to the early 1800's. Most recently Martin Yoelson, historian of the National Park Service in Philadelphia, has reported that still further investigations have produced new evidence placing the date of the *painting* as not later than 1795, the year of Savage's arrival.

It is doubtful whether, in arguing authorship, enough attention has been paid to the portraits in the picture. The artist carefully portrayed Jefferson handing a draft of the Declaration to John Hancock, seated; John Adams and Roger Sherman, members of the drafting committee, behind Jefferson; Franklin (who died in 1790) seated in the central foreground; Charles Carroll of Carrollton seated behind Franklin; Robert Morris seated near a table at the left; and Francis Hopkinson (who died in 1791) writing at Hancock's table. Comparison of this material with the known portraits of the same persons by Pine, Savage, and others may yield helpful clues. Pine, rather than Savage, seems to have busied himself with portraits of a fairly wide range of persons who had been active in the Revolutionary effort. Large portions of Savage's time must have perforce been devoted to his panorama showing London and Westminster—the first such large painting without visible beginning or end to be shown in the United States—exhibited as early as 1795 in a special building erected for the purpose.

It is not necessary here to cast a vote. The simple fact that the painting is likely of the eighteenth century is of the highest significance in considering the early consciousness of the historical importance of the event. It is regrettable that the straightforward documentary atmosphere of the work, which itself assists in a general dating of it, was not favored by Trumbull and others, who presented more self-conscious and grandiose, if more romantic, impressions of Revolutionary scenes.

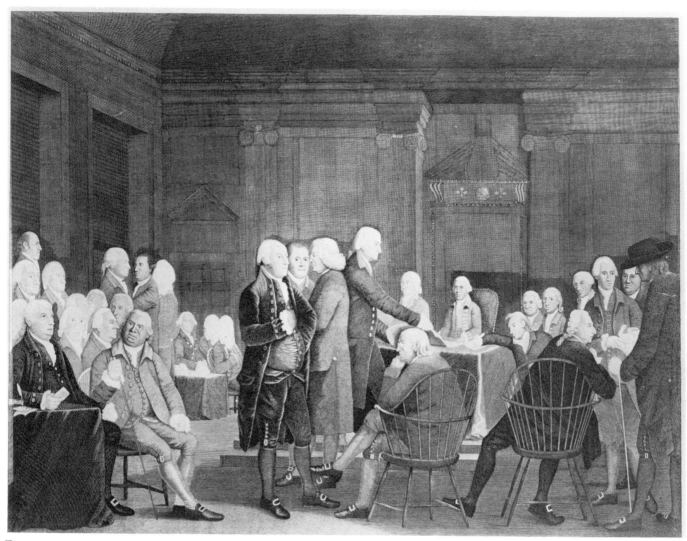

Fig. 92

(133) *Fig. 91.* (Congress Voting Independence), by Robert Edge Pine and/or Edward Savage. Oil on canvas, c. 1788–95, 19¾ × 26½. Source: Historical Society of Pennsylvania.

Fig. 91

REPRINT

(133a) *Fig. 92.* Unfinished engraving, untitled and without attribution, 18⅞ × 25⅝, follows the above but probably dates from post-1800. The plate is at the Massachusetts Historical Society.

Fig. 92

Italian Version of Reed's City Map, 1790

The pleasant custom of European travelers taking local maps and views home for republication in their travel books seems to have commenced, so far as Philadelphia is concerned, with Count Luigi Castiglioni's visit in 1785. His introduction to Franklin a year earlier was probably a factor in his plans to examine the American coast in depth.

Castiglioni spent two years observing American cities and society as a traveler and studying the flora and fauna scientifically. A Milanese, his accomplishments as a botanist led to his election in 1786 as a member of the American Philosophical Society. In turn both Franklin and Benjamin Rush, whom Castiglioni met during a stay of some length in Philadelphia, were elected to the Italian Societa Patriottica, based in Castiglioni's native city and instituted by Maria Theresa.

Knowing that his travels and pioneer work in plant geography would be published at home, Castiglioni was on the lookout for material to illustrate the book. His effort to find the latest map current in Philadelphia led to that of John Reed issued in 1774. The book appeared in 1790 and contained a republication of the city portion of the very large Reed original, as engraved by one Benedetto Bordiga. Untitled, the map faithfully reproduced the area Reed had shown as built upon, and included a key of ten points of interest numbered on the map itself but described only on the facing printed page. Since Reed had not identified buildings or streets, the republication made no effort to do so. Using names assigned by Reed, the keyed items were limited to the rivers, public squares, and areas outside the city itself. The result, factual and without artistic embellishment, appears to be the only map of the city published between the Revolution and 1794.

Fig. 93

(134) *Fig. 93.* (La Cita di Filadelfia), after John Reed and James Smither. Engraving, by Benedetto Bordiga, 1790, 7 × 9¼. Attribution: Benedetto Bordiga. inc Tom. 2. pag. 29 Tav. IX. Source: Luigi Castiglioni, *Viaggio negli Stati Uniti dell'America Settentrionale fatto negli anni 1785, 1786, e 1787 da Luigi Castiglioni* (Milan, 1790), vol. 2, opp. p. 29.

Fig. 93

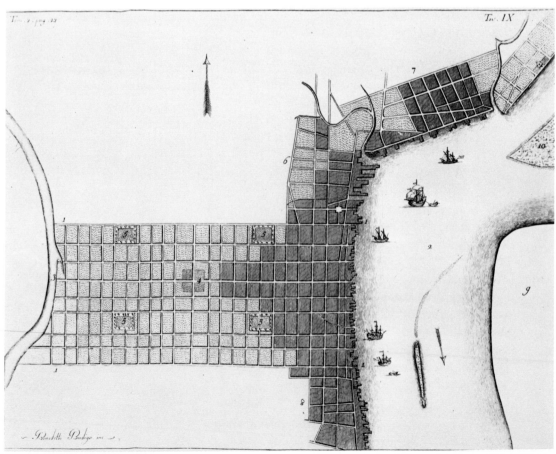

1790–1800

7
The Flowering of Prints

THE SELECTION of Philadelphia as the national capital for the ten years from 1790 through 1800 helped to increase the urban-area population by an estimated fifty percent to more than 80,000 in these years alone. The Statehouse complex became the focal point of national government. Franklin died, but Washington was in residence. More governmental buildings sprang up. Culture joined goverment in physical partnership on Independence Square with the erection of a new headquarters for the American Philosophical Society. New commercial structures, churches, and fine homes sprouted in profusion. The neoclassical style of architecture was introduced and adapted even to a new water-pumping station. The city became known as the "Athens of America."

Visitors were everywhere. Guidebooks were published for their assistance. A bustle of accomplishment was in the air. Some of the rawness and confusion that accompanies an era of building was visible. Large new maps were issued locating two theaters, three banks, a new library building, ropewalks, brickyards, most extensive wharves and docks, taverns, and no less than twenty-one churches.

In this welter of activity and growth, what Joseph Jackson has called "the alluring presence of art" was quite manifest. The most impressive pictorial record of the city as the capital and microcosm of the new nation was produced by William Birch and his son Thomas, arrivals from England in 1794. They were so enthusiastic as to undertake to cut twenty-eight engravings in a systematic geographical coverage of Philadelphia. Withal, a sense of history of the area was spreading ever wider. At the end of the century the artist Matthew Pratt was drawing admiring crowds to view his new sign board, "The Convention of 1787," painted for a tavern at Fourth and Chestnut streets.

Quieter local scenes were also being sketched in increasing number. American landscape painting had broken away from its formalized, traditional approach. Artists like Charles Willson Peale and Jeremiah Paul, James Peller Malcom, and many others drew landscapes as they actually saw them. Beginning with the beautiful large landscape print by John Joseph Holland of Philadelphia as seen

from across the Schuylkill River, formal city views appeared even before the Birches began their series of plates, the first dated 1798.

Variety was now the keynote in local views. They reappeared as book illustrations and in the form of political cartoons. The first of decades of disaster prints was published after a fire destroyed the Lutheran church at Christmastide. After the end of the earlier magazines, a new one ran for a time in 1798 and by including two views of the city kept the way open for the nineteenth-century *Portfolio Magazine*. The Schuylkill retained its great popularity with artists, even as a portrait background. An American traveler drew pen sketches of local scenes, while a British visitor's book, published in England, utilized the Statehouse to add interest to his text. City-life, landscape, and architectural artists, with map designers, were recording the fulfillment of a prophecy made by de Chastellux some twenty-five years earlier, when during the conflict with the mother country he wrote:

> This revolution comes very opportunely, at a time when the public has derived every benefit from [the Quakers] they could expect; the walls of the house are finished—it is time to call in the cabinetmakers and upholsterers.*

A Series of Nine Watercolors by James Peller Malcom, 1792

One of the most important groups of Philadelphia views drawn after the city became the national capital is also apparently the earliest of this final period: nine watercolors by James Peller Malcom.

Malcom's movements have already been traced until his departure for England, probably in 1789 at the age of twenty-two, as the protégé of Rev. Jacob Duché, Thomas Willing, and other Philadelphians. By his own account he then spent three years studying landscape and historical painting at the Royal Academy, where he exhibited in 1791. The key to this series of Philadelphia watercolors lies in the statement in 1834 by William Dunlap that Malcom is believed to have returned to Philadelphia about 1792–93.

No definite record of his return has been located, but the watercolors appear to have been made at that time. The reference to Malcom's visit is based upon knowledge by Alexander Lawson, a Philadelphia artist, of engravings Malcom then executed. Lawson found them "scratchy and poor, but indicating talent." Lawson refers to one of them as an interior view of Christ Church, and photographs of such a view attributed to Malcom are extant. It seems it was never published or sold, however.

It is likely that Malcom returned not only to settle matters of family property but to test the ground for opportunities as an artist at the new capital. If so, his instinct was sound. Indeed, he was just a few years ahead of the influx of British artists including William and Thomas Birch, William Groombridge, John James Barralet, and George

* Howard C. Rice, Jr., ed., *Travels in North America . . . by the Marquis de Chastellux* (Chapel Hill, N.C., 1963), 1:130.

Isham Parkyns. Nevertheless, he appears not to have found the opportunity he sought for financial security from his painting. He soon departed finally for England, where he delved deeply into local history, until his death in 1815, with sufficient reputation to merit a biographical account in the *Gentleman's Magazine*.

Assuming Malcom's watercolors were all drawn at the same time—and this is the logical conclusion from the paper he used and from their size—internal evidence shows they could not have antedated 1792. He probably hoped to sell several of the scenes as engravings for American or British magazines, since three such scenes had already been published in London. The new work is all of the proper size for such use, approximately four by seven inches.

The drawings are strong and clear, the colors pleasing. There is much freedom in the choice of subjects and much innovative spirit. Landscape mingles easily with buildings when appropriate, and at other times is separately, and always realistically, presented. The result surpasses the watercolor sketches of several others made later in the same decade.

Most numerous are the landscapes. They include the Falls of the Schuylkill as seen from upriver; the Wissahickon Creek, apparently at its confluence with the Schuylkill River; a most interesting view from the British redoubt of 1777 atop Fairmount; and a prospect of the Schuylkill with the towers of the city beyond it, as seen from the road atop the hill sloping down from the west to Gray's Ferry.

The series contains three pictures of country seats. One depicts Beveridge, overlooking the Schuylkill opposite and just above today's Museum of Art. William Birch's family shared this house for a summer in the 1790's with that of Mr. Jaudennes, the Spanish minister to the United States. Another is a delightful picture of The Woodlands as seen from the nearby bridge at Gray's Ferry. The last may be the only eighteenth-century view of Lansdowne, overlooking the Schuylkill in what is now West Fairmount Park. The imposing Italianate house was built about 1773 on some two hundred acres by John Penn, grandson of William; owned after his death by Senator William Bingham; burned slightly by an accidental fire on the Fourth of July 1854; and torn down by the city shortly thereafter when acquired for Fairmount Park (although it is said a few hundred dollars would have restored it completely).

Two fine cityscapes round out Malcom's series as now known. One of these depicts the area of the almshouse of 1767. The other shows Independence Hall with the 1775 jail in the background and is noteworthy for including on the Chestnut Street lawn of the Statehouse a small ship, which could not have been placed there earlier than the summer of 1788. This was an actual ship refurbished to serve as one of the floats in the Federal Procession of that Fourth of July, as witness the report written by Francis Hopkinson as it describes the 32d item in the grand parade:

> The Federal Ship "Union," mounting twenty guns. . . . The crew, including officers, consisted of twenty-five men. The ship "Union" is thirty-three feet in length; her width and depth in due proportion. Her bottom is the barge of the ship "Alliance," and the same barge which formerly belonged to the "Serapis," and was taken in the memorable engagement of Capt. Paul Jones of the "Bon Homme Richard" with the "Serapis."

> The "Union" is a masterpiece of elegant workmanship, perfectly proportioned and complete throughout, decorated with emblematical carving, and finished even to a stroke of the painter's brush. And what is truly astonishing, she was

begun and completed in less than four days. . . . The workmanship and appearance of this beautiful object commanded universal admiration and applause, and did high honor to the artists of Philadelphia who were concerned in her construction.*

Hopkinson further says that the ship was "moored" at Bush Hill, the terminus of the parade, in the center of a very large circle of tables covered with awnings, where an outdoor banquet was served and a speech given. Scharf and Westcott add that "after the procession this little ship was placed in the State-House yard, from whence it was subsequently removed to Gray's Ferry."

Although the appearance of the "Union" in Malcom's scene places it not earlier than 1788, the proof of 1792 as the date for the series comes from another circumstance. In the foreground of the view from Fairmount appears the Delaware-Schuylkill Canal. A company was formed in 1792 to create it, and it was in that year that it was dug across the northern section of the city, skirting Fairmount. Construction was stopped for lack of funds and the project was never completed; but it extended some distance up the Schuylkill as appears from the John Hills and Peter C. Varlé maps of 1796 and William Birch's drawing of Fountain Green in 1808.

Fig. 94 and Colorplate 6	(135) *Fig. 94 and Colorplate 6.* View of Philada. from the Hill above Gray's Ferry, by James Peller Malcom. Watercolor, c. 1792, 3½ × 6¼. Attribution: Drawn at the spot by J. P. Malcom. (Apparently titled in Malcom's hand.)
Fig. 95 and Colorplate 7	(136) *Fig. 95 and Colorplate 7.* Woodlands the Seat of W. Hamilton Esqr from the Bridge at Grays Ferry, by James Peller Malcom. Watercolor, c. 1792, 3⅞ × 6⅜. Attribution: Drawn on the spot by J. P. Malcom. (Apparently titled in Malcom's hand.)
Fig. 96 and Colorplate 8	(137) *Fig. 96 and Colorplate 8.* Falls of Schuylkill, by James Peller Malcom. Watercolor, c. 1792, 4¼ × 6¾.
Fig. 97	(138) *Fig. 97.* Beveridge, by James Peller Malcom. Watercolor, c. 1792, 4 × 6⅜.
Fig. 98	(139) *Fig. 98.* Wissahickon, by James Peller Malcom. Watercolor, c. 1792, 4 × 7.
Fig. 99	(140) *Fig. 99.* Lansdowne Mansion, by James Peller Malcom. Watercolor, c. 1792, 4 × 6⅞.
Fig. 100	(141) *Fig. 100.* Alms House Philada., by James Peller Malcom. Watercolor, c. 1792, 3⅛ × 6¼.
Fig. 101 and Colorplate 9	(142) *Fig. 101 and Colorplate 9.* from the Works thrown up by the British Army in 1777 near the Middle Ferry on Schuylkill, by James Peller Malcom. Watercolor, c. 1792, 4 × 6⅝.
Fig. 102 and Colorplate 10	(143) *Fig. 102 and Colorplate 10.* (Statehouse and Congress Hall), by James Peller Malcom. Watercolor, c. 1792, 3⅞ × 6⅞.

* J. Thomas Scharf and Thompson Westcott, *History of Philadelphia* (Philadelphia, 1884), 1:449.

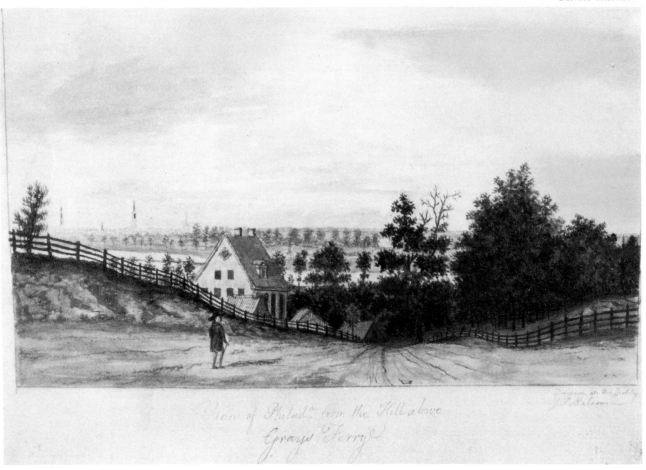

View of Philad.ª from the Hill above Grays Ferry

Fig. 94

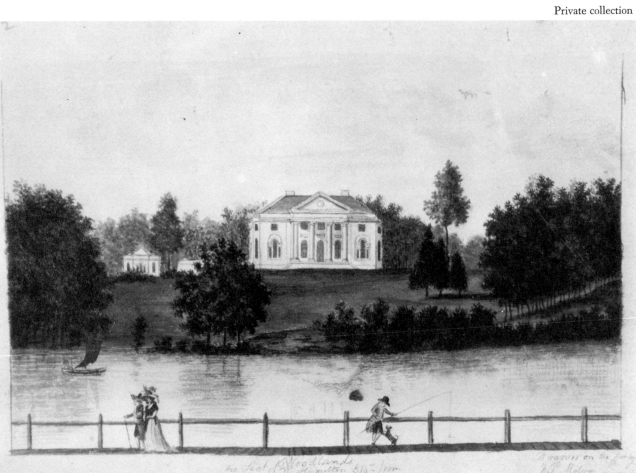

the Seat of W.ᵐ Hamilton 6½ᵗʰ from the Bridge at Grays Ferry

Fig. 95

Fig. 96

Fig. 97

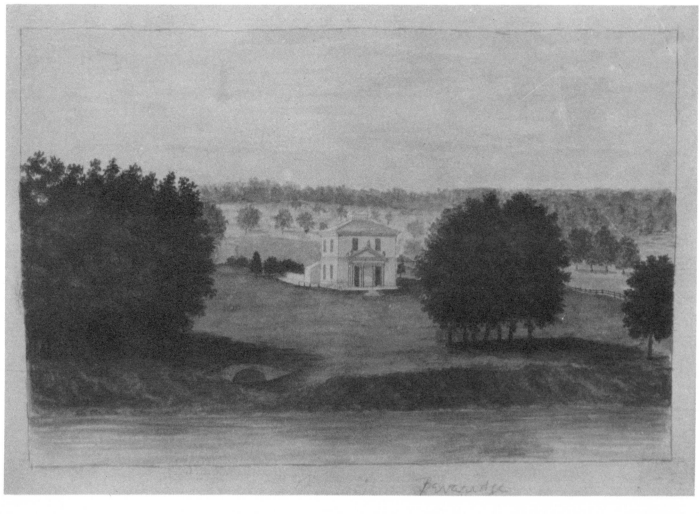

Fig. 98
Fig. 99

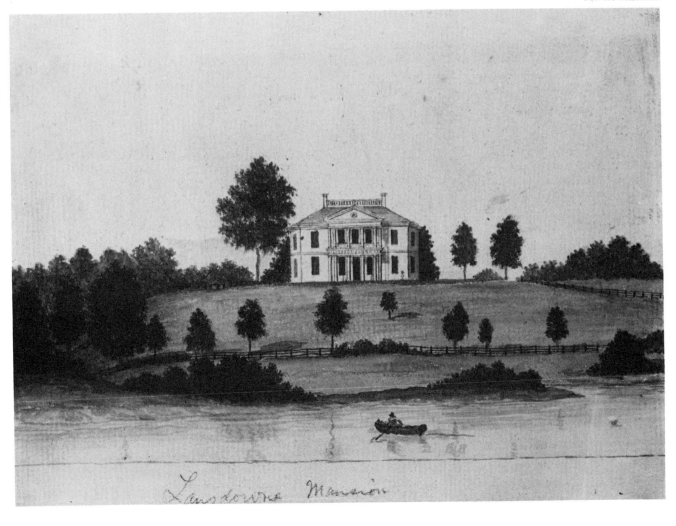

Lansdowne Mansion

Fig. 100

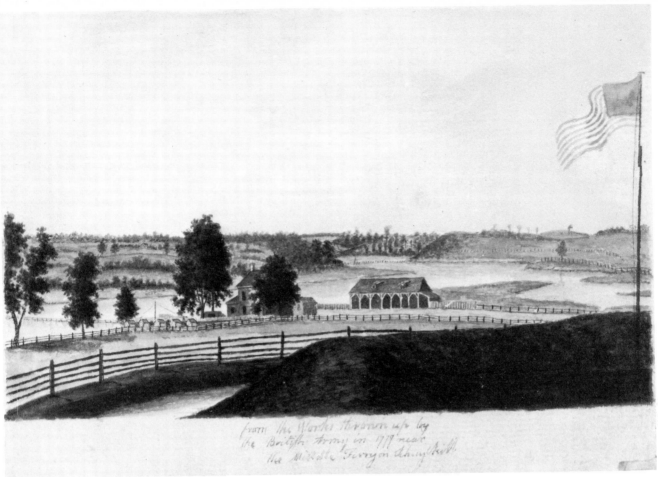

from the Works thrown up by
the British army in 1779 near
the Middle Ferry on Schuylkill

Fig. 101

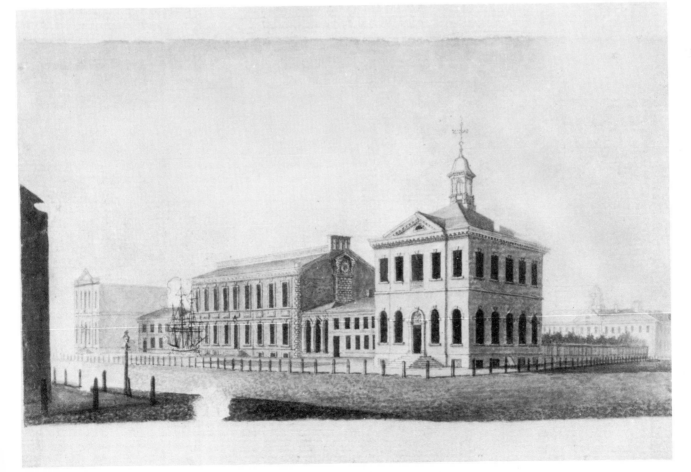

Fig. 102

(144) (145) (146) All the foregoing are in private ownership, plus three unfinished watercolors, of similar size, titled in other hands: Morris House Germantown, Mansion of Col. Gurney, and View in Woodlands.

(147) For the engraving of the interior of Christ Church said to be Malcom's work, but showing no title or attribution, see David McNeely Stauffer, *Westcott's History of Philadelphia* (extended to 32 volumes), presented to the Historical Society of Pennsylvania (Philadelphia, 1913), 30:2351 and illustration; *idem, American Engravers Upon Copper and Steel* (New York, 1907), vol. 2, no. 2169.

The First Formal Schuylkill River Landscape, 1793

According to the secondary sources William Groombridge came from England to Philadelphia in 1794, already an experienced landscape artist. But the Santa Barbara Museum of Art has his painting *The Woodlands* signed and dated 1793, and there is other evidence verifying his arrival in that year. Even this date seems to give him the distinction of being the first artist to prepare a formal oil painting of a scene along the Schuylkill River.

Like his contemporary William Birch, Groombridge kept to the kind of work he had done in England. He had studied under James Lambert of Sussex and had exhibited more than fifty landscapes, portraits, and miniatures in London. Surely he felt prepared to make a reputation in the new United States. He was active in his profession; in 1795 he was one of the founders of the first organization of professional artists in the country, the Columbianum, which is said to have met regularly in his home.

Groombridge's choice of The Woodlands as an early local subject was faultless. The property stood on a fine site over a sharp bend in the river and looked south for a long distance along its shores. The house stood in full sight of Gray's Ferry Bridge, making it one of the first imposing monuments telling the many visitors to Philadelphia arriving from that quarter that they were approaching the country's capital and largest city. Built in the 1740's, the structure had recently been enlarged or rebuilt consistently with its owner's style of living. It housed his large collection of paintings. Extensive gardens set out a famous assemblage of exotic plants, for William Hamilton introduced both the Lombardy poplar and the ginkgo to North America. His grandfather Andrew had designed the Statehouse and had won fame for his defense of New York printer Peter Zenger, who had been accused of seditious libel. William's father James had served as lieutenant governor of the colony and mayor of Philadelphia. William, the present owner, was a man of taste and leisure whose estate and collections had been his great pursuits. William Birch's inquiring eye found more to say about this one property than any other he included in his picture book *Country Seats of the United States* in 1808, when the place remained unchanged from fifteen years earlier:

> This noble demesne has long been the pride of Pennsylvania. The beauties of nature and the rarities of art, not more than the hospitality of the owner, attract to it many visitors. It is charmingly situated on the winding Schuylkill, and commands one of the most superb water scenes that can be imagined. The ground is laid out in good taste. There are here a hot house and green house containing

a collection in the horticultural department, unequalled perhaps in the United States. Paintings &c. of the first master embellish the interior of the house, and do credit to Mr. Wm. Hamilton, as a man of refined taste.

Groombridge's painting was executed in a splendid large size, perhaps with the hope, or possibly the encouragement, that it would become a part of the Hamilton collection. Nothing indicates, however, that Hamilton ever became interested in the work of this artist. Groombridge's work never achieved sufficient popularity or interest in Philadelphia to support himself and his wife. It was probably her operating a girls' school from 1794 to 1804 that met that need. In the latter year the couple moved to Baltimore, where the pattern was repeated with a similar school. Only there, as will be seen subsequently, did the artist find a champion of his work.

(148) *Fig. 103.* (The Woodlands), by William Groombridge. Oil on canvas, 1793, 45⅝ × 58⅛. Attribution: W. Groombridge Pinxit, 1793. Source: Santa Barbara Museum of Art.

Fig. 103

Fig. 103

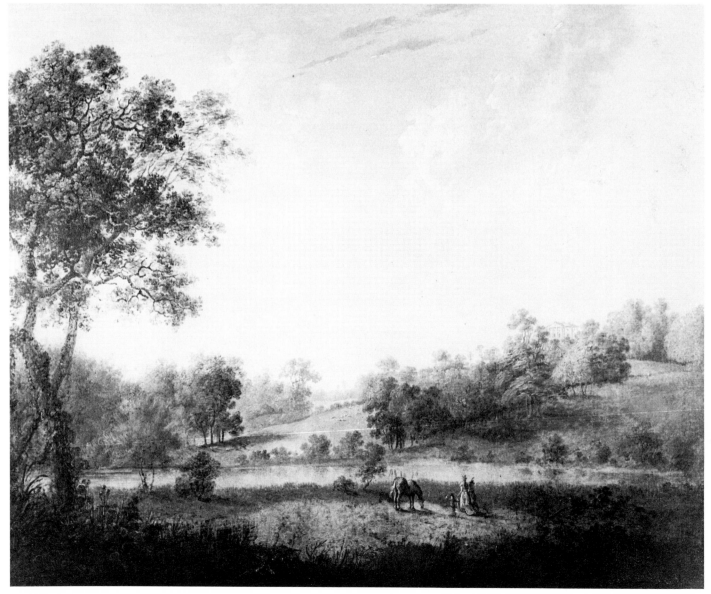

The Statehouse and Its Flanking Buildings, 1792

We are indebted to the German-language almanacs not only for an American print reproducing Scull and Heap's *East Prospect,* but also for apparently the earliest picture of the Statehouse flanked by the City Hall building to the east (about 1791), used by the United States Supreme Court, and Congress Hall to the west (about 1789), used by both houses of Congress—the focal point of the government of the United States. These latter structures had long been anticipated: Committees to secure funds for their erection had been appointed as early as 1775, with local government uses in mind.

The almanac cover cut was prepared in 1792 for Samuel Saur, grandson of the first Christopher, whose *High-German-American Calender* had first appeared for 1739. Samuel's almanac, which he published with a Chestnut Hill imprint (some ten miles from Philadelphia), was the *New High-German-American Calender.* He continued to use the Statehouse cover even after he moved to Baltimore, where he published the edition for 1802.

In the traditional fashion, the street scene stands in the lower half of the woodcut, while the upper half is given over to the full sun, partial moon, and in this case a figure of Fortune standing upon the winged globe. The delineation of only a few buildings at close range, as opposed to the earlier waterfront almanac cover, enabled the artist to employ much fine detail and achieve a result of much better quality. He not only introduces figures but outlines the rigging of ships a half mile or more away. With care he shows the low wooden cap that had replaced the rotted tower of the Statehouse.

As had been done when the waterfront cover first appeared, Saur gave the inside front cover over to an explanation of the print, whose buildings were labeled for identification.

This cover cut can readily be attributed to Justus Fox, already mentioned as employed by the Saurs. After the death of the second Christopher Saur in 1784, the Saur almanac was sold to Michael Billmeyer of Germantown and the type foundry to Samuel. Fox continued to be active until his death in 1805 and must have remained close to the Saur family. For Samuel's *New High-German-American Calender,* Fox would be not only the most skilled artist, but the natural choice. Frederick Reiche, another German wood engraver, can probably be eliminated as the artist, as he was first listed in the Philadelphia directory in 1794.

It is noteworthy that the Statehouse scene appears to have broken new ground pictorially, for the waterfront almanac cover had simply been copied from earlier work. Not until 1804, for the second edition of his *Philadelphia Views,* did William Birch make use of a similar scene in substitution for his earlier approach to the Chestnut Street façade of the Statehouse.

Fig. 104

(149) *Fig. 104.* (Statehouse and Flanking Buildings), attributed to Justus Fox. Wood engraving, 1792, 6¾ × 5½. Source: Samuel Saur, *Der Neue Hoch Deutsche Americanische Calender, Auf das Jahr Christi,* 1793 (Chestnut Hill, Pa., 1793), and subsequent years.

Viel leichter ist das Glük zu finden,
Als zu behalten und zu binden.

Samuel Saur's Calender auf das Jahr 1793.

Fig. 104

Two New Maps of the National Capital, 1794

Visitors to the national capital in 1794 were able to secure the first new maps of the
city to be published since revolutionary war days for use at home. There was by now
so much new growth to plot and identify that the twenty-three keyed references on
the Clarkson-Biddle map of 1762 grew to thirty-seven in the smaller of the new issues
and sixty-four in the larger.

The smaller map was a delayed publication, projected in 1793 but published a year

later by a penurious local bookseller and author. James Hardie arrived in Philadelphia from New York in 1792. Along with writing, proofreading, statistics, and sales he found time a year later to publish one of the city's earliest directories. In the preface he noted that:

> It was the intention of the Editor to have illustrated this Directory with a plan of the city; but as it was not possible to get a plate engraved so early as was necessary, it is in this edition unavoidably omitted. There is however annexed a particular list of the situations of the streets, lanes, and alleys, of the places appropriated to public worship, of public offices, &c. which it is expected will nearly answer the same purpose.

Not only did the volume include brief "Information concerning the City of Philadelphia" and lists of streets and residents, but also seventy pages comprising a "Register" describing important governmental, business, cultural and charitable organizations, and places of amusement.

In 1794 Hardie's map was published with textual material similar to the Register. The two were placed in a separate pamphlet, *A Short Account of the City of Philadelphia and of the different Charitable and Literary Institutions therein.* The pamphlet condensed much of the 1793 Register text into forty pages—ten of them general in scope and the remainder taken from the earlier presentation of particular subjects. The title page stated that it was "Embellished with a Correct Plan of the City." In this form it was distributed before Hardie's 1794 directory was published. When the latter finally appeared, both the map and *A Short Account* formed a part of it.

A respected figure in the publishing business for whom Hardie performed various services was Matthew Carey. A few of Hardie's letters to him are extant and shed light on the delayed publication of the 1794 directory. On 19 August Hardie wrote Carey:

> I would have called on you before now, but found it absolutely necessary to be indefatigably busy with respect to the Directory, which is now brought near a close.

Even on 8 November publication was in the future:

> The Directory is now in so great forwardness, that provided I can be supplied with paper, it will be finished on Tuesday next—The want of paper is owing to the want of money. Twenty dollars would effectually compleat the business. If you, Sir, would be so obliging as to accomodate me with that sum, I shall return it on Thursday with thanks I am—

But by 29 December the day of publication had passed:

> The bearer will deliver you 20 Directories; the retail price. 62½ Cents
> 12 Pamphlets 37 ½ Do &
> 12 Plans 19 Do. . .
> The reason I have not sent you more Directories is owing to the Binder (no more being ready at present).

Versatile as Hardie was, he must have retained a surveyor to draw the map and an

engraver to reproduce it. Their names remain unknown. It would appear that the center-city portion of the old John Reed map furnished a prototype for the new one, which showed some extension of the developed part of the city and contained many new identifications. At Hardie's price the map could not attain to elegance, and its intended use limited its size. It was fourteen inches wide and had to be folded into the separate booklet and into the directory. Hard wear rather than framing and display was anticipated. The map lacked even Hardie's name, being captioned only *Plan of the City of Philadelphia.*

By the summer of 1795 Hardie had sold out and moved to Princeton, New Jersey, after pawning a cream jug which he informed Carey "my wife values highly." Within another year he was back in New York, where he remained active for many more years.

Thomas Stephens must have bought what Hardie could leave behind in his trade. Stephens issued the Philadelphia directory for 1796 and included the 1794 engraved map, now titled *Stephens Plan,* by which name it has become known. In his directory Stephens described himself as a wholesale and retail bookseller who also offered "elegant Prints, Paintings, and every article in the Stationery business."

In addition to adding his own name to the map, Stephens included decorations around the expanded title. As early as 18 January 1796 he advertised his directory as published at three-fourths of a dollar, "With a Plan of the City." No Stephens edition

Fig. 105

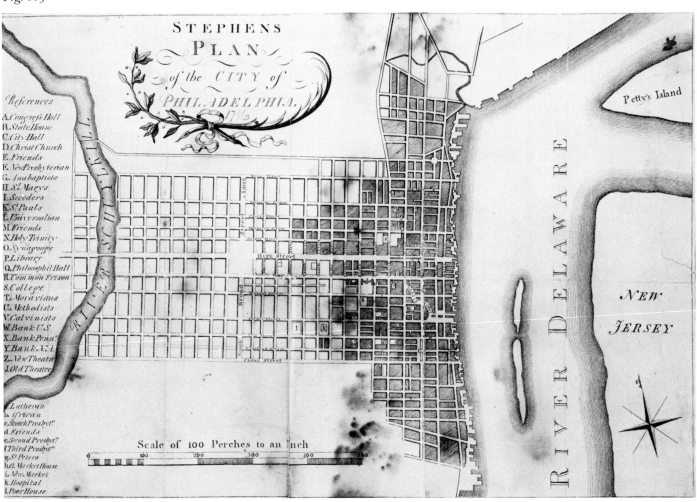

appeared for 1797: On 1 February of that year he offered for sale his complete stock of prints, books, and other merchandise.

So ended the copperplate, but not the map. In publishing *The Philadelphia Directory for 1797*, Cornelius W. Stafford had the map renewed through an almost identical plate cut by Joseph Bowes, an architect and engineer who had arrived in the city in 1794 and who was to engrave at least one other Philadelphia view in 1798. Naturally the title "Stephens" was omitted; but the more important distinguishing feature of the replacement map is its identification of the new United States Bank under construction in 1797 on South Third Street, whereas the earlier plate had located it in Carpenters' Hall. Except for a few other minor differences Bowes's work was a pirating performance, although it remains possible that he had also engraved the map of 1794.

In contrast to Hardie's publication, the larger of the 1794 maps was an exceptionally well-advertised publication of much formality. A. P. Folie, a French geographer from Santo Domingo, had published in 1792 in Philadelphia a large map of Baltimore, engraved from his own surveys by a Philadelphia friend from Martinique, James Poupard. Folie commenced similar new surveys of the capital city and sought a publishing affiliation for another map he contemplated; while Benjamin Davies, a local bookseller, had the idea, similar to Hardie's, of a guide-history for the multitude of visitors now arriving. Folie and Davies combined their talents and the map was issued with a booklet entitled "Some Account of the City of Philadelphia."

Plans for the combined effort became final by early 1794. Davies, like Hardie, referred to his booklet as a "pamphlet"; but Joseph Jackson (either unaware of Hardie or ignoring him) saw it in the 1930's as "by far the best account that had been published up to that time [which] might be regarded as the forerunner of the long line of guide books to the city." The map was to be engraved on a plate twenty-six inches square by Robert Scot, already mentioned, and Samuel Allardice, who was either still his pupil or already his partner.

More details unfolded through a lavish series of advertisements in the *U.S. Gazette* beginning 28 February. The map was to contain all manner of details and to be "ornamented by a view of the shipping in the harbor, and an elevation of Congress-Hall, and of the other public buildings that occupy the ground contiguous."

> In short, nothing will be omitted to render this useful and desirable work accesible to an enlightened public, that is in the author's power; and it shall be completed with the greatest possible dispatch, as soon as the generous encouragement of subscribers shall insure to the author such a sum as will be sufficient to defray expenses.
>
> A Pamphlet will be delivered with each Plan, which will contain an alphabetical list of the Subscribers names, and information concerning the police, population, and present state of the city.
>
> The price to subscribers will be Two dollars and one third, to be paid at the time of delivering the Plans.

This announcement appeared in many subsequent issues during March and April, until on 14 April Davies was able to announce:

It is with pleasure that the publisher has to inform his subscribers and the public in general, that the plate is now under the hands of the engraver, and in greater forwarding than was at first contemplated. At the same time he begs leave to remind them, that subscription papers are still open at most of the noted book-stores in the city.

After that notice had appeared in nearly a hundred issues, Davies reported in the press on 14 October and regularly thereafter:

This MAP . . . will be delivered as may best suit the purchasers, either in sheets plain or coloured, or canvassed and affixed to rollers; or to fit them for the pocket, they will be cut and folded in cases.

Those who have been so obliging, as to receive Subscriptions for this Plan, are requested to forward the names to the Editor at No. 68, in Market-Street, as above directed; as he intends to close the list in a short time, and to send it to the Press, to be inserted in the front of the Pamphlet which will be delivered with the Plan.

On 11 November both map and pamphlet were ready for delivery:

JUST PUBLISHED,
And to be sold by
Benjamin Davies,
No. 68, Market street.
A Ground Plan
of the
City and Suburbs
of
Philadelphia.
Taken from late and accurate survey.

. . .

With each plan will be given a Small
Pamphlet, containing a List of the
Subscribers names, and
Some Account
of
Philadelphia

. . .

This final announcement was published at least fifteen times.

The pamphlet, ninety-four pages in length, was much like that published by Hardie, although broader in the subjects of some of its discussion. It made no mention of the map until, on the last page, there appeared a "List of Subscribers For the Plan of Philadelphia." Approximately 120 names appeared, with fifty copies going to one of them. They included Thomas Mifflin, to whom as "Governor and Commander in Chief of the State of Pennsylvania" the map was dedicated on the plate. It adopted an unusual approach in that the compass point "west" appeared at the top. The Statehouse inset, almost seven inches wide, revived the practice of Scull and Heap, Faden, and Lotter and included, as advertised, the new Congress and Supreme Court buildings.

The handsomely finished Folie map enjoyed sufficient popularity to merit three edi-

tions: A second seems to have accompanied a reissue, with changes, in 1799 of *Some Account of Philadelphia*; and the third was published as late as 1819 after the plate had come into the hands of one of the first antiquarian booksellers of Philadelphia, Robert Desilver. While the small Hardie-Stephens-Stafford map was by its nature ignored through those years and later, peculiarly it was reprinted at the time of the Centennial when the Folie map in turn was apparently overlooked.

(150) Plan of the City of Philadelphia. Engraving, 1794, 9⅝ × 14⅜. Source: James Hardie, *The Philadelphia Directory and Register, 2d edition* (Philadelphia, 1794).

LATER STATE

Fig. 105 (150A) *Fig. 105.* As above, but with "Stephens" added above the word "Plan" and addition of decorations surrounding title. Source: Thomas Stephens, *Stephens' Philadelphia Directory, for 1796* (Philadelphia, 1796).

REPRINT

(150a) Fac Simile of Stephens Map of Philadelphia in 1796. By Theo. Leonhart & Son, Philadelphia, 1876. Small pictures across top; Centennial scenes across bottom.

(151) Plan of the City of Philadelphia. Engraving, 1797, 9½ × 14. Attribution: J. Bowes, sc. Source: Cornelius W. Stafford, *The Philadelphia Directory for 1797* (Philadelphia, 1797).

Note: Title lacks the word "Stephens;" decoration surrounding title differs from that on plate above; descriptive title "Petty's Island" omitted; reference to "New Bank U.S." added.

Fig. 106 (152) *Fig. 106.* To Thomas Mifflin Governor and Commander in Chief of The State of Pennsylvania This Plan of the City and Suburbs of Philadelphia Is respectfully inscribed by The Editor 1794, by A. P. Folie. Engraving, by Robert Scot and Samuel Allardice, 1794, 25 × 25⅜. Attribution: A. P. Folie Del. R. Scot & S. Allardice Sculpsit. Source: Benjamin Davies, *Some Account of the City of Philadelphia* (Philadelphia, 1794). Inset: Front elevation of Statehouse complex (untitled).

LATER STATES

(152A) As above, but with titles above buildings in inset, "City Hall," "State House," and "Congress Hall."

(152B) As (152A) above, but title changed to: This Plan of the City of Philadelphia and Environs is respectfully inscribed to William Sansom Esqr who has contributed more than any other Citizen to Embellish the same, by the Number, Beauty, and Uniformity of his buildings; "District Court House" substituted for "Congress Hall;" and substituted attribution line: Improved a. Published by Robert Desilver, Jan. 1st 1819. No. 110 Walnut St.

REPRINT

(152a) Modern color reproduction issued by Historic Urban Plans, Ithaca, New York, 1973.

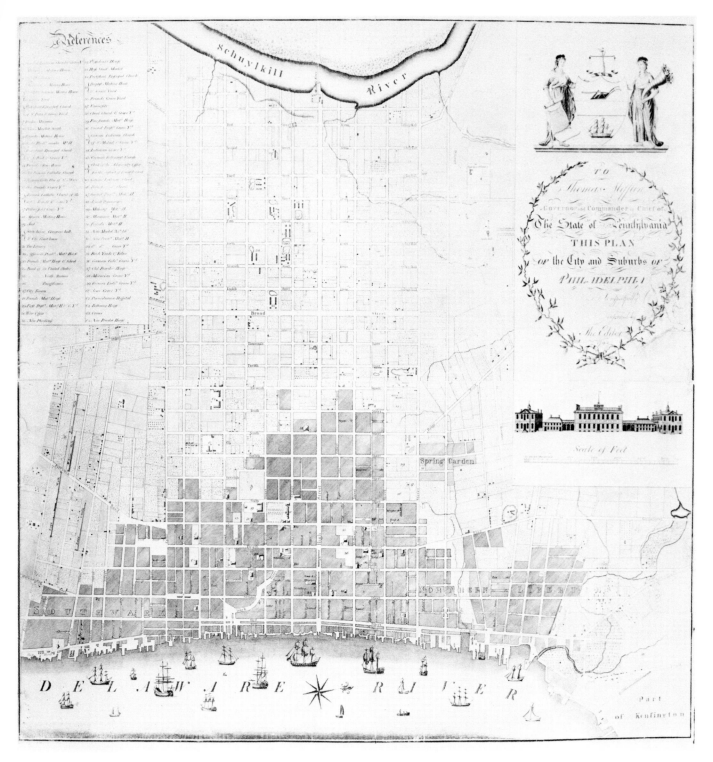

Fig. 106

(153) A manuscript map of Philadelphia, 35¼ × 29, undated, in the Bureau of Surveys, Philadelphia Survey Department, appears to be the only other 1790's map oriented similarly with the Folie map above. Since it includes Dock Street, it postdates 1784; and since the new United States Bank does not appear, it presumably antedates 1797. It lists and identifies twenty-three buildings. Compartment no. 149, Bureau of Surveys; photostat at Free Library of Philadelphia.

Three Watercolor Views by Jeremiah Paul, 1794

Jeremiah Paul, a somewhat elusive figure, has excited considerable speculation because of his seeming artistic promise, which was never fully realized. He appears to have been born in Philadelphia, was listed in its 1790 census as a schoolmaster, and remained there as an artist until shortly after 1800. He later lived in Charleston, Baltimore, Pittsburgh, and the West, and died in St. Louis in 1820.

William Dunlap, who wrote with a personal knowledge of Paul, characterized him as having a vulgar appearance and awkward manners, lacking the education and "the means of improvement" for a career in his chosen field. While his behavior may have been erratic, it produced flashes of performance at a high level. James Thomas Flexner finds one of Paul's canvases "exciting" and poses the question whether ultimately he "will not fill an important place in the history of American art."

Paul is known for painting a variety of subjects, including portraits, figures, and animals. He experimented with perspective. While still in Philadelphia—possibly during his years as an art student—he kept a sketchbook which includes three drawings in watercolor of Philadelphia scenes, of uniform size and all from fresh vantage points. They are dated in the summer of 1794.

One shows details of the temporary bridge that at this time ran at water level across the Schuylkill at the Upper Ferry (the site now being occupied by bridges at the Philadelphia Museum of Art). This vicinity had been pictured in more general fashion in the *Massachusetts Magazine,* September 1792, and in one of Malcom's 1792 watercolors.

Paul's second sketch seems to be the only picture showing the detailed appearance of Robert Morris's country house, The Hills, during his use of it. As such it is the final link in the chain of evidence needed to settle what may now be stated as the fact —until recently the subject of much uncertainty—that today's Lemon Hill mansion in Fairmount Park was not Morris's house either in its original or in remodeled form. Comparison of the building Paul shows, placed between greenhouses, with later pictures showing the greenhouse building still standing near the mansion known as Lemon Hill, makes it quite clear that The Hills and the greenhouse structure later depicted are one and the same. The Hills remained, then, and was remodeled to increase the size of the river façade and to create an orangerie or the like. Thus both the erection of Lemon Hill and the improvement of The Hills was accomplished by Henry Pratt, who bought the estate after Morris went bankrupt.

In a painting of 1807 the old house stands out clearly from among its now more splendid greenhouse surroundings. In engravings of 1813 and 1824 it is apparent that still more embellishment has been added to the greenhouse façade over the years. Yet the original house, now well disguised, still looms above its center. In all these later pictures Pratt's new mansion, Lemon Hill, stands near the old building but farther toward the point of land stretching into a sharp bend of the Schuylkill. Both Paul's watercolor and *Upper Ferry on Schuylkill*—the engraving already mentioned published in the *Massachusetts Magazine*—emphasize the greater distance of The Hills from the point, although the latter is indistinct as to the true outline of the house.

Under Pratt the greenhouses (said to extend 220 feet in length and 16 in width), when combined with the gardens, "may be pronounced unrivalled in the Union." But

sometime after sale of the estate at auction following upon his death in 1838 and its purchase by the city in 1844 to protect the purity of the municipal water supply, The Hills was razed. Thompson Westcott found in 1875 that "no trace of it now remains."

Paul's third sketch, *A N.W. View of the Pennsylvania Hospital,* was drawn a few weeks after the other two. It is the only view of the incomplete hospital building that looks from the northwest into the angle formed by the east wing of earliest construction and the separate laboratory building later placed along Eighth Street.

Other unidentified drawings in Paul's same sketchbook probably depict scenes along the Schuylkill.

(154) *Fig. 107.* A View near the Upper Ferry on Schuylkill. July 10, by Jeremiah Paul. Watercolor, 1794, 4⅜ × 6⁷⁄₁₆. Source: Jeremiah Paul sketchbook, Historical Society of Pennsylvania.

Fig. 107

(155) *Fig. 108.* Robert Morris' Seat on Schuylkill. July 10, by Jeremiah Paul. Watercolor, 1794, 4⅜ × 6⁷⁄₁₆. Source: Jeremiah Paul sketchbook, Historical Society of Pennsylvania.

Fig. 108

(156) *Fig. 109.* A N.W. View of the Pennsylvania Hospital. August 1, by Jeremiah Paul. Watercolor, 1794, 4½× 6½ (oval). Source: Jeremiah Paul sketchbook, Historical Society of Pennsylvania.

Fig. 109

Fig. 107

The Historical Society of Pennsylvania

A View near the Upper Ferry on Schuylkill — July 10.

Robert Morris' SEAT on Schuylkill

Fig. 108

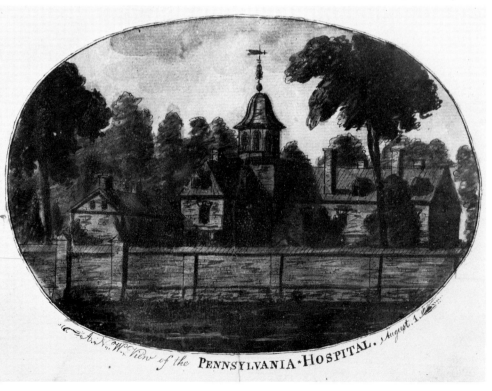

A N W View of the PENNSYLVANIA·HOSPITAL, August 1

Fig. 109

The Burning of the Lutheran Church, 1794

On the night after Christmas 1794, a great fire consumed the Zion Lutheran Church at Fourth and Cherry streets, burning steadily from eight o'clock until midnight. The holocaust gave rise to the first nonpolitical picture of a current event in Philadelphia, the kind so often depicted in the disaster prints of the nineteenth century.

The scene was engraved by Frederick Reiche, a member of the German community who produced woodcut illustrations for German-language publications. Apparently he had never issued any print as large as he now executed, nor had he worked upon copper. In stiff, primitive fashion he sought to show the fire in progress. Fascinating details emerged: the use of firefighting equipment; the passing of full water buckets by the men's conveyor line; and the return of the empties through a corresponding line of women.

Reiche conveyed a lively sense of the spectacle. Naturally the loss of the largest

Fig. 110

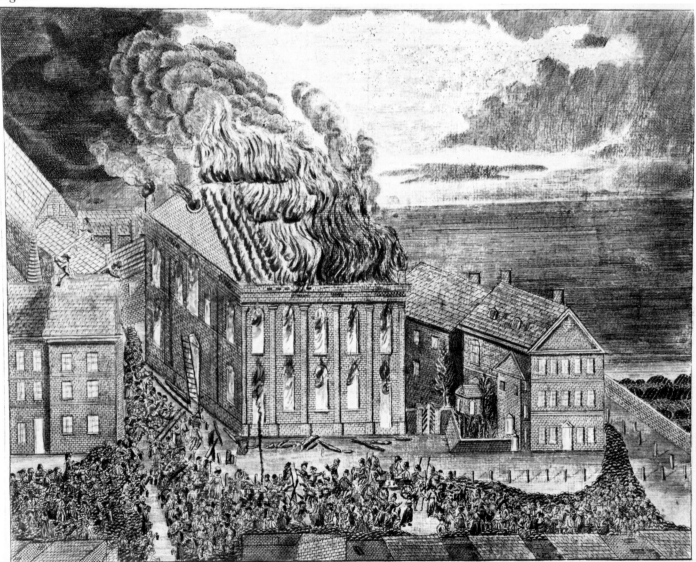

Prospect
Der neuen Lutherischen Kirche in Philad? welche den 26 ten Dec. 1794
Abends von 8 bis 12 Uhr vom Feuer verzehret worden ist

Prospect
Of the new Lutheran Church in Philad? which was on the 26 th of Dec. 1794
in the evening from the hour of eight till twelve consumed by fire

church in the city would be witnessed by the great crowds thronging his plate. The building had accommodated the Continental Congress in October 1781 when it marked Cornwallis's surrender at Yorktown.

Below the picture Reiche set forth the facts of the loss in parallel columns of English and German text. This feature implies that the print was published for special purposes: to report as a news event to German-speaking communities in southeast Pennsylvania, and at the same time to garner funds for rebuilding plans. In fact, a new structure replaced the old only two years later.

Little can be said for the artistic merit of this print, but much can be said for its rarity. Probably because of its ephemeral subject matter, very few copies are known.

Fig. 110 and Colorplate 11 (157) *Fig. 110 and Colorplate 11.* Prospect Of the new Lutheran Church in Philada. which was on the 26th. of Dec. 1794 in the evening from the hour of eight till twelve Consumed by Fire, by Frederick Reiche. Engraving, by Frederick Reiche, 1795, 10⅝ × 12⅜. Attribution: fr. Reiche sc Philada.

LATER STATE

(157A) As above, but with addition of "Printed by Joseph Brown, 52 New Market St."

Note: The title also appears separately in German.

Views by European Visitors, 1795–98

In the 1790's at least three visitors from abroad made their own drawings or arranged publication of subjects in the capital that interested them.

Henry Wansey, an English mill owner, traveled to the United States in 1794 "to view the new nation." Upon his return home he published in Salisbury his *Journal of an Excursion to the United States of North America in the Summer of 1794,* which went through a first edition in 1796 and another two years later. His ties with America included both a strong interest in its manufacturing methods and a real-estate speculation of 1,200 acres on the Susquehanna River.

Wansey's most southerly visit was to Philadelphia, which received much attention in his book and was made the subject of an illustration in the form of an elevation of the Statehouse. This was probably copied from the façade of the building appearing on the Folie map. Wansey would naturally have purchased Davies's *Some Account of Philadelphia,* published in the very year of his visit and containing the map. The print, in aquatint, simplifies the features of the structure and creates an unusual result.

In 1797 a book under Wansey's authorship appeared in Berlin containing a poor copy of the English aquatint, further reduced in size and rendered as a line engraving. Its title is copied directly from the Salisbury prototype.

Another 1794 visitor was William Strickland of Yorkshire, a baronet-farmer who had introduced new methods of crop rotation at home. He landed in New York with

a list of questions on subjects of interest to the British Board of Agriculture. With New York as a base, he traveled through the interior to Albany and found the back country in a "state of barbarism." After a tour through coastal New England he moved to Philadelphia for the first half of 1795. It served as his point of departure for two more trips to the Chesapeake area, Maryland, Virginia, North Carolina, and Washington, where he talked with farmers, innkeepers, and many other types of citizens.

His stay in the capital afforded Strickland the opportunity to become a friend of Washington and others of note in the "most interesting society of which I ever did or probably ever shall make a part." Among these was Governor Mifflin, from the porch of whose home Strickland looked down to sketch the Falls of the Schuylkill— for he knew how to produce simple but creditable drawings. For the present-day viewer this conveys perhaps the best impression of how the falls looked before being flooded. Doubtless Mifflin's home was placed specifically for the view down the bending river.

The year 1796 saw the arrival in Philadelphia of a very different type of amateur artist: a displaced person. Count de Colbert Maulevrier had fought in the French Fleet off Yorktown and joined Washington's Society of the Cincinnati. When the French Revolution forced temporary exile upon him, he decided to revisit the land of liberty. He remained in Philadelphia for almost three years, a frequenter of the shop of Moreau de Saint Méry. In 1798 two sightseeing trips took him first up the Schuylkill and the Susquehanna and later up the Delaware and on to distant Quebec. Maulevrier left in the notebooks of these two tours a collection of simple, factually accurate drawings that have been characterized as "a singularly lively picture of American life in this back country little known to foreigners which opened to civilization at the end of the 18th century." Two of them depict Philadelphia scenes as he saw them upon leaving or returning to the city.

In *Upper Ferry Tavern* the low wooden bridge over the Schuylkill at the narrows by today's Museum of Art stretches to the west bank where the tavern lies low to the river, dominated by the country home of Mr. Beveridge upstream, and occupied perhaps that very summer by the artist William Birch and his patron, the Spanish minister to the United States. In *Philadelphia vu de l'Upper Ferry* the reverse view is presented. Having arrived at the tavern, Maulevrier drew the city as it sat back and across the river, its towers glimpsed through trees near the artist.

Maulevrier received authorization in 1799 to return to France. He married there after the turn of the century and saw more service in the military before he died in 1820.

(158) *Fig. 111.* State House at Philadelphia. 400 Feet in Length and 100 in Depth, built of Brick with Freestone Cornices, by A. P. Folie. Aquatint, 1796, 4 × 7⅝. Attribution: Published by J Easton Salisbury 1796. Source: Henry Wansey, *The Journal of An Excursion To the United States of North America, in the Summer of 1794* (Salisbury, England, 1796), p. 131, and second edition (1798), p. 117 (with folds).

Fig. 111

(159) Original unsigned pen and wash drawing for the aquatint is in a private collection. See David John Jeremy, ed., *Henry Wansey and His American Journal 1794* (Philadelphia, 1970), p. xv.

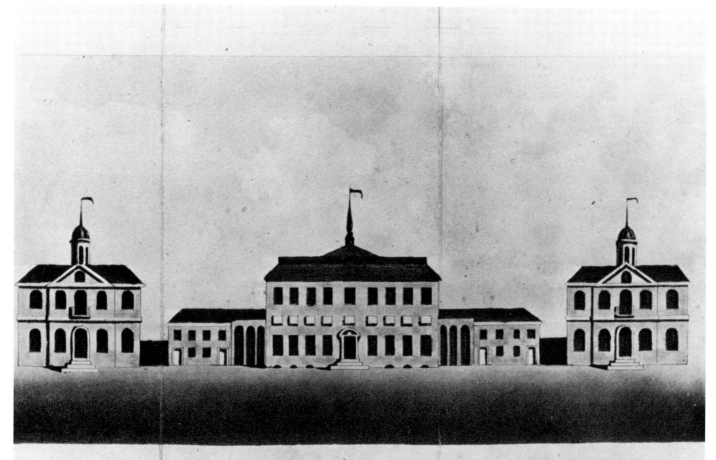

State House at PHILADELPHIA. 400 Feet in Length and 100 in Depth, built of Brick with Freestone Cornices.

Published by J.Easton Salisbury 1796.

Fig. 111

Fig. 112 (160) *Fig. 112.* Das Staatenhaus in Philadelphia 400 Fuss lang und 100 Fuss tief. Engraving, 1797, 3 × 6. Source: Henry Wansey, *Tuchmanufakturisten in der Grafschaft wilts, und Mitgliedes den antiquarischen Gesellschaft* (Berlin, 1797).

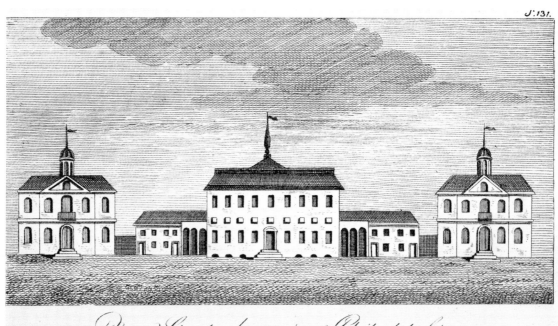

Das Staatenhaus in Philadelphia
400 Fuss lang und 100 Fuss tief

Fig. 112

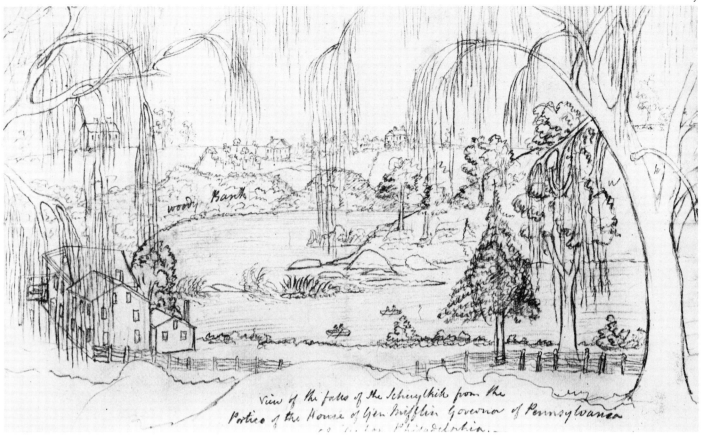

View of the falls of the Schuylkill from the Portico of the House of Gen Mifflin Governor of Pennsylvania 5 miles from Philadelphia.

Fig. 113

(161) *Fig. 113.* View of the falls of the Schuylkill from the Portico of the House of Gen Mifflin Governor of Pennsylvania 5 miles from Philadelphia, by William Strickland. Drawing, 1795, 8 × 13½. Source: New-York Historical Society.

Fig. 113

(162) *Fig. 114.* Philadelphia vu de l'Upper Ferry, by Count de Colbert Maulevrier. Watercolor, 1798, 3⅜ × 6¼ (reproduction). Source: Maulevrier Journal.

Fig. 114

Private collection

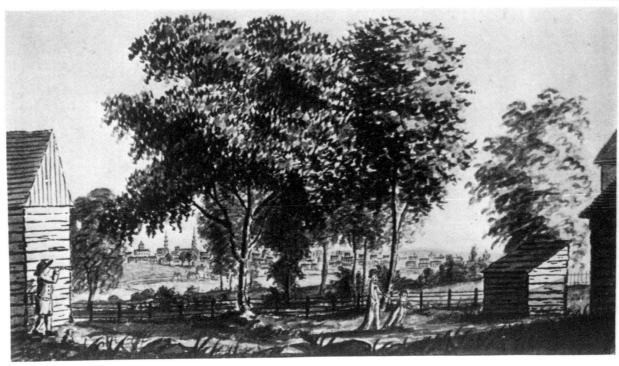

Fig. 114

Fig. 115

Fig. 115

(163) *Fig. 115*. Upper Ferry Tavern, by Count de Colbert Maulevrier. Watercolor, 1798, 3⅜ × 6¼ (reproduction). Source: Maulevrier Journal.

Two Views of Philadelphia from the West, 1796

The Philadelphia theatrical world and the increasing interest in landscape views combined to produce one of the great pictorial records of the city at the end of the eighteenth century.

At the close of the theatrical season of 1790, the withdrawal of the chief comedian of the old theater on South Street set in motion plans for a new building. This would be equipped in such a style as to provide a fitting background for the social life of the nation's capital—the scene of the most glittering social occasions in the country. The New Theatre designed for this purpose at Sixth and Chestnut streets was commenced in 1791. Charles C. Milbourne, an eminent London scene painter, was sent to the site in 1792 to paint the scenery and equipment, and he occupied himself with that task for at least a year. In April 1794, soon after the opening of the theater, an engraving of the interior published in the *New York Magazine* was accompanied by a glowing description: "The paintings and scenery are equal to the generality of the European, and do the greatest credit to the pencil and genius of Mr. Milbourne." Seating 2,000, the structure was the first in America comparing favorably with those in England. It was said to have been copied closely from the Theatre Royal at Bath, which supplied some of the actors seen on the new stage.

Milbourne stayed on until 1796 as scene painter. In that year a young man of twenty with experience in such work was brought from London to replace him. This was John Joseph Holland, who is said to have had a keen knowledge of architecture and a talent for watercolor. During the summer both Milbourne and Holland appear to have produced views of the city that are almost identical except for their size. Holland's, as etched on copper, was far the larger and more formal.

We can visualize the two setting out together on a landscape-sketching expedition in June. Possibly a scene at the theater called for the painting of a view of the city. After leaving it far behind, they crossed the Schuylkill in open country at the Upper Ferry Bridge (alongside today's Museum of Art) and climbed to a point looking back over the river in the foreground to the city in the distance. From slightly different vantage points each drew the panorama before him. Milbourne's, on a small sketch pad, is extant and bears the date June 1796. Holland's drawing was probably lost in the making of a handsome etching, simply titled *View of The City of Philadelphia*, presumably published that same year. The etching work was accomplished by Gilbert Fox, who soon also joined the company at the theater.

Fox was Holland's exact contemporary. He had come from England in 1795 when discovered in London as an engraver's apprentice by a Philadelphian. After teaching drawing in a school for young ladies, eloping with a pupil, and losing his appointment, Fox joined the theater in 1798 as an actor and singer; but he continued to etch beyond the turn of the century.

I. N. Phelps Stokes has expressed doubt that Holland's view is authentic, but his doubt is clearly unjustified. Particularly when the renderings by Holland and by Milbourne are examined together, the two records made independently fit together per-

Fig. 116

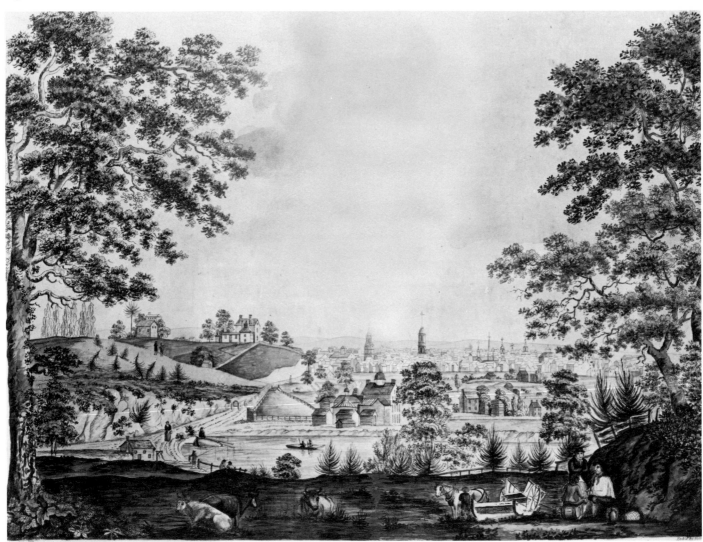

fectly. The low "floating" bridge at Fairmount was a cause for concern to Stokes. This is dissipated not only by comparison with Milbourne's watercolor, but also by the Malcom watercolor and the *Massachusetts Magazine* engraving of the Upper Ferry (both 1792), and Jeremiah Paul's sketch (1794). The abrupt rise of Fairmount and both the country homes Springettsbury and Bush Hill appear in proper position and perspective. Farms occupy the area between the Schuylkill and the city, as shown on a number of maps of the period. The steeples of Christ Church and of the Second Presbyterian Church appear very tall in both the pictures; this probably resulted from the contrast between their height and that of the other towers in the city. The low cap replacing the first tower of the Statehouse, the single lantern atop the Pennsylvania Hospital, and the almshouse closer to Holland are all readily identifiable.

So far as is known, Holland's view has never been reissued in any other form despite its uniqueness and great interest—probably because copies were not known in the nineteenth century.

Fig. 116 and
Frontispiece

(164) *Fig. 116 and Frontispiece*. View of the City of Philadelphia, by John Joseph Holland. Etching, by Gilbert Fox, c. 1796, 15 × 20¹³⁄₁₆. Attribution: Drawn by I. I. Holland. Etch'd by Gilbert Fox.

EARLIER STATE

(164A) As above, but with etched signature inside color line.

Fig. 117

(165) *Fig. 117*. Philadelphia Penn, by Charles C. Milbourne. Watercolor, 1796, 5½ × 9. Attribution: Drawn by C. C. Milbourn June 1796. Source: Free Library of Philadelphia, Castner Collection, 7:67.

Castner Collection, Free Library of Philadelphia

Phila. lphia Penn Drawn by C. C. Milbourn Jun. 1796

Fig. 117

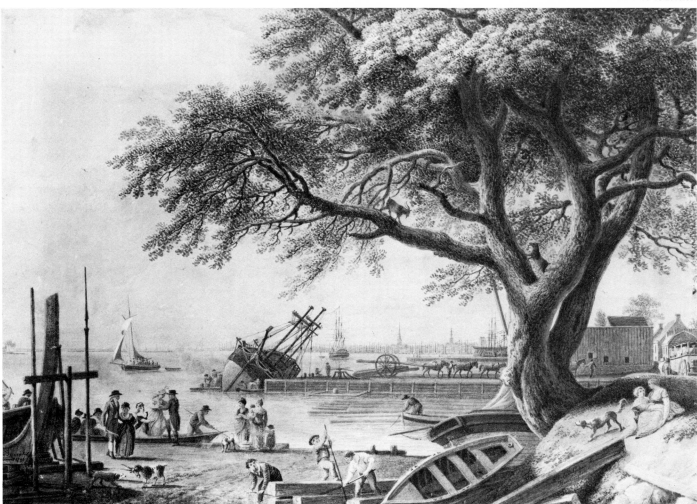

Fig. 118

Barralet's Landscape View of Philadelphia from Kensington, 1796

With Scull and Heap's *East Prospect* showing the city from the Delaware, the Garrison engraving portraying it from the south, and Holland's etching drawn from the west, only a view from the north was needed to complete a series of fine "external" pictures of Philadelphia before 1800. This appeared in the same year as Holland's view, in the form of a large watercolor. It was drawn beside the great elm of Shackamaxon on the Delaware, the legendary site of Penn's treaty with the Indians, now commemorated by the Penn Society's monument standing in Penn Treaty Park. The city appeared in the distance, carefully drawn as it lay behind a great curve in the river.

The artist was John James Barralet, whom Dunlap identified as an Irishman of French parentage. He had arrived in Philadelphia only shortly before this watercolor was drawn. Signed and dated 1796, it is perhaps the earliest record of his being a local resident.

Barralet's view is very close to that painted upon a large canvas by young Thomas Birch a few years later. The engraving of Birch's painting has become probably the best known of all views of Philadelphia, although Barralet appears to have been the

innovator. Barralet's drawing was never printed, while Birch's multiple copies quickly found their way to England and the Continent and became in later generations possessed of a firm reputation at home. There is no suspicion that Birch copied Barralet. Rather, the city had spread northward along the river, linking with the Kensington area; the ancient tree was already a landmark; and the site with its interesting ship-building activities furnished a natural point for viewing the great city and its towers. Benjamin West is said to have painted the tree itself more than twenty years earlier, by sketches that went with him to London and became a part of his widely acclaimed picture (1771) of the Penn Treaty.

Fig. 118 (166) *Fig. 118.* (Philadelphia from Kensington), by John James Barralet. Watercolor, 1796, 16 × 24. Attribution: J. J. Barralet 1796. Source: Private collection.

COPY

(166a) Copy in oil on canvas by Xanthus Smith, 1866, described in Nicholas B. Wainwright, *Paintings and Miniatures at the Historical Society of Pennsylvania* (Philadelphia, 1974), p. 302, as having been produced from an earlier copy now unlocated.

The Varlé Map of Philadelphia, 1796

Peter C. (or Charles) Varlé, author of one of the most complete maps of the city in the 1790's, had only a temporary residence there. He appeared in the 1794 city directory, and he was listed for that year only as a member of the city militia. His map of generous size, although smaller than those of Folie (1794) and John Hills (1796), is well documented and contains many identifications of estates (not listed in its reference table) that are not recorded elsewhere.

Richard Stephenson of the Library of Congress has traced Varlé from his native France to Haiti, and in 1794 to Philadelphia, where he worked in the War Department. But by 1795 he had undertaken an engineering assignment in Maine, and later another in Boston. By 1798 he had moved to Maryland, and he remained a resident of Baltimore until his death in the 1830's.

Varlé seems to have come to Philadelphia with his superior, the chief engineer of Haiti, when a general native uprising forced many French to flee the island. Thompson Westcott, however, has put forth a different story. He says Varlé was the companion of an Englishman who came to the city to investigate the conditions of a property in which he claimed an interest under an ancient land title. The claim was unsuccessful, but Varlé spent his time in Philadelphia utilizing his skill as a geographer and engineer by preparing the map.

Varlé's map is carefully done, and readily identified by small insets of the State-house and its flanking buildings, the new library building nearby, and the Bank of the United States. The engraving work was supplied by Robert Scot, who had performed the same service for Folie.

The map seems clearly to have been prepared on the basis of Varlé's 1794 surveys

but after he had left Philadelphia behind for some time. The date of issue appears to fall within the latter months of 1796. An unsigned advertisement on 25 June, which was repeated in late July and on 3 August 1796 in the *Philadelphia Gazette*, can refer to none other than Varlé's map:

> Shortly will be Published,
> From actual Survey,
> A New Plan of the City & Evirons of Philadelphia,
> Which comprises more than any extant, by
> the addition of three of the grandest public
> Edifices in the city, namely, The State House,
> Library, New Bank and above 150 rural villas and
> plantations in the environs.
> No expence has been spared to render it
> accurate and worthy the attention of the curious.
> Price to subscribers one dollar and fifty
> cents, to two dollars.

One of the unsettling features of the map in relation to a 1796 publication date has been its featuring of the Bank of the United States on Third Street below Chestnut. But although that new building was not occupied until July 1797, construction continued during all of the previous year. The advertisement makes it clear that this partially completed edifice was shown in Varlé's work as though it were already completed. Presumably Scot, with whom the manuscript map had been left for publication, arranged the advertisement and directed this addition in order to make Varlé's presentation of the capital city a current one.

In 1802 Scot published a second state of the plate showing that date and labeled a "new plan." Among the additions was a newly projected real-estate development just west of the Schuylkill, centered on Market Street, which may well have been the reason for the new edition. It has been pointed out that the formal system of squares, diagonal streets, and an oval open space shown there "would have provided a magnificent entrance to the city from the west and an interesting contrast to the rectangular block pattern of the old city." In its proposal of a particular street system west of the river, Varlé's revised map returned basically to a feature shown by Holme in his map of the province a hundred years earlier—when it was expected that the city would develop equally along both rivers.

Three nineteenth-century reprints of Varlé's map, and at least one after 1900, have appeared—all copied from the first state of the plate.

(167) *Colorplate 12.* To the Citizens of Philadelphia this Plan of the City and its Environs is respectfully dedicated By the Editor, by Peter C. Varlé. Engraving, by Robert Scot, c. 1796, 17¾ × 24½. Attribution: P. C. Varlé Geographer & Enginr. Del. Scott Sculp. Philada. Insets: 1. City Hall, State House, and Congress Hall. 2. Library. 3. Bank of the United States. *Colorplate 12*

LATER STATE

(167A) *Fig. 119.* As above, but "this New Plan"; date 1802 added; additions and changes in plate and table of references. *Fig. 119*

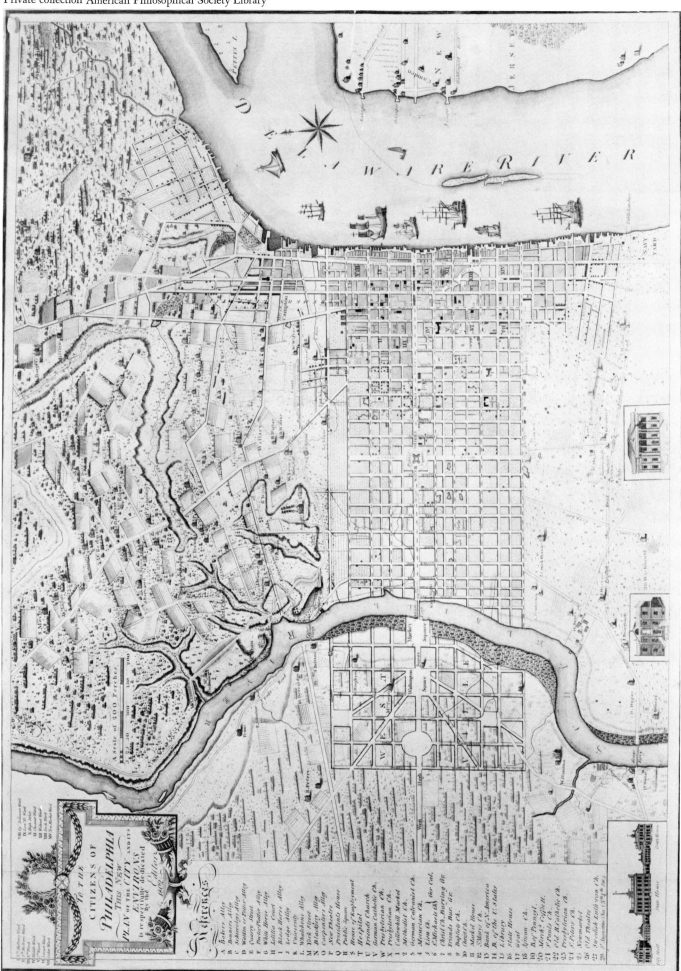

Fig. 119

(167a) Lithograph titled: Philadelphia 100 Years Ago. By H. J. Toudy & Co., Philadelphia, for W. E. Lyndall, 1875. Also photolithographed for W. E. Lyndall by J. Carbutt, Philadelphia.

(167b) Lithograph titled: Philadelphia in 1796. Published by Bradley & Company, Philadelphia, n.d. Also published in Charles D. Kaufmann, *Street Atlas of Philadelphia by Wards* (Philadelphia, 1895).

(167c) Facsimile with cartouche and "1776" at upper left, no attribution.

(167d) As (167c), but "Compliments of The Colonial Trust Company Philadelphia," 1926.

(167e) As (167c), but "Cape May Country Store, Ken. & Marge Ewer, Props. Cape May, N. J."

(167f) As (167c), but "Old Curiosity Shop, Philadelphia."

Philadelphia Seen from New Jersey, 1796

The botanist John Bartram had the pleasure of seeing his interests carried forward by his son William, who combined a lifelong interest in botany with a considerable talent in drawing.

William received more advantages by way of education than his father had. He attended the new Academy of Philadelphia, pictured by Du Simitière, and came under the influence of Charles Thomson, in later years secretary of the Continental Congress. As a faculty member Thomson taught Greek and Latin. As a patriot his example was strong both in respect to relations with England and in protest against the then prevalent policy of thoughtless and unfair treatment of the Indians. But it was in botany and drawing that young Bartram never tired. Even in his early teens he was shooting and drawing birds and sending his drawings to Europe.

Botanical drawings required backgrounds, and one of these became a view of Philadelphia as seen from a point northeast of the city and across the Delaware in New Jersey, probably at Cooper's Point. Drawn in 1796 during Bartram's fifties, the distant scene contains the familiar array of steeples and towers identifying Christ Church, Independence Hall, the Presbyterian church, and other public buildings. An island in the foreground can only be a perhaps-fattened version of Windmill Island. The description in Bartram's hand—a combination of Latin and English—attributes to the North American orchid he was picturing a habitat native to both New Jersey and Pennsylvania. By combining a foreground in the first state with a background in the second, the artist made his point pictorially as well as in his words.

(168) *Fig. 120.* Arethusa divaricata, by William Bartram. Watercolor, 1796, 14¾ × 8¾. Attribution: W. B. Etat. 56. 1796. Source: American Philosophical Society.

Fig. 120

Fig. 120

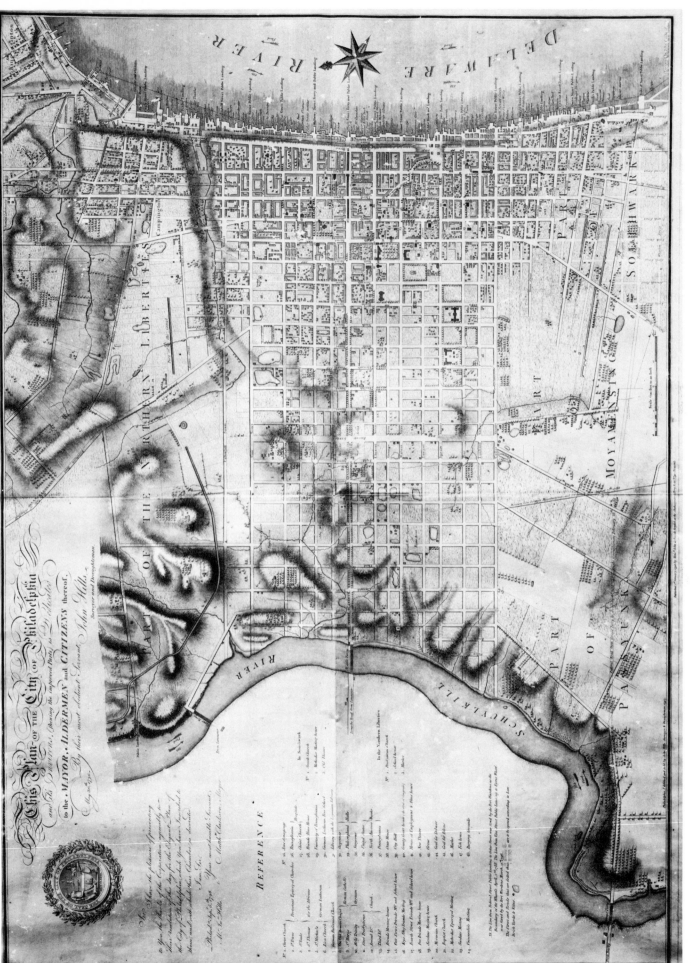

Fig. 121

The John Hills Map of Philadelphia, 1796

This most important map of the city published by John Hills, obviously from his own surveys, was on a scale somewhat reminiscent of his two plans of 1788. Intended for copperplate engraving, it was nonetheless a yard wide. This permitted the author to name and locate each of the dozens of wharves along the Delaware and to give the details of construction then existing in every city block to, and even beyond, the Schuylkill. The topography received equally minute treatment. Even brickyards and small ponds were identified singly.

On 30 May 1796 the map was dedicated to the mayor, aldermen, and citizens of Philadelphia. The whole effort was of such obvious quality as to bring forth a responsive written commendation from the City Council. Hills sent the plan to London for engraving (presumably to ensure the best reproduction on copper) and had the commendation cut into the plate.

According to the publication line, this fine map was "published and sold" by Hills only in 1797. Local publication apparently preceded sale in London, for it was offered there at the start of the year 1798 by the Boydells, print dealers of the highest reputation in Cheapside. Copies appear with, and others without, the English publication line.

A republication was made in the nineteenth century, but not in time for the Centennial. Samuel Smedley, chief engineer and surveyor of the city, brought the item to light in 1881 in his indefatigable searches and had it photolithographed for sale by a local print dealer. In 1959 came a further reprint undertaken photographically by the Society of Colonial Wars.

Hills's major production completed in 1796 by no means exhausted his output. In 1799 came a plan of Ormiston, one of the early houses still preserved in Philadelphia's Fairmount Park: a watercolor aerial view that used perspective and showed the Schuylkill in the background, as well as a front elevation of the house itself. The summers from 1801 to 1807 found Hills surveying the environs of the city. This work culminated in a very large engraved map of 1808, round in form but enclosed within a square, covering an area extending ten miles in all directions from the pumphouse in Center Square, the site of today's City Hall.

Hills's last listing in the city directories was in 1817, presumably the year of his death. The rank of the early John Hills in the British army's campaign in America bespeaks a young man whose normal span would bring him forward to such a year.

(169) This Plan of the City of Philadelphia and its Environs, (shewing the improved Parts), is Dedicated to the Mayor, Aldermen, and Citizens thereof, By their most obedient Servant, John Hills, Surveyor and Draughtsman. May 30th. 1796, by John Hills. Engraving, by John Cooke, drawn 1796, published 1797, 26⅜ × 36½. Attribution: Philadelphia, Published, and Sold, by John Hills, Surveyor, & Draughtsman. 1797. Engraved by John Cooke, of Hendon, Middlesex, near London.

LATER STATE

Fig. 121 (169A) *Fig. 121.* As above, but with addition at bottom center of: Published, 1st. January, 1798, by Messrs. John & Josiah Boydell, at the Shakespeare Gallery, & at No. 90. Cheapside.

Fig. 122

REPRINTS

(169a) Photolithograph by Thomas Hunter, Philadelphia, published by Samuel L. Smedley, Chief Engineer & Surveyor, 1881.

(169b) Photographic reproduction, Society of Colonial Wars in the Commonwealth of Pennsylvania, 1959.

(170) *Fig. 122.* A Plan of Ormiston Villa, the property of Edward Burd Esqr. Situated on the Banks of the Schuylkill, in the State of Pennsylvania, by John Hills. Watercolor, 1799, 5¾ × 5⅝ (elevation of the house), 18¼ × 22½ (plan). Attribution: Surveyd by John Hills 1799. Source: Historical Society of Pennsylvania.

Fig. 122

Two Pen Drawings by a Baltimorean, 1797

In the year 1797 a leisured Baltimore collector, then only twenty-three years old, passed through Philadelphia on a tour of the eastern states. Notebook in hand, he sketched as he went. Two of the scenes he chose to record in pen drawings were Lansdowne Mansion, then standing in present-day Fairmount Park, and a quiet stream, the Pennypack, flowing beneath a stone bridge carrying the King's Highway (now Frankford Avenue) to New York. The bridge remains standing as the first stone-arch bridge in America, built in 1697.

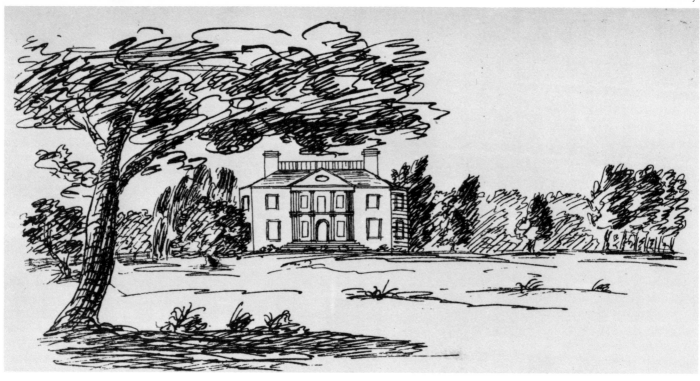

Fig. 123

The traveler was Robert Gilmor, Jr., whose father had organized the merchant house of Robert Gilmor & Sons, active in international trade, and occupied Beech Hill overlooking Baltimore City. The son early developed an omnivorous interest in paintings, drawings, and engravings, which he began to cultivate abroad on his first trip of 1799. His interests were catholic. His acquisitions included works in the French, Flemish, Dutch, Spanish, and Italian schools. Lawrence painted well-known portraits of Gilmor and his wife. His American artistic tastes ran to Thomas Cole, Thomas Doughty, and William Sidney Mount. He did business with John Trumbull as an art dealer.

Financial reverses at the end of Gilmor's life made it necessary for his executors to sell his collection, and of course to catalogue it. The resulting inventory showed 225 paintings, 25 folios of drawings and engravings, 62 boxes of autographs, 2,000 books,

Fig. 124

and sculpture. The collection had been assembled over a period of perhaps fifty years, since Gilmor died in 1848.

Gilmor's manuscript *Memorandums made in a Tour to the Eastern States in the Year 1797* was purchased at auction in Boston in 1878 and is now in the Boston Public Library. A companion *Sketchbook of a European Holiday* resides at the Maryland Historical Society.

(171) *Fig. 123.* Lansdowne, by Robert Gilmor, Jr. Pen drawing, 1797, 4½ × 7⅝. Source: Robert Gilmor, Jr., *Memorandums made in a Tour to the Eastern States in the Year 1797* (manuscript at Boston Public Library), reprinted in *Bulletin of the Boston Public Library* 11 (1892): 72.

Fig. 123

(172) *Fig. 124.* View of the Bridge at Frankfort (Pennsylvania), by Robert Gilmor, Jr. Pen drawing, 1797, 3⅛ × 7. Source: Robert Gilmor, Jr., *Memorandums made in a Tour to the Eastern States in the Year 1797* (manuscript at Boston Public Library), reprinted in *Bulletin of the Boston Public Library* 11 (1892): 72.

Fig. 124

First Picture of the United States Bank, 1797

A second foreshadowing of the work of William Birch, after Barralet's view of the city from Kensington, came from the hand of a teacher of drawing in Philadelphia, E. F. Duvivier, of whom little is known. Duvivier and Son were in the city during the two years 1796–97, when they advertised themselves as skilled in portraits, landscapes, and still lifes. M. Duvivier held himself out as a member of the Royal Academy at Paris.

When the "academy" operated by the partners moved from Race Street to Strawberry Alley, between Second and Third streets south of Market, they were within easy walking distance from the work then in progress of erecting the first United States Bank on Third Street below Walnut. This new building, constructed according to the designs of the amateur architect Samuel Blodgett, Jr., forms the central object in a large watercolor signed by E. F. Duvivier. The façade of the bank is viewed from the north. Third Street stretches into the distance. A number of figures appear in an active street scene similar in flavor to the Birch engravings.

The drawing is mounted on another sheet bearing the title. The latter ascribes the view to the year 1797, which seems correct because the bank was completed in that year; but the title was clearly added later, for it describes the structure as "The United States Bank, now Girard Bank." Girard purchased the property in 1812, after the bank's charter expired. This in no way detracts from the validity of the picture itself, which is perhaps the earliest concentrating on the classical façade of the bank.

The date of Duvivier's watercolor is only one year before that of the first of two Birch engravings of the same subject. The two men were undoubtedly at least acquaintances, and Birch could even have had Duvivier's work in mind in first engraving the scene from almost the same vantage point. But Birch quickly replaced his first plate with a new one featuring the façade of the bank as seen from an intersecting street to the east. His intent was obviously to show off the building more impressively as a part of the new Philadelphia than he had earlier made it appear. This second plate became one of the most popular in the whole series of the Birch views.

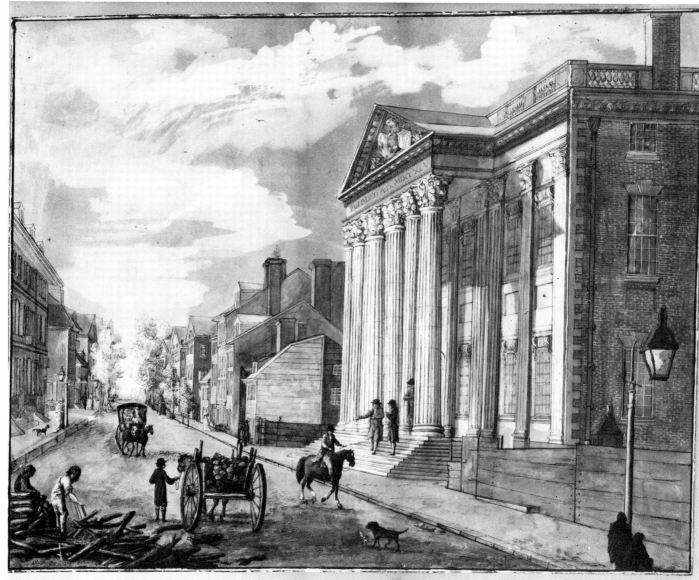

The United States Bank now Girard Bank, Third St below Chestnut St.
1797.

Fig. 125

Fig. 125 (173) *Fig. 125.* The United States Bank now Girard Bank, Third St. below Chestnut St, by E. F. Duvivier. Watercolor, 1797, 16½ × 21½. Attribution: E. F. Duvivier, fecit. Source: Private collection.

(174) Another watercolor of this structure, undated but probably before 1800, apparently without attribution, and somewhat smaller, is in a private collection.

Two Last Magazine Views, 1798

In 1798 Thomas Condie, a bookseller, instituted *The Philadelphia Monthly Magazine, or, Universal Repository of Knowledge and Entertainment,* which was published only during the first half of that year. In keeping with standard magazine practice, the issues for February and June displayed engraved views of buildings in the city.

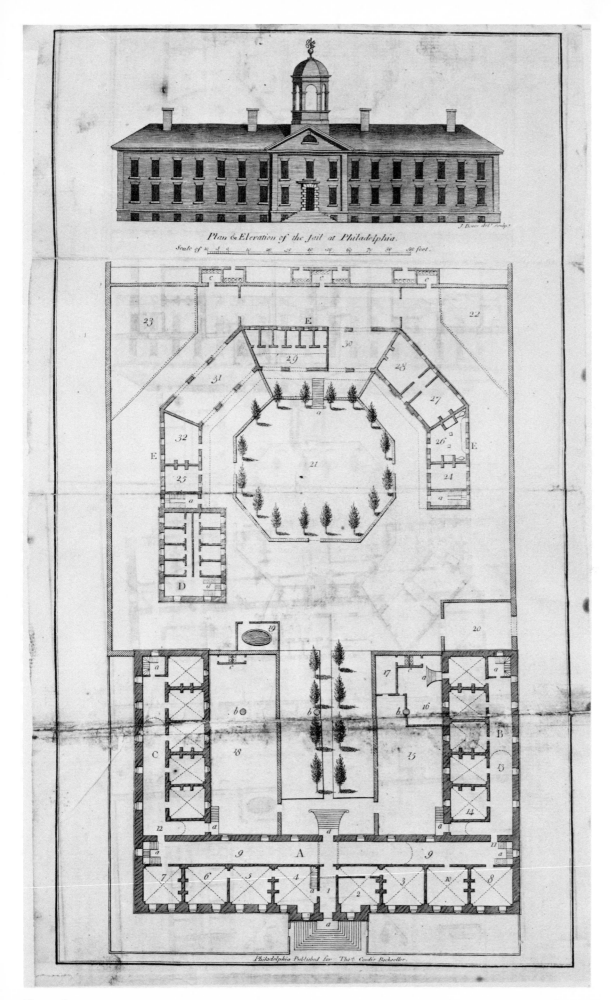

Plan & Elevation of the Jail at Philadelphia.

Scale of

Philadelphia Published for Thos. Condie Bookseller.

Fig. 126

The first of these, a *Plan & Elevation of the Jail,* combined a front elevation of the Walnut Street building with a plan of both the structure and the grounds that it occupied. The whole appeared somewhat in the manner of a broadside, with the picture at the top and the plan below. It was a departure from recent views and a throwback to the format given the city and its surroundings in the very early map by Scull and Heap surmounted by the Statehouse in elevation. The new print was far more detailed than any of the several earlier views of the jail and was accompanied by text referring to its social value.

Parts of the jail grounds other than the front along Walnut Street were the scenes of public events from time to time, such as Blanchard's balloon ascension of 1793 (the balloonist armed with a letter from Washington for encounters with hostile tribes, and Washington an onlooker to his takeoff). Only this plan shows the area made available for these purposes and the apartments for bankrupts.

The view for June copied as a separate engraving the rendering of the Statehouse and its recent additions that had appeared on the Folie map of 1794. The buildings are drawn in a size identical to that of the earlier map inset, but with minor changes from the original. The picture contains its own title, which did not appear on the map, and an attribution line crediting Condie. It is apparently from this plate, after certain erasures, that restrikes have been run on more modern paper. From some the attribution line has been expunged; in others not even a title appears.

The Jail plate was executed by Joseph Bowes, the architect and engineer who had re-engraved the Stephens plan and whose last year in Philadelphia seems to have been that of this print. He probably also engraved the Statehouse elevation, although no name appears on it.

Fig. 126 (175) *Fig.* 126. Plan & Elevation of the Jail at Philadelphia, by Joseph Bowes. Engraving, by Joseph Bowes, 1798, 13⅛ × 7⅜. Attribution: J. Bowes delt. sculpt. Philadelphia Published for Thos. Condie Bookseller. Source: *Philadelphia Monthly Magazine* 1 (1798): opp. p. 100.

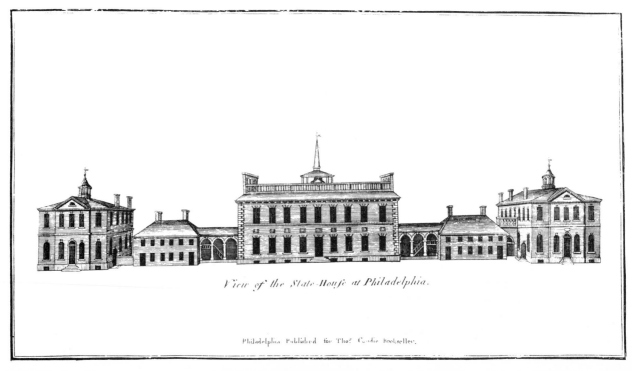

View of the State-House at Philadelphia.

Philadelphia Published for Thos Condie Bookseller.

Fig. 127

(176) *Fig. 127.* View of the State-House at Philadelphia, attributed to Joseph Bowes. Engraving, attributed to Joseph Bowes, 1798, 3¾ × 6⅞. Attribution: Philadelphia Published for Thos. Condie Bookseller. Source: *Philadelphia Monthly Magazine* 1 (1798): opp. p. 333.

LATER STATES

(176A) As above, but without attribution.

(176B) As (176A), but without title.

The Interior of Congress Hall, 1798

During the actual sessions of Congress early in 1798 there took place the first physical confrontation between two United States Representatives. Because of its political connotations the incident was promptly lampooned in two etched cartoons that show the interior of Congress Hall where that body met.

The tale is full of interest. Roger Griswold of Connecticut mentioned on the floor of the House an old rumor that his colleague, Matthew Lyon of Vermont, had once been sentenced to wear a wooden sword to atone for cowardice in the field. Lyon immediately spat in Griswold's face. Some days later the affair erupted again when Griswold returned to the fray by attacking Lyon with a stick. Lyon met him with tongs, which he seized spontaneously from the fireplace, and the two fought until separated.

In one of the ensuing prints, *Cudgeling as by late Act in Congress, USA,* a lion-headed man opposes his adversary, each armed as mentioned, in an open area before the Congress, whose members are seated in three tiers of semicircular benches. The attribution, etched in the plate, is "C. P. Eldwood, 1798." This scene was a valuable source for the recent restoration of Congress Hall to its original appearance by Independence National Historical Park personnel.

In the second cartoon the entire scene is burlesqued to a much greater degree. The antagonists are shown in wild disarray. The Speaker and other dignitaries of the House are grossly maligned in appearance, to the extent that in all but the initial states of the copperplate they are identified by numbered references. These scurrilous features of the print are accompanied by a rhyme that compresses the story:

> He in a trice struck Lyon thrice
> Upon his head, enrag'd sir,
> Who seiz'd the tongs to ease his wrongs,
> And Griswold thus engag'd, sir.

This work is entitled *Congressional Pugilists* and bears reference to the place of the event. On none of its several editions did an author's name appear.

The plate for *Congressional Pugilists* was preserved at least until 1860. In that year Philadelphia antiquarian John McAllister, Jr., already mentioned, having formed his collection of copperplates of early Philadelphia views, had numbers cut into the series and pulled proofs, some of which went into bound volumes. This plate then received number "17."

Fig. 128

Fig. 128

(177) *Fig. 128*. Cudgeling as by late Act in Congress, USA. or—. Etching, 1798, 8⅜ × 12¾. Attribution: C. P. Eldwood, 1798. Source: Only known copy is at the Essex Institute, Salem, Mass.

(178) Congressional Pugilists. Etching, 1798, 6 × 8½.

LATER STATES

Fig. 129

(178A) *Fig. 129*. As above, but with addition of the words "Congress Hall, in Philada. Feb. 15. 1798."

(178B) As (178A), but with numbered references identifying the Speaker, Clerk, and Chaplain of the House and addition of "S. E. Cor. 6th. & Chesnut St."

(178C) As (178B), but with figure "17" at top right outside neat line, 1860 (plate then owned by John McAllister, Jr.).

Benjamin Latrobe's Watercolors, 1798–1800

At the end of the century Benjamin Latrobe introduced still another element into the pictorial record: that of the professional architect-engineer portraying the buildings he designed.

Despondent over his wife's death, Latrobe sailed from England to America in 1796, already an experienced architect and consulting engineer. During that summer he spent a night at Mount Vernon with Washington, sketching as was his wont, and produced a profile of the patriarch. After another two years in the South he arrived in Philadelphia, where he practiced for more than twenty years as this country's first trained professional architect.

Soon Latrobe received commissions for the design of public buildings, the requirements for which were unusually adapted to his engineering talents. In 1799 no less than four important tasks occupied him.

His success in placing his new Greek-Revival Bank of Pennsylvania on an irregular lot bounded by four streets, on Second above Walnut, was most important for his career. It led to his remaining in Philadelphia where he produced a large output of important work and ultimately became engaged in plans for the National Capitol in Washington. The foundation stone for the handsome white marble bank building was laid 6 April 1799. Although Latrobe regretted the directors' insistence that the structure imitate a temple, the result was beautiful, simple, and useful, featuring a great circular banking hall. It was occupied in 1801, completed entirely without the use of

Fig. 129

He in a trice struck Lyon thrice
upon his head, enrag'd sir.

Who seiz'd the tongs to ease his wrongs,
And Grifwold thus engag'd, sir.

Congress Hall,
in Philad.ª Feb. 15, 1798.

wood except for floors, trim, and the roofs of the wings. Latrobe's watercolors of the structure are preserved, two being dated 1800, along with his plans, sections, and elevations drawn in the same medium.

Another 1799 activity related to two buildings for Philadelphia's water supply. Pure water was a problem that had to be met promptly. In a later manuscript volume, prepared in Latrobe's hand, appears his essay discussing the excessive cost of bringing it from the Wissahickon Creek or the new Delaware and Schuylkill Canal and showing the genesis of the plan in which he was engaged of taking it from the Schuylkill close to the city. He designed two new functional buildings that would serve as pumphouses. Of these, one became very well known as the "Pepper Box" in Center Square, now the site of Philadelphia's massive City Hall. In the center of a park Latrobe set a classical shell, square on the ground floor to house the central pump and offices around the sides, round on the floor above to house the storage reservoir distributing the water by gravity through pipes beneath the city streets. The second building was an engine house of square, squat but interesting outlines erected at Chestnut Street and the Schuylkill. The engine supplied the power to elevate the clean water from the river to a level at which it would flow to Center Square. This served its purpose only a short time when its inadequate capacity forced the installation of far larger works at Fairmount. By the late 1820's the picturesque engine house had become the manufactory for producing Tucker chinaware, and the Pepper Box was removed.

Watercolor elevations for Latrobe's bank and water supply buildings appear in his manuscript volume *Designs of Buildings erected in the year 1799* at the Historical Society of Pennsylvania.

The fourth of Latrobe's 1799 designs was very different in purpose and spirit: that for "Sedgley," generally considered to be the earliest American house designed in the Gothic style. Sedgley overlooked the Schuylkill at a location in present-day Fairmount Park near the eastern end of the Girard Avenue Bridge. Latrobe's large watercolor of the structure is undated, but there remain in his sketchbook three Schuylkill-Wissahickon watercolors dated in the summer of 1799. By inference the Sedgley view may be attributed to the same year, when the house was built.

Of the three watercolors last mentioned, the most interesting looks up the Schuylkill from the then village of East Falls and is accompanied by text identifying the homes shown and describing the rock ledge forming the Falls of the Schuylkill which, "when the river is full may be easily passed by the boats coming from the upper country."

Pictures of Latrobe's work at Philadelphia are important, for it has been said that he changed the city's taste to new architectural usages and that "his buildings, whether Greek or Gothic, had a way of being the first of their kind in America."

Drawings by Latrobe of the Bank of Pennsylvania

(179) Bank of Pennsylvania at Philadelphia U. S., by Benjamin Latrobe. Watercolor, probably 1800, 10 × 17⅝. Attribution: Designed by B H Latrobe Esq. Source: Maryland Historical Society.

(180) North-Flank Bank of Pennsylvania 1800, by Benjamin Latrobe. Watercolor, 1800, 11⅝ × 21½. Attribution: B Henry Latrobe architect. Source: Historical Society of Pennsylvania.

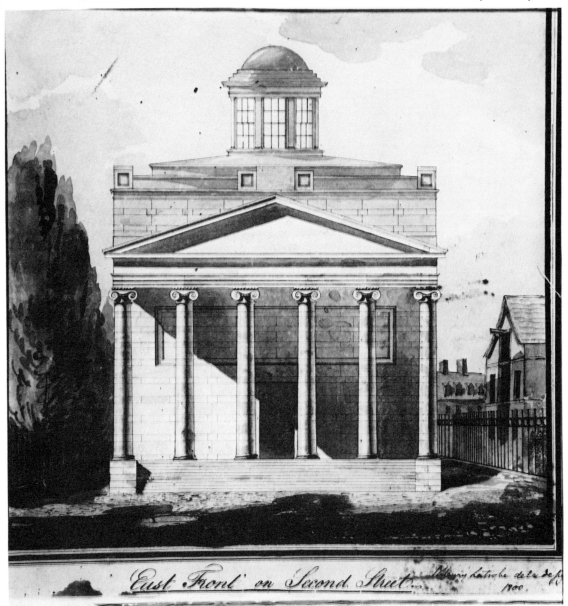

East Front on Second Street

Fig. 130

(181) *Fig. 130.* East Front on Second Street, by Benjamin Latrobe. Watercolor, 1800, 10½ × 10¾. Attribution: B Henry Latrobe del & desig. Source: Historical Society of Pennsylvania. *Fig. 130*

(182) West Front under the Portico, by Benjamin Latrobe. Pen drawing, probably 1800, 5⅞ × 6⅝. Source: Historical Society of Pennsylvania.

Watercolors in Latrobe's manuscript volume at Historical Society of Pennsylvania, Designs of Buildings Erected in the Year 1799 in Philadelphia

(183) (Bank of Pennsylvania) West Elevation, 4⅜ × 3⅜.

(184) (Bank of Pennsylvania) East Elevation, 2⅞ × 3⅜.

(185) (Bank of Pennsylvania) Elevation of the North and South Flanks, 4⅜ × 9¼.

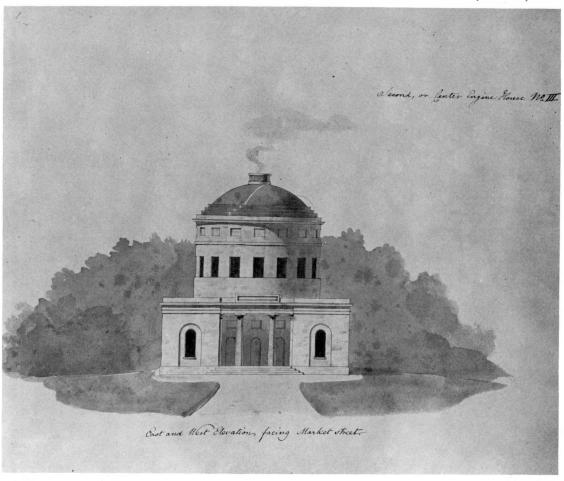

Second, or Center Engine House No. III.

East and West Elevation, facing Market Street

Fig. 131

Fig. 131

(186) *Fig. 131.* (Center Square Engine House) East and West Elevation, facing Market street, 6 × 10¼.

(187) (Schuylkill Engine House) North & South Elevation, as along Chesnut Street, 3½ × 9⅝.

(188) (Schuylkill Engine House) West Elevation, looking to the Schuylkill, 3 × 4⅛.

(189) (Schuylkill Engine House) East Elevation along Front street, Schuylkill, 3 × 4⅛.

Watercolor of Sedgley by Latrobe at Fairmount Park Commission, Philadelphia

Fig. 132

(190) *Fig. 132.* (Sedgley), probably 1799, 12¾ × 23¾.

Schuylkill-Wissahickon watercolors in Latrobe's manuscript sketchbook 5 at Maryland Historical Society

(191) View of the Schuylkill—taken Augt. 31st. 1799 looking up the river from a spot on the East Shore, a little below the Falls, 8½ × 18¾.

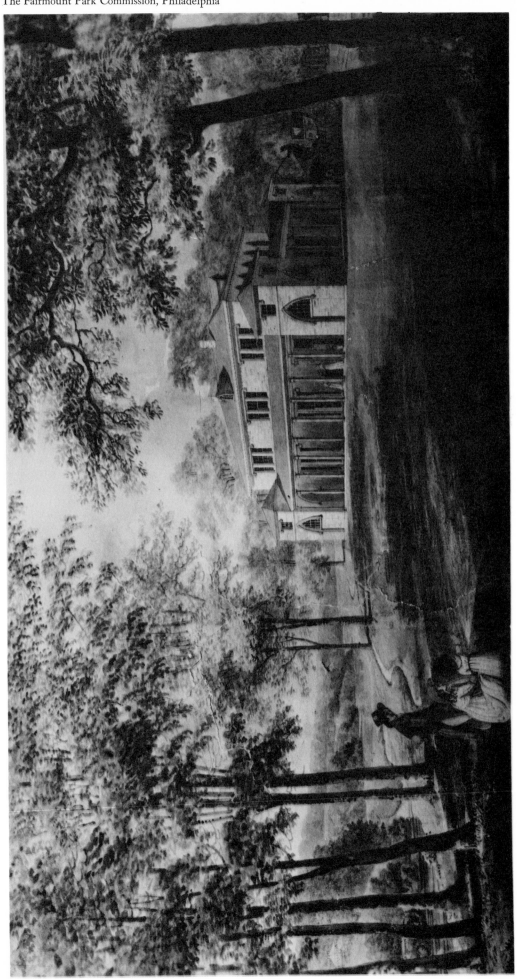

Fig. 132

(192) View on Wissahickon Creek, about ½ a mile above its junction with the River Schuylkill; taken from the Southern Banks Septr. 16th, 8½ × 18¾.

(193) View of an old Mill on Wissahickon, Septr. 18th 1799, 8½ × 18¾.

Two Schuylkill River Landscapes in Oil, 1800

As William Birch and his son were finishing the work on their engraved views, William Groombridge, whose *Woodlands* was painted as early as 1793, traveled north of the city area the Birches were portraying and produced two additional formal paintings of scenes along the Schuylkill River.

Groombridge was apparently as delighted with the river as was William Birch, who eight years later was to make a number of engravings of scenes along it. The combination of its wooded areas, its cliffs tumbling into the water, its sharp bends, its falls and islands, and the dappling of the substantial country homes along its banks—all in back country without the intrusion of commerce or industry—must have been ideal for their purposes.

One 1800 Groombridge painting known as *Fairmount and Schuylkill River* shows such a scene: a view through trees extending across the stream, the focal point in the distance a mansion on the opposite bank. The title is a misnomer and was probably bestowed later, for Fairmount is not shown. In the opinion of Philip B. Wallace, a twentieth-century photographer of Philadelphia buildings, the house in the picture is Strawberry Mansion as then just completed by Judge William Lewis and without its later flanking wings.

View of the Schuylkill was painted in the same year and employs the same technique. The river bends sharply out of sight, but at the point selected the sloping banks are cattled and anglers stand, absorbed, in the foreground. The right background displays a fine set of residential structures, unmistakably those of Mount Pleasant Mansion built in 1761 by Captain McPherson and sold during the Revolution to Benedict Arnold who, however, never occupied it.

Although Groombridge's paintings elicited no interest in Philadelphia, Baltimore, where the family moved in 1804, provided a welcome contrast. There Groombridge found his work championed in the public press without his asking. He now had to compete with a rival, another English emigré, Francis Guy. Probably he had known Guy earlier, for Guy too had come to Baltimore from Philadelphia. Guy's style, while distinctive, was totally nonacademic. An exhibition and sale took place where the paintings of both men were offered. Many more of Guy's were sold. This infuriated Eliza Anderson, editor of the Baltimore newspaper *The Observer*. Convinced that the public's error had resulted from its lack of education, she sought to mold opinion in Groombridge's favor by publicizing his "distinguished talent." It is a pungent comment on the inability of American artists to make a living from their canvases that those of both artists, when not specially commissioned, had to be disposed of by raffling.

Baltimore contrasted with Philadelphia in another happy way when the distinguished art collector and connoisseur Robert Gilmor, Jr., already mentioned, included Groombridge in his famous collection of many works of the great masters and relatively few by American artists.

Groombridge maintained some Philadelphia ties, for twenty-one of his paintings

were exhibited at the Pennsylvania Academy of the Fine Arts beginning in the year of his death, 1811, and continuing until 1819. Thirteen landscapes were included, one of them the *View of the Schuylkill.*

Groombridge and William Birch were clearly friends, for upon the former's death a listing of the volumes in his library disclosed a copy of Birch's *Views of Philadelphia* among several hundred books and portfolios of prints and drawings. It was valued in Groombridge's estate at five dollars.

Groombridge has a place in the lengthy development of art and public attitudes through which American landscape painting finally attained full recognition in the 1820's; but modern reaction to the quality of his work has varied. At one pole of criticism stands James Thomas Flexner, for he views the Groombridge landscapes as "proper, conventional, and insipid," and regards his work along with that of other Baltimore painters as having "the sterile and withered charm of an old maid who has not forgotten that once—long, long, ago—she was beautiful." A more favorable viewpoint is that of Oliver Larkin, whose studies indicated to him that Groombridge's "swift notation of foliage had the Gainsborough touch." J. Hall Pleasants seems at midpoint in characterizing the Groombridge landscapes as "typical examples of the academic English school of landscape painting of the period."

(194) *Fig. 133.* (Schuylkill River landscape), by William Groombridge. Oil on canvas, 1800, 25 × 36. Attribution: W. Groombridge Pinxt. 1800. Source: Historical Society of Pennsylvania.

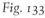

Fig. 133

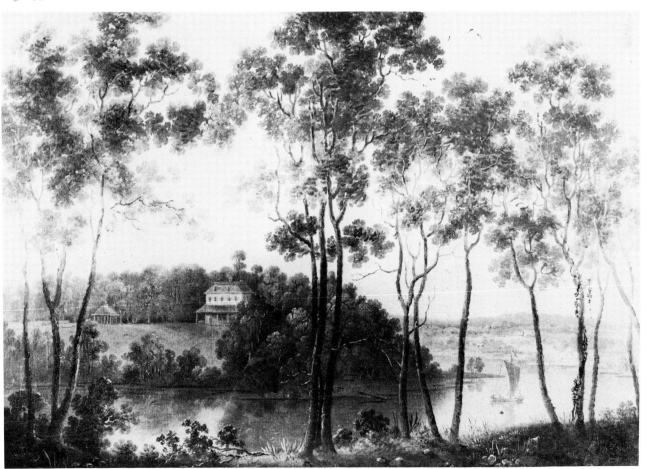

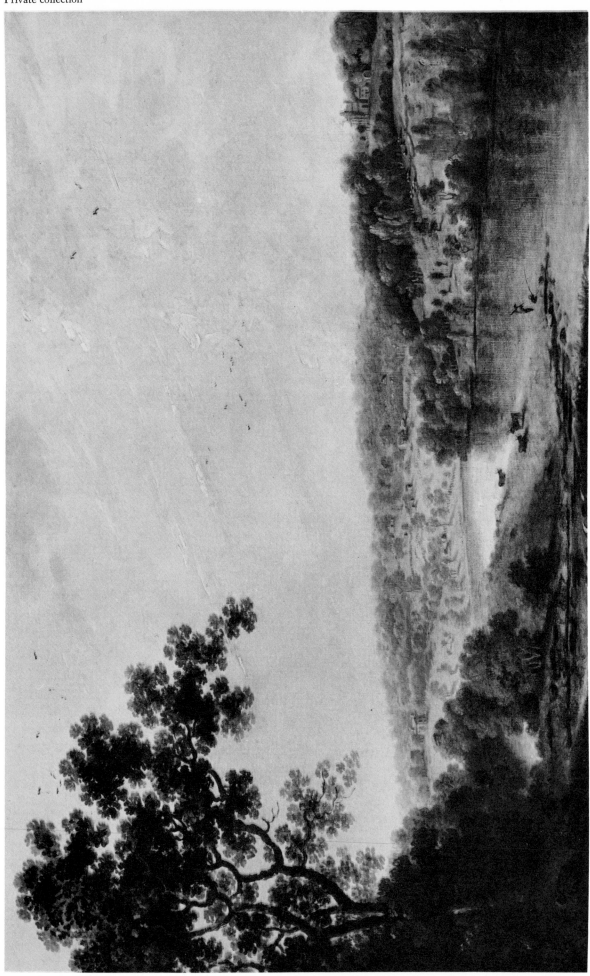

Fig. 134

(195) *Fig. 134.* (View of the Schuylkill), by William Groombridge. Oil on canvas, 1800, 25 × 36. Attribution: W. Groombridge, Pinxit 1800. Source: Private collection.

Fig. 134

Note: Groombridge also exhibited at the Pennsylvania Academy of the Fine Arts paintings described as: View from a public road near Germantown, and View at the Mouth of the Wissahiccon, both unlocated.

The Falls of the Schuylkill and East Falls Village in Two Paintings, 1800

Still another English artist who arrived in America at the time of Birch and Groombridge was George Isham Parkyns, a native of Nottingham. Like Birch, he had published a book of views in England. His abilities lay both in painting and in aquatint engraving.

Parkyns does not appear to have been truly a Philadelphia resident, except possibly for two or three years at the very end of the century. Rather his base of operation was New York, where in 1795 he announced the first proposed series of American aquatint scenic views, to be issued in partnership with James Harrison, publisher. A Philadelphia subject was to be included. The number was fixed at twenty-four, the size at seventeen by twenty-four inches, and the price at three dollars each if "black or brown" and five dollars if colored. An engraved title page, map, and list of subscribers was to appear with the last view. The subject matter seems to have comprehended both pure landscapes and city views. Parkyns was skilled in aquatint, so it is unfortunate that the Philadelphia view never appeared. The series attained to only four items. This has been attributed to the requirement that each subscriber agree to take the whole series, thus pledging payment of a large sum.

A few years later Parkyns acted as architect in designing one of the Schuylkill River mansions, *Egglesfield.* Robert Egglesfield Griffith became owner of a tract lying on the west side of the river near today's Girard Avenue Bridge. His name was given to the house built in 1798 by John Borie, who must have given Parkyns the commission as architect for it. The mansion is depicted in Cephas Childs's *Views of Philadelphia and its Vicinity.*

In 1800 came Parkyns's handsome painting of a country scene somewhat farther up the Schuylkill. The artist seated himself by the corner of an old mill on the west side and looked across at the village of East Falls, now a part of Philadelphia. The falls themselves appear in the mid-distance, while in the left background what is now Midvale Avenue winds uphill from the stream through scattered homes and farms. The cross-river area is carefully delineated and repays study of its details. The scene may have been intended for the still-projected series of aquatints as a landscape item additional to the planned view of Philadelphia.

Although Parkyns lived until about 1820, his connection with Philadelphia seems to have ended soon after his Schuylkill River painting was made. At about that time he was retained by the managers of the Pennsylvania Hospital to prepare an engraving of it (presumably in aquatint) that would serve as a new form of student diploma. Parkyns produced a watercolor, probably early in 1801, which had to be sent to Lon-

don for engraving because by March of that year he had left Philadelphia. His next stop may have been Nova Scotia: Four aquatints of Halifax were published in his name at the end of April. Parkyns is mentioned as "somewhat erratic in his life and inclined to nomadic habits." He returned to England before 1808.

In the same year that Parkyns painted his panorama from across the Schuylkill, one of America's best-known portrait painters included a silvery distant view of the Falls of the Schuylkill in a large portrait of Dr. William Smith, who had a country home there. Gilbert Stuart had come to Philadelphia late in 1794 for the purpose of painting General Washington. He was lodged in the home of Smith's son at Fifth and Chestnut streets, where apparently he stayed until 1796 when the great number of visitors to his city studio forced his removal to Germantown. There he remained until he followed the national government to Washington.

Germantown was close to the Falls of the Schuylkill and to "Smith's Folly," the house built by Dr. Smith as early as 1765 overlooking the falls on the Germantown side. The unusual home was semioctagonal in shape, from which fact came its sobri-

Fig. 135

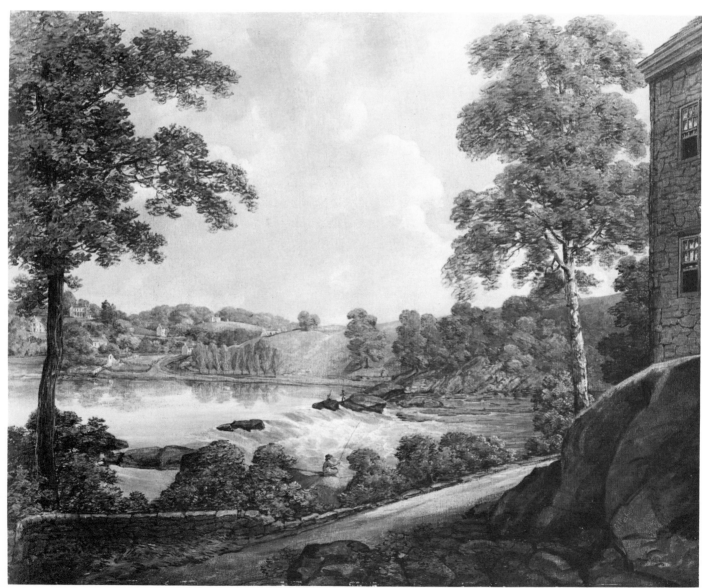

Fig. 136

quet. Smith commuted to and from it as a relief from the official home assigned to him at Fourth and Arch streets as provost of the College of Philadelphia, later the University of Pennsylvania. Although his doctorate was in theology, he was an activist in science, literature, and education, was a strong voice in political and social questions, and was one of Philadelphia's best-known figures. Withal, he had a keen eye for real estate and owned land on both sides of the Schuylkill.

Stuart portrayed Dr. Smith seated at his desk, papers in hand and books close by. In the background a curtain partially drawn back reveals the river at the falls, rocky boulders protruding—probably as seen from the window of Smith's Folly. The treatment of the landscape seems more distant than that by Parkyns.

The scene as painted by Stuart has been praised as demonstrating his real ability in pure landscape as well as in portraiture. Because of Smith's public position in eighteenth-century Philadelphia and the desires of his descendants, at least six copies of the original portrait have been made.

Fig. 135 (196) *Fig. 135.* (Falls of the Schuylkill), by George Isham Parkyns. Oil on canvas, 1800, 28 × 36. Attribution: G I Parkyns 1800. Source: Private collection.

A small nineteenth-century engraving by Cephas Childs of the scene at the Penn Treaty Tree states that it was copied from an original by Parkyns in 1794. No such painting or drawing has been located, but the same scene appears on an eighteenth-century French engraving (197) titled: Orme sous lequel Guillaume Penn conclut, à Kensington, son premier traité avec les Indiens (copy at Historical Society of Pennsylvania).

Another English artist, George Beck, who was in Philadelphia c. 1795–1804, painted a view of The Woodlands and a scene on the Schuylkill River, which may have been executed by 1800. See J. Hall Pleasants, "Four Late Eighteenth-Century Anglo-American Landscape Painters," *Proceedings of the American Antiquarian Society* 52 (1942):187, 200, 204, 210.

Fig. 136 (198) *Fig. 136.* (Portrait of William Smith), by Gilbert Stuart. Oil on canvas, 1800, 37 × 60. Source: University of Pennsylvania Archives.

The Birch Series of Philadelphia Views, 1798–1800

By 1798 William Birch and his son Thomas were depicting not one scene, but the whole of the United States capital, in the first plates of a large series of engravings completed within the next two years. To this work all previous portrayals of the appearance of Philadelphia became a prelude.

The Birch set of twenty-eight views within the city was so intensive in the planning and so effective in execution as to make all earlier efforts—no matter how important individually—simply sparks of light in a great void. Birch illumined. His aim was not to commemorate a single event or to show a single new structure, but to record a city. He systematically reviewed its whole extent and both its public and private buildings. Even this was only a part of his approach. He wanted to portray not only the background for living, but also to show the full quality of that living itself: the vitality of

the place; the atmosphere of expansion and growth; the busyness of its streets with market life; Indians; soldiery; and citizenry.

Birch's adventure in producing his book—for the making and the selling of it fell in that category—has been researched and described in detail. The idea must have seized him very shortly after his arrival from England in 1794. All the preliminary work was complete by 1798, the date that appears on two of the regularly published plates (as well as one quickly replaced and one altered upon the death of Washington). The bulk of them, fifteen, appeared with the date 1799, and seven are dated 1800. Four, including a new map of the city, were issued undated.

Birch made separate studies for parts of his pictures. He reworked copperplates which when printed from did not fully meet his goals. In some cases he scrapped finished plates for entirely new ones. Apparently he made drawings that did not progress to the engraving stage: A 1798 picture of the old city almshouse (1732) between Third, Fourth, Spruce, and Pine streets, known to watercolorist David J. Kennedy but since lost, seems to have been replaced a year later with a view of the newer almshouse (1767) on Pine at Eleventh Street. The later building was more imposing and forward-looking, and Birch definitely was not looking backward.

Fig. 137

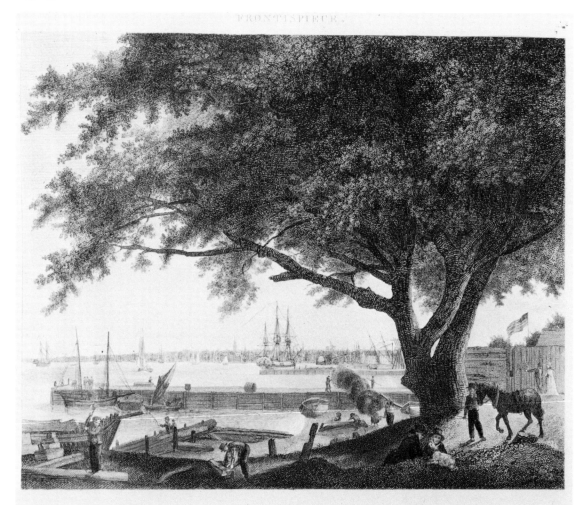

The City & Port of PHILADELPHIA, on the River Delaware from Kensington.

Other books of Philadelphia views followed Birch's, but only after almost thirty years. He blazed a trail in quality. The only views of his predecessors which appear favorably in comparison with his are the "exterior" views portraying the city as a whole. Birch created only one such, because they were too general for his purpose. The earlier "interior" prints, on the other hand, reflecting years of gradual development and of increasing ability on the part of the artists, never rose to Birch's quality. A good example of the great difference between his approach and that of others working even in the same years is provided by the Statehouse. Only three of the many pre-Birch representations show it as more than a façade, and all from the same vantage point. Birch alone equaled this number with fine variety: He devoted one plate to its formal front on Chestnut Street; another to the area of the outside clock and tower; and still a third to a lively scene in the Statehouse garden along Walnut Street.

So many new vantage points for pictures of subjects never before considered, so many interesting details of street life of a kind not before transferred to copper, and such enthusiasm and ingenuity as Birch brought to his heavy task, produced a complete cross section of the city that at that time represented the zenith of American culture and achievement. The individual views have always increased steadily in interest and popularity.

Birch's *Views* were the product of his own abilities and experience, including his earlier publication of a volume of English views, and of his individual reaction to the dynamic burgeoning of Philadelphia into a true capital city of the infant United States. With him the capital for the first time kindled in an artist the desire to depict the place in full as he saw it, "raised, as it were, by magic power, to the eminence of an opulent city" in less than a century from "ground in a state of wild nature, covered with wood, and inhabited by Indians." Surely Birch was conscious of the turn of a hundred years when he assigned to his book the publication date of the very last day of the year 1800. His was essentially an act of faith, a record of the present made with a conscious eye to what the future would think when looking back upon it.

The City of Philadelphia, in the State of Pennsylvania North America; as it appeared in the Year 1800 consisting of Twenty Eight Plates, by William Russell Birch and Thomas Birch. Engravings, by the artists and Samuel Seymour, 1798–1800, approximately 8½ × 11¼. Attribution: [normally] Drawn, Engraved & Published by W. Birch & Son. Sold [or Published] by R. Campbell & Co No. 30 Chesnut Street Philada (date). Source: Folio volume with attribution: Published by W. Birch, Springland Cot, near Neshaminy Bridge on the Bristol Road, Pennsylvania. Decr 31st 1800.

Fig. 137 and Colorplate 13	(199) *Fig. 137 and Colorplate 13.* Frontispiece. The City & Port of Philadelphia, on the River Delaware from Kensington.
Fig. 138	(200) *Fig. 138.* Plan of the City of Philadelphia.
Fig. 139	(201) *Fig. 139.* Arch Street Ferry, Philadelphia.
Fig. 140	(202) *Fig. 140.* Arch Street, with the Second Presbyterian Church. Philadelphia.
Fig. 141	(203) *Fig. 141.* New Lutheran Church, in Fourth Street Philadelphia.

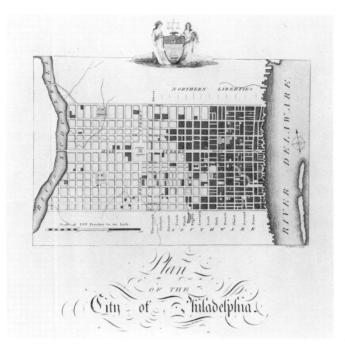

Fig. 138

Fig. 139

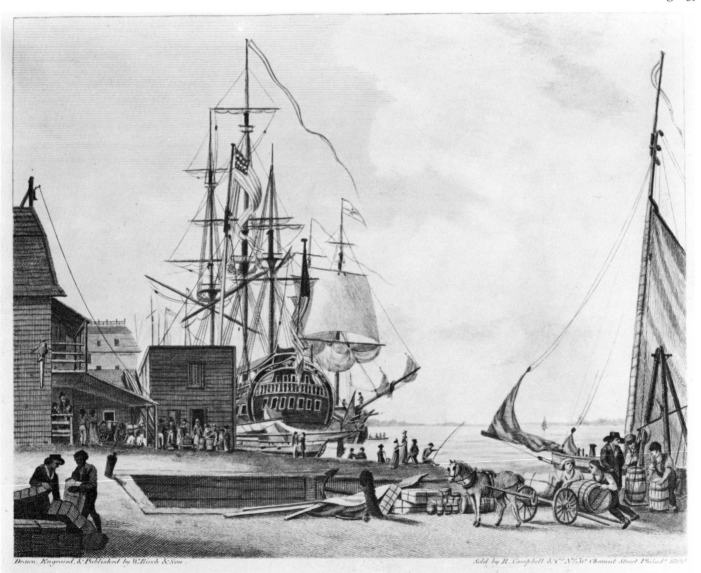

ARCH STREET FERRY, PHILADELPHIA.

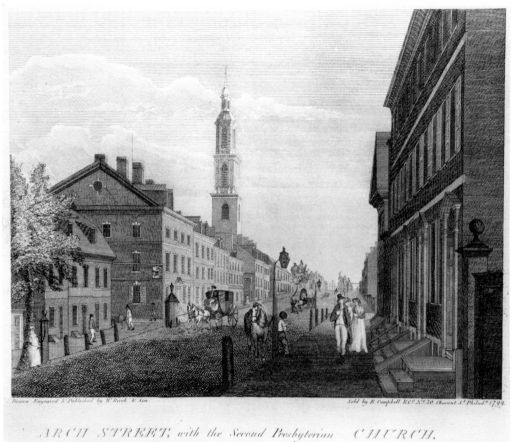

ARCH STREET, with the Second Presbyterian CHURCH.
PHILADELPHIA.

Fig. 140

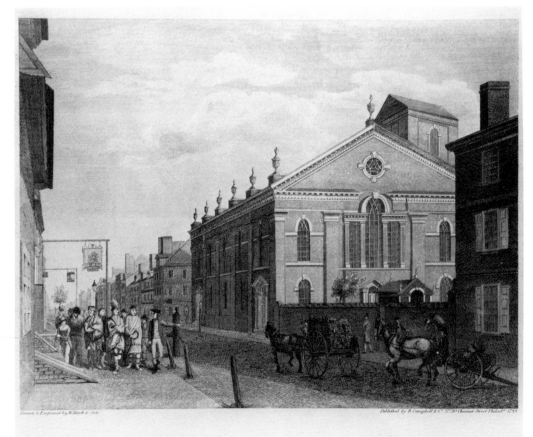

New LUTHERAN CHURCH, in Fourth Street PHILADELPHIA.

Fig. 141

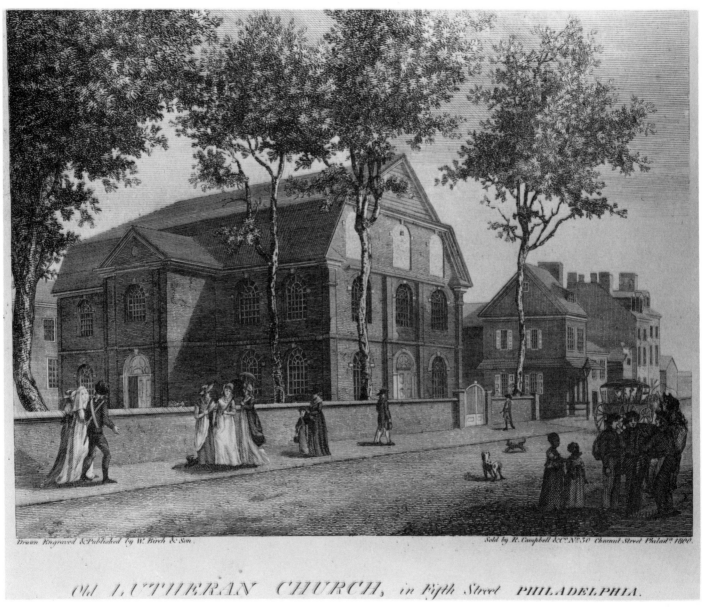

Drawn Engraved & Published by W. Birch & Son. Sold by R. Campbell & Co. No. 30 Chesnut Street Philad.ª 1800.

Old LUTHERAN CHURCH, in Fifth Street PHILADELPHIA.

Fig. 142

Fig. 143

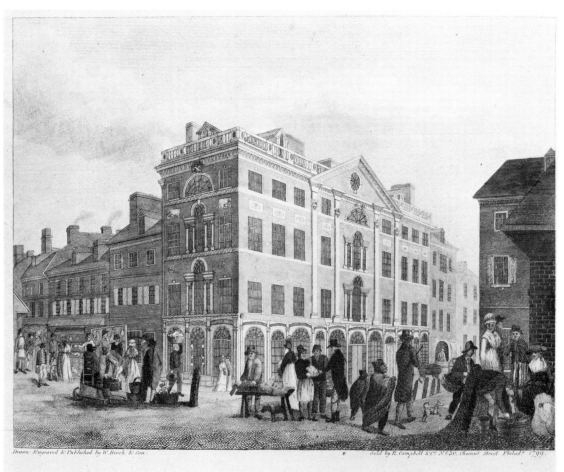

Drawn Engraved & Published by W. Birch & Son. Sold by R. Campbell & Cº Nº 30. Chesnut Street Philadª 1799.

South East *CORNER of THIRD,* and *MARKET* Streets.

PHILADELPHIA.

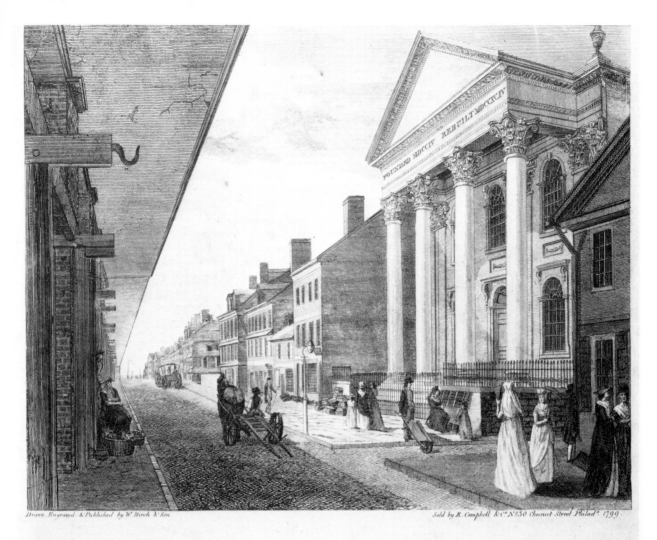

HIGH STREET, with the First Presbyterian CHURCH,

PHILADELPHIA.

Fig. 144

Fig. 145

HIGH STREET MARKET. PHILADELPHIA.

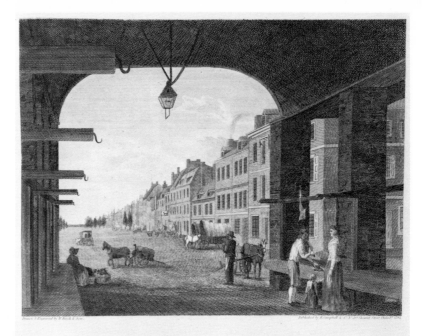

Fig. 146

HIGH STREET, From the Country Market-place PHILADELPHIA.

Fig. 147

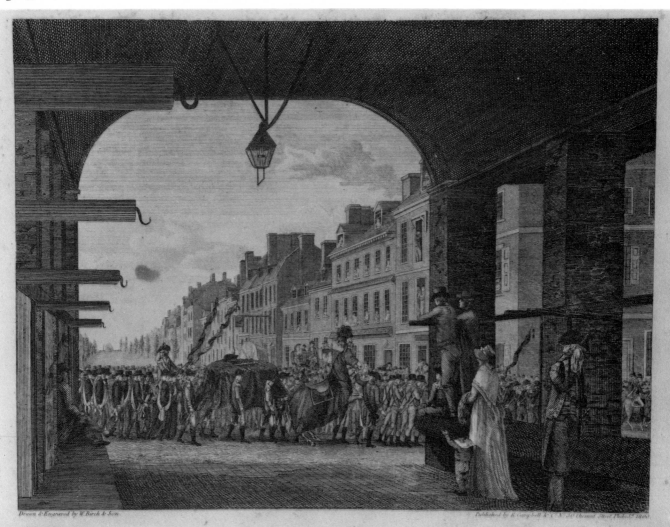

HIGH STREET, From the Country Market-place PHILADELPHIA.

with the procession in commemoration of the Death of GENERAL GEORGE WASHINGTON, *December 26.th 1799.*

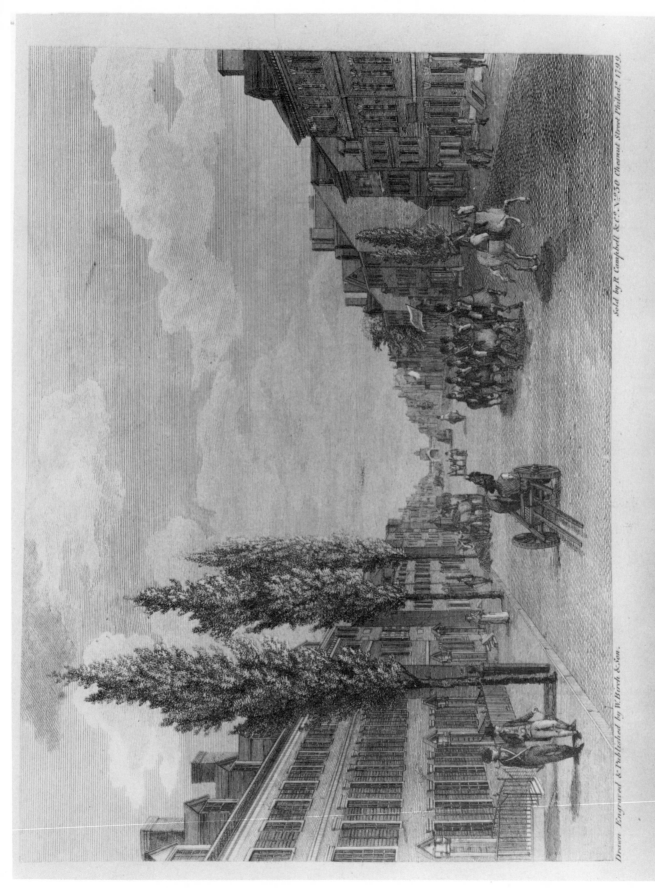

Drawn Engraved & Published by W. Birch & Son.

Sold by R. Campbell & Co.ᵃ N.º 30 Chesnut Street Philadᵃ. 1799.

HIGH STREET, from Ninth Street. PHILADELPHIA.

Fig. 148

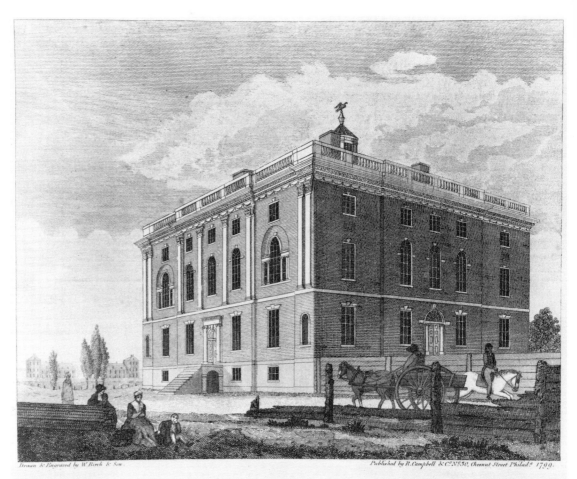

Drawn & Engraved by W. Birch & Son. Published by R. Campbell & C.º Nº 30, Chesnut Street Philadª 1799.

THE HOUSE intended for the PRESIDENT of the UNITED STATES,

in Ninth Street PHILADELPHIA.

Fig. 149

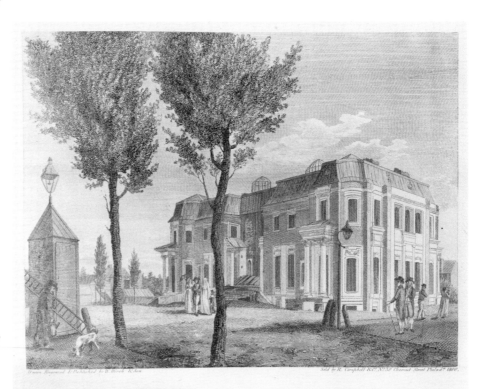

Drawn Restored & Published by W. Birch & Son. Sold by R. Campbell & C.º Nº 30, Chesnut Street Philadª 1800.

An UNFINISHED HOUSE, in Chesnut Street PHILADELPHIA.

Fig. 150

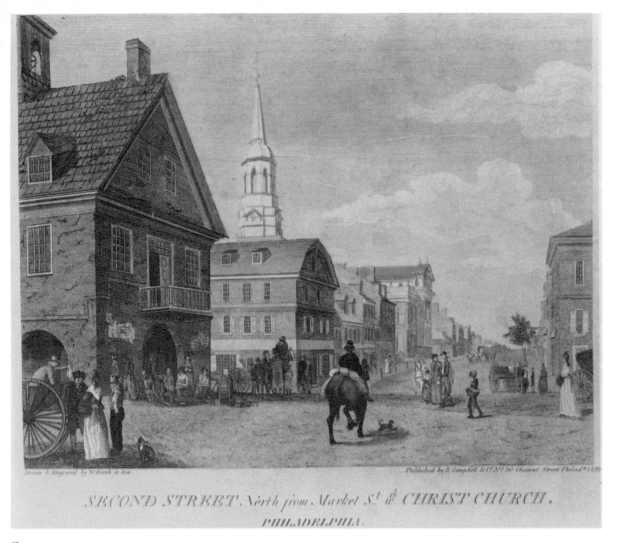

Drawn & Engraved by W.Birch & Son. Published by R.Campbell & C.º N.º 30 Chesnut Street Philad.ª 1799.

SECOND STREET. North from Market S.ᵗ w.ᵗʰ CHRIST CHURCH.
PHILADELPHIA.

Fig. 151

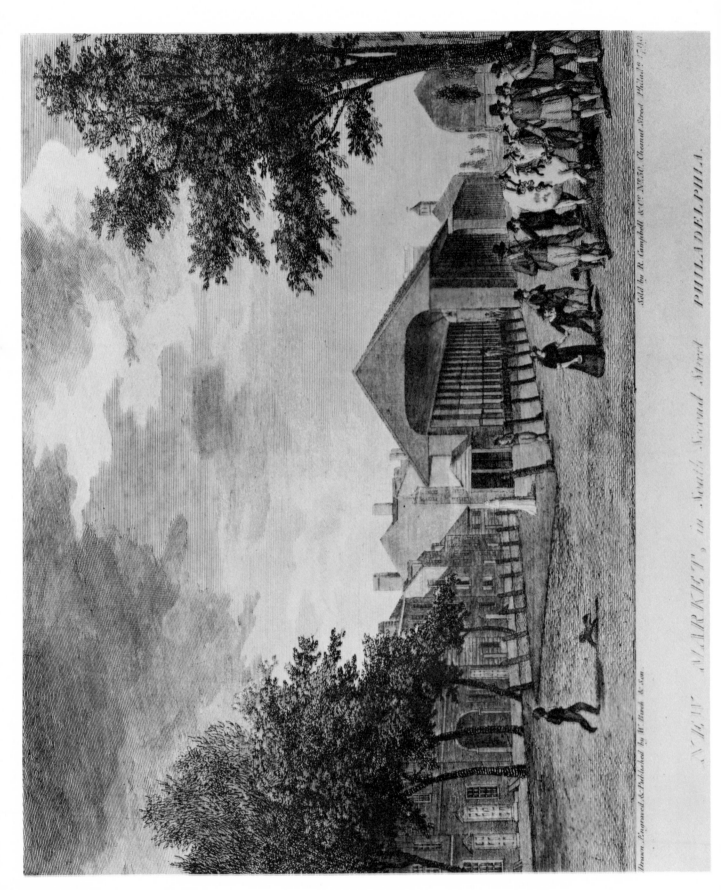

Drawn, Engraved & Published by W. Birch & Son

Sold by R. Campbell &C°. N°.30. Chesnut Street Philad°. 1799.

NEW MARKET, in South Second Street PHILADELPHIA.

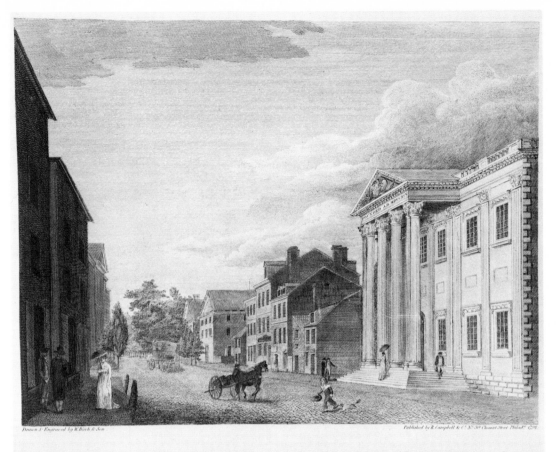

BANK of the UNITED STATES, With a View of Third Street PHILADELPHIA.

Fig. 153

Fig. 154

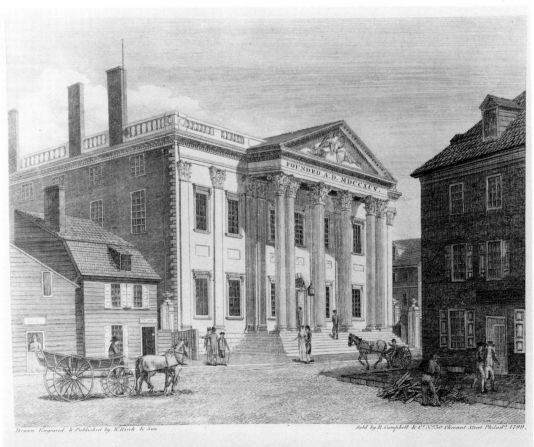

BANK of the UNITED STATES, in Third Street PHILADELPHIA.

Drawn, Engraved & Published by W. Birch & Son, Neshaminy Ferry.

View in *THIRD STREET*, from *Spruce Street PHILADELPHIA.*

Fig. 155

LIBRARY and SURGEONS HALL, in Fifth Street PHILADELPHIA.

Published by R. Campbell & C.º N.º 30 Chesnut Street Philadª 1799.

Drawn & Engraved by W. Birch & Son.

Fig. 156

CONGRESS HALL and NEW THEATRE, in Chesnut Street PHILADELPHIA.

Drawn. Engraved & Published by W.Birch & Son. Neshaminy Bridge. 1800.

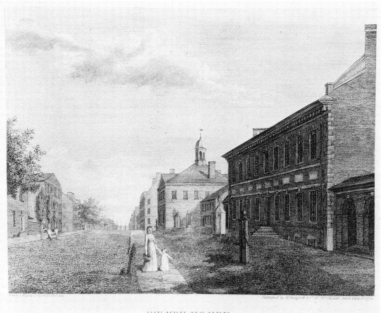

STATE-HOUSE,

With a View of Chesnut Street PHILADELPHIA.

Fig. 158

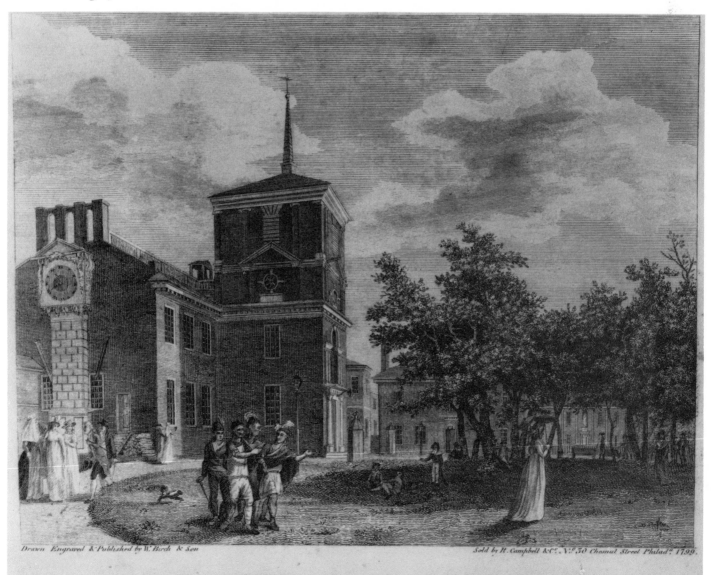

Drawn Engraved & Published by W. Birch & Son

Sold by R. Campbell & Co. No. 30 Chesnut Street Philad.d 1799.

BACK of the STATE HOUSE, PHILADELPHIA.

Fig. 159

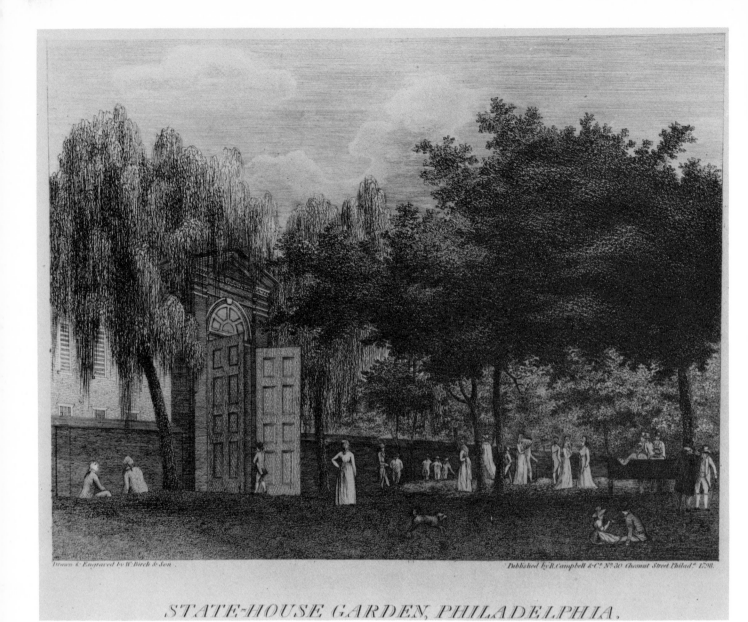

Drawn & Engraved by W. Birch & Son. Published by R. Campbell & Co. No. 30 Chesnut Street Philada. 1798.

STATE-HOUSE GARDEN, PHILADELPHIA.

Fig. 160

Note: The following watercolors and oil painting relating to Birch's *Philadelphia Views* are extant in addition to the engravings:

Watercolors of the first (228) of two engraved views of High Street Market and of (229) the engraved view of the State-House, With a View of Chesnut Street, Historical Society of Pennsylvania.

Watercolors of the engraved view of (230) An Unfinished House, in Chesnut Street; the first (231) of two engraved views of the State-House Garden; and the second (232) of two engraved views of the Bank of the United States; together with watercolor studies for the engraved views of the New Lutheran Church (233) and of Christ Church (234), all at Library Company of Philadelphia.

(235) Watercolor of the engraved view of High Street, with the First Presbyterian Church, private collection.

(236) Oil painting on canvas by Thomas Birch of Philadelphia from Kensington, 39¼ × 50, depicting the same scene as the engraved frontispiece to the volume, Historical Society of Pennsylvania.

The David J. Kennedy Collection at the Historical Society of Pennsylvania includes his watercolors of the first city almshouse at Fourth and Union streets (1–39) copied from a drawing by William Birch made in 1798, and of Fairmount (2–18) copied from a painting by Thomas Birch made in 1800—both originals unlocated.

An earlier (1789) drawing by Charles Bullfinch of the façade of the William Bingham town house (Fig. 155) is at the Library of Congress.

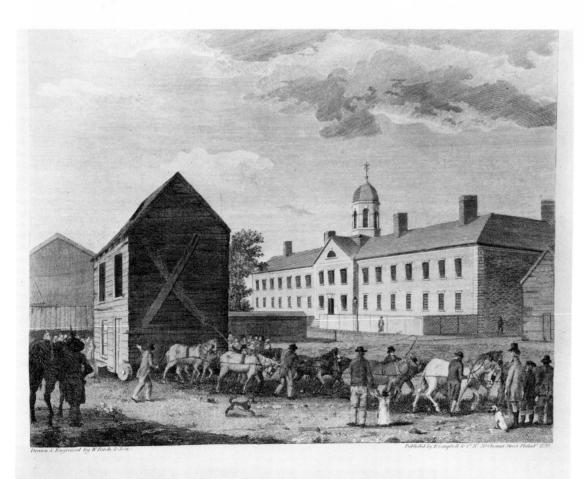

Drawn & Engraved by W. Birch & Son. *Published by R. Campbell & C.º N.º 30 Chesnut Street Philad.ª 1799.*

GOAL, in Walnut Street PHILADELPHIA.

Fig. 161

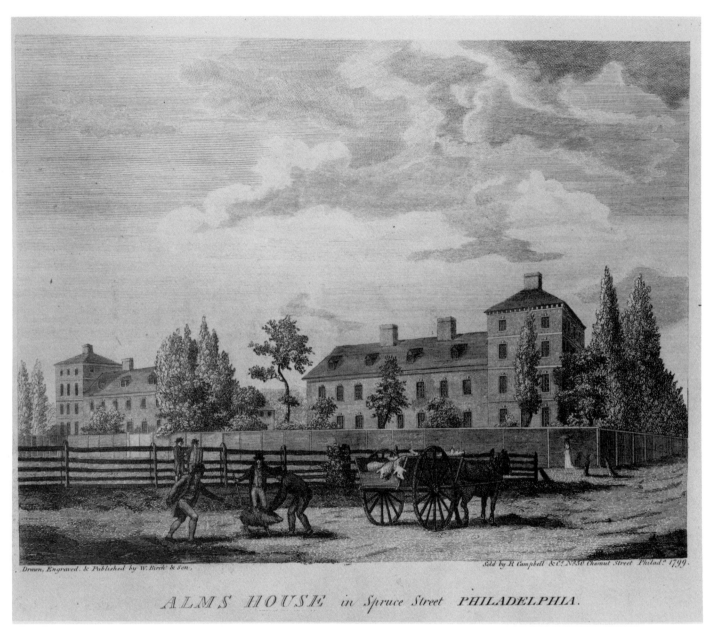

Drawn, Engraved, & Published by W. Birch & Son.

Sold by R. Campbell & C.º Nº 30 Chesnut Street Philadª. 1799.

ALMS HOUSE in Spruce Street PHILADELPHIA.

Fig. 162

Fig. 163

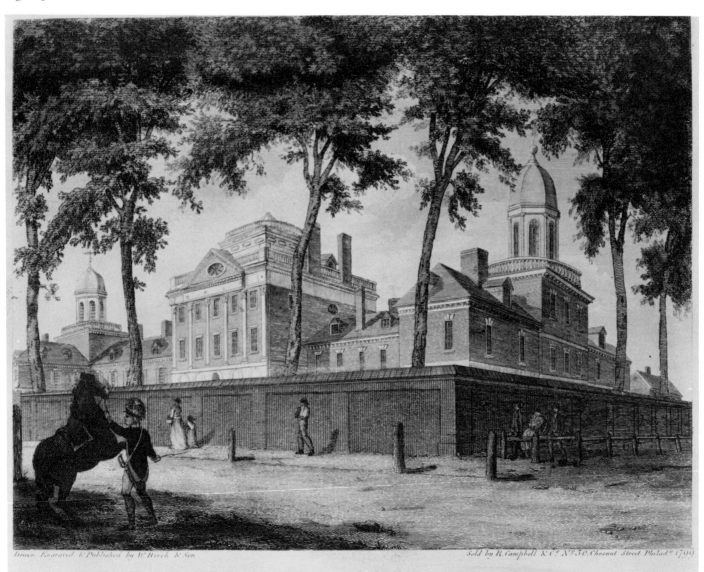

Drawn, Engraved & Published by W. Birch & Son. Sold by R. Campbell & Cº. Nº 30. Chesnut Street Philadª 1799.

PENNSYLVANIA HOSPITAL, in Pine Street PHILADELPHIA.

Fig. 164

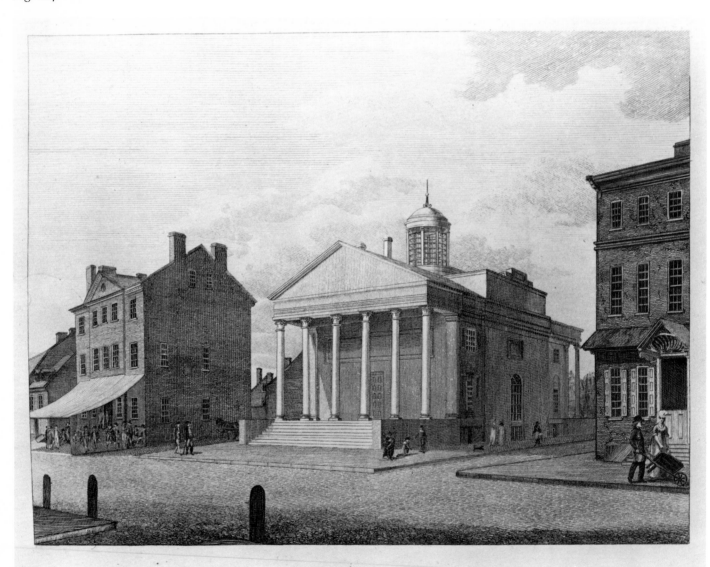

BANK OF PENNSYLVANIA, *South Second Street* PHILADELPHIA.

Drawn Engraved & Published by W.ᵐ Birch & Son Neshaminy Bridge.

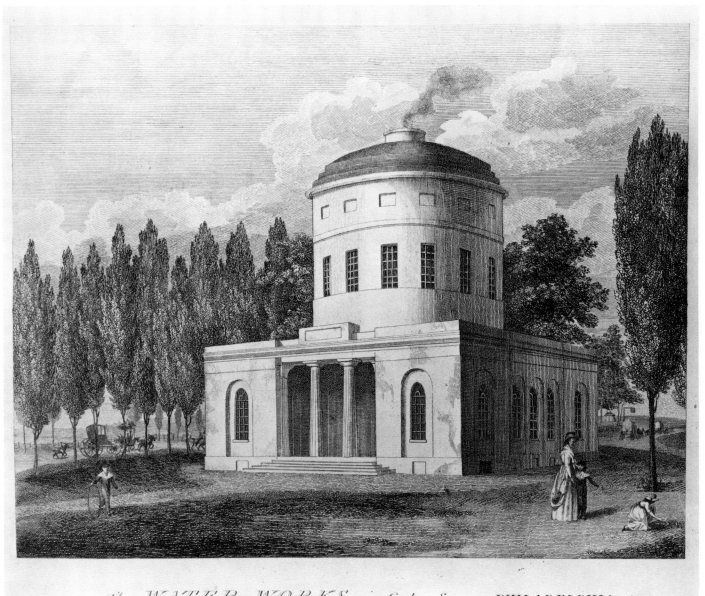

The WATER WORKS, in Centre Square PHILADELPHIA.
(at the intersection of Broad & Market St.)
Drawn Engraved & Published by W. Birch & Son Neshaminy Bridge.

Fig. 165

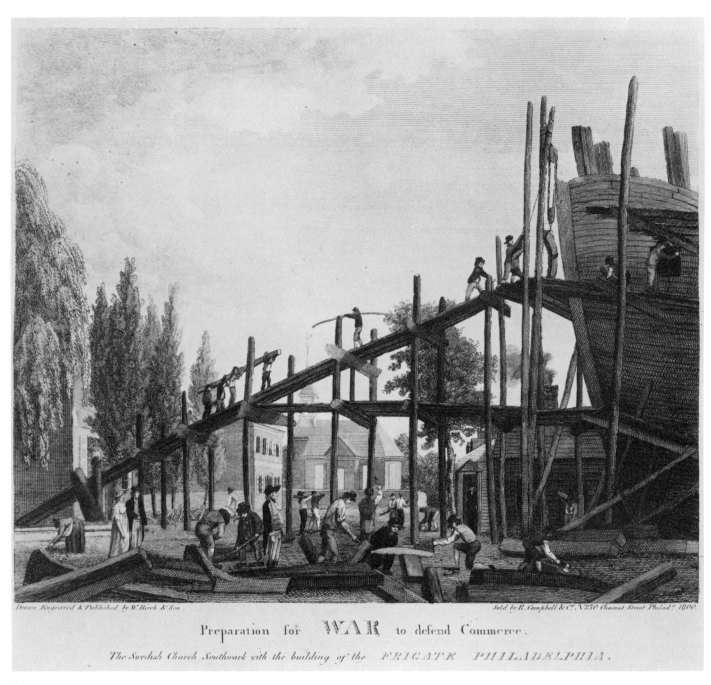

Preparation for WAR to defend Commerce.

The Swedish Church Southwark with the building of the FRIGATE PHILADELPHIA.

Fig. 166

Postface

THUS IT WAS, pictorially, that Philadelphia mushroomed from raw frontier in 1682—a late date for the planting of an American colony—to a boom town of 80 houses and cave-homes a year later; to an advertised utopia of 2,000 homes, mostly of brick, in 1700; to the second largest English-speaking city and informal capital of the colonies; to the nerve center of the American Revolution; to the scene of the Constitutional Convention; and finally to the capital for ten years of the struggling United States.

Peter Cooper in 1720 may have had something of a premonition of this, and Scull and Heap in the 1750's may have foreseen a great future for the city. Continued growth, and with it increased importance, became obvious to all by the winning of the Revolution and the establishment of the Constitution. But it remained for William Birch, lattermost yet foremost, to reproduce for all time the capital city he described as "famous for its trade and commerce, crouded in its port, with vessels of its own producing, and visited by others from all parts of the world." His magnificent pictorial record displays what was best not only in Philadelphia—then ending its tenure as the national capital—but in all early America.

And yet, like so many seeming endings, this one proved only another beginning.

Eighteenth-Century Fictitious Views of Philadelphia

In the eighteenth century it was common for artists to copy the works of others without permission. But those years also saw many instances of a different approach to the needs of the day: that of the fictitious view. Instead of copying another picture outright, one simply drew what he thought a scene would be if he could be there, or copied a work lying at hand and deliberately mislabeled it.

As a subject for artists, Philadelphia was not immune from this practice. In its case such efforts were sometimes directed to showing simply an interesting-looking place, as when the artist needed to complete a series of city views. On other occasions the intent was to show a historic event that observers had failed to record pictorially when it occurred. Still a third kind of imaginary view was that appearing in satirical prints.

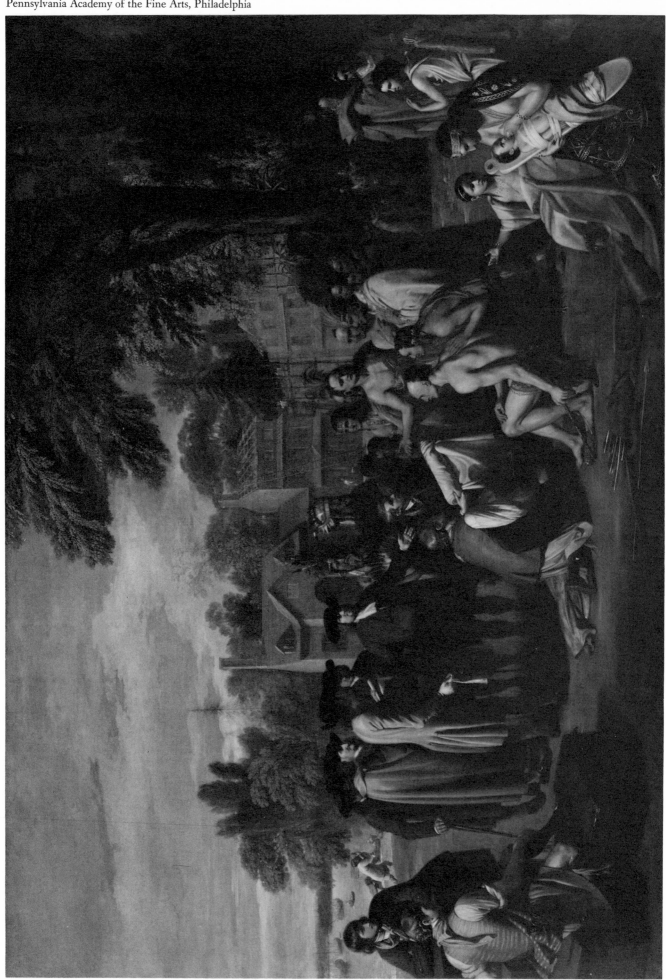

Fig. 167

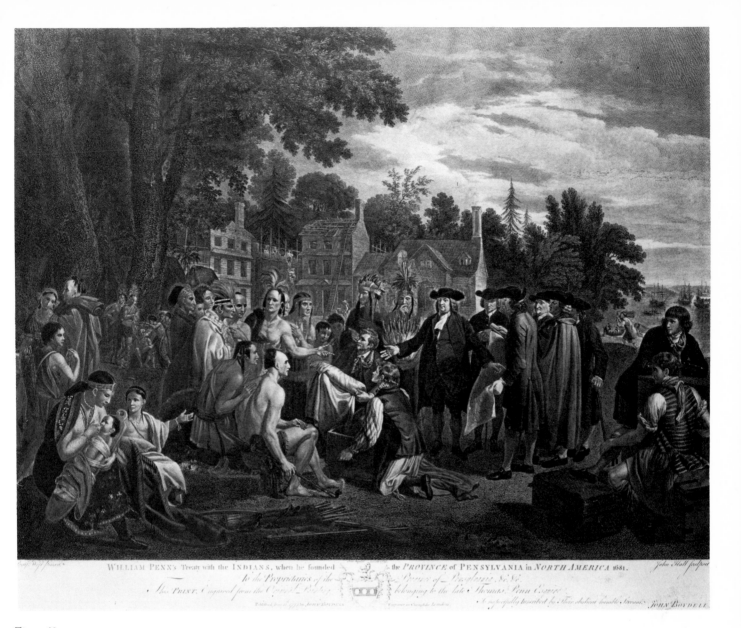

Fig. 168

The earliest (and today the most available) fanciful Philadelphia scene is that of the legendary *William Penn Treaty with the Indians,* painted by Benjamin West in London. Ellen Starr Brinton states in a study of the painting that it, like the Scull and Heap *East Prospect of Philadelphia,* was ordered by the proprietor of Pennsylvania. Upon its completion in 1771, it was first exhibited at the Royal Academy and thereafter sent to the Penn home at Stoke [Poges] Park, where it remained for nearly a century. In 1848 it was put up at the auction of the effects of William Penn's great-grandson but failed to fetch the minimum price fixed. Withdrawn from the sale, it was sold privately three years later to a Philadelphian, Joseph Harrison, and shipped to the United States. By 1878 it was the property of the Pennsylvania Academy of the Fine Arts, where it is today.

The *painting* greatly enhanced West's reputation. It was accepted in England as true in every particular, and indeed West's collection of Indian costumes vouched for that portion of it; but the buildings were presumably added for interest's sake, and the

costumes of the Quakers were more like those of the late eighteenth century rather than contemporary with the scene.

Copies of West's scene are legion. A number survive in oil. West seems also to have executed a small version in oil for use in preparing the original engraving of 1775. A very large drawing on paper is probably the preliminary sketch for the painting.

The *engraving* is one of the best-known prints of a Philadelphia scene. Issued with the Penn coat of arms and a typical florid dedication, it is in the reverse aspect of the painting. A drawing for use in the transfer to copper was made by John Hall and is now at the Historical Society of Pennsylvania. A number of trial proofs before letters also exist, some at the same institution. The persons involved in making and marketing the print were highly qualified. Hall engraved a number of works after West's paintings and became historical engraver to George III. The prints were sold by John Boydell, said to have been the first truly prosperous English print publisher and later Lord Mayor of London. On 1 January 1773 Boydell issued a broadside announcing the publication within two years of a pair of prints at fifteen shillings each, one of them the *Penn Treaty*. The actual publication date on the engraving is 12 June 1775.

In the 1890's the copperplate was found in London and brought to the United States. Copies of newly struck prints were sold before and after the plate was placed with the Society of Friends in 1909.

Copies by others of the Penn Treaty scene appeared as early as 1778. George Louis le Rouge prepared an upright version of considerable size as the frontispiece of his atlas *Pilote Américain Septentrional,* published in Paris in that year. In so doing, he reversed the picture a second time, restoring it to the scene presented by West. J. M. Moreau le Jeune prepared in 1780 apparently the first of many copies in much smaller size. Numerous lithographic reissues and variants appeared in the nineteenth century.

Fig. 167 (237) *Fig. 167.* (William Penn's Treaty with the Indians), by Benjamin West. Oil on canvas, 1771, 75½ × 108¾. Attribution: B. West 1771. Source: Pennsylvania Academy of the Fine Arts.

Fig. 168 (238) *Fig. 168.* William Penn's Treaty with the Indians, when he founded the Province of Pensylvania in North America 1681, after Benjamin West. Engraving, by John Hall, 1775, 16¾ × 23¼. Attribution: Benj: West pinxit. John Boydell excudit 1775. John Hall sculpsit. Published June 12th 1775 by John Boydell Engraver in Cheapside London.

Fig. 169 (239) *Fig. 169.* Guillaume Penn Traite avec les Indiens Etablissant la Province de Pensilvanie dans l'Amerique Septentrionale en 1681, after Benjamin West. Engraving, 1778, 16½ × 11¾. Attribution: Benj: West pinxit D.* Sculp. A Paris Chez Le Rouge rue des Grands Augustins. Source: George Louis le Rouge, *Pilote Américain Septentrional* (Paris, 1778), frontispiece.

(240) Penn achette des Sauvages le pays qu'il veut occuper, after Benjamin West. Engraving, by Villerey, c. 1780, 5¾ × 3⅝. Attribution: J. M. Moreau le Jeune Del 1780. Villerey Sculp. Liv. XVIII.

(241) An engraving similar in title, size, and year bears the attribution: N. de Lauray aqua forti fecit H. Guttenberg, Sculp. Liv. XVIII Pag 15. For others, some reversed,

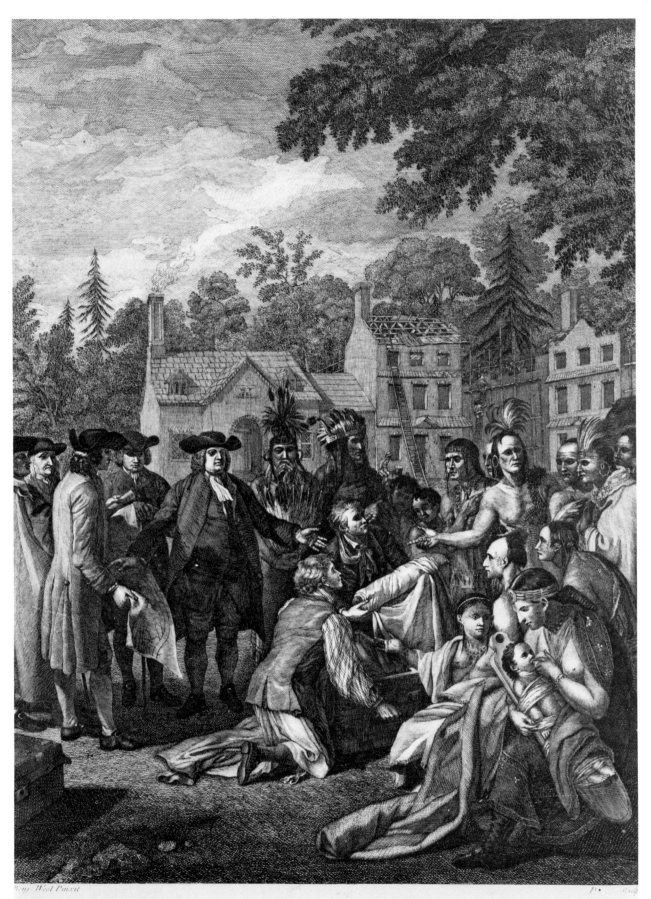

GUILLAUME PENN TRAITE AVEC LES INDIENS

Etablissant la Province de Pensilvanie dans l'Amerique Septentrionale en 1681.

Fig. 169

see Ellen Starr Brinton, "Benjamin West's Painting of Penn's Treaty with the Indians," *Bulletin of Friends' Historical Association* 30 (1941): 147.

By contrast, the second among the imaginary views is much less formal. It is a harbor scene, Italianate in flavor, titled simply *Vue de Philadelphie,* and is said to be in actuality a representation of the Seamen's Hospital in Greenwich, England. The engraving is the work of Balth Frederic Leizelt of Augsburg, and the issue date about 1776. Leizelt and François Xavier Habermann engraved a large number of fictitious plates for their Collection of Prospects. Their prints were made to be shown in the peep-show machine already mentioned. This held mirrors set at 45-degree angles so as to lend depth and perspective. The street vendors of the day used such devices to show views for a very small amount, supposedly a penny. The title appears in reverse so as to be readable through the diagonal mirrors, while the remaining descriptive material is readable to the eye. In early copies the scene is colored in opaque gouache, often varying from print to print—a device that heightened the effect in the viewing machine and makes the result strong and decorative today.

In about 1790, Leizelt's fictitious view was copied in a new and slightly smaller engraving issued by the print seller Basset, of Paris.

Fig. 170

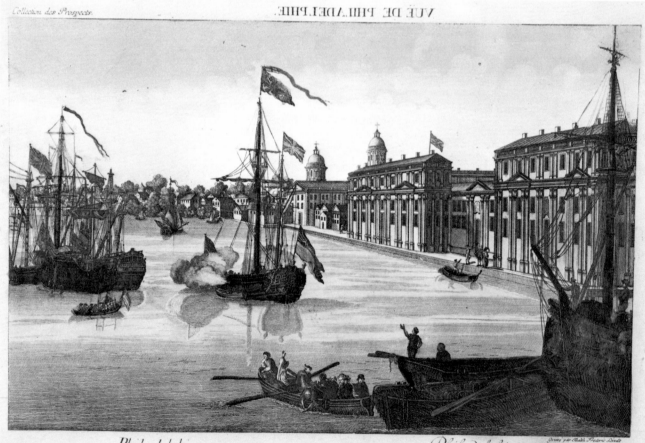

Collection des Prospects. VUE DE PHILADELPHIE.

Gravé par Balth. Frederic Leizelt

Philadelphia. *Philadelphie.*

Die Haupt Stadt in der Nord-Americanischen Provinz Pensylvanien, La Ville Capitale de Pensylvanie Province Nord-Americaine.
sie ist vom William Penn (dem Caroll II. König in Engelland William Penn, à qui Charles II Roi d'Angleterre donna cette
die ganze Provinz geschencket hatte) un Iahr 1682 zwischen Province entiere la planta en 1682 entre deux fleuves navi-
2. Schiffreichen Flüssen angelegt und desswegen Philadelphia genen- gables et l'apella Philadelphia, parceque les habitans y vi-
net worde, weil die Einwohner in Brüderlicher Einigkeit daselbst leben sollen. voient dans une Harmonie fraternelle.

Se vend a Augsbourg au Negoce commun de l'Academie Imperiale d'Empire des trois liberaux avec Privilege de Sa Majesté Imperiale et avec Défense ni d'enfaire ni de vendre les Copies.

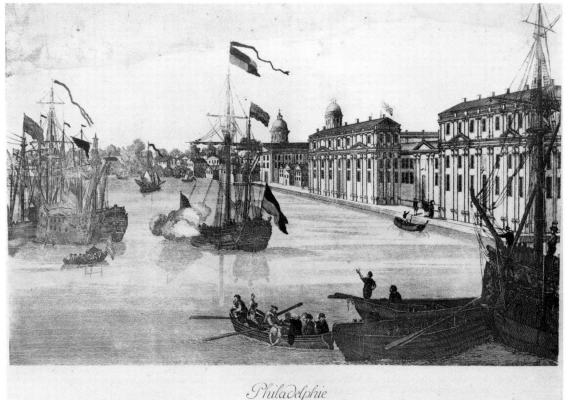

Philadelphie

La Ville Capitale de Pensylvanie Province Nord-Americaine William Penn, à qui Charles II Roi d'Angleterre donna cette Province entiere la planta en 1682 entre deux fleuves navigables et l'opella Philadelphie, parceque les habitans y vivoient dans une Harmonie fraternelle

Presentement chez Basset rue Saint Jacques au coin de celle des Mathurins, Tient Fabrique de Papiers

Fig. 171

(242) *Fig. 170 and Colorplate 16.* Collection des Prospects (at top). Vue de Philadelphie (at top, engraved in reverse), by Balth Frederic Leizelt. Engraving, by Balth Frederic Leizelt, c. 1776, 9⅞ × 15½. Attribution: Gravé par Balth Frederic Leizelt Se vend a Augsbourg au Negoce comun de l'Academie Imperiale d'Empire des Arts Libereaux avec Privilege de Sa Majesté Imperiale et avec Defense ni d'en faire ni de vendre les Copies. Source: F. X. Habermann and B. F. Leizelt, *Collection des Prospects.*

Fig. 170 and Colorplate 16

LATER STATE

(242A) As above, but with title in reverse shortened to: Philadelphie.

REPRINT

(242a) Modern color reprint titled: Vue du Port de Philadelphie (1760).

(243) *Fig. 171.* Philadelphie, after Balth Frederic Leizelt. Engraving, c. 1790, 9½ × 15⅛. Attribution: Presentement chez Basset rue Saint Jacques au coin de celle des Mathurins, Tient Fabrique de Papiers.

Fig. 171

In 1778 there appeared a famous kaleidoscopic scene, published in London, that jibed at the sorry state many thought England to be in at the time. As first issued in the *Westminster Magazine*, it was captioned *A Picturesque View of the State of the Nation for February 1778.* Accompanying text explained that the British economy was like a cow being milked by other nations, while the British lion, symbol of her governmental power, lay asleep being despoiled by a dog. England's current military

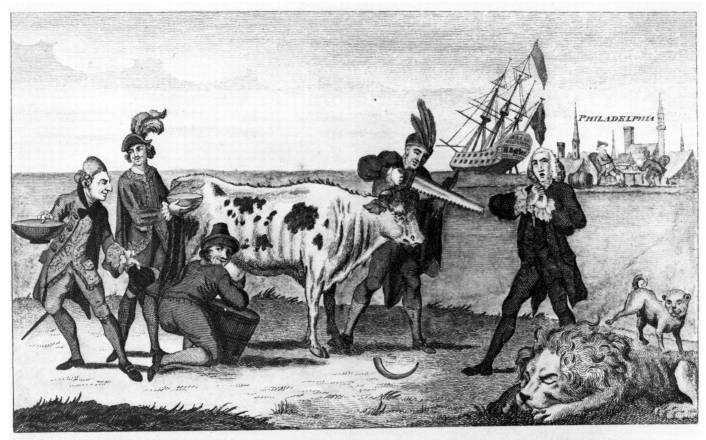

A Picturesque View of the State of the Nation for February 1778.

Fig. 172

posture was depicted by the flagship *Eagle* lying aground, separated from the fleet invading America, as had happened in the Battle of Fort Mifflin a few months earlier. Seated sleeping before a city in the background appear the brothers Howe, in charge of the land and naval forces at Philadelphia, besodden with wine. The city is labeled as Philadelphia.

In a very short time this popular lampoon was reissued in England, Philadelphia, France, Holland, and probably Germany. In the nineteenth century it appeared as a transfer print on china, designed to please the American consumer although manufactured in England.

Fig. 172 (244) *Fig. 172.* A Picturesque View of the State of the Nation for February 1778. Engraving, 1778, 3¹⁵⁄₁₆ × 6¾. Source: *Westminster Magazine* (London, February 1778), p. 64 and plate.

REISSUES

Fig. 173 (244a) *Fig. 173.* Many Dutch and French copies, and some published in America and England, quickly appeared. They have been attributed to c. 1780. Most are of larger size, approximately 6½ to 6¾ by 10 to 10½. In a few the scene is reversed from the original. Changes appear among them in the details of the drawing. Some lack both a title and descriptive wording on the plate; others carry key numbers with en-

graved descriptions. The Dutch variants appear to have been accompanied by a separate letterpress explanation. Various of these republications are described in the reference books cited in the notes.

Other more reportorial efforts to depict the city and its experiences during the Revolution exist. A simple and decorative French watercolor map of Philadelphia of about 1780 appears to have been prepared from some other manuscript rather than on the spot. The Delaware runs along the bottom of the sheet, an orientation used in 1762 but which did not reappear until the 1790's. A large gouache drawing of a local battle of 1777, said to have been drawn about 1782 upon commission by a British officer involved in it, is the work of one Xavier Della Gatta. It is a lively rendering of the Battle of Germantown at Cliveden Mansion on the Germantown Road, which still stands. The drawing forms one of a pair with a portrayal of the Paoli Massacre outside the city.

Fig. 173

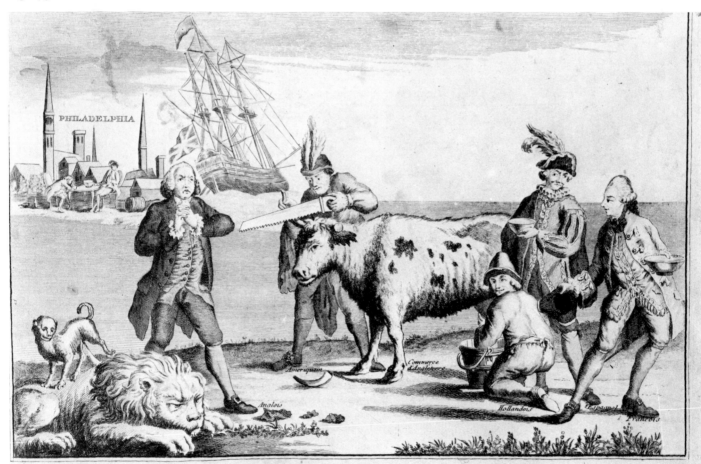

MAL LUI VEUT MAL LUI TOURNE DIT LE BON HOMME RICHARD

Sujet Mémorable des Révolutions de l'Univers

Le Commerce de la Grande Bretagne sous la Forme d'une Vache

Le Congrès representés par l'Ameriquain occupé a lui enlever ses Armes
deffensive en lui sciant les Cornes.
Le Hollandois d'un Air content, s'occupe à tirer la Vache.
Un Francois s'avance avec politesse pour avoir du lait.
l'Espagnol d'un Air grave se presente aussi pour le même objet

Un seul Vaisseau de la formidable Flotte Angloise paroit seul, et est
Embourbé près Philadelphie, Les Generaux dans l'inaction dans cette Ville.
Le Lion Brittannique profondement endormie pendant qu'un petit dogue
lui marche sur le Corp; l'Anglois en Deuil Consternés et Abatie
n'a pas la force de reveillé le Lion pour deffendre ses prerogative;

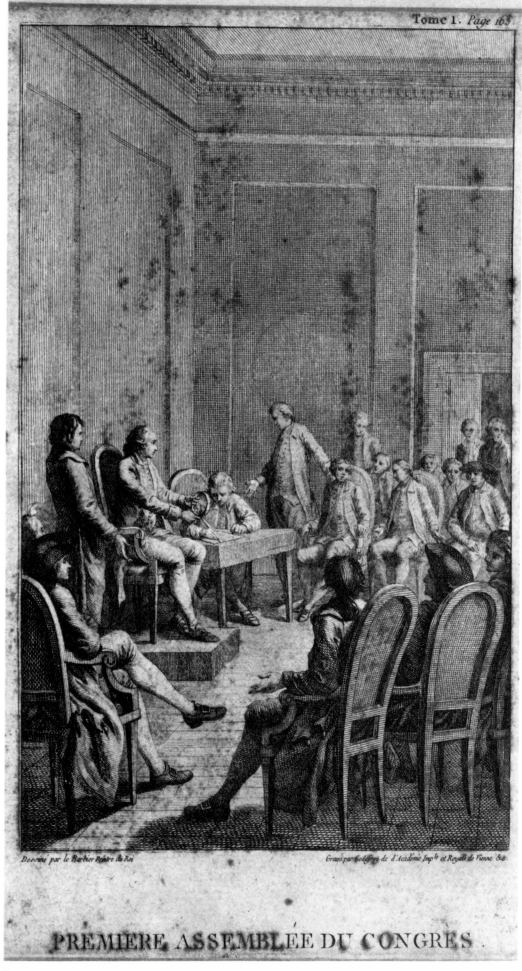

Dessiné par le Barbier Peintre du Roi

Gravé par Godefroy de l'Académie Imp.le et Royale de Vienne &c.

PREMIÈRE ASSEMBLÉE DU CONGRÈS.

Fig. 174

(245) plan de la ville de philadelphie capitale de la pensilvanie, un des etats-unis de l'amerique septentrionale. Watercolor, c. 1780, 7¾ × 12¼.

(246) (The Battle of Germantown at Cliveden), by Xavier Della Gatta. Gouache, c. 1782, 13⅝ × 22½. Source: Valley Forge Historical Society.

Before Americans created pictures glorifying their own great historical events, the interest of Europeans led to their being depicted in book illustrations in Europe. A French engraving of the *Première Assemblée du Congrès* dates from about 1783; an English view of the public reading of the Declaration of Independence was published in about the same year; and two imaginary German views of the signing of that document appeared during the decade.

(247) *Fig. 174.* Premiere Assemblée du Congrès, by Jean J. F. le Barbier. Engraving, by François Godefroy, 1782–83, 6¼ × 3⅞. Attribution: Dessiné par le Barbier Peintre du Roi Gravé par Godefroy de l'Académie Imple. et Royale de Vienne &c. Tome 1. Page 163.

Fig. 174

Fig. 175

Fig. 175

(248) *Fig. 175*. The Manner in which the American Colonies Declared themselves Independant of the King of England, throughout the different Provinces, on July 4, 1776, by William Hamilton. Engraving, by George Noble, 1783, 11 × 7¼. Attribution: Hamilton delin. Noble sculp. Engraved for Barnard's New Complete & Authentic History of England. Source: Edward Barnard, *The New, Comprehensive and Complete History of England* (London, 1783), p. 688.

(249) Der Congress erklart die 13 vereinigten Staaten von Nord America fur independent am 4ten July 1776. Engraving, 1784, 3 × 2. Source: Haude and Spener, *Historisch-genealogischer Calendar oder Jahrbuch . . . fur 1784* (Leipzig, 1784).

(250) (Congress Voting Independence), by H. Ramburg. Pen, ink, and sepia wash, c. 1784, 3⅛ × 2⁹⁄₁₆. Source: Metropolitan Museum of Art, Charles Allen Munn Bequest.

The 1780's also brought forth a second fictitious view of the harbor of Philadelphia. The engraving states that it was derived from a painting by the French artist Claude Joseph Vernet. Although this may well be so, the scene has been analyzed as the harbor at Lisbon. The work was apparently done to provide one of a volume of views of seaports.

Fig. 176

(251) *Fig. 176*. Vue du Port Philadelphie dans l'Amérique Gravée d'après le Tableau de Vernet, by Claude Joseph Vernet. Engraving, c. 1785, 5¾ × 8¼. Attribution: Vernet pinxit. d. 4.

REPRINT

(251a). As above, but with inscription: Photo-Collagraph by J. Carbutt, Phila. Pa., c. 1876, 5½ × 7⅛.

Apparently the year 1787 saw the first American fictitious view of the city in the form of a small woodcut: A locally published Latin-English dictionary sought to depict both Philadelphia and London in its frontispiece. Fortunately the two are labeled. Later that same year John Norman, who had earlier lived in Philadelphia, published in Boston *Weatherwise's Federal Almanack* for 1788 and used for its cover a woodcut depicting the Constitutional Convention held some months earlier at the Statehouse.

(252) (Philadelphia). Wood engraving, 1787, 1⅞ × 2½. Source: James Greenwood, *The Philadelphia Vocabulary, English and Latin* (Philadelphia, 1787), title page.

Fig. 177

(253) *Fig. 177*. (The Constitutional Convention), probably by John Norman. Woodcut, 1787, c. 3⅜ × 3¼. Source: John Norman, *Weatherwise's Federal Almanack, for the year of our Lord, 1788* (Boston, 1787).

In portraying historic events of the birth of the country, the imaginary scenes may be considered generally as news items, differing in their purpose from the much more

Vernet pinxit

VUE DU PORT PHILADELPHIE

DANS L' AMERIQUE

Gravée d'après le Tableau de Vernet

Fig. 176

Fig. 177

showy and romanticized works of John Trumbull. An aide to General Washington in the early days of the Revolution, he spent the decade of the 1780's in London as a student of Benjamin West, completing paintings with American historico-military themes in preparation for a career in that field. By 1790 he announced in the *Pennsylvania Packet* that he had lately returned from Europe and "has in contemplation" various pictures including *The Congress of 1776 in the declaration of Independence*. This was painted over the years 1786 to 1797, and now hangs at the Yale University Art Gallery. Except for the portraits it contains, it was apparently completed in London. Trumbull's romantic treatment of the Assembly Room in Independence Hall is to be contrasted with the documentary approach to the same scene taken in the Pine-Savage painting already reviewed. His attempt to enliven pictorially that which was only psychologically exciting still left the dominant feature, the figures, with the calm aspect criticized by many, including Halleck and Drake in the *National Advertiser:*

> How bright their buttons shine! how straight
> Their coat-flaps fall in plaited grace;
> How smooth the hair on every pate;
> How vacant each immortal face!

Yet thirty-six of the figures were drawn from life and nine others were copied from portraits. A greatly enlarged version prepared by Trumbull was installed in the rotunda of the rebuilt United States Capitol; and in about 1820 the painting was faithfully copied on copper by Asher B. Durand, later a famous painter, at the then very large expense of $3,000. With the appearance of the engraving, dozens of smaller reproductions were published—even on linen—to the point that this was surely one of the most widely distributed patriotic scenes of nineteenth-century America.

(254) *Fig. 178.* (Congress Voting Independence), by John Trumbull. Oil on canvas, 1786–97, 21⅛ × 31⅛. Source: Yale University Art Gallery.

Fig. 178

COPIES

(254a) A much later (1831), larger (72½ × 108¹¹⁄₁₆), and simpler version prepared by Trumbull in oil on canvas is now at the Wadsworth Atheneum, Hartford.

(254b) Another large copy (40 × 60) in the diplomatic reception rooms of the Department of State, Washington, is "attributed" to Trumbull.

REPRINT

(254c) *Fig. 179.* The first engraving, 20⅛ × 30⅜, bears the copyright date 1820, but is said to have been published in 1823.

Fig. 179

(255) A drawing of the Assembly Room was made by Joseph Sansom, probably from memory. Photograph at Historical Society of Pennsylvania.

A second example of the quite early appearance of patriotic feeling in American painting lies in a picture by James Peale, brother of the portraitist Charles Willson Peale, which is attributed to about 1795. It depicts the encounter of Captain Allen

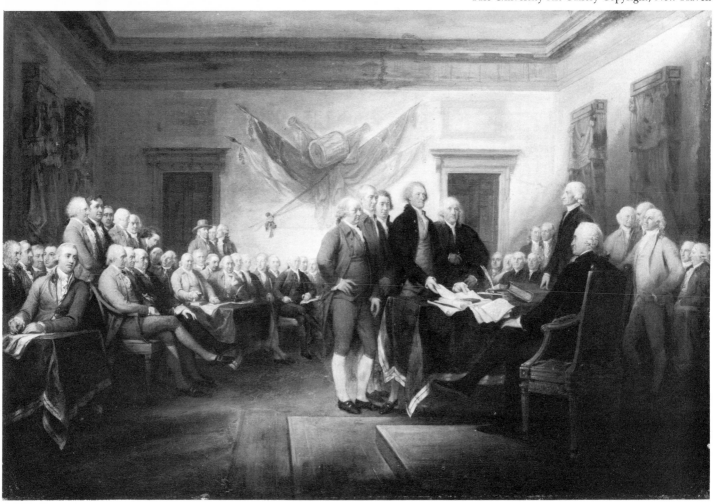

Fig. 178

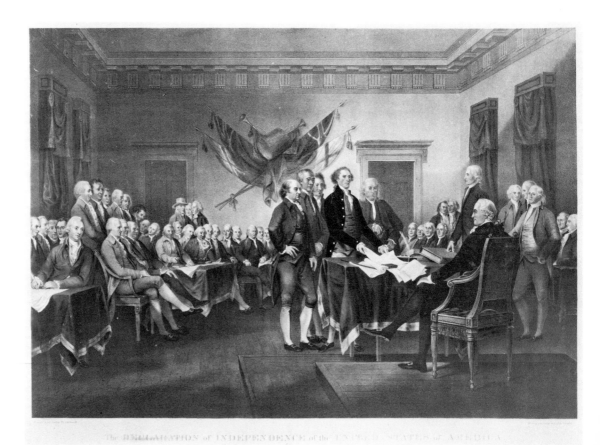

Fig. 179

Fig. 180

McLane, a native Philadelphian, with two British dragoons during the occupation of the city in 1777–78. McLane was in command as a partisan of certain American outposts that he covered on horse. The tale of the incident has been variously told, but the versions agree in their main outlines. At dawn McLane fell into a British ambush from which he escaped, only to fall into a second group that chased him for miles from the vicinity of Frankford to that of Germantown, both within the present city but far beyond the British lines blockading Philadelphia. When overtaken by the last two survivors of the chase, he either killed both or put one out of combat, but suffered a badly slashed hand. He staunched the flow of blood in the cold water of a mill-pond and hid in a swamp until nightfall. This patriot nonetheless lived until 1829, so he could have advised Peale as to the details of the painting.

(256) *Fig. 180.* (Encounter of Captain McLane with British Dragoons), by James Peale. Oil on canvas, c. 1795, 27¼ × 35½. Source: Private collection. *Fig. 180*

In 1797 an English engraved portrait of then Lieutenant General Thomas Musgrave, whose unit had held off the Americans from Cliveden at Germantown twenty years earlier, included a view of the mansion. The imaginary rendering fails to do justice to the house, now the property of the National Trust for Historic Preservation.

(257) Lieutenant General Musgrave, by L. Abbot. Engraving, by G. L. Facius, 1797, 13½ × 11. Inscription: Engraved from a Picture painted in 1786; with a view of Mr. Chews House, near Germantown, in Pensylvania 1777. Attribution: L. Abbot pinxt. 1786 G. L. Facius sc. 1797.

(258) Another drawing of a Philadelphia home depicts Fairhill, that of the Norris family, as it stood outside the city to the north before its destruction by the British late in 1777. This bears the name of Samuel Norris but not necessarily as its maker. Apparently drawn on eighteenth-century paper, it appears to be a retrospective scene drawn from memory and stylistically could be a nineteenth-century work. Title: Fairhill, The Seat of Isaac Norris Esqr. Erected 1712. Burnt by the British Army Novr. 22nd 1777. The Henry Francis du Pont Winterthur Museum, Norris Scrapbook.

Eighteenth-Century Views and Maps of the Area Surrounding Philadelphia

In the year before William Penn arrived in Philadelphia, a map was published for him in London in order to display the area he sought to settle. The unnamed site of the city appears without a designation. The engraving sets out and identifies a number of native trees, a fact that has inspired searches for and a book about the twentieth-century survivors from among Penn's primeval forest.

Fig. 181 (259) *Fig. 181.* A Map of Some of the South and east bounds of Pennsylvania in America, being partly Inhabited. Engraving, 1681, 16⅝ × 20⅜. Attribution: Sold by John Thornton at the Signe of England Scotland and Ireland in the Minories, and by John Seller at his Shop in Popeshead Alley in Cornhill. London.

REPRINTS

(259a) Albert Cook Myers, Philadelphia, 9 December 1923.

(259b) John Carter Brown Library. Attribution: From the original in the John Carter Brown Library, Brown University, 1943. Reproduced in collotype by The Meriden Gravure Company.

Note: Some copies are accompanied by letterpress text affixed to bottom. This accords with the statement by William Penn in his letter cited in the notes that "There is likewise Printed a Map of Pennsylvania, together with a Description at the End of it; and some Proposals."

For other pre-Philadelphia maps of the Delaware see (260) Johannes Vingboons, manuscript titled: Caerte vande Suydt Rivier in New Nederland, c. 1640, at Library of Congress; (261) P. Lindstrom, engraving titled: Nova Suecia hodie dicta Pensylvania, mapped 1654–55, in Thomas Campanius Holm, *Kort Beskrifnung om Provincien Nya Swerige uti America* (Stockholm, 1702) p. 37; and (262) Pieter Goos, engraving titled: Paskaerte Van de Zuydt en Noordt Revier in Nieu Nederland, c. 1660.

See also probably the first map of the Delaware to show Philadelphia, an ink drawing by Jasper Danckaerts titled: Caerte van de Suid Rivier of anders delaware in America, at Long Island Historical Society.

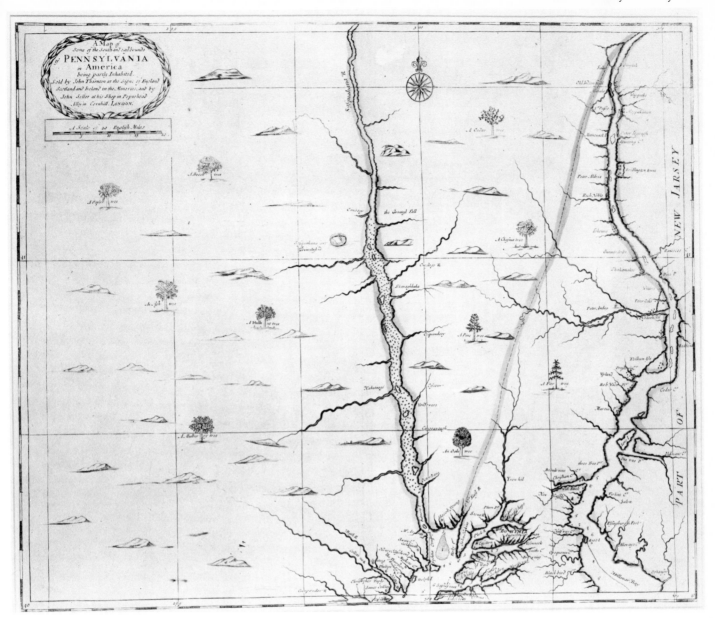

Fig. 181

In the same decade there appeared Thomas Holme's map of the Province of Pennsylvania, which has already been discussed because of its inset of the plan for Philadelphia. Despite its title, the scope of this publication was limited to the settled area around the city.

In 1702 Thomas Campanius Holm published in Stockholm an account of the Swedish settlements on the Delaware. This included an engraved scene of uncertain location, probably the first print to show a meeting between Europeans and American Indians in the Delaware Valley.

(263) *Fig. 182. Novae Sueciae Seu Pensylvaniae in America Descriptio.* Engraving, by Thomas Campanius Holm, 1702, 5⅜ × 5⅜. Attribution: Th. C. H. sc. Source: Thomas Campanius Holm, *Kort Beskrifnung om Provincien Nya Swerige uti America* (Stockholm, 1702), frontispiece.

Fig. 182

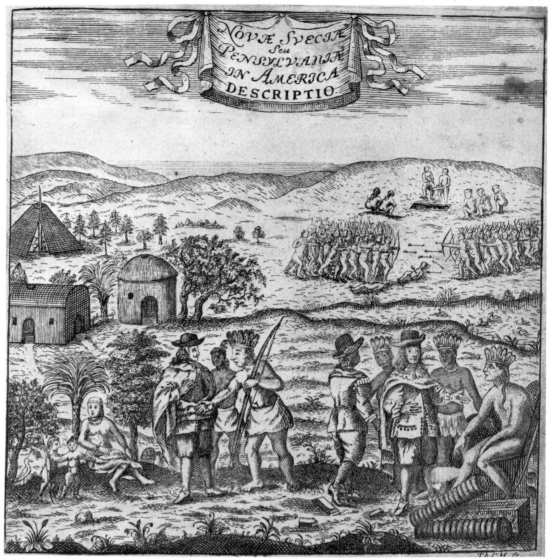

Fig. 182

Note: While this plate has often been referred to as Penn's treaty with the Indians, it may more probably represent John Moll's purchase in 1680 of most of New Castle County, Delaware. See Nicholas B. Wainwright, "The Penn Collection," *PMHB* 87 (1963):393, 412.

In 1731 Benjamin Eastburn, surveyor general of the province, prepared the important manuscript map of the environs of the city which clearly foreshadowed Scull and Heap's 1752 map of Philadelphia and "Parts Adjacent" and has been mentioned in that connection.

A most important Philadelphia-vicinity plan was first published in 1756 by Joshua Fisher, a former hatter of Lewes, a town situated near the mouth of Delaware Bay. This detailed the bay and its shoals for part of the distance to Philadelphia and was created with the express purpose of aiding pilots in bringing ships to the city. A second plate of about 1775 included the river to and beyond Philadelphia. This was the source for numerous British and French reissues during the Revolution. The city appears in grid form at the extreme right of the second large engraving. This latter chart was still for sale in the city at the end of the century.

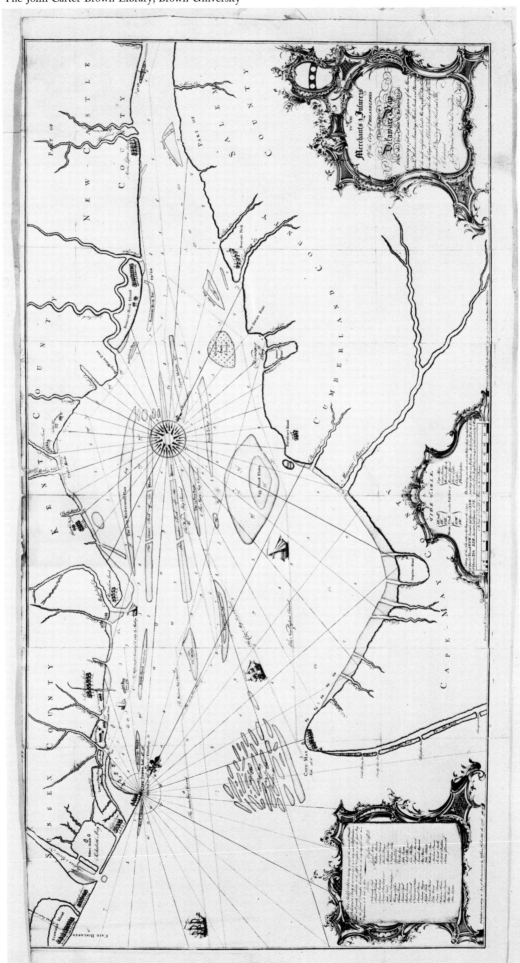

Fig. 183

Fig. 183

(264) *Fig. 183.* To the Merchants & Insurers Of the City of Philadelphia This Chart of Delaware Bay From the Sea-Coast to Reedy Island . . . Is dedicated By a Friend to Trade and Navigation Joshua Fisher, by Joshua Fisher. Engraving, by James Turner, 1756. Attribution: Published according to Act of Parliament, by Joshua Fisher Feb: 28, 1756. Engraved by Jas. Turner, and Printed by John Davis for, and sold by the Author in Front-Street, Philadelphia.

(265) To the Merchants & Insurers of the City of Philadelphia This Chart of Delaware Bay and River . . . Is Dedicated By a Friend to Trade and Navigation Joshua Fisher, by Joshua Fisher. Engraving, c. 1775, 18^{15}/16 × 27½.

REPRINTS

(265a) William Faden, 12 March 1776, 18½ × 27, in *North American Atlas* (London, 1777); and *Atlas of Battles of the American Revolution* (London, 1793). See Randolph G. Adams, *British Headquarters Maps and Sketches* (Ann Arbor, Mich., 1928), p. 77; and Trustees of the British Museum, *Catalogue of Printed Maps, Charts and Plans* (London, 1967), 4:883, for states.

(265b) Sayer and Bennett, 10 July 1776, in *The North-American Pilot, Part the Second* (London, 1777), reproduced in Naval History Division, Navy Department, *The*

Fig. 184

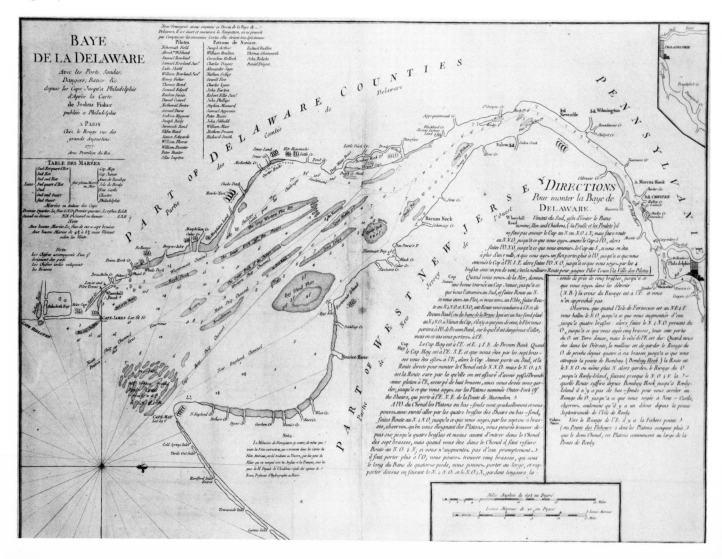

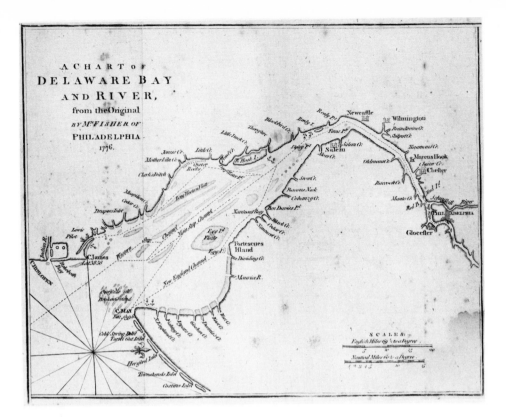

Fig. 185

American Revolution, 1775–83: An Atlas of Eighteenth Century Maps and Charts (Washington, 1972), plate 8.

(265c) Andrew Dury, 30 November 1776, 18 × 27¼, London.

(265d) John Hills, drawing, 1777, 24½ × 55, no. 16 in *A collection of plans . . . of the province of New Jersey,* 1777–82 at Library of Congress.

(265e) *Fig. 184.* George Louis le Rouge, 18½ × 25½, in *Pilote Americo-Septentrional* (Paris, 1778) (two states, the second containing sailing directions). *Fig. 184*

(265f) M. de Sartine, 1778, 23⅜ × 17, in *Neptune Americo-Septentrional* (Paris, c. 1780).

(265g) *Fig. 185. Gentleman's Magazine,* 7³⁄₁₆ × 9³⁄₁₆ (London, July 1779), p. 369. *Fig. 185*

(265h) R. Laurie and J. Whittle, 1794, 19 × 27, in *North American Pilot,* new ed., (London, 1800).

(265i) Julius F. Sachse photo-sculp., Philadelphia, 1904.

(266) *Fig. 186.* The Historical Society of Pennsylvania has a manuscript of probably *Fig. 186*
the original drawing of (265). Others (267) are at the Library of Congress. Copies of
(265) are in Atwater Kent Museum, Philadelphia, and the British Museum.

Compare (268) J. W. F. DesBarres, A Chart of Delawar Bay with soundings . . . by A. S. Hammond, June 1, 1779, 30¼ × 21⅞, in *The Atlantic Neptune* (London, 1780), with chart of the Delaware River from Philadelphia to Bombay Hook, *ibid.* [see (85) *Fig. 56*].

As was the case with the city itself, the Revolution brought forth a volume of material concerning its surroundings, some produced locally and some abroad.

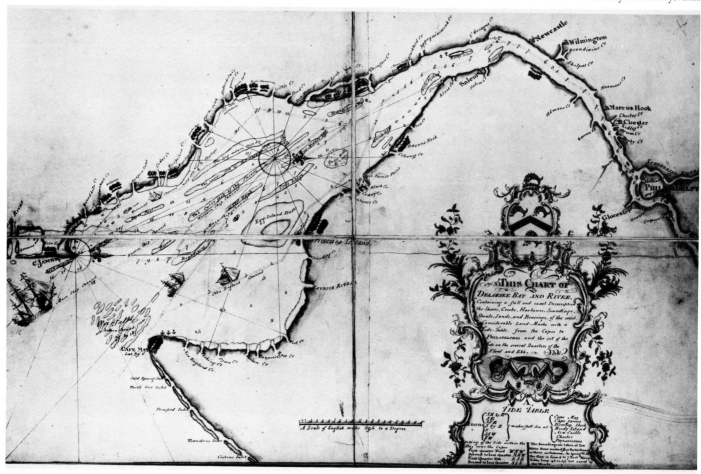

Fig. 186

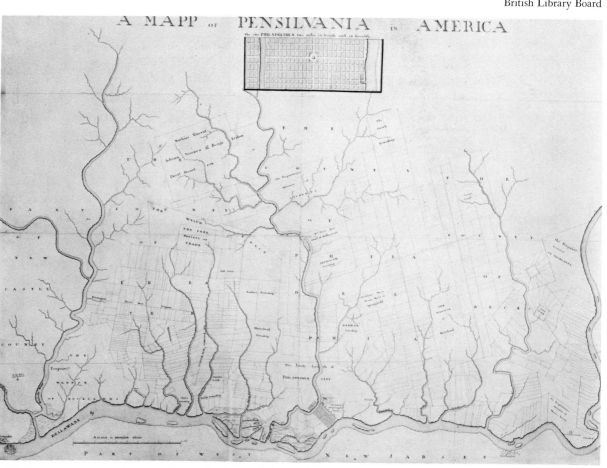

Fig. 188

Fig. 187

As early as February 1777 J. F. W. DesBarres of London reproduced Thomas Holme's seventeenth-century map of the eastern part of the Province of Pennsylvania as a double plate in the *Atlantic Neptune*. The old work was updated particularly to show the road system developed around Philadelphia over the intervening ninety years. DesBarres saw many years of American service in the British army. He was returned to London in 1774 to edit and publish his own coastal surveys prepared during that service.

Fig. 187

(269) *Fig. 187.* (Environs of Philadelphia), after Thomas Holme. Engraving, 1777, 30¼ × 41⅛ (in two sheets). Attribution: Publish'd according to Act of Parliament Feb. 19. 1777, by J. F. W. DesBarres Esqr. Source: *The Atlantic Neptune* (London, 1780).

Reprint

(269a) Barre Publishers, Barre, Massachusetts, 1968, No. 38, Pennsylvania Counties, two sheets.

Fig. 188

(270) *Fig. 188.* A manuscript map, probably the original for this engraving, is in the British Museum map room, 29⅜ × 41⅞, titled: A Mapp of Pensilvania in America; with inset: The City Philadelphia two miles in length and in Breadth.

The progress of the British troops toward Philadelphia in the fall of 1777 was duly recorded in engravings published in London by William Faden. The subject of one of these, the *Battle of Brandywine* on 11 September, was also depicted on other English, Hessian, and American manuscript plans.

Fig. 189

(271) *Fig. 189.* Battle of Brandywine in which The Rebels were defeated, September the 11th. 1777, by the Army under the Command of General Sr. Willm. Howe, in part by S. W. Werner, Lieutenant of Hessian Artillery. Engraving, by William Faden, 1778, 19¼ × 17¼. Attribution: Published according to Act of Parliament by Wm. Faden, Charing Cross. April 13th. 1778. Source: William Faden, *Atlas of Battles of the American Revolution* (London, 1793).

Later state

(271A) As above, but printed on nineteenth-century paper.

(272) The original drawing for the engraving and (273) a corrected proof are at the Library of Congress, Faden Collection, nos. 78 and 79.

For manuscript plans see:

(274) Plan of the Battle of Brandywine fought 11th September 1777, at Valley Forge Historical Society.

(275) "Laid down at 200 ps in an inch, the 27th day of August, An. Domi 1777., Pr Jais Broom, Survr. N. Castle Coy," with notes in the hand of Washington, at Historical Society of Pennsylvania. See Justin Winsor, *Narrative and Critical History of America* (Boston, 1887), 6:420–21.

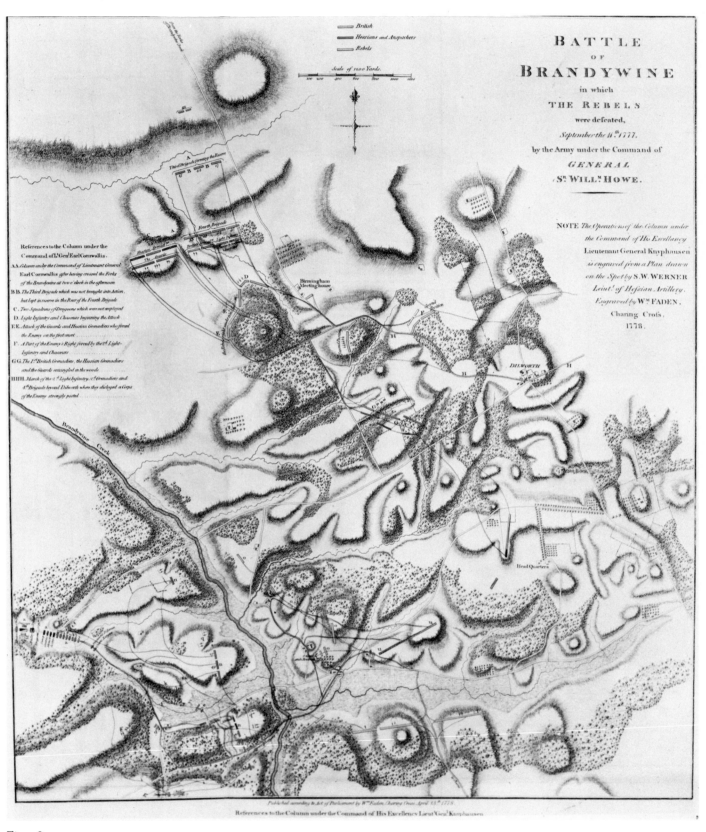

Fig. 189

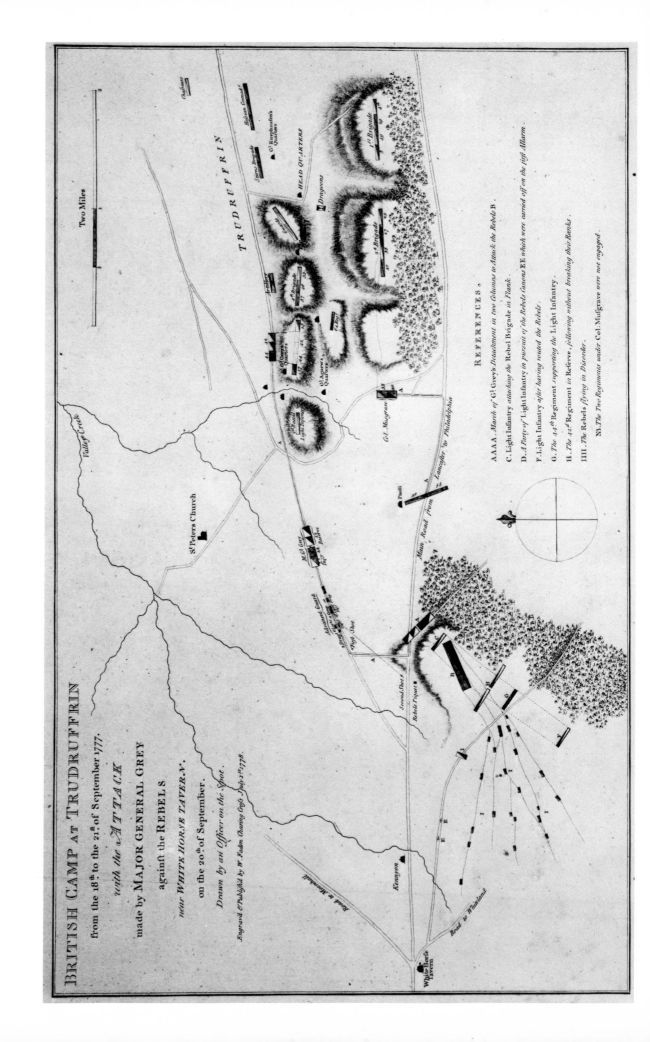

BRITISH CAMP AT TRUDRUFFRIN

from the 18th to the 21st of September 1777.

with the *ATTACK*

made by MAJOR GENERAL GREY

against the REBELS

near *WHITE HORSE TAVERN*.

on the 20th of September.

Drawn by an Officer on the Spot.

Engrav'd & Publish'd by W. Faden Charing Cross July 31st 1778.

Two Miles

TRUDRUFFRIN

St Peters Church

Valley Creek

Road to Marshall

Road to Whiteland

Kennyon

Whitehorse Tavern

Main Road from Lancaster to Philadelphia

Paoli

Col. Musgrave

Advanced Guard

Picquet Shot

Second Shot

Rebels Picquet

McEl Guy
Infy 44 Battn

Hessian Grenadiers

Chasseurs

Genl. Knyphausen's Quarters

HEAD QUARTERS

Dragoons

1st Brigade

2d Brigade

3d Brigade

4th Brigade

Artillery

Col. George's Quarters

Col. Agnew's Quarters

2d Battn. Light Infantry

1st Battn. Light Infantry

REFERENCES.

AAAA. March of Genl. Grey's Detachment in two Columns to Attack the Rebels B.

C. Light Infantry attacking the Rebel Brigade in Flank.

D. A Party of Light Infantry in pursuit of the Rebels. EE. which were carried off on the first Allarm.

F. Light Infantry after having routed the Rebels.

G. The 44th Regiment supporting the Light Infantry.

H. The 42d Regiment in Reserve, following without breaking their Ranks.

IIII. The Rebels flying in Disorder.

N. The Two Regiments under Col. Musgrave were not engaged.

(276) Hessian map: Plan Generale des operations de l'armée Britannique contre les Rebelles, at Library of Congress. See Justin Winsor, *Narrative and Critical History of America* (Boston, 1887), 6:422.

(277) Battle of Brandewyne on the 11th September 1777, and (278) Position of part of the Army at Brandewyne the 12th Septr. 1777, by John André, at Huntington Library, San Marino, California, pictured in Henry Cabot Lodge, ed., *Major André's Journal* (Boston, 1903), 1:84–85, 88.

The other British victory while approaching the city, the surprise night attack at Paoli, using only bayonets, is plotted upon a smaller Faden engraving and in manuscript plans by John André.

(279) *Fig. 190.* British Camp at Trudruffrin from the 18th. to the 21st. of September 1777. with the Attack made by Major General Grey against the Rebels near White Horse Tavern. on the 20th. of September. Drawn by an Officer on the Spot. Engraving, by William Faden, 1778, 10 × 16. Attribution: Engrav'd & Publish'd by W. Faden Charing Cross July 1st. 1778. Source: William Faden, *Atlas of Battles of the American Revolution* (London, 1793).

Fig. 190

(280) The original drawing for the engraving is at the Library of Congress, Faden Collection, no. 81.

Fig. 191

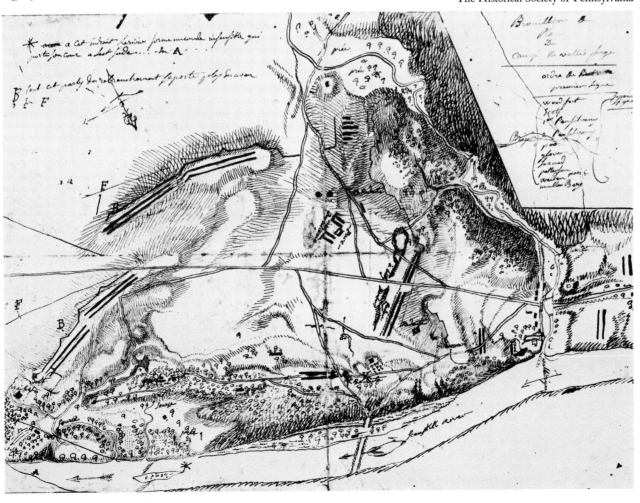

For manuscript plans related to the engraving see (281) Position of the Army at Trudruffrin the 19th Septr. 1777, and (282) Surprize of a Rebel Corps in the Great Valley the 21st Sept. 1777, by John André, at Huntington Library, pictured in Henry Cabot Lodge, ed., *Major André's Journal* (Boston, 1903), 1:90, 94.

The bitter American encampment at Valley Forge over the winter of 1777–78 was charted both in a Louis Duportail manuscript plan and in Du Chesnoy's drawings of the American positions, as well as in other unsigned maps. While no battle occurred there, an interesting series of five plans by Du Chesnoy traced a military maneuver that avoided a battle at a Valley Forge outpost. This was Lafayette's withdrawal from Barren Hill, some twelve miles from the city, on 28 May 1778, when the Americans were breaking up their main encampment.

Fig. 191

(283) *Fig. 191.* Brouillon Ou Plan Du Camp De vallie forge, by Louis LeBeque de Presle Duportail. Pen drawing, c. December, 1777, 11¼ × 15¼. Source: Historical Society of Pennsylvania.

Related manuscript plans at the Library of Congress (284) and Historical Society of Pennsylvania (285) are described in Peter J. Guthorn, *American Maps and Map Makers of the Revolution* (Monmouth Beach, N.J., 1966), pp. 16, 40.

(286) A plan of Valley Forge encampment, at William L. Clements Library, University of Michigan, is described in Randolph G. Adams, *British Headquarters Maps and Sketches* (Ann Arbor, 1928), pp. 78–79.

(287) A plan of the encampment of the British Army in the vicinity of Valley Forge, at the Huntington Library, is pictured in Henry Cabot Lodge, ed., *Major André's Journal* (Boston, 1903), 1:94.

Fig. 192

(288) *Fig. 192.* Plan de la Retraite de Barrenhill en Pensilvanie, ou un detachement de 2200 hommes sous le General la Fayette, etoit entourre par l'armée Anglaise sous les Gx. Howe, Clinton, et Grant. le 28 May 1778, by Michel Capitaine Du Chesnoy. Watercolor, 1778, 13¼ × 20⅜. Attribution: Major Capitaine A. D. C. du Gl Lafayette. Source: Historical Society of Pennsylvania.

(289) (290) (291) (292) Above is one of five nearly identical originals now in different repositories, all described in Peter J. Guthorn, *American Maps and Map Makers,* pp. 9–11.

(293) An engraving titled: Sketch of Fayette's Position at Barren Hill, 8½ × 6¾, appears in Charles Stedman, *The History of the . . . American War* (London, 1794), 1:377, with account of the action.

The war produced a wide variety of other items, including road plans, records of military actions in New Jersey connected with the reduction of Fort Mifflin, and maps published in London books and magazines. Charles Willson Peale appears to have drawn the ferry house at Bristol, Pennsylvania, some fifteen miles from Philadelphia—probably on his way to or from inspecting the battlefield at Princeton, New

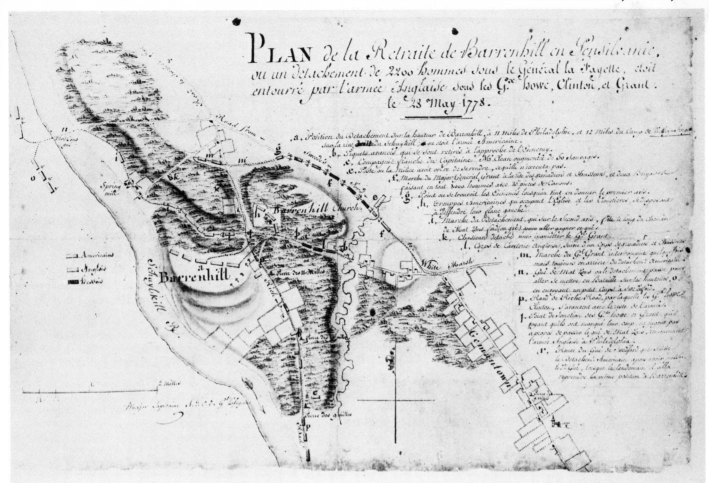

Fig. 192

Jersey. And as an official note of finale, the inveterate Faden traced on one engraving of 1784 (from the manuscript plan by John Hills already mentioned) all the movements of the British army from its landing at the head of the Chesapeake to its departure from Philadelphia in May 1778, with the Philadelphia area as the obvious hub.

(294) A Plan of the River Schuylkill . . . Together with the Means Proposed for Improving the Navigation of sd River, by David Rittenhouse. Drawing, 1773 (copied 1779), 14¾ × 147. Source: New-York Historical Society.

Note: As copied by Robert Erskine, this is one of a large number of his manuscript plans, rough field sketches, and surveys as geographer to the Continental Army. He sometimes used the product of others. For a list of his work see Peter J. Guthorn, *American Maps and Map Makers* (Monmouth Beach, N.J., 1966), pp. 17–22, 29; and as to the vicinity of Philadelphia, see particularly nos. 57 (295), 58 (296), 68 (297), 69 (298), 73 (299), and 87 (300) as listed therein.

Erskine's work was continued after his death in 1780 by Simeon DeWitt as geographer-in-chief, who also did both original and copy work. See, e.g., respecting the vicinity of Philadelphia, *ibid.*, pp. 14–15, items 66 (301) and 127 (302).

The Scull and Heap format was also used for field sketches by the Americans. See, e.g., maps of almost the original size titled: (303) Map roads round Philadelphia 1777, and: (304) roads about Skippack Germantown &c taken October 1777, both at Historical Society of Pennsylvania.

On the British side, a number of sketches (305) of Army positions near Philadelphia were prepared by John André. See Peter J. Guthorn, *British Maps of the American Revolution* (Monmouth Beach, N.J., 1973), p. 9; and Henry Cabot Lodge, ed., *Major André's Journal* (Boston, 1903), 1, for reproductions.

(306) Les Marches du Corps du Lord Cornwallis de Billingsport jusqu'a Philadelphia au Mois de Novembre, 1777, by Lieutenant von Wangenheim. Pen drawing, 13 × 21½. Source: Library of Congress.

(307) (308) (309) (310) Related plans of the New Jersey portion of the Battle of Fort Mifflin are reproduced in Samuel Stelle Smith, *Fight for the Delaware 1777* (Monmouth Beach, N.J., 1970), pp. 17, 19, 22; and in John W. Jackson, *The Pennsylvania Navy, 1775–1781* (New Brunswick, N.J., 1974), pp. 132, 146, 148.

Note: John Norman, the engraver and print seller already mentioned [see (101) Fig. 62], advertised for sale 12 June 1776 in the *Pennsylvania Journal* a print depicting "the engagement between the Row Gallies of this city, and the Roebuck and Liverpool English men of war." This two-day naval battle took place 8 and 9 May 1776 off Wilmington, Delaware. The print remains unlocated. For a full description of the action see *ibid.*, ch. IV.

(311) Campaign of MDCCLXXVII. Inset to: Campaign of MDCCLXXVI. Engraving, 1780, 9½ × 8½ (full map, 20¾ × 17½). Source: Captain Hall, *The History of the Civil War in America* (London, 1780), 1, frontispiece.

Fig. 194

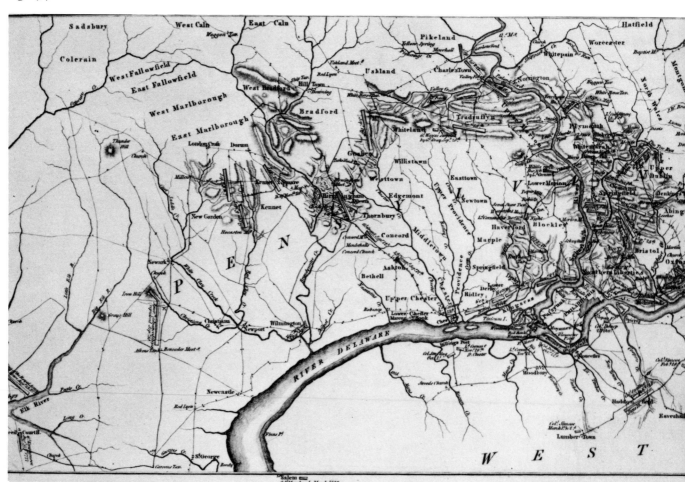

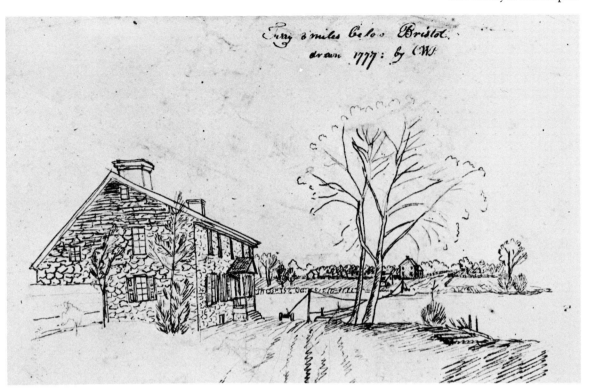

Fig. 193

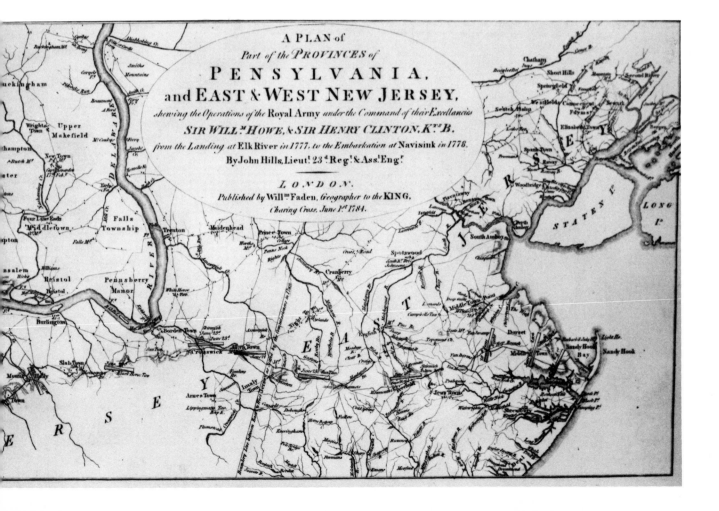

Note: The manuscript drawing (312) for the inset map appears to be in the Library of Congress, stamped with the name of John Montrésor; likewise a smaller manuscript item (313). See P. Lee Phillips, *A Descriptive List of Maps and Views of Philadelphia in the Library of Congress* (Philadelphia, 1926), nos. 318, 325.

Compare engraving titled: A Plan of the Operations of the British & Rebel Army, in the Campaign, 1777 [see (77)], and compare anonymous watercolor of army positions (314), untitled, 9½ × 7, at Atwater Kent Museum, Philadelphia.

Fig. 193

(315) *Fig. 193.* Ferry 3 miles below Bristol, drawn 1777: by CWP, attributed to Charles Willson Peale. Ink over pencil, 6½ × 11⅝. Source: Free Library of Philadelphia.

Fig. 194

(316) *Fig. 194.* A Plan of Part of the Provinces of Pensylvania, and East & West New Jersey, shewing the Operations of the Royal Army under the Command of their Excellencies Sir Willm. Howe, & Sir Henry Clinton, Kts. B. from the Landing at Elk River in 1777, to the Embarkation at Navisink in 1778, by John Hills. Engraving, by William Faden, 1784, 8¾ × 28⅝. Attribution: By John Hills, Lieut. 23d. Regt. & Asst. Engr. London. Published by Willm. Faden, Geographer to the King, Charing Cross, June 1st. 1784.

LATER STATE

(316A) As above, but printed on nineteenth-century paper.

Note: For apparently the original drawing (317) for the engraving, see Randolph G. Adams, *British Headquarters Maps and Sketches* (Ann Arbor, Mich., 1928), pp. 75–76.

Fig. 195

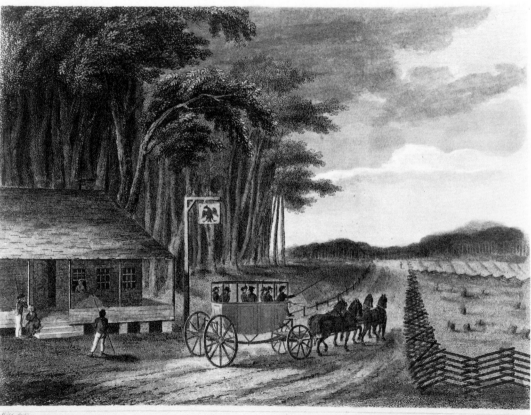

AMERICAN STAGE WAGGON
Published Dec 20 1798 by J Stockdale Piccadilly

The notebook of Pierre Eugène Du Simitière, at the Library Company of Philadelphia, states in June 1778 that he then copied from an original by John André "a plan of the progress of the british army from their landing in Elk river to their taking possession of Philadelphia 26th Sept 1777." The original (318) at the Huntington Library, San Marino, California, is pictured in Henry Cabot Lodge, ed., *Major André's Journal* (Boston, 1903), 1:32–33. A rough sketch (319) is described in Peter J. Guthorn, *British Maps of the American Revolution* (Monmouth Beach, N.J., 1973), p. 10 item 31. See also *ibid.*, p. 57 items 1–3.

(320) An engraving by Faden titled: Plan of the Operations of General Washington against the Kings Troops in New Jersey. from the 26th. of December 1776. to the 3d. January 1777. completes the military record, although issued earlier (15 April 1777) than the engraving prepared from Hills's drawing.

In an echo of the conflict from abroad, Xavier Della Gatta executed an atmospheric gouache drawing that attempted to re-create the British night attack near Paoli—one of a pair with his reconstruction of the fighting in the Battle of Germantown.

(321) (The Paoli Massacre), by Xavier Della Gatta. Gouache, c. 1782, 13⅝ × 22½. Source: Valley Forge Historical Society.

Note: For the companion picture depicting the Battle of Germantown see (246).

In contrast to the large output occasioned by the Revolution, the later years brought few items not devoted to the city itself. Jeremiah Paul, when sketching in the summer of 1794, crossed the Delaware to draw a scene from the New Jersey shore. Isaac Weld's book of travels, published in London at the end of the century, carried an engraving of the Spread Eagle Tavern. This stood on the old Lancaster Pike at Strafford, in modern Philadelphia's western suburbs, until it yielded to modernization along the city's so-called Main Line.

(322) A View on the Jersey Shore; opposite Kensington. 94. July 9, by Jeremiah Paul. Watercolor, 1794, 4⅜ × 6⁷⁄₁₆. Source: Jeremiah Paul sketchbook, Historical Society of Pennsylvania.

Note: For Paul's Philadelphia sketches see (154) Fig. 107, (155) Fig. 108, and (156) Fig. 109.

(323) *Fig. 195.* American Stage Waggon, by Isaac Weld. Engraving, by James Storer, 1798, 6⁹⁄₁₆ × 9. Attribution: I. Weld delt. J. Storer sculpt. Published Dec. 21. 1798, by I. Stockdale, Piccadilly. Source: Isaac Weld, *Travels through the states of North America . . . during 1795, 1796 and 1797* (London, 1799).

Fig. 195

LATER STATE

(323A) Plate appears in later editions of the book, with folds.

Notes

The notes are arranged under the chapter and title headings and according to the sequence of the numbered items.

Chapter 1. Grid Plans Projecting a New-World Town, 1683–1720

Thomas Holme's Portraiture of Philadelphia, *1683*

(1) Hazel Shields Garrison, "Cartography of Pennsylvania Before 1800," *Pennsylvania Magazine of History and Biography* (hereafter cited as *PMHB*) 59 (1935): 255, 265, respecting Holme.

Anthony N. B. Garvan, "Proprietary Philadelphia as Artifact," in *The Historian and the City,* eds. Oscar Handlin and John Burchard (Cambridge, Mass., 1963), pp. 177, 190, 193–95.

Walter Klinefelter, "Surveyor General Thomas Holme's 'Map of the Improved Part of the Province of Pennsilvania,'" *Winterthur Portfolio* 6 (Charlottesville, Va., for The Henry Francis du Pont Winterthur Museum, Winterthur, Del., 1970): 41, 46–47.

John C. Lowber, *Ordinances of the Corporation of the City of Philadelphia* (Philadelphia, 1812), p. 282.

John W. Reps, *The Making of Urban America* (Princeton, N.J., 1965), pp. 157–74, discussing the origins of the grid plan for Philadelphia, particularly Richard Newcourt's plan proposing five public squares for the rebuilding of London after the fire of 1666.

Hannah Benner Roach, "The Planting of Philadelphia: A Seventeenth-Century Real Estate Development," *PMHB* 92 (1968): 3, 143.

Dutch and German Editions of the First Plan of Philadelphia, 1684

(2–3) William I. Hull, *William Penn and the Dutch-Quaker Migration to Pennsylvania* (Swarthmore, Pa., 1935), pp. 313–14; and pp. 328–29, 339–40, respecting Furly.

Hope Frances Kane, "Notes on Early Pennsylvania Promotion Literature," *PMHB* 63 (1939): 144, 149, 164.

(5) Ir. C. Koeman, *Atlantes Neerlandici* (Amsterdam, 1970), 4: 152, 169, 276, 351; *idem, Collections of Maps and Atlases in the Netherlands* (Leiden, 1961), pp. 127, 133.

P. Lee Phillips, *A List of Geographical Atlases in the Library of Congress* (Washington, D.C., 1909), vol. 1, no. 1170 fn.; *idem, A Descriptive List of Maps and Views of Philadelphia in the Library of Congress* (Philadelphia, 1926), no. 171 (a 1782 edition).

Grid Plans of Philadelphia, 1687–1720

(6) Oliver Hough, "Captain Thomas Holme, Surveyor-General of Pennsylvania and Provincial Councillor," *PMHB* 19 (1895): 413, 422–25.

Klinefelter, "Surveyor General Thomas Holme's 'Map . . . of Pennsilvania,'" pp. 41, 43–44, 72, 74.

Phillips, *Maps and Views of Philadelphia,* no. 149.

(7) Klinefelter, "Surveyor General Thomas Holme's 'Map . . . of Pennsilvania,'" pp. 65–66, 74.

Chapter 2. The Primitive Town, 1698–1750

Second and High Streets, 1698

(8) Joseph Jackson, *Encyclopedia of Philadelphia* (Harrisburg, Pa., 1931), 3: 836; idem, *Market Street Philadelphia* (Philadelphia, 1918), p. 22.

J. Thomas Scharf and Thompson Westcott, *History of Philadelphia* (Philadelphia, 1884), 2: 857.

John F. Watson, *Annals of Philadelphia, and Pennsylvania, in the Olden Time,* new and enlarged ed. (Philadelphia, 1877), 1: 350, 356, 358; 3: 118, 178.

The Peter Cooper South East Prospect, c. 1720

(9) Edwin Swift Balch, *Art in American Before the Revolution* (Philadelphia, 1908), pp. 10–11.

James N. Barker, *Sketches of the Primitive Settlements on the River Delaware* (Philadelphia, 1827), p. 46.

Richard B. Holman, "William Burgis," in *Boston Prints and Printmakers, 1670–1775,* ed. Walter Muir Whitehill (Boston, 1973), pp. 57–62.

Jackson, *Encyclopedia of Philadelphia,* 1: 116, 154–55.

John Nichols, *Illustrations of the Literary History of the Eighteenth Century* (London, 1822), 4: 206.

Pennsylvania Academy of the Fine Arts, *Philadelphia Painting and Printing to 1776* (Philadelphia, 1971), p. 12.

Scharf and Westcott, *History of Philadelphia,* 2: 1030.

Robert C. Smith, "Two Centuries of Philadelphia Architecture, 1700–1900," in *Historic Philadelphia,* ed. Luther P. Eisenhart (Philadelphia, 1953), p. 289 and fn.

I. N. Phelps Stokes, *The Iconography of Manhattan Island* (New York, 1915), 1: 239–42; 4: 974.

Edwin Wolf, II, *The Annual Report of the Library Company of Philadelphia for the Year 1966* (Philadelphia, 1967), pp. 9–11.

The G. Wood Watercolor of Philadelphia, 1735

(10) *Old Print Shop Portfolio* 14 (New York, 1955): 228–29.

First Printed View, 1740

(11) Clarence S. Brigham, *History and Bibliography of American Newspapers, 1690–1820* (Worcester, Mass., 1947), 2: 890.

Sinclair Hamilton, *Early American Book Illustrators and Wood Engravers, 1670–1870* (Princeton, N.J., 1958), 1: 28, no. 86.

Joseph Jackson, *Iconography of Philadelphia* (Philadelphia, 1934), pp. 5–6.

Frank Luther Mott, *A History of American Magazines, 1741–1850* (Cambridge, Mass., 1938), pp. 71–72 and plate.

Chapter 3. The First Flowering: Scull and Heap, 1750–60

The Scull and Heap Map of Philadelphia, 1752

(12) Hazel Shields Garrison, "Cartography of Pennsylvania Before 1800," *PMHB* 59 (1935): 255, 265.

Old Print Shop Portfolio 3 (New York, 1944): 132–33, respecting Scull.

Nicholas B. Wainwright, "Scull and Heap's Map of Philadelphia," *PMHB* 81 (1957): 69; *idem,* "Scull and Heap's East Prospect of Philadelphia," *PMHB* 73 (1949): 16–17 (biography of Heap).

(14) Joseph Jackson, *Iconography of Philadelphia* (Philadelphia, 1934), pp. 7–8.

The Scull and Heap East Prospect, 1754

(17) Lawrence Henry Gipson, *Lewis Evans* (Philadelphia, 1939), p. 25, fn. 20.

Jackson, *Iconography of Philadelphia,* pp. 8–9.

I. N. Phelps Stokes and Daniel C. Haskell, *American Historical Prints, Early Views of American Cities, Etc.* (New York, 1933), p. 18.

Wainwright, "Scull and Heap's East Prospect of Philadelphia," p. 16.

The Contracted Scull and Heap East Prospect, 1756

(18) Samuel T. Freeman & Co. catalogue, *Old Philadelphia Prints: The Latta Collection* (Philadelphia, 1916), no. 133 (separate *lower* half of engraving).

Thomas Jefferys, *A General Topography of North America and the West Indies* (London, 1768), table of contents and plate 44.

Stokes and Haskell, *American Historical Prints,* p. 18.

Wainwright, "Scull and Heap's East Prospect of Philadelphia," pp. 16, 22–25.

John Bartram's House and Gardens, 1758

(20) Joseph Jackson, *Encyclopedia of Philadelphia* (Harrisburg, Pa., 1931), 1: 244–51.

D. T. Povey, "Garden of a King's Botanist," *Country Life* 119 (London, 1956): 549.

Chapter 4. The Awakening City and Broadening Iconography, 1760–75

The Jacob Duché House, c. 1760

(21) Joseph Jackson, *Encyclopedia of Philadelphia* (Harrisburg, Pa., 1931), 2: 605–7.

Edward D. Neill, "Rev. Jacob Duché," *PMHB* 2 (1878): 58.

John F. Watson, *Annals of Philadelphia, and Pennsylvania, in the Olden Time,* new and enlarged ed. (Philadelphia, 1877), 1: 413; 3: 266.

Thompson Westcott, "A History of Philadelphia," *Philadelphia Sunday Dispatch* (1867), chap. 218; *idem, The Historic Mansions and Buildings of Philadelphia* (Philadelphia, 1877), pp. 88–90.

Competing Views of the Pennsylvania Hospital, 1761

(23) *Pennsylvania Gazette,* 29 October; 5, 12, and 19 November; 3 and 10 December 1761.

(24) *American Paintings & Historical Prints from the Middendorf Collection* (New York, 1967), pp. 84–85.

Carl Bridenbaugh, *Cities in Revolt* (New York, 1955), p. 407.

Carl W. Drepperd, *Early American Prints* (New York, 1930), pp. 34–35 (Steeper).

"Minutes of Meetings of the Managers of the Pennsylvania Hospital," 10 April and 17 May 1762; 26 April 1763 (manuscript at Pennsylvania Hospital, Philadelphia).

Thomas G. Morton, *The History of the Pennsylvania Hospital, 1751–1895* (Philadelphia, 1895), p. 321 and plate p. 36.

Pennslyvania Gazette, 22 and 29 October; 5, 12, 19, and 26 November; 3 and 10 December 1761; 25 March 1762 (advertisement by Steeper); supplement, 30 September 1762; 16 July, 27 August, and 10 September 1767.

Alfred Coxe Prime, ed., *The Arts & Crafts in Philadelphia, Maryland and South Carolina, 1720–1785* (Topsfield, Mass., 1929), 1: 27 (Steeper), 37–38 (Kennedy), and 13, 308 (Winter).

English and American Adaptations of the Scull and Heap East Prospect, 1761 *and* 1765

(26) Samuel Atkins, *Kalendarium Pennsilvaniense* (Philadelphia, 1685).

Sinclair Hamilton, *Early American Book Illustrators and Wood Engravers, 1670–1870* (Princeton, N.J., 1958), 8, no. 24, and 1: 28, no. 86. The woodcut pictured in plate 13 is not considered to represent Philadelphia. See Charles L. Nichols, "Justus Fox: A German Printer of the Eighteenth Century," *Proceedings of the American Antiquarian Society* 25 (1915): 65.

Bulletin of the Historical Society of Pennsylvania (March, 1973).

Nichols, "Justus Fox," pp. 55, 64–65.

Christopher Saur, *Der Hoch-Deutsche Americanische Calender Auf das Jahr 1743* (Germantown, Pa., 1742), first issue with cover picture, *et seq.*

European Reproductions of the Scull and Heap Map, 1761 and 1764

(27) P. Lee Phillips, *A Descriptive List of Maps and Views of Philadelphia in the Library of Congress* (Philadelphia, 1926), no. 156.

The Clarkson-Biddle Map of Philadelphia, 1762

(29) Drepperd, *Early American Prints,* p. 35, attributes a map of Philadelphia of this size to the engraver James Turner (who died in 1759) and states it was published in 1762. James Clements Wheat and Christian F. Brun, in *Maps and Charts Published in America Before 1800: A Bibliography* (New Haven, Conn., 1969), no. 456, suggest Henry Dawkins as the probable engraver of the Clarkson-Biddle map.
In 1774 John Reed accused Benjamin Eastburn of bearing responsibility for the moving of Broad Street and the loss of the public squares (see "Reed's Map of Philadelphia, 1774"). While these changes are reported as fact on Eastburn's plan reproduced by Clarkson and Biddle, it seems that Eastburn was not responsible for

them. See Westcott, "A History of Philadelphia," chap. 21; and John W. Reps, *The Making of Urban America* (Princeton, N.J., 1965), p. 169.

The loss of use of the two eastern squares seems to have been due to population pressures; their restoration to more enlightened attitudes that prevailed when the city spread to the areas set aside for the western squares.

Eastburn's contributions as surveyor general have probably not been sufficiently recognized.

Bridenbaugh, *Cities in Revolt,* p. 198, respecting Clarkson.

Minutes of the Common Council of the City of Philadelphia, 1704 to 1776 (Philadelphia, 1847), pp. 676–77.

Pennsylvania Gazette, 30 July 1761 *et seq.,* 2 and 16 September, 7 and 14 October, 11 and 18 November, and 2 December 1762.

Pennsylvania Supreme Court, *The Commonwealth v. Alburger* (1836), 1 Wharton Reports, pp. 468, 481–88.

Prime, ed., *Arts & Crafts in Philadelphia,* 1: 36 (advertisement 7 March 1763, showing sale of the map through Henrich Miller, a German publisher).

Hannah Benner Roach, "The Planting of Philadelphia: A Seventeenth-Century Real Estate Development," *PMHB* 92 (1968): 143, 156, gives an explanation of the change in the location of Broad Street.

Wheat and Brun, *Maps and Charts,* no. 469.

Will of Nicholas Scull, dated 24 August 1761, probated 19 October 1762, *Philadelphia County Will Book M,* p. 392.

The Four Political Cartoons of 1764–65

(30) Wilford P. Cole, "Henry Dawkins and the Quaker Comet," *Winterthur Portfolio* 4 (Charlottesville, Va., for the Henry Francis du Pont Winterthur Museum, Winterthur, Del., 1968): 35, 40–41.

Joseph Jackson, *Market Street Philadelphia* (Philadelphia, 1918), p. 22; *idem, Encyclopedia of Philadelphia,* 2: 593–95, concerning Dove.

The Month at Goodspeed's 24 (Boston, 1952): 9–13.

William Murrell, *A History of American Graphic Humor* (New York, 1933), 1: 13, 20–21, and plate 9.

J. Thomas Scharf and Thompson Westcott, *History of Philadelphia* (Philadelphia, 1884), 1: 240–42.

I. N. Phelps Stokes and Daniel C. Haskell, *American Historical Prints, Early Views of American Cities, Etc.* (New York, 1933), p. 21.

(31) Westcott, "A History of Philadelphia," chap. 215, attributes this plate to Dawkins.

(32) Murrell, *American Graphic Humor,* plate 12.

(33) *Ibid.,* plate 10.

The City from the South, 1767

(35) Charles Lawrence, *History of the Philadelphia Almshouses and Hospitals* (Philadelphia, 1905), pp. 22–23, 35–36.

The Month at Goodspeed's 14 (Boston, 1942): 69–70.

Morton, *History of the Pennsylvania Hospital,* p. 321 and plate.

Pennsylvania Gazette, 16 July 1767 (Garrison's dry goods advertisement).

William John Potts, "Du Simitière, Artist, Antiquary, and Naturalist," *PMHB* 13 (1889): 341, 374.

Stokes and Haskell, *American Historical Prints*, pp. 22–23.

Baptism on the Schuylkill at Spruce Street, 1770

(36) Morgan Edwards, *Materials Towards a History of the American Baptists* (Philadelphia, 1770), 1: 129–32.

Mantle Fielding, *American Engravers upon Copper and Steel* (Philadelphia, 1917), no. 1477 (attribution to Smither).

Jackson, *Encyclopedia of Philadelphia*, 1: 237.

Watson, *Annals of Philadelphia*, 1: 431; 3: 290.

First Building of the College of Philadelphia, c. 1770

(37) Jackson, *Encyclopedia of Philadelphia*, 4: 1087, respecting Du Simitière's black-lead silhouettes.

Potts, "Du Simitière, Artist, Antiquary, and Naturalist," p. 341 (for mention of "a drawing in black lead," see p. 356).

I. N. Phelps Stokes, *The Iconography of Manhattan Island* (New York, 1915), 3: 863, respecting Du Simitière.

William L. Turner, "The Charity School, the Academy, and the College," in *Historic Philadelphia*, ed. Luther P. Eisenhart (Philadelphia, 1953), pp. 179–180.

Charles Willson Peale's Portrait Backgrounds, 1770 and 1773

(38) Charles V. Hagner, *Early History of the Falls of Schuylkill and Manayunk* (Philadelphia, 1869), p. 10.

Charles Coleman Sellers, *Charles Willson Peale with Patron and Populace* (Philadelphia, 1969), p. 13.

Ibid., referring to an oil painting of the same subject, p. 30; referring to a drawing by Peale of a ferry across the river, p. 15.

(39) Charles Coleman Sellers, *Portraits and Miniatures by Charles Willson Peale* (Philadelphia, 1952), p. 68, no. 217.

Nicholas B. Wainwright, *Colonial Grandeur in Philadelphia* (Philadelphia, 1964), pp. 112–13.

(40) Sellers, *Portraits and Miniatures*, p. 69, no. 221.

Reed's Map of Philadelphia, 1774

(41) The three copperplates engraved by Smither for the Reed map are probably the same ones afterward bought by the engraver Lawson and cut up for small plates. See William Dunlap, *A History of the Rise and Progress of the Arts of Design in the United States*, new ed. (Boston, 1918), 1: 184.

Bridenbaugh, *Cities in Revolt*, p. 431.

Charles F. Hoban, ed., *Pennsylvania Archives, Eighth Series* (Harrisburg, Pa., 1935), 8: 7300, for payment to Reed of twenty-five pounds by the Pennsylvania Assembly 29 September 1775, apparently for copies purchased.

Oliver Hough, "Captain Thomas Holme, "Surveyor-General of Pennsylvania and Provincial Councillor," *PMHB* 19 (1895): 413, 423 fn.

William E. Lingelbach, "William Penn and City Planning," *PMHB* 68 (1944): 398, 409.

Manuscript map showing location of lots as granted to the first purchasers is at Free Library of Philadelphia, map no. 21580.

Pennsylvania Journal, 21 April 1768, for Smither's first advertisement in Philadelphia.

Pennsylvania Supreme Court, *The Commonwealth v. Alburger* (1836), 1 Wharton Reports, pp. 468, 484.

John Reed, *An Explanation of the Map of the City and Liberties of Philadelphia* (Philadelphia, 1774); and Charles L. Warner reprint (Philadelphia, 1870).

Reps, *Making of Urban America,* p. 169.

Roach, "Planting of Philadelphia," p. 46, fn. 76; p. 144, fn. 2.

Royal Gazette (New York, 22 May 1779), quoted in Stokes, *Iconography of Manhattan Island,* 5: 1086.

Lloyd P. Smith, ed., *John Reed, An Explanation of the Map of the City and Liberties of Philadelphia* (Philadelphia, 1846), preface.

Westcott, "A History of Philadelphia," chap. 21.

Wheat and Brun, *Maps and Charts,* nos. 457–58.

Arthur P. Whitaker, "Reed and Forde: Merchant Adventurers of Philadelphia," *PMHB* 61 (1937): 237.

The New Walnut Street Jail, 1775 and 1778

(42) Jackson, *Encyclopedia of Philadelphia,* 2: 338 (top), 495, 497; 4: 1023.

Eric P. Newman, *The Early Paper Money of America* (Racine, Wis., 1967), p. 255.

George B. Tatum, *Penn's Great Town* (Philadelphia, 1961), p. 37.

Negley K. Teeters, *The Cradle of the Penitentiary: The Walnut Street Jail at Philadelphia, 1773–1835* (Philadelphia, 1955), p. 10.

Westcott, "A History of Philadelphia," chap. 256.

(43) Prime, ed., *Arts & Crafts in Philadelphia,* 1: 25, quotes an advertisement on 14 July 1778 of sale by John Norman of a "neat engraving of the New Gaol," which presumably was offered as a separate print, unlocated.

See "A Locally Produced Map of Philadelphia, 1778."

Chapter 5. The Period of the American Revolution, 1776–82

European Republications of the Clarkson-Biddle Map, 1776–78

(44) See (265c) for Dury's large engraved copy of the Joshua Fisher chart of the Delaware River, which he also published in November 1776. A separate copy of his reduced inset to the Plan of Philadelphia was republished by the *Gentleman's Magazine* in 1779. See (265g).

See "The Clarkson-Biddle Map of Philadelphia, 1762" concerning Benjamin Eastburn.

European Republications of the Scull and Heap Map, 1777–78

(47) Peter J. Guthorn, *British Maps of the American Revolution* (Monmouth Beach, N.J., 1973), p. 61.

P. Lee Phillips, *A List of Geographical Atlases in the Library of Congress* (Washington, D.C., 1909), vol. 1, no. 1337 (remainder of original Faden engraved maps

acquired and published by Bartlett and Welford, New York City, 1845, together with some copies on nineteenth-century paper).

(48) *Ibid.,* vol. 3, no. 3517.

(49) *Ibid.,* vol 1, no. 1210.

The Line of British Defense Forts, 1777

(53–56) Guthorn, *British Maps,* pp. 34–36.

Pennsylvania Journal, supplement, 21 April 1768 (Nicola's advertisement as a merchant with circulating library).

Howard C. Rice, Jr., ed., *Travels in North America . . . by the Marquis de Chastellux* (Chapel Hill, N.C., 1963), 1: 172–73, 292–93.

G. D. Scull, ed., "Journal of Captain John Montrésor, July 1, 1777 to July 1, 1778," *PMHB* 5 (1881): 393; 6 (1882): 34, 189, 284, 372.

Townsend Ward, "North Second Street and Its Associations," *PMHB* 4 (1880): 164, 181, locates each of the British forts.

The Battle of Germantown, 1777

(57–62) Guthorn, *British Maps,* pp. 9, 24.

Maps and Views of Fort Mifflin and Its Locality, 1777–78

(63–77) *An Album of American Battle Art, 1755–1948* (Washington, D.C., 1947), plates 19–20.

John W. Jackson, *The Pennsylvania Navy, 1755–1781* (New Brunswick, N.J., 1974), chaps. 9–11, and reproductions as follows of items described: pp. 229 and 262 (64); pp. 165 and 260 (65); pp. 160, 226, 228, and 241 (70–73); and 232 (75).

P. Lee Phillips, *A Descriptive List of Maps and Views of Philadelphia in the Library of Congress* (Philadelphia, 1926), no. 328, treats the watercolor first described (63). A collection of British manuscript maps at the Library of Congress, described in *ibid.,* nos. 169–70 and 318–29, appears to constitute most of Montrésor's own collection of such items.

Rice, ed., *Travels in North America,* 1: 315–16.

Scull, "Journal of Captain John Montrésor," p. 299, quotes his plan for a final attack on the fort.

(78) Mary Dorothy George, *Catalogue of Political and Personal Satires Preserved in the Department of Prints and Drawings in the British Museum* (London, 1935), vol. 5, no. 5402.

(79–85) Marion Balderston, "Lord Howe Clears the Delaware," *PMHB* 96 (1972): 326.

Hubertis M. Cummings, "The Villefranche Map for the Defense of the Delaware," *PMHB* 84 (1960): 424.

Worthington Chauncey Ford, "Defenses of Philadelphia in 1777," *PMHB* 18 (1894): 19 *et seq.;* 19 (1895): 72 *et seq.*

Jackson, *The Pennsylvania Navy,* pp. 284, 233, reproduces items (82) and (84).

C. Henry Kain, "The Military and Naval Operations on the Delaware in 1777," *Philadelphia History* (City History Society, 1917), 1: 177.

(86) Jackson, *The Pennsylvania Navy,* pp. 477–78.

I. N. Phelps Stokes and Daniel C. Haskell, *American Historical Prints, Early Views of American Cities, Etc.* (New York, 1933), p. 31 (the authors mistakenly considered this an American print).

The Robertson Watercolor View of Philadelphia, 1777

(87) The artist is to be differentiated from Archibald Robertson, who, with his brother Alexander, operated a successful school of drawing in New York; as to whom see James Thomas Flexner, "The Scope of Painting in the 1790's," *PMHB* 74 (1950): 74, 82; and Kennedy Galleries, Inc., *American Drawings, Pastels and Watercolors, Part One* (New York, 1967), pp. 13–19.

Guthorn, *British Maps,* p. 40.

Stokes and Haskell, *American Historical Prints,* p. 31 and plate 26b.

Montrésor's Map of Philadelphia and Its Approaches, 1777–78

(88) Guthorn, *British Maps,* p. 37 (Nicole).

(92– *Ibid.,* p. 17 (Clinton).
99)

The Carington Bowles Reissue of the Scull and Heap East Prospect, 1778

(100) *Catchpenny Prints . . . originally published by Bowles and Carver* (New York, 1970).

Joe Kindig, III, "The Perspective Glass," *Antiques* 65 (1954): 467.

The Month at Goodspeed's 14 (Boston, 1942): 9; 22 (1951): 83; 37 (1965): 148–49.

Old Print Shop Portfolio 5 (New York, 1946): 195–97.

I. N. Phelps Stokes, *The Iconography of Manhattan Island* (New York, 1915), 1: 267–69.

Stokes and Haskell, *American Historical Prints,* p. 14.

A Locally Produced Map of Philadelphia, 1778

(101) Peter J. Guthorn, *American Maps and Map Makers of the Revolution* (Monmouth Beach, N.J., 1966), p. 28, item 33.

Charles E. Peterson, ed., *The Carpenters' Company 1786 Rule Book* (Princeton, N.J., 1971), p. xviii, fn. 3.

Phillips, *Maps and Views of Philadelphia,* no. 168a; and James Clements Wheat and Christian F. Brun, *Maps and Charts Published in America Before 1800: A Bibliography* (New Haven, Conn., 1969), no. 459, both attribute the engraving to Norman.

See Alfred Coxe Prime, ed., *The Arts & Crafts in Philadelphia, Maryland and South Carolina, 1720–1785* (Topsfield, Mass., 1929), 1: 25, for advertisement on 14 July 1778 of sale by John Norman of "a plan of the city of Philadelphia"; and 1: 19–20 and 2: 71, respecting Norman.

The Statehouse by Charles Willson Peale, 1779

(102) Charles Coleman Sellers, *Portraits and Miniatures by Charles Willson Peale* (Philadelphia, 1952), p. 86, no. 292; idem, *Charles Willson Peale with Patron and Populace* (Philadelphia, 1969), p. 63.

The Mock Execution of Benedict Arnold, 1780

(103) Milton Drake, *Almanacs of the United States* (New York, 1962), 2: 970.

William Murrell, *A History of American Graphic Humor* (New York, 1933), 1: 29, 32, and plate 25 (showing Rogers's facsimile).

Prime, ed., *Arts & Crafts in Philadelphia*, 1: 16 (advertisement by Bailey 1 November 1780).

Charles Coleman Sellers, *Charles Willson Peale* (New York, 1969), pp. 185–86; *idem, Charles Willson Peale with Patron and Populace*, pp. 16, 88.

Scott T. Swank, "The Lancaster New Church," *Journal of the Lancaster County Historical Society* 76 (1972): 69, 71 (Bailey).

Thompson Westcott, "A History of Philadelphia," *Philadelphia Sunday Dispatch*, 30 June 1872, chap. 276 (reprinting contemporary account).

(104) Sinclair Hamilton, *Early American Book Illustrators and Wood Engravers, 1670–1870* (Princeton, N.J., 1958), 2: 13 and plate 7.

Visits by the French Army, 1781 and 1782

(105–7) Rice, ed., *Travels in North America*, 1: 325, fn. 100.

Howard C. Rice, Jr., and Anne S. K. Brown, eds., *The American Campaigns of Rochambeau's Army* (Princeton, N.J., 1972), 1: 46, 77, 134, 162; 2: 75 and plates 57, 73, 137.

Chapter 6. Postwar Beginnings, 1784–96

Carpenters' Hall, 1786

(109) The plate, which appears also in later editions of the Articles and Rules, viz. edition Philadelphia 1805, is preserved at Carpenters' Hall. See Charles E. Peterson, *The Carpenters' Company 1786 Rule Book* (Princeton, N.J., 1971), p. xx, fn. 27.

Charles E. Peterson, "Carpenters' Hall," in *Historic Philadelphia*, ed. Luther P. Eisenhart (Philadelphia, 1953), pp. 96, 105; *idem, Carpenters' Company 1786 Rule Book,* frontispiece, and pp. xvi–xvii.

Hannah Benner Roach, "Thomas Nevell (1721–1797), Carpenter, Educator, Patriot," *Journal of the Society of Architectural Historians* 24 (1965): 153, 159, fn. 39.

The Pennsylvania Hospital, 1787

(110) "Minutes of Meetings of the Managers of the Pennsylvania Hospital," 7th month 30th, 8th month 27th, 9th month 24th, 10th month 29th, and 11th month 26th, 1787. (Manuscript at Pennsylvania Hospital, Philadelphia.)

Pennsylvania Packet, 5 June 1781 (advertisement by Scot).

The Accident in Lombard Street, 1787

(111) Charles Coleman Sellers, *Charles Willson Peale* (New York, 1969), pp. 223–24.

Edgar P. Richardson, "Charles Willson Peale's Engravings in the Year of National Crisis, 1787," *Winterthur Portfolio* 1 (Charlottesville, Va., for the Henry Francis du Pont Winterthur Museum, Winterthur, Del., 1964): 166, 178 *et seq.*

Magazine Illustrations: Eighteen Philadelphia Views, 1787–95

(113, 115–16) As to the three plates reissued by John A. McAllister, Jr., his printed index of restrikes dated February 1860 is at the Library Company of Philadelphia.

(113–15, 117–20) Charles Coleman Sellers, *Charles Willson Peale with Patron and Populace* (Philadelphia, 1969), pp. 15, 24, 28–30; idem, *Charles Willson Peale,* pp. 234–35 (Gray's Ferry).

Richardson, "Charles Willson Peale's Engravings," pp. 166, 169, 175–78.

(113–15, 118–20) Robert D. Crompton, "James Trenchard of the *Columbian* and Columbianum," *Art Quarterly* 23 (1960): 378.

(113–20) William J. Free, *The Columbian Magazine and American Literary Nationalism* (The Hague, 1968), p. 14.

(113–30) James Thomas Flexner, "The Scope of Painting in the 1790's," *PMHB* 74 (1950): 74, 81–83.

Joseph Jackson, *Encyclopedia of Philadelphia* (Harrisburg, Pa., 1931), 1: 166; 2: 355 (Bush Hill), 424 (theater), 626 (*Columbian Magazine*), 3: 647 (Federal Procession), 650–51 and 668 top (ferries).

Walter W. Ristow, ed., *A Survey of the Roads of the United States of America, 1789, by Christopher Colles* (Cambridge, Mass., 1961), pp. 46–49, 98 (Tiebout, Falls of the Schuylkill, and Gray's Ferry).

(116) Robert D. Crompton, "James Thackara, Engraver, of Philadelphia and Lancaster, Pa.," *Journal of the Lancaster County Historical Society* 63 (1958): 65.

(117, 124, 128) Thompson Westcott, *The Historic Mansions and Buildings of Philadelphia* (Philadelphia, 1877), pp. 417, 422–23 (Bush Hill).

(121–25, 127) *Old Print Shop Portfolio* 5 (New York, 1946): 232 (Hoffman).

(124–25, 127) I. N. Phelps Stokes, *The Iconography of Manhattan Island* (New York, 1915), 5: 1234 (Tiebout), 1293 (Scoles).

(128–30) Alfred Coxe Prime, ed., *The Arts & Crafts in Philadelphia, Maryland and South Carolina, 1720–1785* (Topsfield, Mass., 1929), 2: 70 (Malcom).

See "A Series of Nine Watercolors by James Peller Malcom, 1792."

The First Plans of South Philadelphia, 1788

(131–32) John Daly, *Descriptive Inventory of the Archives of the City and County of Philadelphia* (Philadelphia, 1970), paragraphs 42.1–2.

Pennsylvania Statutes at Large, 1682–1801 (Harrisburg, Pa., 1906), 12: 580.

P. Lee Phillips, *A List of Geographical Atlases in the Library of Congress* (Washington, D.C., 1909), vol. 1, no. 1339, fn.

Prime, ed., *Arts & Crafts in Philadelphia,* 1: 36.

Thompson Westcott, "A History of Philadelphia," *Philadelphia Sunday Dispatch* (1867), chap. 420 (last paragraph).

See "The John Hills Map of Philadelphia, 1796."

The Interior of Independence Hall, c. 1788–96

(133) Pine was a protégé of Robert Morris. See Sellers, *Charles Willson Peale,* p. 202.

Oliver Larkin, *Art and Life in America* (New York, 1964), p. 72.

The Month at Goodspeed's 29 (Boston, 1957): 10–11, 58.

James M. Mulcahy, "Congress Voting Independence: The Trumbull and Pine-Savage Paintings," *PMHB* 80 (1956): 74.

Lee H. Nelson, "Restoration in Independence Hall: A Continuum of Historic Preservation," *Antiques* 90 (1966): 64.

Prime, ed., *Arts & Crafts in Philadelphia*, 1: 7.

Westcott, "A History of Philadelphia," chap. 416.

Italian Version of Reed's City Map, 1790

(134) Castiglioni's manuscript *Journal* of his trip to the United States (film at the American Philosophical Society) contains drawings copied from the John Reed map of 1774 [see 41e).] Whitfield J. Bell, Jr., librarian of the Society, has prepared biographical material and a bibliography relating to Castiglioni.

Chapter 7. The Flowering of Prints, 1790–1800

A Series of Nine Watercolors by James Peller Malcom, 1792

(135– William Dunlap, *A History of the Rise and Progress of the Arts of Design in*
47) *the United States,* new ed. (Boston, 1918), 1: 389.

 Gentleman's Magazine (London, May 1815), pp. 467–69.

 Joseph Jackson, *Encyclopedia of Philadelphia* (Harrisburg, Pa., 1931), 2: 356, 365 (Delaware-Schuylkill Canal); 4: 1222–23 (Lansdowne).

 J. Thomas Scharf and Thompson Westcott, *History of Philadelphia* (Philadelphia, 1884), 1: 449, 452.

The First Formal Schuylkill River Landscape, 1793

(148) *Aurora General Advertiser* (Philadelphia), 28 July 1797 (advertisement of the Groombridge school mentioning "four years residence in Philadelphia").

 Thompson Westcott, *The Historic Mansions and Buildings of Philadelphia* (Philadelphia, 1877), pp. 424–25.

 See "Two Schuylkill River Landscapes in Oil, 1800."

The Statehouse and Its Flanking Buildings, 1792

(149) Charles L. Nichols, "Justus Fox: A German Printer of the Eighteenth Century," *Proceedings of the American Antiquarian Society* 25 (1915): 55, 61.

Two New Maps of the National Capital, 1794

(150) *Aurora General Advertiser* (Philadelphia), 1 February 1797.

 Philadelphia Gazette, 18 March 1794 (the 1793 directory), and 18 January 1796 *et seq.*

 Lawrence B. Romaine, "Talk of the Town: New York City, January 1825," *Bulletin of the New York Public Library* 63 (1959): 173, 176–77. A bibliography of Hardie's books appears on pp. 185–88.

 Rollo G. Silver, "Grub Street in Philadelphia, 1794–1795: More About James Hardie," *Bulletin of the New York Public Library* 64 (1960): 130.

(152) Second state (152A) probably issued 1799. See James Clements Wheat and Christian F. Brun, *Maps and Charts Published in America Before 1800: A Bibliography* (New Haven, Conn., 1969), no. 473; cf. no. 462.

A competing map of Philadelphia, projected and advertised by Reading Howell in 1794, appears not to have been published. See proposals for publishing it, *Aurora General Advertiser* (Philadelphia), 19 March 1794; and March, April, May, and June, to 24 June; and notice of filing the title for it with the court clerk, 20 March 1794; and April, May, and July, to 5 July. See also Wheat and Brun, *Maps and Charts,* no. 464.

Jackson, *Encyclopedia of Philadelphia,* 2: 573.

Philadelphia Gazette, 1 December 1794.

Alfred Coxe Prime, ed., *The Arts & Crafts in Philadelphia, Maryland and South Carolina, 1720–1785* (Topsfield, Mass., 1929), 2: 65 (Allardice), 83.

I. N. Phelps Stokes and Daniel C. Haskell, *American Historical Prints, Early Views of American Cities, Etc.* (New York, 1933), p. 37 (Folie), 38 and plate 29.

United States Gazette (Philadelphia), 28 February, 14 April, 14 October, and 11 November 1794.

Three Watercolor Views by Jeremiah Paul, 1794

(154–56) Dunlap, *Rise and Progress of the Arts of Design,* 2: 102–3.

James Thomas Flexner, "The Scope of Painting in the 1790's," *PMHB* 74 (1950): 74, 79.

(155) Harold Donaldson Eberlein and Cortlandt Van Dyke Hubbard, *Portrait of a Colonial City Philadelphia* (Philadelphia, 1939), p. 383.

Fairmount Park (Philadelphia, 1871), p. 25 (seems incorrect as to date of construction and as to woodcut identified as the Morris house, actually Lemon Hill).

John T. Faris, *Old Gardens in and about Philadelphia* (Indianapolis, Ind., 1932), p. 283, opp. 288 (labeling as The Hills a copy of Breck's drawing of Lemon Hill).

Virginia N. Naudé, "Lemon Hill Revisited," *Antiques* 89 (1966): 578.

Edward Parker, publisher. Engraving, 1824, titled: View of the Dam and Water Works at Fairmount, Philadelphia, drawn by Thomas Birch.

See *Portfolio Magazine* 2 (Philadelphia, 1813): 166, for an engraving titled: A View of Lemon Hill the Seat of Henry Pratt Esqr.

Thompson Westcott, "A History of Philadelphia," *Philadelphia Sunday Dispatch* (1867), chap. 421 (seems incorrect as to date of construction of Lemon Hill).

The Burning of the Lutheran Church, 1794

(157) Stephanie Munsing, ed., *Made in America: Printmaking, 1760–1860* (Library Company of Philadelphia, 1973), no. 16.

Prime, ed., *Arts & Crafts in Philadelphia,* 1: 37 (Joseph Brown).

Views by European Visitors, 1795–98

(158–59) See David John Jeremy, ed., *Henry Wansey and His American Journal, 1794* (Philadelphia, 1970), p. xv and figure 23, noting differences between Wansey's portrayal of the Statehouse and other contemporary views of it.

(161) J. E. Strickland, ed., *Journal of a Tour in the United States of America, 1794–1795, by William Strickland* (New York, 1971), p. 209.

(162– Gilbert Chinard, ed., *Voyage dans l'Intérieur des Etats-Unis et au Canada, par*
63) *Le Comte de Colbert Maulevrier* (Baltimore, 1935), opp. pp. 2, 4.

Two Views of Philadelphia from the West, 1796

(164) Jackson, *Encyclopedia of Philadelphia*, 1: 162 (Holland); 3: 684 (Fox).

 Old Print Shop Portfolio 5 (New York, 1946): 112.

 Stokes and Haskell, *American Historical Prints*, p. 44.

(165) Samuel T. Freeman & Co. catalogue, *Old Philadelphia Prints: The Latta Collection*
 (Philadelphia, 1916), no. 240.

 Jackson, *Encyclopedia of Philadelphia*, 1: 161 (Milbourne); 2: 422–24 (New
 Theater).

 Westcott, "A History of Philadelphia," chap. 417 (theatrical scenes of Philadel-
 phia by Milbourne).

Barralet's Landscape View of Philadelphia from Kensington, 1796

(166) Henry A. Boorse, "Barralet's 'The Dunlap House, 1807,' and Its Associations,"
 PMHB 109 (1975): 131, 145–55 (Barralet).

 Jackson, *Encyclopedia of Philadelphia*, 1: 162, 241 (Barralet).

 Old Print Shop Portfolio 19 (New York, 1959): 50.

The Varlé Map of Philadelphia, 1796

(167) A competing map of Philadelphia, projected by Nicholas Gouin Dufief, Jr., in
 1796, appears not to have been published. See advertisement of the deposit of the
 title for it with the court clerk on 29 April in *Aurora General Advertiser* (Phila-
 delphia), 9 May 1796, *et seq.;* Wheat and Brun, *Maps and Charts,* no. 466; and
 Westcott, "A History of Philadelphia," chap. 618 (Dufief).

 Thomas L. Montgomery, ed., *Pennsylvania Archives, Sixth Series* (Harrisburg,
 Pa., 1907), 5: 514.

 John W. Reps, *The Making of Urban America* (Princeton, N.J., 1965), pp. 161,
 165, 264–65.

 Richard W. Stephenson, "Charles Varlé: Nineteenth Century Cartographer," *Pro-
 ceedings of the American Congress on Surveying and Mapping,* 32d Annual Meet-
 ing (Washington, D.C., 1973), p. 189.

 Westcott, "A History of Philadelphia," chap. 420.

Philadelphia Seen from New Jersey, 1796

(168) Ernest Earnest, *John and William Bartram* (Philadelphia, 140), pp. 90–91.

 Joseph Ewan, *William Bartram: Botanical and Zoological Drawings, 1756–1788*
 (Philadelphia, 1968), p. 9 (critique of his artistic talent).

Two Pen Drawings by a Baltimorean, 1797

(171– Anna Wells Rutledge, "Robert Gilmor, Jr., Baltimore Collector," *The Journal of*
72) *the Walters Art Gallery* 12 (1949): 19.

First Picture of the United States Bank, 1797

(173) Carl W. Drepperd, *American Pioneer Arts & Artists* (Springfield, Mass., 1942),
 pp. 42–43.

Prime, ed., *Arts & Crafts in Philadelphia*, 2: 47–48 (advertisements by Duvivier 1796, 1797).

The Interior of Congress Hall, 1798

(177) William Murrell, *A History of American Graphic Humor* (New York, 1933), 1: 42–43, and plate 36.

(178) *Ibid.,* and plate 37.

 Frank Weitenkampf, *Political Caricature in the United States* (New York, 1953), p. 12.

Benjamin Latrobe's Watercolors, 1798–1800

(179– Talbot Hamlin, *Benjamin Henry Latrobe* (New York, 1955), chap. 8.
93)
 Jackson, *Encyclopedia of Philadelphia*, 4: 1078 (Sedgley), 1173 (pumphouses).

 Oliver W. Larkin, *Art and Life in America* (New York, 1964), p. 92.

 George B. Tatum, *Penn's Great Town* (Philadelphia, 1961), p. 59.

Two Schuylkill River Landscapes in Oil, 1800

(194– James Thomas Flexner, *Light of Distant Skies* (New York, 1954), pp. 118, 186;
95) *idem,* "Scope of Painting in the 1790's," pp. 74, 85–87.

 Larkin, *Art and Life in America,* p. 136.

 J. Hall Pleasants, "Four Late Eighteenth-Century Anglo-American Landscape Painters," *Proceedings of the American Antiquarian Society* 52 (1942): 187.

The Falls of the Schuylkill and East Falls Village in Two Paintings, 1800

(196) Cephas G. Childs, *Views in Philadelphia and Its Environs, from original Drawings taken in 1827–30* (Philadelphia, 1827), respecting "Eaglesfield."

 Dunlap, *Rise and Progress of the Arts of Design,* 3: 322 (Parkyns's Philadelphia employment).

 Kennedy Quarterly 7 (Kennedy Galleries, Inc., New York, 1967): 240–41.

 Thomas G. Morton, *The History of the Pennsylvania Hospital, 1751–1895* (Philadelphia, 1895), p. 322.

 Stokes and Haskell, *American Historical Prints,* pp. 39, 45.

(198) Eberlein and Hubbard, *Portrait of a Colonial City Philadelphia,* pp. 401–3 ("Smith's Folly").

 Jackson, *Encyclopedia of Philadelphia,* 4: 1120–22.

 Lawrence Park, *Gilbert Stuart: An Illustrated Descriptive List of His Works* (New York, 1926), 1: 47, 55; 2: 701–3; 4: 478. Park cites six later copies.

The Birch Series of Philadelphia Views, 1798–1800

(199– For full information as to the volume described, the plates comprising the
236) work, their states, editions of the publication, and reprints, see Martin P. Snyder, "William Birch: His Philadelphia Views," *PMHB* 73 (1949): 271; *idem,* "Birch's Philadelphia Views: New Discoveries," *PMHB* 88 (1964): 164.

Postface

Eighteenth-Century Fictitious Views of Philadelphia

(237) Ellen Starr Brinton, "Benjamin West's Painting of Penn's Treaty with the Indians," *Bulletin of Friends' Historical Association* 30 (1941): 99.

(242) Charles F. Hummel and M. Elinor Betts, eds., *Philadelphia Reviewed* (Winterthur, Del., 1960), p. 7.

St. George Spendlove, *The Face of Early Canada* (Toronto, 1958), p. 83.

Thieme-Becker, *Kunstler-Lexicon* (Leipzig, 1929), 23: 5.

See "The Carington Bowles Reissue of the Scull and Heap East Prospect, 1778."

(243) Pierre Louis Duchartre, *L'Imagerie de la Rue Saint-Jacques* (Paris, 1944).

(244) Mary Dorothy George, *Catalogue of Political and Personal Satires Preserved in the Department of Prints and Drawings in the British Museum* (London, 1935), vol. 5, nos. 5472, 5726, 5726A, 5726B, 5726C, 5727, 5728.

Willard E. Keyes, "The Cow and the Sleeping Lion," *Antiques* 60 (1941): 25.

John Norman, *The Philadelphia Almanack For the Year 1779 Calculated For Pensylvania and the neighbouring Parts*, frontispiece.

Weatherwise's Town and Country Almanack for 1781 (Boston), shows the same scene with background city labeled as New York.

Edwin Wolf, II, *The Annual Report of the Library Company of Philadelphia for the Year 1970* (Philadelphia, 1971), pp. 48–49; ibid. for 1971, pp. 40–42.

(245) *Old Print Shop Portfolio* 29 (New York, 1970): 109.

(246) Reproduced in *The American Heritage Book of the Revolution*, ed. Richard M. Ketchum (New York, 1958), p. 226.

(250) Reproduced in *ibid.*, p. 150.

(252) Sinclair Hamilton, *Early American Book Illustrators and Wood Engravers, 1670–1870* (Princeton, N.J., 1958), 1: 32.

(253) *Ibid.*, p. 33.

(254) Larkin, *Art and Life in America*, pp. 128–29, 132.

James M. Mulcahy, "Congress Voting Independence, The Trumbull and Pine-Savage Paintings," *PMHB* 80 (1956): 74.

Prime, ed., *Arts & Crafts in Philadelphia*, 2: 35.

Theodore Sizer, ed., *The Autobiography of Colonel John Trumbull* (New Haven, Conn., 1953), pp. 316–21; idem, *The Works of Colonel John Trumbull* (New Haven, Conn., 1967), p. 96.

(256) Scharf and Westcott, *History of Philadelphia*, 1: 375–76.

Townsend Ward, "The Germantown Road and Its Associations," *PMHB* 5 (1881): 1, 17.

Eighteenth-Century Views and Maps of the Area Surrounding Philadelphia

(259) "First Map of Pennsylvania under William Penn, 1681," *Bulletin of Friends' Historical Association* 13 (1924): 22.

Worthington Chauncey Ford, "On the First Separate Map of Pennsylvania," *Proceedings of the Massachusetts Historical Society* 62 (1923): 172.

William Penn, *A Brief Account of the Province of Pennsylvania* (London, 1681).

Edward E. Wildman, *Penn's Woods, 1682–1932* (Philadelphia, 1944).

(264) Lawrence C. Wroth, "Joshua Fisher's 'Chart of Delaware Bay and River,'" *PMHB* 74 (1950): 90, 99–101.

(265) *Ibid.,* pp. 104–9.

 Marion V. Brewington, "Maritime History of Philadelphia," *PMHB* 63 (1939): 93.

 Hazel Shields Garrison, "Cartography of Pennsylvania Before 1800," *PMHB* 59 (1935): 255, 279–81.

(269– *Catalogue of the Manuscript Maps, Charts and Plans in the British Museum*
70) (London, 1962), 3: 519.

 G. N. D. Evans, *Uncommon Obdurate: The Several Public Careers of J. F. W. DesBarres* (Salem, Mass., 1969), pp. 20–22.

 Robert Lingel, "The Atlantic Neptune," *Bulletin of the New York Public Library* 40 (1936): 571.

 The Month at Goodspeed's 29 (Boston, 1957): 100–103.

(271– Peter J. Guthorn, *British Maps of the American Revolution* (Monmouth Beach,
78) N.J., 1973), p. 58, items 22–24.

 Howard C. Rice, Jr., ed., *Travels in North America . . . by The Marquis de Chastellux* (Chapel Hill, N.C., 1963), 1: 148, 313, fn. 66.

 G. D. Scull, ed., "Journal of Captain John Montrésor, July 1, 1777 to July 1, 1778," *PMHB* 6 (1882): 295; and Henry Cabot Lodge, ed., *Major André's Journal* (Boston, 1903), 1: 83–88 (contemporary British accounts of the battle).

(279) Prime, ed., *Arts & Crafts in Philadelphia,* 2: 82 (the plan advertised for sale).

(279– Henry Cabot Lodge, ed., *Major André's Journal* (Boston, 1903), 1: 92–95 (ac-
82) count by André).

 Henry Pleasants, Jr., "The Battle of Paoli," *PMHB* 72 (1948): 44.

 See (321).

(283– Paul G. Atkinson, Jr., "Archaeological Sites Along Valley Creek, Valley Forge,
87) Pa., *The Picket Post* (Valley Forge Historical Society, July, 1972), p. 19.

(288– Rice, ed., *Travels in North America,* 1: 170–72, 324, fn. 98.
93)

 Justin Winsor, *Narrative and Critical History of America* (Boston, 1887), 6: 443.

(294– Walter W. Ristow, "Maps of the American Revolution: A Preliminary Sur-
302) vey," *Quarterly Journal of the Library of Congress* 28 (Washington, D.C., 1971): 196, 206 (Erskine, DeWitt).

(306) P. Lee Phillips, *A Descriptive List of Maps and Views of Philadelphia in the Library of Congress* (Philadelphia, 1926), no. 321.

(306– Guthorn, *British Maps,* p. 57, items 11 and 13.
10)

(315) For a discussion of the date and the attribution to Peale, see Charles Coleman Sellers, *Charles Willson Peale with Patron and Populace* (Philadelphia, 1969), p. 15.

(321) Reproduced in *The American Heritage Book of the Revolution,* ed., Richard M. Ketchum (New York, 1958), p. 225.

(323) J. Jefferson Miller, II, "Unrecorded American Views on Two Liverpool-Type Earthenware Pitchers," *Winterthur Portfolio* 4 (Charlottesville, Va., for The Henry Francis du Pont Winterthur Museum, Winterthur, Del., 1968): 109–10, 112–13.

Index

HEAD-QUARTERS,

THE General has been informed
reported, that it is the Design and
Army, to burn and destroy the C
and scandalous Report, he thinks it ne
remain in the City, that he has received
Congress, and from his Excellency Gener
City of Philadelphia, against all Invaders
Attempt to burn the City of Philadelphia
out Ceremony, punish capitally any Incen
to attempt it.

The General commands all able bodied
conscientiously scrupulous against bearing
fore to entertain such Scruples, to appear
at ten o'Clock, with their Arms and A
with; the General being resolutely deterr
idle Spectator of the present Contest, wh
Cause, or who may refuse to lend his A
entious Scruples, as before mentioned, or

All Persons who have Arms and Acc
to employ in Defence of America, are h
TOWERS, who will pay for the same. T
or Accoutrements will be severely punishe

IS.